THE MEXICAN MURALISTS IN THE UNITED STATES

The MEXICAN

FOREWORD BY DAVID W. SCOTT

University of New Mexico Press
ALBUQUERQUE

MURALISTS

in the United States

LAURANCE P. HURLBURT

Para Dolores.

Library of Congress Cataloging in Publication Data

Hurlburt, Laurance P., 1937-
 The Mexican muralists in the United States / Laurance P. Hurlburt,
 foreword by David W. Scott. — 1st ed.
 p. cm.
 Bibliography: p.
 Includes index.
 ISBN 0-8263-1134-2
 1. Mural painting and decoration, Mexican—United States.
2. Mural painting and decoration—20th century—United States.
3. Politics in art. 4. Orozco, José Clemente, 1883–1949—Criticism
and interpretation. 5. Rivera. Diego. 1886–1957—Criticism and
interpretation. 6. Siqueiros, David Alfred—Criticism and
interpretation. I. Title.
ND2608.H84 1989
759.13—dc19
88-30000
CIP

Designed by Tina Kachele

CONTENTS

FOREWORD

David W. Scott

Of all the murals painted during the long history of mural painting in the United States, the most powerful and colorful group came from the hands of three Mexican artists during a few short years in the 1930s. The first of these, José Clemente Orozco's *Prometheus* at Pomona College in Claremont, California, was begun in April 1930, within a few blocks of my home. At that time I was thirteen years old and totally unaware of the drama that was being played out at Frary Hall, the new men's dormitory and refectory at Pomona. Within a few short years, however, I had become infected by the excitement over art that was in the very air of the Claremont Colleges, and Orozco's *Prometheus* had become my touchstone for greatness.

It is impossible to assess all the varied impacts of that mural on the students who have attended the college and the artists who have come to know it. In my own case, I have been constantly inspired, as an artist, by Orozco's humanity and expressive vigor. As an art historian who lived many years in Claremont, I must at the same time concede that almost no California painters—even the muralists—reflect a direct influence, perhaps because few shared Orozco's tragic sense of the human condition. Rico Lebrun, in his great *Job* mural, also at Frary Hall, is the outstanding exception, but Lebrun, for all his technical subtlety and the violence of his distortions, casts veils over his content in a manner quite foreign to Orozco's outspoken expressiveness. Before the war, painting in Southern California, in general, joined in uncritical praise of landscape and life, of the delights of the perceived world and of creating art. Nationwide, however, we have many echoes of the Mexicans in our heritage of New Deal murals. After the war, as Laurance Hurlburt points out in his introduction, America's mood was more critical and questioning, but directed inwardly. No one presented large-scale challenges to the public's conscience, as *los tres grandes* had the generation before.

This is not to say that the art of Orozco and, in some aspects, that of Siqueiros, do not lead into postwar American expressionism. As cases in point, Francis V. O'Connor has noted the apparent influence of both artists on Pollock, and the description of Siqueiros's Workshop method, quoted by Hurlburt, strongly reminds one of Pollock's later technique.

Orozco's tragic epics may also be seen as unique American precursors of the moving, monumental ensembles painted by Barnett Newman and Mark Rothko in the sixties (*The Stations of the Cross* and the de Menil Chapel). These examples, however, were rare in intent; the general course of American art until the seventies was toward increasing disengagement from subject matter (from abstract expressionism to color fields and minimalism to optical and pattern art) and even from painting itself (conceptual art). Counter currents, leading to funk art and cartoonlike forms, bring us back again to Orozco and Rivera, who had on occasion monumentalized caricature unforgettably. Caricatured distortions are a hallmark of the new mural movement enjoying a renaissance in Los Angeles, New York, and the entire country. This movement cannot, of course, be considered a simple reincarnation of the thirties murals, but it constantly recalls the work of the Mexicans in audacity, raw vigor, and social concern. The outdoor location has precedence in the Mexicans' social credo, and particularly in Siqueiros's Olvera street painting. Recent murals in the Southwest display a vigorous outburst of Chicano painting, which frequently reveals explicit cultural ties to the work of *los tres grandes*.

Thus it is not apparent that strands from the Mexican mural movement are by now woven firmly into the fabric of art in the United States. The question follows: how well do we know the history of that movement, and especially of the murals painted in this country in the thirties? What is their ideological content and background? How were they painted technically? How do they come about, and what motivated the commissions and the artists?

These questions have not previously been addressed systematically, impartially, and in depth. This book supplies a much needed survey based on extensive original research by the author and on a number of recent studies of various topics by scholars in the field. Of particular interest are the insights gained from interviews by Mr. Hurlburt with still-living participants in the scenes of the thirties—sources of first-hand memories that will soon be no longer available.

In the notes preceding the bibliography, Mr. Hurlburt describes the shortcomings of the books that have customarily served students of the period both as orientation and source material. The surveys of modern Mexican painting by Laurence Schmeckebier, Bernard Myers, and Justino Fernández are, by their very scope, unable to devote a thorough treatment to the murals in the United States. When it comes to the biographies of Orozco and Rivera, the prime sources are unfortunately neither entirely trustworthy nor—from the art historian's viewpoint—systematic and complete. This is particularly and lamentably true of Alma Reed's *Orozco*. The fantasies of that loyal supporter and promoter of the artist have never been exposed before. It has been assumed that, because she was so intimately connected with his three North American mural projects, her writings are valid source material. The reader of Hurlburt's account of the story behind the *Prometheus* will discover that not only Miss Reed but also the artist's other principal supporter, José Pijoan, painted verbal pictures from lively, self-serving imaginations. Regrettably and inevitably, some of their assertions have found their way into reputable secondary sources.

Fortunately, the passage of time has given us a historical perspective as we look back on red flags and partisanships. The works of the period speak more clearly than ever, partly because of our increasing political and aesthetic objectivity, partly because of better understanding resulting from the investigations of recent scholars, and partly because of the quality of preservation and restoration to the murals themselves. Only the work of Siqueiros is in large part lost to us today. Rivera's murals in San Francisco and Detroit are still eloquent, however much we must regret the loss at Rockefeller Center. Orozco's three great works have fortunately been restored to their original freshness. It is especially gratifying that the paint-

ings at the New School, long in such poor condition as to be impossible to assess and at the same time often dismissed as relatively unsuccessful, now stand fully revealed and have been judged by Roberta Smith of the New York *Times* as "a remarkable tour de force, a piece of history full of contemporary life and freighted with messages about both the power of freedom and the power of art." At long last New York can show with pride at least one major work to represent the movement and the three masters.

As a new generation of critics, scholars, artists, and laymen recognizes the strength of the Mexican murals and their historical and contemporary revelance, it is especially important for us to have Laurance Hurlburt's comprehensive account of this dramatic infusion from Mexico into the stream of our national life.

ACKNOWLEDGMENTS

I wish first to express my gratitude to the National Endowment for the Humanities, whose Division of Research Programs grant during 1980 and 1981 enabled me to conduct research and travel to various mural sites in the United States and Mexico; indeed, without these funds I could not have undertaken this research project. Moreover, I especially appreciate the interest of then Deputy Chairperson Patricia McFate, whose pertinent suggestions regarding preparation of the research proposal greatly assisted me. I would also like to credit the assistance of the following individuals and institutions in the research and writing of *The Mexican Muralists in the United States*.

In New York, I first approached the New Deal and Jackson Pollock scholar Francis V. O'Connor in 1970 (as Pollock had been a member of Siqueiros's New York Workshop), and he has from the beginning generously given his encouragement and astute criticism of my work on the Mexicans. I also thank him for reading the first draft of the manuscript and suggesting improvements in structure and content. Harold Lehman provided me with important written and visual documentation concerning the Siqueiros Experimental Workshop and discussed his association with Siqueiros in Los Angeles in interviews and correspondence. Reuben Kadish shared his interviews concerning his work with Siqueiros in Los Angeles and the murals he and Philip Guston collaborated on during the 1930s in Los Angeles and Mexico. At the Museum of Modern Art Library, the Latin American bibliographer at this time, James Findlay, shared with me his knowledge of the library's excellent Latin American collection. Albert Landa, vice-president of research and development for the New School for Social Research, provided me with the little extant documentation in New School files regarding the Orozco murals, and Dr. William B. Scott of Kenyon College's History Department provided me letters from the Alvin Johnson Papers, Yale University Library. I must also thank Curtis Clow, archivist of the private archives of the Messrs. Rockefeller; the Rockefeller Center Archives; and Mary-Anne Martin, then in charge of Sotheby's Latin American department.

In Washington, D.C., while writing my M.A. thesis, I sought out Dr. David W. Scott, whose pioneering study of Orozco's first North Ameri-

can mural, the *Prometheus* at Pomona College, I greatly admired. Dr. Scott kindly read my thesis, gently pointed out its imperfections, and has since stimulated my interest in the Mexicans. Further, I thank him for allowing me to use research material he brought together on the *Prometheus* during the early 1950s, for sharing his knowledge and appreciation of Orozco's art with me in interviews and correspondence, and for his critical reading of the first draft of the Orozco chapter. I gratefully acknowledge the assistance of Garnett McCoy, senior archivist of the Archives of American Art; the staff of the National Museum of American Art, particularly William Walker, librarian, Dr. Lois Fink, and Eleanor Fink, chief of the Office of Visual Resources, for her aid in consulting the Juley Photography Archives; Thomas Beggs, a member of the Pomona College art faculty when Orozco worked there, for taping his recollections of this period; and Arq. Alberto Campillo, Cultural Attaché at the Mexican Embassy, for his interest in my work.

In Hanover, New Hampshire, Kenneth Cramer, archivist of Dartmouth College, provided valuable help, as did Anne Scotford, Dartmouth College Photographic Records; Margaret Moody, registrar of Dartmouth College Hopkins Center Art Gallery; and Churchill Lathrop, a Dartmouth College Art Department member during Orozco's time in Hanover.

In Detroit, I must thank Linda Downs, curator of education at the Detroit Institute of Arts, for selecting me to organize the NEH symposium and allowing me to incorporate into my book the results of her extensive research on Rivera's *Detroit Industry* murals at the Detroit Institute of Arts. Her patience in dealing with my many questions on Rivera and her insightful comments on the first draft of the Rivera chapter are greatly appreciated. Professor Dorothy McMeekin of the Michigan State University Natural Science Department permitted me to use her published and unpublished articles on the small scientific panels from Rivera's Detroit mural cycle.

In the San Francisco area, Stephen Pope Dimitroff and Lucienne Bloch Dimitroff, assistants to Rivera in Detroit and New York, provided detailed recollections of this period, and Mrs. Bloch Dimitroff offered her superb photographic documentation of these mural projects. I thank Harry Mulford, then archivist of the San Francisco Art Institute; Paul Karlstrom of the Archives of American Art (West Coast branch); and at the San Francisco Museum of Modern Art, Deputy Director Michael McCone, Katharine Holland of the Permanent Collections Department, and Librarian Eugenie Candau. Mr. and Mrs. Richard Goldman; Edward Bettini, manager of the San Francisco Stock Exchange Luncheon Club; Peter Stackpole; and Dr. James D. Hart, director of the Bancroft Library, University of California–Berkeley, all were helpful. Mrs. Masha Zakheim Jewett personally led a tour of local WPA-FAP murals, arranged a meeting with her father, Bernard Zakheim (one of the Coit Tower muralists), and allowed me to consult her interview notes with Michael Goodman, the interior designer of the San Francisco Stock Exchange Luncheon Club. The Hoover Institution on War, Revolution and Peace (Stanford University) permitted me access to the voluminous Bertram Wolfe Collection, which contains many of Rivera's papers from his North American years. Emmy Lou Packard, an assistant to Rivera at his Golden Gate International Exposition mural (1939–40), shared her recollections of that time, and Professor John D. Goheen (University Ombudsman, Stanford University) shared his correspondence dealing with Orozco's time at Pomona College and allowed me to publish drawings for the *Prometheus* from his collection—studies for which Professor Goheen posed. I would also like to thank Sotheby's and Mary Anne Martin for assistance with Rivera's California mural studies.

In Claremont and Los Angeles, Mr. and Mrs. Earl Merritt, rectors of Pomona College Frary Hall (the site of Orozco's *Prometheus*) in 1930, shared their reminiscences over a lengthy interview and later related correspondence. Dean of Students Emeritus Sheldon Beatty and Mrs. Caroline Beat-

ty described the general ambiance of Pomona College and offered me Mrs. Beatty's archival research. Pomona College officials, especially Virginia Crosby, then special assistant to President David Alexander, and Sandra Doubleday, director of the Pomona College News Bureau, facilitated my investigation of Pomona College administrative records; Jean Beckner and Tania Rizzo of the Claremont Colleges Honnold Library Special Collections Department gave their enthusiastic attention to my research needs; and Jean Ames, emeritus professor of the Scripps College Art Department, recalled watching Orozco paint the *Prometheus*. Dr. E. Wilson Lyon, president emeritus of Pomona College and author of *The History of Pomona College, 1887–1969*, spent time discussing the period with me. Marjorie Harth Beebe, director of galleries of the Claremont Colleges, was most helpful. Nathan Zakheim provided me with a detailed description and diagrams of his restoration of the *Prometheus*. Jean Bruce Poole, director of El Pueblo de Los Angeles State Historic Park (in the Olvera Street district, where Siqueiros painted his *Tropical America* in 1932) provided photographic documentation. Katherine Grant, Los Angeles Public Library art and music librarian, supplied me with relevant documentation from the period, and Jacob Zeitlein, art dealer and book seller, had numerous helpful recollections of Siqueiros's time in Los Angeles. Professor Robert Hansen of the Occidental College Art Department described his experiences as a youthful student of Siqueiros's in San Miguel de Allende.

In Mexico, Sra. Angélica Arenal de Siqueiros permitted me access to Siqueiros's archives during my dissertation research in 1973. Sra. Lucrecia Orozco, Orozco's daughter, and the artist's widow, Sra. Margarita Valladares de Orozco, provided me with photographs of studies for Orozco's North American murals. Srta. Berta Valdivia, then secretary of the Museo José Clemente Orozco in Guadalajara, shared with me her knowledge of Orozco's later years in Guadalajara and Orozco familial relationships. Lic. Ester R. de la Herrán de Martínez and her staff at the Instituto Nacional de Bellas Artes branch, the Departamento de Documentación e Investigación, supplied me with important documentation the office has collected from various Mexican sources on Rivera, Orozco, and Siqueiros. Sr. Armando Colina, director of the Galería Arvil, was most kind in contacting people on my behalf. Sr. Roberto Berdecio gave a lengthy interview on his association with Siqueiros during the 1930s. I thank Professor Xavier Moyssén of the National University (UNAM) Instituto de Investigaciones Estéticas and Sra. Ruth Sample Gutíerrez, widow of the artist and technician José Gutíerrez, for her interviews regarding Gutíerrez's time in the United States during the 1930s and his later work with Siqueiros. Sr. Gilberto Crespo Iglesia gave biographical information concerning his father, Orozco's assistant at Pomona College, Jorge Juan Crespo de la Serna.

In New Mexico I am indebted to my editor, Dana Asbury, for her conscientious work on my manuscript. Her detailed attention to matters of craft, such as simplification of my prose style and improvement of syntax, has resulted in a far more effective presentation of my material.

In Wisconsin, Professor James M. Dennis of the University of Wisconsin–Madison Art History Department, and my former major professor, read the first draft of the manuscript. Dr. Murray Fowler, professor emeritus, University of Wisconsin English Department, shared recollections of his time as Orozco's roommate at Pomona College and permitted me to publish a study for the *Prometheus* from his collection. My typist and friend, Genny Mittnacht, was a source of never-failing patience and good humor and superb work during the preparation of three manuscript drafts. Finally, I thank my wife for introducing me to the mural art of *los tres grandes*, for traveling with me throughout this country and Mexico as project research assistant, and for her devoted interest, criticism, and support of my work over more than a decade and a half.

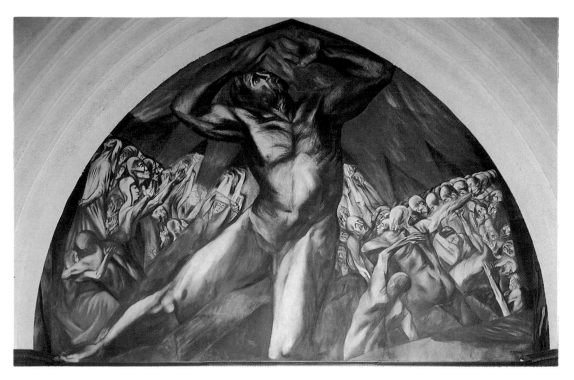

1. José Clemente Orozco, *Prometheus*, Pomona College, 1930. Fresco, 20 x 28.5 ft. (*Courtesy of David Scott, plates 1–3.*)

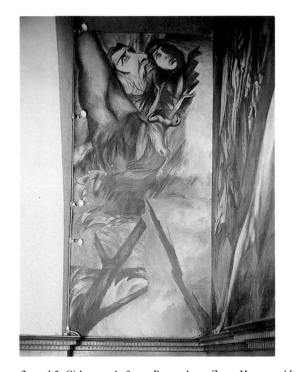
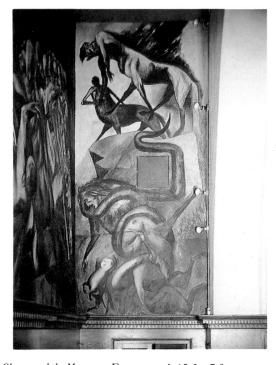

2. and 3. Side panels from *Prometheus: Zeus, Hera, and Io* and *Chaos and the Monsters*. Fresco, each 15.3 x 7 ft.

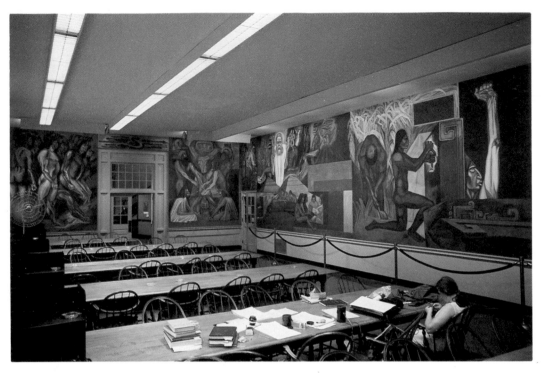

4. José Clemente Orozco, Pre-Cortesian section of the Baker Library mural, Dartmouth College, 1932–34. (*Courtesy of Dartmouth College, plates 4–6.*)

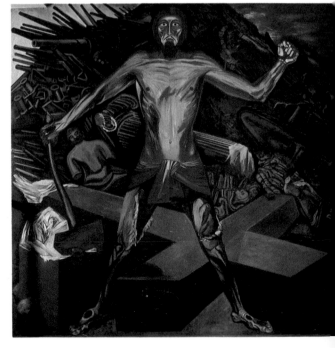

5. and 6. *Ancient Human Migration* and *Modern Migration of the Spirit.*

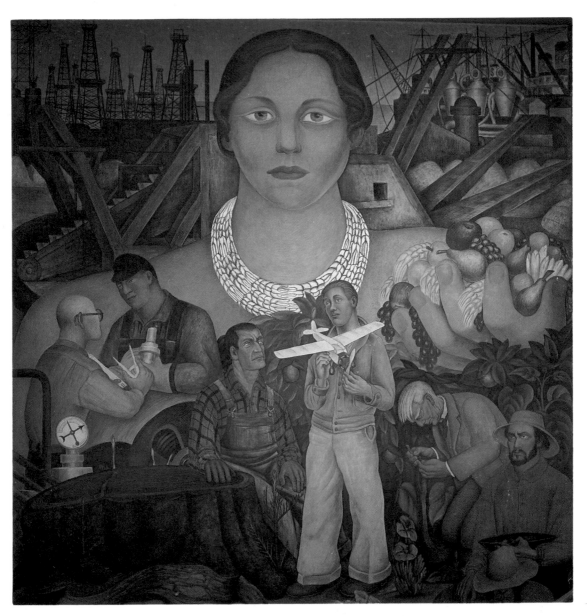

7. Diego Rivera, *Allegory of California* (detail), San Francisco Stock Exchange Club, 1930. (*Courtesy of Orville O. Clark, Jr.*)

8. Diego Rivera, Stern home mural, Atherton, California, 1931.

9. Diego Rivera, California School of Fine Arts mural, 1931.

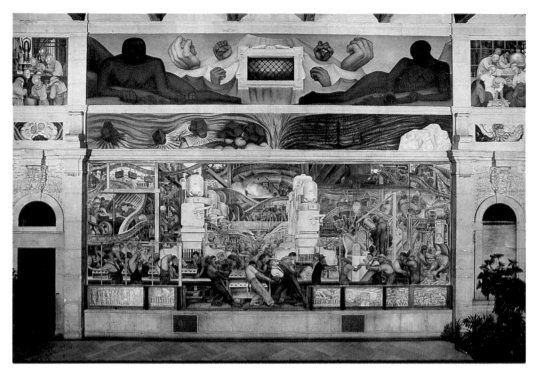

10. Diego Rivera, *Detroit Industry*, north wall, 1933. (*Courtesy of the Detroit Institute of Arts. Founders Society Purchase, Edsel B. Ford Fund and Gift of Edsel B. Ford, plates 10–11.*)

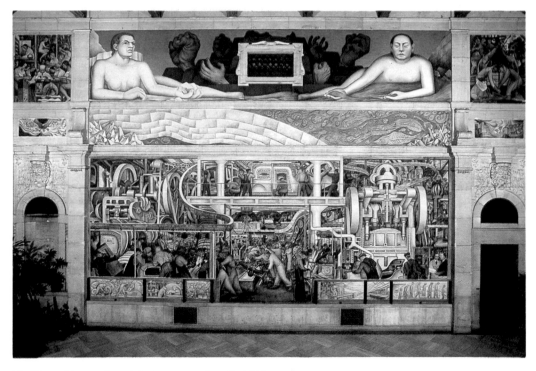

11. Diego Rivera, *Detroit Industry*, south wall, 1933.

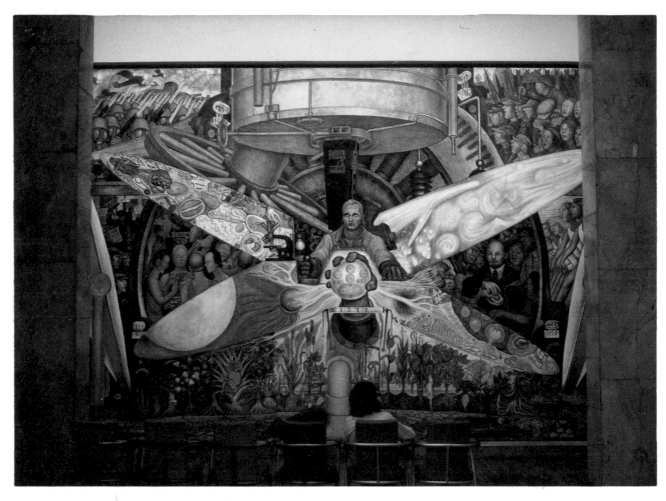

12. Diego Rivera, later version of of the Rockefeller Center mural, National Palace of Fine Arts, Mexico City, 1934.

13. David Alfaro Siqueiros, *Portrait of Present-Day Mexico* (detail), Santa Monica, California, 1932.

14. David Alfaro Siqueiros, *Collective Suicide*, 1936. Duco on wood with applied sections, 49 x 72 in. (*Courtesy of the Museum of Modern Art, New York, gift of Dr. Gregory Zilboorg.*)

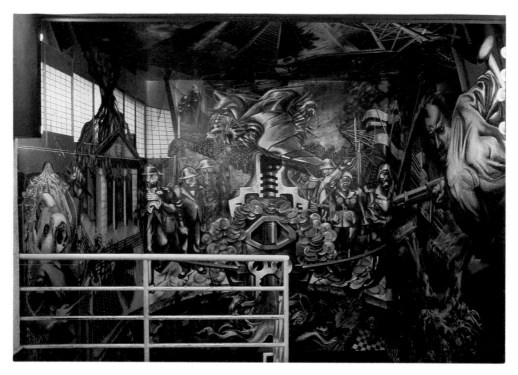

15. David Alfaro Siquieros, *Portrait of the Bourgeoisie,* Mexican Electricians Union, Mexico City, 1939–40. Nitrocellulose pigment on cement.

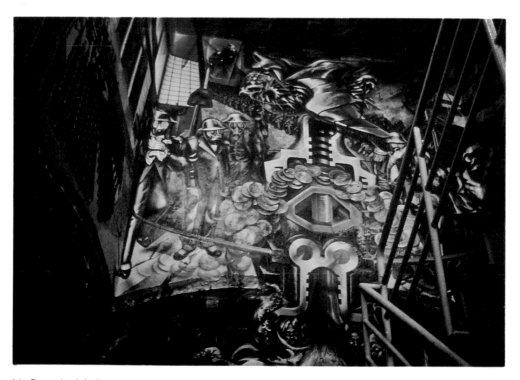

16. *Portrait of the Bourgeoisie,* view from below.

THE MEXICAN MURALISTS IN THE UNITED STATES

INTRODUCTION

My interest in the murals of José Clemente Orozco (1883–1949), Diego Rivera (1886–1957), and David Alfaro Siqueiros (1896–1974) arose from viewing their work in Mexico in the late 1960s. A decade earlier, while I was an undergraduate at Dartmouth, Orozco's panels on civilization on the American continent had, alas, loomed far over the head of a youth both politically naive and ignorant of art history. My wife, Dolores Valdivia Hurlburt, already knew the murals of *los tres grandes* ("the big three," as the artists are known in Mexico); indeed, her engineer-cousin, Ing. José Luis de la Mora Araiza, had directed the architectural restoration of the Hospicio Cabañas in 1955, the site of Orozco's largest mural cycle in his native city of Guadalajara. She persuaded me to see their work at first hand. I found myself captivated by the painted walls of Mexico that succeeded in integrating monumental painting infused with sociopolitical commentary with its architectonic environment. Rivera's murals in Mexico City are superb examples, especially his encyclopedic depiction of Mexican cultures, geography, work, and customs at the Secretariat of Public Education (1923–28) covering some 1,600

square meters of wall space, in which he also managed to synthesize the highly diverse imagery of the 124 panels into a Marxist-oriented view of postrevolutionary Mexico. Then the visual and political dynamism of Siqueiros excited me, such as his murals at Chapultepec Castle (1957–66) depicting the overthrow of the dictatorial Porfirio Díaz regime by the surging force of revolutionary socialism. My supreme experience, however, came in viewing Orozco's three Guadalajara murals (1936–39); first, I reacted to the sheer intensity and immediacy of the painting, which marks Orozco's Dionysian creativity at its most exalted state. Beyond this the artist portrayed a fiercely independent political point of view in these works that proclaimed Marxism *not* to be the salvation of twentieth-century Mexico. His position not only ran counter to those of Rivera and Siqueiros, but also presented a boldly opposing outlook during the progressive administration of Lázaro Cárdenas (1934–40).

My enthusiastic response to the Mexicans' murals led me to graduate research, when I discovered the important, if largely unexplored, topic of the activities of Orozco, Rivera, and Siqueiros

3

in the United States during the 1930s. For Orozco and Siqueiros, these years constituted a "breakthrough" period in terms of style and content, and in Siqueiros's case in technique as well. In contrast, Rivera arrived in this country a mature artist and accomplished fresco master who would treat comprehensively for the first time in his mural art the themes of modern industrial technology and capitalism. During the 1930s—the decade of the "Mexican craze" or "Mexican invasion," as contemporary art critics termed it—these artists created masterworks (Orozco at Pomona and Dartmouth colleges, Rivera at the Detroit Institute of Arts) and enjoyed immense critical and popular acclaim. Moreover, the example of the Mexicans' murals in their own country from the 1920s supplied the impetus for the public support of United States' artists through the various New Deal art projects. The Mexicans' art directly addressed the central concerns of North American intellectuals and artists during the early and mid-1930s, which cultural historian Richard H. Pells has termed the "twin doctrines of community and collectivism."[1] In their staunch affirmation of a public art of social commitment that could bring the artist into meaningful contact with society at large, the Mexicans offered a concrete alternative to the growing sense of alienation and isolation felt by North American intellectuals. Further, the Mexicans provided the artistic model writers such as Edmund Wilson called for, artists willing to confront daily life, to commit themselves, to *act*. Thus, North American artists looked to the Mexicans as cultural and political heroes whose murals of the 1920s (particularly Rivera's at the Secretariat of Public Education, Chapingo, and Cuernavaca) were seen as integral expressions of the new postrevolutionary Mexican society. North American intellectuals and artists also looked to the Marxist political stance of Rivera and Siqueiros as a possible way out from the apathy, hopelessness, and confusion of the early 1930s, for "values and commitments more suitable to their sense of moral outrage at the chaos and brutality of the capitalist system."[2] The Mex-

icans were examples of artists who had discovered the realities of their native land through the cataclysmic upheaval of the Mexican Revolution of 1910–20 that dwarfed the disruption, however massive, of our depression. Critics such as Wilson and Matthew Josephson were also urging North Americans to discover their native roots in their essays in *The New Republic*.

Orozco's New School for Social Research murals (New York, 1930–31) can be seen as a visual portrayal of the causes championed by pro-Marxist intellectuals during the depression era. Pells describes them as characterized by "social commitment over personal independence, cohesiveness over fragmentation, the community over the individual."[3] Although these panels are uncharacteristic of Orozco's typical pessimistic view of the human condition, they read as illustrations to the writings of social critics such as Lewis Mumford, John Dewey, and Charles Beard. The series begins outside the walls of what was then the refectory with an allegory depicting the cooperation of artist, scientist, and worker to improve the lot of mankind. Following in axial sequence inside are panels picturing a contented and well-nourished (both in terms of food and culture) proletarian family, and various races and creeds seated at "The Brotherhood of Man." On the side walls Orozco painted what progressive intellectuals posited as radical alternatives to capitalism and imperialism: Mexico (notably the Yucatán of socialist Felipe Carrillo Puerto), the Soviet Union, and India. The paintings mirror Charles Beard's contention of the vital importance of education for the new American society, and the fundamental lesson to be taught in the classroom: "the subordination of personal ambition and greed to common plans and purposes."[4]

Beyond the role models of Rivera, Orozco, and Siqueiros as socially committed public artists and their profound influence on North American artists during these years lay the more general attraction of Mexico itself to North American intellectuals. They saw in the Mexican pueblo (the small village or town, as opposed to urban

centers, especially Mexico City) a viable alternative to the individualism and competition, the concern for acquisition as an end in itself, mechanization and the specialization of labor, and the overproduction and unemployment of contemporary United States society. Waldo Frank, a contributing editor of *The New Republic* at this time, wrote of "Mexico's immediate importance to all intelligent citizens of the United States" as he contrasted her culture—"an incarnate spirit of the soil"—to "our culture in agony: the *rigor mortis* of death."[5] *Pilgrimage* was the word Frank used to describe the nature of the trips made by North American intellectuals to Mexico during the late 1920s and early 1930s, and "devotional" the tone of the books that subsequently appeared. Writers such as Stuart Chase, Carleton Beals (both of whom had books illustrated by Rivera), Ernest Greuning, Frank Tannenbaum, Hubert Herring, and Anita Brenner projected Mexican society above all as "organic," as a functional, economical, ordered, and sane pattern of life. Intellectuals viewed the Soviet Union in much the same way at this time, although, of course, the USSR represented a far more comprehensive and industrial-oriented social experiment. Chase contrasted Mexico, "an organic, breathing entity," with the United States, "the vast, sprawling body of mechanical civilization."[6] Chase buttressed his impressions of Mexican rural society and popular culture with references to Robert Redfield's pioneering anthropological study *Tepoztlan, A Mexican Village* (1930; the Mexican counterpart of the Lynds' *Middletown*) and saw almost an ideal state of mankind:

> Men are governed not by clocks but by the sun and the seasons; recreation is not a matter of paid admissions or forced disciplines, but as spontaneous as eating. The individual to survive must learn many useful crafts; he does not atrophy his personality by specializing in one. Costs . . . are lower for many articles than is conceivable under the most efficient methods of mass production, and all work is directed to specific function with a maximum economy and a minimum of waste. Overproduction is as

> unthinkable as unemployment. Life in a handicraft community is to be lived, not to be argued about, to be thwarted by economic conditions or postponed hopefully until one has made one's pile.[7]

Chase did detect flaws in Mexican society; he particularly abhorred what he called the "white Mexican" and his habitat of Mexico City, but his selective view of contemporary Mexico ignored the repressive nature of the regimes controlled by Plutarco Elias Calles during the late 1920s and early 1930s that violently suppressed leftist movements and resulted, to cite one case, in Siqueiros's exile in 1932. Later in the decade, North American artists and intellectuals would be overwhelmed by conditions in Europe—the rise of Fascism and the accompanying events of the Spanish Civil War, the invasions of Poland and Finland, the Nazi-Soviet nonaggression pact, as well as the disturbing revelations regarding Stalin's purges in the Soviet Union. In response they saw their political role as supporters of the pragmatic approach of the New Deal rather than of any radical restructuring of North American society. In turn, artists in the United States rejected the cause of radical social commitment to nationalism and the glorification of "the American way," and their art, now focused on European examples instead of Mexican, became more formally and personally oriented. Yet, for most of the depression era, North American intellectuals embraced with a fervor the example of "Mother Earth" Mexico (Rivera had used this specific imagery in his Chapingo murals) as a replacement for the moribund American Dream. They viewed Mexico as a society "that contrasts poignantly with our lost-ness and strangeness among our own blood-people in Middletown and Mainstreet."[8] Our artists saw in the work of Rivera, Orozco, and Siqueiros an ideal of reforming art to address the day-by-day existence of the common person, thereby creating a new communal sense in our society. This passion flickered throughout the post–World War II decades as many artists who came of age during the depression and subse-

quently became college and university art instructors continued to cling to their dreams for the social commitment of art that had been so brilliantly exemplified by the Mexicans' murals. They traveled with their students to see the work *in situ*. North American interest in the Mexicans burst once more into flame in the late 1960s with a new generation of young American artists-activists. Many of these younger artists were the politically and socially oppressed of the black, Chicano, and Asian ghettoes and sought to emulate the example of the Mexicans' monumental political art and particularly the radical confrontational rhetoric and massive foreshortened figures of Siqueiros, the last surviving member of *los tres grandes*. The hundreds of community murals created throughout the country have, to this point at least, produced only a faint echo of the towering achievements of their Mexican masters.

Orozco's North American years, 1927–34, must be seen as a period of enormous significance in his artistic evolution. In the *Prometheus* (Pomona College, Claremont, California, 1930), Orozco achieved by direct, painterly means his first completely developed expression of the theme of the creative rebel who heroically sacrifices himself for the good of man, a motif that dates back to Orozco's first murals of 1923–24, most of which he destroyed. Next, working under the strict compositional tenets of "Dynamic Symmetry" at the New School for Social Research, Orozco treated in far less successful paintings various twentieth-century revolutionary and independence movements (Mexico, the Soviet Union, India), and illustrated—most uncharacteristic themes for Orozco—his conceptions of the brotherhood of man and a harmonious proletarian class. Finally, at Dartmouth College (Hanover, New Hampshire, 1932–34) Orozco created his most ambitious mural program in this country, covering some 3,000 square feet of the Baker Library Reserve Room. Here Orozco turned from the rigid compositional scheme of the New School murals to a

much freer geometrical armature for his panels. Technically the works reveal an ever-increasing spontaneity in drawing, design, and brushwork. At Dartmouth Orozco presented an interpretation, rather than a historical narrative, of the development of civilization on the American continent from its origins to the present day. In the pre-Conquest section he further explored the central thematic concern of his North American murals, the creative rebel who acts for mankind, here with the greatest of all indigenous American gods, Quetzalcoatl. In the purposefully jarring images of the post-Conquest scenes Orozco pictured the Spanish Conquest and twentieth-century subject matter: industrialism, Anglo and Hispanic-American societies, education, and nationalism. Here the artist rejected the doctrinaire socialism of the New School murals, and his savagely independent criticism of contemporary society directly anticipated the even further heightened sociopolitical negativism of the Guadalajara murals.

Although Orozco's North American murals exhibit various stylistic, expressive, and thematic concerns, David Scott has also correctly noted what he terms the "kinship" of the three cycles involving Orozco's philosophical conception of mankind. All the programs address themselves to these underlying motifs: an initial higher source, a hero drawing on this source, the overthrow of corrupt orders, the role of the hero(es) and the masses, and, finally, the ultimate hope for better future orders of mankind.[9]

Rivera had far greater success regarding mural commissions and critical acclaim than did his compatriots during the "Mexican invasion" period, which attests not only to his artistic genius but also to his enormous skills in the arena of public relations. Earlier, in Mexico during 1924, he alone maintained government support despite the shift in Education Ministry directors (the governmental patron of the muralists), and in the ensuing years he obtained so many large-scale public commissions that by 1930 his disgruntled colleagues took to calling him "the hog of walls." Also, Rivera alone had secured a North American commis-

sion in Mexico; in 1929 U.S. Ambassador Morrow had donated a handsome fee for Rivera to paint at the Palace of Cortés in Cuernavaca. Finally, only he arrived in the United States with a mural contract in hand. From 1930 to 1933 Rivera's career blazed incandescently across the country, as he, a self-proclaimed Marxist artist, paradoxically worked for blue-chip capitalist patrons from coast to coast.

Although Rivera's North American murals generally retain the stylistic tendencies and technical means of the Mexican works of the 1920s, in this country Rivera would work with completely new subject matter: twentieth-century North American industrial technology and its relationship to capitalism. Rivera's lifelong interest in mechanical objects and their operations dated back to his childhood, when he had been nicknamed "the engineer." It must have been stimulated with his arrival in San Francisco in late 1930, as he immediately immersed himself in sketching the Bay Area industrial environment. Yet Rivera arrived at a comprehensive treatment of his new thematic interests gradually, as his three San Francisco murals, begun in late 1930, depicted industrial objects only superficially. Further, in these murals Rivera chose to muffle the revolutionary ideology of his earlier Mexican works.

After returning to Mexico during the summer of 1931, Rivera arrived in New York later that year to complete "portable" fresco panels for his one-man Museum of Modern Art retrospective—a hugely successful event that captivated critics while breaking all MOMA's attendance figures. Working at the Detroit Institute of Arts during 1932 and 1933 Rivera produced his masterwork of this period, a twenty-seven-panel mural that brilliantly portrays a comprehensive picture of the worker's role in the contemporary industrial milieu of Detroit while it comments on the prospects of creating good or evil with machine technology. In the last two mural projects of this time, both painted in New York during 1933 (Rockefeller Center and the New Workers School), Rivera

turned to increasingly leftist political subject matter. His North American success ended suddenly and finally with the Rockefeller Center controversy. Rivera came close to completing a mural calling for the socialist transformation of North American society on the walls of a bastion of capitalism, the RCA Building in the $250 million Rockefeller Center complex then undergoing construction. Finally, at the New Workers School of the anti-Stalinist "Communist Party Opposition," Rivera depicted the group's sectarian view of United States history from the colonial period to the present day in a mammoth revolutionary "picture-book" teeming with hundreds of characters in twenty-one panels.

Siqueiros, by far the youngest and least experienced of the artists, arrived last, in 1932, as the only orthodox Marxist of the group. Indeed, Siqueiros's political activities at times threatened to engulf his artistic career. From 1925 to 1930, for example, he abandoned art entirely to organize workers in western Mexico. In contrast to Orozco and Rivera, he came to the United States as a political exile. Politics would continue to have great significance for Siqueiros throughout the 1930s: he was deported because of his political activism from the United States in 1932 and from Uruguay in 1933; he participated in the Spanish Civil War from 1937 to 1939 and was involved, for reasons that have never been adequately explained, in the bungled assassination attempt on Trotsky in 1940. During the thirties, Siqueiros also attempted to express his revolutionary political message using what he viewed as equally revolutionary technical means from modern technology, such as the spray gun, nitrocellulose pigments, and photography for mural production. In his three Los Angeles murals Siqueiros first experimented with the tools of modern North American industry and used a collective "team" painting effort in his attack on racism, imperialism, and contemporary political conditions in Mexico. Deported because of the strident leftist message of his murals, he spent 1933 in Argentina and Uruguay, where he and his artistic team created the

critically important mural *Plastic Exercise,* utilizing nitrocellulose pigments and silicates for the first time in his career and photographs in lieu of traditional preliminary drawings. The mural was the first to be conceived as a visually active "plastic box" with different viewing positions for the spectator.

Returning to the United States in 1936 as a delegate to the American Artists Congress (as did Orozco), he formed the Siqueiros Experimental Workshop to continue investigating radical technical materials and techniques; he also devoted much of his artistic efforts to illustrating the political aims of the Communist Party of the United States of America (CPUSA). Not until 1939, when Siqueiros returned to Mexico from active service in Spain and began work on his mural at the Mexican Electricians Union building in Mexico City, would he first successfully integrate modern technology in a mural and realize a coherently planned composition based on the spectator's route through the physical space of the mural. Here Siqueiros employed technique and composition to denounce capitalism and what he saw as its inevitable consequence, fascism, as they related to his experience of the Spanish Civil War. He called for the combative opposition of militant communism.

During the 1930s the monumental political art of the Mexicans exercised an immense influence on socially oriented North American artists. As muralist Anton Refregier has commented:

> David Alfaro Siqueiros and his art had a tremendous impact on us in the United States during the 30s when we were seeking a new language in order to state the reality about us brought about by the Depression, the suffering of the people, and the growing threat of war. We were shaken by the first contact with Siqueiros' paintings and the photographs of his monumental art.[10]

Another artist active on the New Deal mural projects, Mitchell Siporin, wrote in the same vein of "the amazing spectacle of the modern renaissance of mural painting in Mexico." He said,

"Through the lessons of our Mexican teachers, we have been made aware of the scope and fullness of the 'soul' of our environment."[11]

The federally sponsored art projects of this decade can also be traced directly to the model of the murals *los tres grandes* and others created in Mexico in the 1920s. Artist George Biddle wrote to President Roosevelt, his friend and former classmate at Groton, in early 1933:

> The Mexican artists have produced the greatest national school of mural painting since the Renaissance. Diego Rivera tells me that it was only possible because [President] Obregón allowed Mexican artists to work at plumber's wages in order to express on the walls of the government buildings the social ideals of the Mexican Revolution. The younger artists of America are conscious as they never have been of the social revolution that our country and civilization are going through; and they would be very eager to express these ideals in permanent art form if they were given the government's cooperation.[12]

North American artists acknowledged the debt they owed to the example of the Mexicans' public art. The U.S. government emulated on a sweeping scale the Mexican government's support of murals in state buildings, and substantial interest in and support of Mexican art came as well from the North American private sector in the 1930s. The Rockefeller family emerged as the single most important private patron of Mexican art during this period through such agencies as the "Mexican Arts Association, Inc.," sponsored by Abby Aldrich Rockefeller. They intended to "promote friendship between the peoples of Mexico and the United States of America by encouraging cultural relations and the interchange of Fine and Applied Arts," by organizing exhibitions both in this country and Mexico, and by training Mexican artisans and distributing their wares.[13] The family also commissioned Rivera to paint at Rockefeller Center and underwrote Orozco's salary and expenses at Dartmouth. Mrs. Rockefeller purchased thousands of dollars worth of

Mexican art and, to indicate the degree of the Mexicans' fashionableness, actually seemed sympathetic to Rivera's Marxist inclinations. As Frida Kahlo, Rivera's wife, commented at the time: ". . . we discussed the revolutionary movement at great length. Mrs. Rockefeller was very nice to us always. She was lovely. She seemed very interested in radical ideas—she asked us many questions."[14]

In another area, the two huge exhibitions of Mexican art flanking the decade, the 1,200-piece traveling show that opened in 1930 at the Metropolitan Museum and the 5,000-piece "Twenty Centuries of Mexican Art" exhibition at the Museum of Modern Art in 1940 (where Orozco painted his six portable fresco panel series *Divebomber*) demonstrate the great interest Mexican art held for North American museums throughout the 1930s. As one might imagine, however, mere cultural altruism did not entirely account for this wide-ranging attraction to Mexican visual arts in the late 1920s and 1930s, as can be seen from the activities of the Rockefellers and Dwight Morrow, U.S. ambassador in Mexico from 1927 to 1930. Nelson Rockefeller's trips to Latin America during the late 1930s illustrate how the family shrewdly merged art and business. In returning to this country from Mexico and other countries laden with works, principally from the pre-Conquest period, intended for the Museum of Modern Art or his own collection, surely Rockefeller's primary objective lay in seeing that Standard Oil succeeded in avoiding what happened in other Latin American countries—the nationalization of foreign-owned oil properties. When Rockefeller went to Mexico City at the end of the decade to discuss Standard Oil's expropriated properties with President Cárdenas, he presented himself to the Mexican people not as a businessman but as the president of the Museum of Modern Art abroad to organize the forthcoming "Twenty Centuries of Mexican Art" exhibition.

Ambassador Morrow represented a most unusual spokesman for United States interest in his low-key approach and seems genuinely to have enjoyed Mexico, its peoples, customs, and art. In order to rectify what he felt was a flawed image of Mexico, the notion of bandits roaming the countryside, and no doubt to reassure potential U.S. investors, he used his influence with the Carnegie Corporation to put together the 1930 Metropolitan exhibition. It was organized by René d'Harnoncourt, a key figure in stimulating interest in Mexican art at this time, who was then living in Mexico and was a friend of Ambassador and Mrs. Morrow. René d'Harnoncourt would later curate the 1940 MOMA show, which led to his professional relationship with Nelson Rockefeller and culminated in his being named director of the museum in 1950. At the same time Morrow commissioned Rivera to paint his Cuernavaca frescoes. Morrow's fundamental and clearly defined mission was to preserve the status quo in Mexico, which his biographer noted as "the compromise he contrived between the rights of American capital and the aspirations of Mexican nationalism."[15] The "rights of American capital" in Mexico involved areas such as oil, where Morrow's friendship with President Calles resulted in preserving the 1924 level of oil investment, with foreign capital remaining at thirty-two times the Mexican level. Also involved were foreign land ownership and foreign land claims against the Mexican government, and the Mexican foreign debt. In sum, the combined actions of Ambassador Morrow in the public sector and the Rockefellers in the private brought Mexican art and culture into greater attention in this country, but these efforts should realistically be seen as diplomatic "sugar-coating" to disguise the underlying pragmatic nature of North American political and financial interests in Mexico.[16]

In contrast to the search for a "usable past" that typified the iconographical approach of North American artists who painted thousands of murals across the country for the New Deal, Mexican artists met the depression head on. They arrived in the United States as experienced political artists, having painted in Mexico during the 1920s

their varying interpretations of what the Mexican Revolution had meant. Although *los tres grandes'* Mexican murals generated much controversy among their compatriots, at least they had had the good fortune not to work for public patrons anxious to avoid controversy at all costs, but rather for private institutions that allowed independent statements or groups that actively encouraged, or required for that matter, a radical political position (for example, Siqueiros's art for CPUSA causes and Rivera's New Workers School murals). While the Mexican muralists differed among themselves in their political views, the irony is that the most forthright, even stridently confrontational, views of the American depression came from these Mexican artists. *Los tres grandes* represented three totally distinct esthetic and political personalities, a point often missed as they have been lumped together (or dismissed) as "Mexican muralists" or "Communist" artists. Orozco moved from the prevailing socialism of the New School murals to the far more independent and pessimistic view of the Dartmouth cycle; Rivera moved increasingly to the left, ending by espousing an oppositional Marxism; only Siqueiros remained consistently an orthodox Communist artist and activist during his time in this country. Further, another decisive element involved the three artists: an intense rivalry, with Rivera holding by far the upper hand in the areas of patronage and both critical and popular acclaim during the 1930s.

I have attempted in this study an independent investigation of the oeuvre of Orozco, Rivera, and Siqueiros, considering primarily the works created in this country, a task made difficult on several fronts. The artists' politics obviously present a problem, especially in the case of Siqueiros, whose work has been summarily rejected by North American Trotskyite and anti-Stalinist intellectuals because of his role in the Trotsky affair. At the same time, his Marxist supporters offer a completely uncritical salute to his art that allows no place for mention of any difficulties, inconsistencies, or paradoxes surrounding Siqueiros's career. A curious situation exists in Mexico where three vociferous camps proclaim as accepted fact "their" artist as the most important of the twentieth century while they dismiss the other two as totally negligible. Finally, the critical reputation of these artists suffered greatly, practically to the point of oblivion, during the post–World War II years of Abstract Expressionism, when matters relating to art and radical politics held little, if no, interest for North American critics and historians. The extent to which the Mexicans fell from favor during these years can be graphically documented by the fate of two of Rivera's San Francisco murals. California School of Fine Arts officials covered his mural during the mid-forties, ostensibly because it "didn't fit" with their exhibitions, and his Golden Gate International Exposition murals (1939–40) were placed in storage boxes after the exhibition and not viewed by the public for more than twenty years.

However, during the 1960s and 1970s many signs of a recurrence of interest in the art of Orozco, Rivera, and Siqueiros have appeared, no doubt stemming from the political and cultural activism particularly in the manifestations of the Chicano movement and the political orientation of murals on inner city ghetto and barrio walls. Renewed attention to the topic of art and politics also characterized these years, an important example being the studies of the New Deal art projects.[17] The Detroit Institute of Arts segment of the 1977–78 NEH/NEA-sponsored "Mexico Today" symposia marked the first contemporary scholarly consideration of the twentieth-century Mexican mural movement. Other events have included the Orozco exhibition that toured Europe during 1979–80, celebrations at the Detroit Institute of Arts (1983) and Dartmouth College (1984) honoring the fiftieth anniversaries of the paintings of these murals, Hayden Herrera's biography of Frida Kahlo (1983), and the exhibition "Diego Rivera: The Cubist Years" (1983–84) that

toured Phoenix, New York, and Washington. More recent exhibitions have included the Diego Rivera retrospective organized by the Detroit Institute of Art (1986–87), "The Latin American Spirit: Art and Artists in the United States, 1920–1970 (Bronx Museum of Arts, 1988), "Images of Mexico: The Contribution of Mexico to Twentieth-Century Art" (Schira-Kuntshalle, Frankfurt, Germany, 1988), and "Hispanic Art in the United States: Thirty Contemporary Painters and Sculptors" (Museum of Fine Arts, Houston/Corcoran Museum, 1988).

The time is certainly ripe for my investigation of these artists, which places their achievements beyond the context of Mexican muralists and within the framework of mainstream twentieth-century art. Orozco, Rivera, and Siqueiros, I would argue, must be considered as the foremost practitioners of monumental political art of the twentieth century, whose murals tower above the achievements of other schools. Our New Deal muralists, for example, recognized the Mexicans as their artistic mentors and also as their political and cultural heroes. Even Siqueiros's staunch adherence to Marxist orthodoxy wavered when it came to a judgment of Soviet artists and mural painters of the Stalinist era, whom he believed lacked any interest in investigating the artistic possibilities of new technical means and materials. Finally, however valid the murals of Third World countries (such as Cuba, the Chile of Allende, Nicaragua) and North American urban ghettoes may be as political commentary, they often entirely lack any esthetic concern, and many are painted by "artists" who have no formal artistic training. The Mexicans, on the other hand, were highly sophisticated artists, whose elevated conceptions of art laid the basis for their sociopolitical subject matter. Rivera, for example, experienced at first hand the genesis of modern art in Europe from 1907 to 1921 and constructed his epic narrative of postrevolutionary Mexico at the Secretariat of Public Education from a profoundly knowledgeable Cubist point of view.

A few words on the organization of the book and on what is included: for Orozco and Siqueiros I consider their earlier Mexican artistic activities in some detail to provide background on the nature of Orozco's muralistic achievements and Siqueiros's strikingly innovative practices in this country. For Siqueiros I have found it necessary to discuss his post–North American career, especially the Mexican Electricians Union mural of 1939–40, since this painting successfully culminated his quest during the 1930s for murals incorporating revolutionary subject matter and radical painterly means utilizing the tools of industrial technology. For Rivera, whose works prior to 1930 include significant paintings in the Cubist manner (1913–17) as well as fresco masterpieces in Mexico (1923–30) requiring monographic studies in their own right, I have instead pointed to certain key elements underlying his artistic production during these years and in the United States from 1930 to 1933. I discuss the artists in chronological order of their arrival in this country and have attempted to relate the text to the illustrations, which present much new visual information. My aim is to recreate the construction of the murals from preliminary studies through the work-in-progress to the completed wall painting(s). Further, I have tried to write a text for the informed layperson, not just the scholar, in keeping with the idea that a mural is intended to appeal to the public at large. In 1929 Orozco expressed this idea:

> The highest, the most logical, the purest and strongest form of painting is the mural. In this form alone is it one with the other arts—with all the others.
>
> It is, too, the most disinterested form, for it cannot be made a matter of private gain; it cannot be hidden away for the benefit of a certain privileged few.
>
> It is for the people. It is for *ALL*.[18]

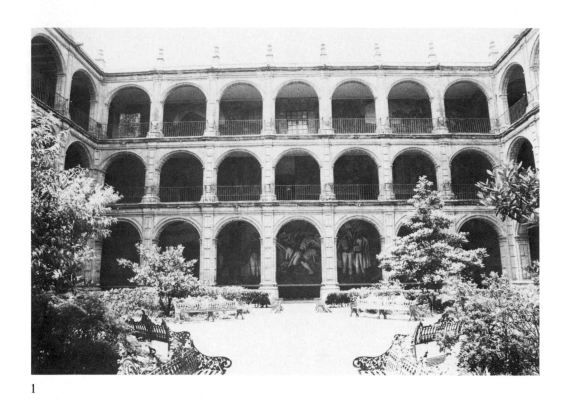

1

1. General view of National Preparatory School
loggias, Mexico City. (*Photos are by author
unless otherwise noted.*)

1

JOSÉ CLEMENTE OROZCO

Roots of the Prometheus *in Early Mexican Modernism:
Orozco's Art of 1906–27*

The *Prometheus*, the first Mexican mural painted in this country, at Pomona College in 1930, occupies a key, even pivotal, position in the career of José Clemente Orozco. It marked the first fully mature expression of the theme of the heroic "Creator-Destroyer"[1] who sacrifices himself for the benefit of mankind, which had been fermenting in Orozco's work since his first Mexican murals of 1923. Further, the *Prometheus* should be seen not only as the culmination of Orozco's early period, but also as the forerunner of the "man of fire" theme that he would so brilliantly treat in the Guadalajara mural paintings of 1936–39.

In retrospect it seems a mural he was "destined" to paint, and the route to the *Prometheus* can be coherently traced in his art of the preceding two decades. Referring to Orozco's first set of National Preparatory School murals (Mexico City) painted during July 1923–July 1924, David Scott sees a definite relationship between these murals and the *Prometheus*: "it was the most fitting and natural theme for Orozco to choose—he had been working toward it, consciously or unconsciously, for eight years."[2] According to Jean Charlot, Orozco's friend and fellow muralist at the Preparatory School at this time, these murals were painted in the following order:

1) Beginning July 7, *Youth*, *Allegory of the Sun, and a group of schoolgirls* (the lower part destroyed nearly on completion, and in the end replaced with the Botticellian *Spring*).

2) To the right, *The Two Natures of Man* (or *Man Strangling a Gorilla*; destroyed and replaced with *Destruction of the Old Order*).

3) To the left, *The New Redemption* (or *Christ Destroying His Cross*; destroyed, with the exception of Christ's head, and replaced with *The Strike*).

4) *Youth* . . . replaced with the Aztec figure of Tzontemoc ("He who lowers his head": one of the gods of the Nahuatl underworld; also the setting sun, ready to enter the realm of the dead).

5) Farther to the left, the first version of *Revolutionary Trinity*—prerevolution in tone (replaced by the version showing a mutilated worker and sobbing old man).

6) To the extreme left, the cartoonish *The Workers Fight* (or *The Rich Banquet While the Workers Quarrel*).

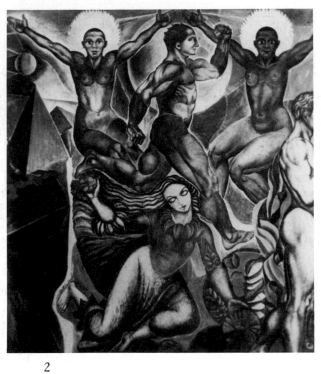

2

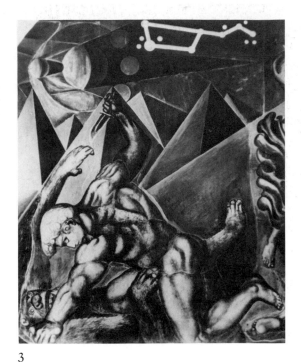

3

2. *Spring*, National Preparatory School, 1923–24. Fresco, approx. 12 x 7 ft. (*Photo by Luis Marquez, Mexico City, courtesy of David Scott.*)

3. *The Two Natures of Man*, National Preparatory School, 1923–24 (destroyed). Fresco, approx. 10 x 8.5 ft. (*Photo by Luis Marquez, courtesy of David Scott.*)

4. *Tzontemoc*, National Preparatory School, 1923–24 (destroyed). Fresco, approx. 10 x 8.5 ft. (*Photo by Luis Marquez, courtesy of David Scott.*)

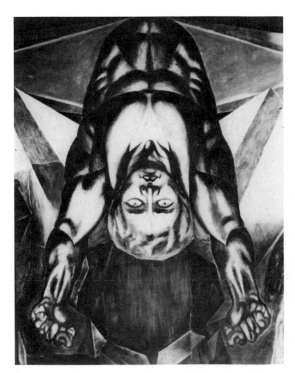

4

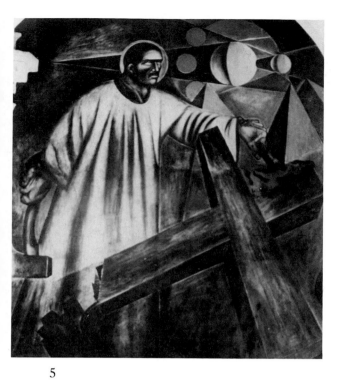

5

6

5. *The New Redemption*, National Preparatory School, 1923–24 (destroyed except for head of Christ, which appears in *The Strike*). Fresco, approx. 10 x 8.5 ft. (*Photo by Luis Marquez, courtesy of David Scott.*)

6. *The Strike* (with Christ's head from destroyed mural), National Preparatory School, 1923–24. Fresco, approx. 10 x 8.5 ft.

7. *The Workers Fight*, National Preparatory School, 1923–24. Fresco, approx. 10 x 8.5 ft.

7

8

9

8. *Maternity*, National Preparatory School, 1923. Fresco, approx. 10 x 8.5 ft. (*Photo by Luis Marquez, courtesy of David Scott.*)

9. *Franciscan Succoning Indian*, 1924. Fresco, approx. 10 x 8.5 ft.

10. *Justice and the Law*, 1924. Fresco, approx. 8.5 x 10 ft.

11. *Social and Political Junkheap*, 1924. Fresco, approx. 8.5 x 10 ft.

7) To the extreme right, another Botticelli-inspired work, *Maternity*. The St. Francis and Cortés panels also date from this period.

8) Last Orozco painted the second-floor processional panels of satire and social commentary, *Justice and the Law*, *The Final Judgment*, *Social and Political Junk-heap*, and *Reactionary Forces*.[3]

These first frescoes of Orozco's career prefigure the *Prometheus* in various thematic and stylistic aspects. First, in different contexts—mythic, religious, and sociopolitical—Orozco explored and developed subject matter dealing with the violent destruction of existing orders and the necessity of creating new and superior ones. This conception lies, of course, at the very heart of the Promethean myth. In *New Redemption* Orozco had already introduced another fundamental element of the later mural, destruction and ultimate salvation by fire, here through the agent of the fiery torch wielded by Christ. The motif of the single heroic image figured prominently in the

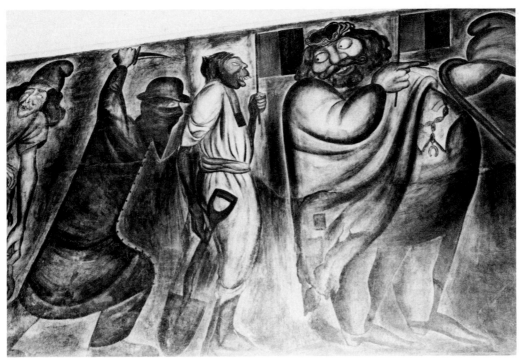

10

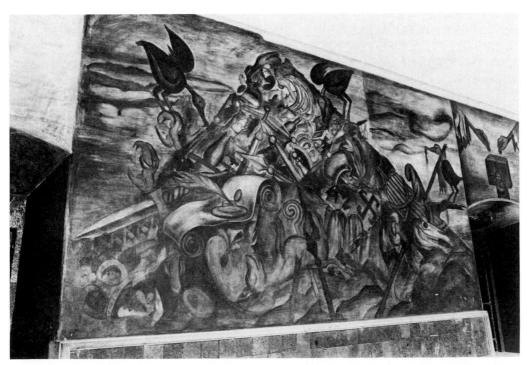

11

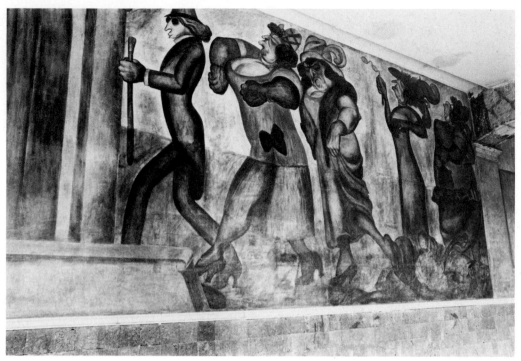

12

destroyed frescoes, and the image of these mus-
cular giants against a backdrop of diverse abstract
geometric shapes anticipated the *Prometheus* in
Orozco's first attempts to portray symbols of cre-
ative force. However, here Orozco found him-
self unable to rise above a mannered academic
style and format, and the impersonal, labored fig-
ures totally lack the dynamic expressive element
that characterizes the *Prometheus*.

An even closer and more direct parallel exists
between the Pomona work and Orozco's next
mural, the *Omniciencia* (House of Tiles, Mexico
City, 1925; executed when protests stopped work
on the Preparatory School frescoes), depicting the
creation of mankind. In the upper register of the
Baroque cornice, hands symbolizing the Divine
Force offer fire, representing wisdom, illumina-
tion, and energy, to smaller hands underneath.
Below, the proud figure of Earth kneeling re-
ceives celestial rays, while to the sides stand nude
male and female human beings, seemingly hav-

ing just been created by the flanking giants. If
similarly lifeless and awkward in figural treatment,
especially the nudes alongside Earth, the mural
does thematically anticipate the *Prometheus* in the
creation motif and the symbolic gift of fire. Fur-
ther, *Omniciencia* closely resembles the later mural
in the central monumental figure, crouched on
one knee at the central point of the composition
and placed under an empty architectural space.

The roots of the *Prometheus* can be traced fur-
ther back into Orozco's career, beyond the first
murals, even to fin-de-siècle and early twentieth-
century Mexico. Surely the origins of Orozco's
interest in the classical nude derived from his
years of study at the Academy of San Carlos from
1906 to 1910. In his autobiography, Orozco not-
ed the meticulous study of the "natural" form
stressed under the directorship of the Spaniard
Antonio Fabrés: "Fabrés' method was less a way
of teaching than an intense training and a vigor-
ous discipline after the norms of European acad-

18

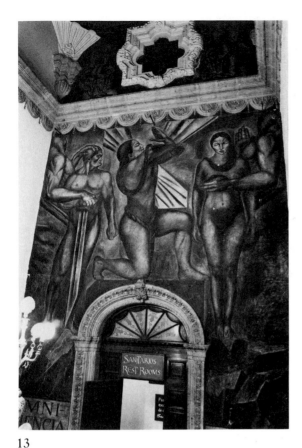

13

12. *Reactionary Forces*, 1924. Fresco, approx.
8.5 x 10 ft.

13. *Omniciencia*, 1925. Fresco, 150.92 sq. ft.

emies. Nature was to be copied with the greatest
photographic exactness, at no matter what ex-
pense of time and effort."[4]

Orozco's exposure to Michelangelo, a strong
influence on one strain of the first murals, can
be traced to his contact with the multifaceted per-
sonage, "Dr. Atl." He was an artist and art crit-
ic, revolutionary, student of philosophy and penal
reform, and volcanologist, who returned to Mex-
ico in 1903 after a seven-year European trip brim-
ming with enthusiasm for the murals of the Italian
Renaissance. As Orozco recalled:

> When he spoke of the Sistine Chapel and of
> Leonardo his voice took fire. The great murals! The
> immense frescoes of the Renaissance, incredible
> things, as mysterious as the pyramids of the Pha-
> raohs, the product of a technique lost these four
> hundred years!
> Atl was drawing muscular giants in the violent
> attitudes of the Sistine. We were copying models
> required to resemble the guilty on Doomsday.[5]

Atl produced murals in the vein of the draw-
ings Orozco described, large-scale heroic single
figures, one of which—*The Man Leaving the
Sea*—strongly recalls the monumental aspect of
Michelangelo. Another, executed on the walls of
the Colegio Máximo de San Pedro y San Pablo
in 1921, is quite interesting with respect to Orozco
as it bears the title *The Titan*. The influence of
Atl's work and his eloquence for the cause of
Michelangelo can be unmistakably seen, if only
partially and awkwardly digested, in Orozco's first
Preparatoria murals, in the superhumanly mus-
cled nudes in *Youth* . . ., and in the colossal fig-
ures of *Tzontemoc*, and the human in *Two Natures
of Man*, whose face appears to have been taken
directly from the *David*. Moreover, Atl's use of
abstract, decorative forms in his murals such as
The Rain may also have been a source of inspira-
tion for Orozco.[6]

Beyond the Classical and Renaissance formal
vocabulary that Orozco absorbed from his train-
ing at the academy, the general theme of the
necessity of a new sociopolitical/cultural order that

appeared in Orozco's murals of 1923–24 ultimately derives from the eager anticipation of Mexican artists and critics active at the turn of the twentieth century, fervent believers that a new artistic epoch had dawned. Leading illustrated journals of the day, *Revista Moderna, El Mundo Ilustrado*, and *El Tiempo Ilustrado*, reveal a knowledge of contemporary European artistic developments, as well as a particular Mexican adaptation of them. For example, the first issue of *Revista Moderna* (July 1898) had a *Centaur in Agony* as its frontispiece, a theme typical of the Symbolist Julio Ruelas, one of Orozco's teachers. The mythological topics of Ruelas and the French and German Symbolists, whose work regularly appeared in the Mexican journals, provide the antecedents for the side panels at Pomona. *Revista Moderna* also published examples of French Art Nouveau and Japanese art, and the influence of these movements had a readily discernible impact on Mexican artists. Yet Mexican critics, fully cognizant of contemporary European trends and what this held in store for Mexico, saw the possibility of a bright new future for Mexico—"a future as *Mexico*, but a Mexico liberated by *international* movements." In 1898 the critic Oscar Herz wrote:

> National art, our true national art, died under the strokes of the conquering swords which hardly left us the indispensable ruins with which to prove its very advanced existence. The Spaniards brought us their European civilization, disdaining and enslaving the aboriginal race. . . . We are an absolutely new country and are obliged to incorporate into ourselves the artistic tendencies of the most advanced nations.

Other critics at this time stressed other aspects of the "new," its relationship to Mexico, and the belief in "new phases of truth and new forms of beauty."[7] Orozco's first Preparatoria murals directly reflect the sensation of a new, vital future for a twentieth-century Mexico to develop her own identity among nations in their call, whether allegorically or politically, for the liberation of mankind from existing orders of society. That these sentiments held a long-lasting influence on Orozco can be demonstrated by his article of early 1929, "New World, New Races, and New Art," in which he again urged new forms of art for the new twentieth-century civilization: "If *new* races have appeared on the lands of the *New* world, such races have the unavoidable duty to produce a *New Art* in a new spiritual and physical medium. Any other road is plain cowardice."[8] Only months after Orozco wrote these words, he would realize them in the *Prometheus*, a truly "new" work which drew on and synthesized many tendencies of his earlier art.

Orozco's earlier graphic art saw his personal manner of working develop in the areas of figural distortion and a free calligraphic linear quality. His work first appeared formally in the 1910 Centennial Year "Show of Works of National Art" at San Carlos Academy, in cartoons and charcoal drawings, now lost, which already show the artist's rejection of the academic manner he had earlier been taught at the academy. One critic wrote, "J. T. [sic] Orozco exhibits many caricatures and compositions. The former are typical of strong draftsmanship, with lines bold and firm, supremely expressive and full of very deep intentions. The latter are in the same vein. Their tormented and convulsive attitudes bring somehow to mind Rodin's drawings."[9] After the unexpected success of the academy exhibition, the students organized under Dr. Atl's supervision the "Artistic Center," with the primary goal of obtaining public walls for murals. The group's preparations were immediately postponed with the outbreak of the revolution on November 20, and Orozco's work remained almost entirely confined to graphics until 1923. In continuing to develop his own personal expressionistic manner, Orozco rejected the "Mexican Impressionism" of Alfredo Ramos Martínez, who headed the Santa Anita "Barbizon" open-air painting school formed after the students struck the academy in 1911:

> Out in the open air the Barbizonians were painting very pretty landscapes, with the requisite violets

for the shadows and Nile green for the skies, but I preferred black and the colors exiled from the Impressionist palettes. Instead of red and yellow twilight, I painted the pestilent shadows of closed rooms, and instead of the Indian male, drunken ladies and gentlemen.[10]

Aside from cartoons Orozco drew in 1911–12 for the political journal *El Ahuizote,* he apparently limited himself to painting women of two distinct social and economic strata: schoolgirls and prostitutes. In a November 1913 article the critic José Juan Tablada found "two essential qualities: movement and expression" to characterize the schoolgirl sketches and admired the "intelligent analysis by virtue of which the artist disdained useless details." In the prostitute studies, reminding Tablada of Toulouse-Lautrec's (an artist Orozco maintained he did not know at the time) "manner of seeing," the critic discerned an original talent: "José Clemente Orozco is a strong artist, very intense, very personal, and eminently distinguished."[11] David Scott has commented on Orozco's artistic growth in these drawings, the so-called *House of Tears* series:

> They show an increasingly varied and subtle use of expressive distortion, delicately effective tonal and color handling, control of pattern, and above all, boldly imaginative and independent vision. They lack—as apparently does all the work of the period—great concern for formal arrangement, especially in depth, and the ability to combine vigorous line with tonal subtleties. Orozco has not yet carried the intense line of his cartoons into his paintings, nor has he evolved his manner of combining in drawing spontaneity with geometric control and simplification.[12]

Faced with the deteriorating military situation in the capital, Orozco fled with his artistic and political mentor, Dr. Atl, in 1914 to join the Carranza forces in Orizaba and observed the revolution at first hand. Orozco also drew cartoons for the Carranza political organ, *La Vanguardia.* and Charlot saw a growing maturity in Orozco's artistic means: "The 1915 drawings are evoked in a

14

14. *The Lecture,* from *House of Tears* series, before 1915. Watercolor, approx. 12 x 16 in.

kind of plastic shorthand, a thick crinkled line jotted down with an ink-loaded brush or reed. An oriental economy of statement tends to cram the fewest possible lines with saturated emotion."[13]

Although Tablada had earlier promised "a curious public" an early opportunity to view Orozco's art, revolutionary conditions prevented this until 1916, when a large exhibition (106 studies of women, 15 cartoons, and a study for the large painting of 1915[?], *The Surrender of the Spanish Troops at San Juan de Ulúa*) took place in September. This, the artist's first one-man showing, summed up Orozco's career until 1916, and in effect until 1923, given his relative inactivity from 1916 to 1923. Orozco encountered a savage personal and artistic onslaught, which, judging from the severity of the attack and the fact that the incident is unmentioned in the autobiography, must have deeply wounded him in the accusations: his painting was sloppy, his technique mediocre, his soul debauched, and his drawing incompetent. Orozco replied in poignant fashion to the "flood of epithets" regarding his technical incompetence and alleged physical and moral degeneracy:

> I am merely a young man who observes. . . . Very humbly and modestly I present the small fruit of my study. I have no job and no income. I live in misery. Every sheet of paper, every tube of paint, is for me a sacrifice and a sadness, and it is unfair to subject me to scorn and hostility and still further to insult me publicly. The critic shall see soon, if he likes, a second exhibit, and he may discover whether or not it is the "soul of an old prostitute" determined to bring one grain of sand to the future monument of Mexican art.[14]

Orozco's early work from the period 1911–16 relates to the first murals of 1923–24 in several respects. The "schoolgirl" type in *Youth* . . . clearly derives from Orozco's earlier sketches, while the highly improbable physicality of the bulging muscled nudes (in *Youth* . . ., *Two Na-*

tures of Man, and *Tzontemoc*) obviously reflect Dr. Atl's enthusiastic proselytizing for the cause of the Italian Renaissance, and Atl's own murals in a Michelangelesque vein. The Botticellian *Maternity*, a subject seemingly so unlikely for someone of Orozco's artistic sensitivities, no doubt also owed its existence to Atl's urgings. The other entirely different manner of these first murals, the cartoonish *Workers Quarrel* and the "funny people" (to use Charlot's term) of the second floor, clearly stem from Orozco's experience as periodical caricaturist. These two tendencies in Orozco's early murals—the image of the heroic nude and a spontaneous manner of working distinguished by a free calligraphic line—would appear, although vastly transformed, as central elements of the *Prometheus*.

Orozco introduced into his second series of Preparatoria murals on the theme of the Mexican Revolution, painted in 1926, a dramatically increased emotional quality and sensation of direct human experience. This series treated for the first time class conflict and the masses, themes that would occupy Orozco for decades in various interpretations. David Scott maintains:

> . . . it was in the process of turning to Revolutionary themes that Orozco found the inspiration that enabled him to fuse the particular and the general in his work. In form and subject, Orozco now began with what he felt personally and intimately: this he simplified until he achieved a statement that combined the poignancy of the immediate with the significance of the universal.[15]

Thus, the revolutionary series—for example, *Wives of the Workers, The Mother's Farewell, The Return to Labor*—anticipates the *Prometheus* in depicting for the first time the necessity of sacrifice for the good of mankind. At the Preparatoria this involved the specific political context of the Mexican Revolution, which Orozco saw as a multifaceted conflict involving both positive and destructive forces; at Pomona Orozco would broaden the scope of his treatment of the inex-

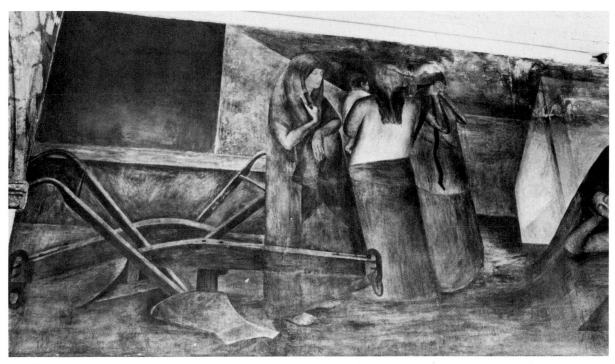

15

tricably linked powers of creation and consumption into a depiction of the universality of the human situation. Compositionally, the 1926 paintings differ from the *Prometheus* in their arrangement of flat, patterned forms on the surface of the picture plane, with little concern for presenting objects and figures in depth, and Orozco's uniformly rendered brushwork has none of the expressive painterly quality of the *Prometheus*.[16]

The main body of work during the period from September 1926, when Orozco's painting at the Preparatoria had been stopped, to 1928, when he did the *Mexico in Revolution* pen-and-ink gouache series, offers a different point of view from the 1926 murals.[17] In this series, proposed by Anita Brenner, Orozco expressed "the whole pent-up volcano of his feelings and experiences in the Revolution," and the drawings so interested the artist that he wound up doing thirty or forty instead of the originally intended six. The drawings, by swift, succinct means, brutally distill the chaos,

15. *Wives of the Workers*, 1926. Fresco, approx. 8.5 x 10 ft.

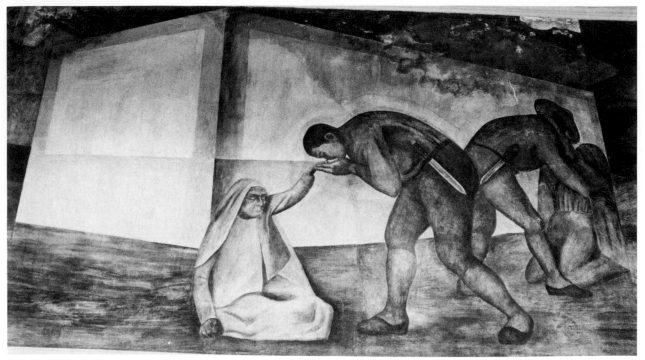

16

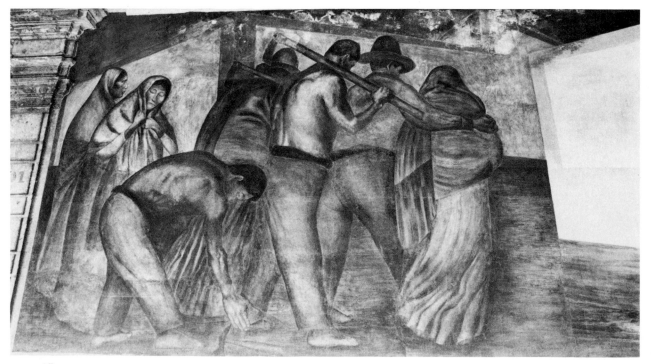

17

24

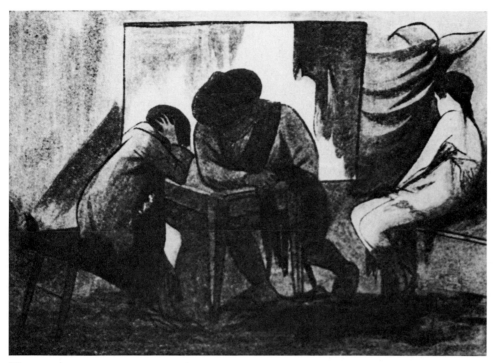

18

destruction, and wanton behavior Orozco saw during the revolution. Orozco would adapt several elements from this series to the *Prometheus;* the rapidly moving calligraphic line, figural distortion, and the theme of the masses all figure prominently in the mural.

16. *The Mother's Farewell*, 1926. Fresco, approx. 8.5 x 10 ft.

17. *The Return to Labor*, 1926. Fresco, approx. 8.5 x 10 ft.

18. *The Return*, 1926–28. Wash drawing, approx. 13 x 18 in.

The Prometheus *of Pomona College, 1930: The Theme of Creative Sacrifice and the Means of Direct Expression*

Orozco came to New York in late 1927. He later wrote in his characteristic laconic fashion that "there was little to hold me in Mexico in 1927, and I resolved to go to New York."[18] In fact, his work on the Preparatoria murals had been inexplicably stopped in September 1926 and, despite efforts of friends such as the art critic Anita Brenner, it failed to resume. Until his departure in the fall of 1927 he continued work on the revolutionary gouache series, which he would finish in New York.[19] His association with Alma Reed's New York literary and cultural salon, the "Ashram," from 1927 to 1930 would prepare the artist to treat the theme of revolution in his painting.

Alma Reed had a deep emotional attachment to Mexico which manifested itself in the late 1920s and 1930s with her championing of twentieth-century Mexican art, and she particularly focused on the individual genius of Orozco, for whom she served as dealer, agent, and patron. What led Alma Reed to dedicate herself to the cause of Orozco's art and, more generally, why did she act through her 57th Street Delphic Studios as a fountain of support for Mexican artists during the 1930s? Reed's association with Mexico began quite accidentally in 1921 by means of her column "Mrs. Goodfellow" for the *San Francisco Call*. In her role as journalist-cum-social worker, she became interested in the issue of prison reform, particularly as it related to the case of Simon Ruíz. Ruíz, a sixteen-year-old Mexican, found employment in Bakersfield, unaware that it harbored strong Ku Klux Klan sentiments, and had been sentenced to hang as a result of an argument with his foreman and that person's subsequent death. Reed publicized the legal travesty, led the struggle to raise the legal hanging age from fourteen to eighteen, and saved Ruíz's life. Deeply appreciative of her efforts, Mexicans in California acclaimed her a heroine, and President

Obregón invited her to visit Mexico as his official guest. Returning to the United States after a prolonged three-month fête, Reed managed to convince Adolph Ochs to hire her to report on the Carnegie Foundation archeological excavation in Yucatán (she had majored in archeology at Berkeley) for the *New York Times*. She sailed with the Carnegie expedition in early 1923, and in addition to her journalistic activities, fell in love with Yucatán's reformist governor, Felipe Carrillo Puerto. The fairy-tale-like romance between the handsome Maya giant and the beautiful *gringa*, the inspiration for the classic Mexican ballad "La Peregrina" ("The Wanderer"), came to a tragic end when reactionaries assassinated Carrillo Puerto during the abortive de la Huerta rebellion in 1924, as Alma Reed prepared for her wedding in San Francisco. Following this calamity, Reed traveled in Europe, took part in underwater archeological explorations in the Mediterranean, and spent two years in Greece, where she translated the poetry of Angelos Sikelianos. By the late 1920s she had returned to the United States with Madame Eve Sikelianos, the poet's widow.[20]

Her zealous appreciation of Orozco's talents, reinforced by her possessiveness, at times led Alma Reed to color and distort events in her biography of Orozco. She perceived her role to be "guerrilla warrior" (as Jean Charlot called her) in the campaign for Orozco against all other artists and critics, both Mexican and North American. Nonetheless, as "a determined and tireless executive on behalf of the master, who was both too retiring and too explosive for sustained and sound human contacts,"[21] she did perform valuable practical tasks for Orozco in the areas of periodical exposure, representation in gallery and museum exhibitions, and searching for private and public commissions.

Orozco's comment to Reed at the dedication

concerning the imagery of the New School murals reveals the extent of his self-perceived indebtedness to her Ashram group: "You are always going to feel very much at home here, Almita. You will be among your friends; it is just another Ashram."[22] Orozco referred to the spiritual-cultural-political salon named after Gandhi's dwelling at Wardha, established at their lower Fifth Avenue apartment by Alma Reed and Eva Sikelianos, whose Greek-oriented activities would so pronouncedly influence Orozco in his choice of the Promethean theme for his Pomona College mural.

The women had come to New York to raise funding for Greek cultural causes, particularly the biennial festivals held at Delphi, the site of Olympic athletic games, exhibitions of popular art, songs, and dances of Parnassian shepherds, and Greek tragedies.[23] Ashram evenings typically featured lectures on political and social themes, and poetry reading, especially from Greek and Indian sources. Alma Reed has noted the wide-ranging nature and idealism of pacifistic discussions at the Ashram, held amidst the decorous ambience of "preserved orange blossoms and rose-flavored Turkish coffee": ". . . we discussed mankind's chances for stemming the blood-red rivers of internecine strife."[24]

Orozco had been introduced to Reed by North American women he had known in Mexico; however, his first impressions of her clique did not note the altruistic concerns but rather described with some acerbity what he felt to be their folkloric (in this case, Greek) indulgences:

Indians from Greece shall be introduced to civilization. Same as in Mexico, the same worn-out cliché. Greek folk art shall be fostered—their serapes are just like ours—dancing there shall be at the tune of Greek bagpipes. All of that will happen in Delphi, plus Olympic Games, and for a finale, a play, "Prometheus."

Thus plans an aged lady, an American millionairess, wed to the poet Sikelianos. . . . A beautiful woman, Miss Alma Reed, is active in the goings-

on. She admires me and bought one of the tragic drawings.[25]

In spite of Orozco's lack of sympathy for the antics of the group, he appreciated that his first New York exhibition after his arrival took place at the Ashram in late September 1928. He wrote enthusiastically of the reception to the *Mexico in Revolution* series: "Propaganda galore, notables present from the New York art world, writers, Greek poets, delegates to a congress of archeology." Soon thereafter Orozco informed Charlot of the "great and magnificent results" of this informal showing—an exhibition of the same drawings in the 57th Street gallery of Marie Sterner, in the company of six French artists, including Matisse. By mid-October Orozco was able to speak of his "success": "By my *success* I just mean that I am working *hard* at paintings to my liking, and that I meet people who *truly count*."[26] Orozco's artistic association with the Ashram continued, as he used a rear room for a studio, the so-called Mexican sector, and he would be formally "adopted" into the Greek pantheon of "true artists" in a "rebaptism" ceremony in which he was named Panselenos, after the Greek muralist of Mistra.[27]

Since the summer of 1928 the Ashram had been actively involved with matters concerning the forthcoming production of *Prometheus Bound*, which took place on Parnassus in May 1930. During this time Orozco heard various readings of the play and attended lectures and group discussions, which invariably centered on "the drama's significance for modern man enmeshed in his many grave problems." Orozco spoke with admiration of what he termed the "grandiose" concept of the heroically defiant Prometheus, and "always seemed most impressed with the scale of the drama's human action."[28] Beyond Orozco's prolonged and wide-ranging exposure to the Aeschylean drama, and Greek culture in general, there existed the obvious parallel between Prometheus's dangerously prophetic role and that of the creative artist bringing his/her vision to the, at times, uncomprehending public. And, as his let-

ters to Jean Charlot in the months following his arrival in New York in late 1927 reveal, Orozco felt a profound sense of isolation and had endured humiliation in his dealings with the New York art world. He wrote, "So-called friends do not exist for me. In New York, one meets only with selfishness, duplicity, and bad faith. I stand quite alone. I count only on my own strength of which, as luck goes, there is still much left."[29]

Orozco's self-identification with the Promethean figure extended beyond the image of the heroic struggle of the artist consumed in the act of creation to the physical realm. As a teenager Orozco had been maimed by an accidental explosion which destroyed his left hand and impaired both his vision and hearing. Octavio Paz's assessment of Orozco's art and personality is most interesting in that it equates Promethean attributes with Orozco: "The personage Orozco is neither matter nor history with its dialectic of darks and lights, but Prometheus, the hero in solitary combat against all the monsters. In very few artists has the will of Mexico been embodied with such violence—our anguish to transcend the situation of our orphanhood. The man Orozco is alone."[30]

The Promethean theme would provide a sense of continuity to Orozco's North American murals which generally depicted the call for the destruction of old or existing human orders—through the sacrificial acts of mythological or actual personages—and the creation of new and superior social systems. However, Orozco did not couch his sociopolitical imagery in Marxist terms, as did Rivera and Siqueiros; rather, he spoke in far more elemental human terms. Orozco's treatment derives, of course, from the magnificent act of defiance on the part of Prometheus, the god responsible for bringing the arts and sciences to mankind. As a result, Prometheus—"the bringer of fire, the vehement and weariless champion against oppression, the mighty symbol for art, literature, and music for all time"[31]—endured the punishment of being chained to a rocky crag in the Caucasus where an eagle daily tore his flesh and ate his liver.

Rather than detailing the range of the god's contribution to mankind, Orozco concentrates on the act itself of his "Conqueror-Savior" figure, the violent confrontation of seizing the fire and the immediate horrible consequences—the consuming of Prometheus in flames. The art historian José Pijoan, who played the major role in bringing Orozco to Claremont, recognized the artist's "new interpretation" of the theme: "The great philosophical importance of the Orozco fresco is that the gift is accepted and shared in different degrees by the crowds of mankind. Those who receive the fire not only laugh and fight with more personality, but also the style of the painting portrays them differently."[32]

Below the giant, caught by Orozco in the midst of his transgression against the gods, appear the masses of mankind in various states of awareness of the enormity of Prometheus's deed. Some, those nearest the flames, eagerly embrace the new gifts, while others exemplify their rejection by turning away from the scene. To the right, perceptive leaders attempt to marshall the lethargic and unseeing into receptive states, but the eternally oblivious remain—personified by the lovers and brawlers on the extreme edges of the painting. Orozco himself emphasized that "there were two real matters in the scene: Prometheus and the crowd," and stressed the eternal, yet everyday human context of the masses:

> You are trying to take the crowd apart and analyze it. This is unnecessary; you miss the meaning. The crowd is just a crowd, like you see anywhere. The crowds are always in motion—I have tried to make them dynamic. They move, they do things. Look at any crowd; it is made up of many people. All of them are active.[33]

Lesser aspects of the story unfold in the niche-like compartments on the sides and ceiling, masked by the arch from a direct frontal viewing of the fresco. Above, Orozco painted a geometric abstraction of the Godhead, or the origin of the fire, after removing a large head of Zeus

"because he wanted a more abstract symbol, a symbol with no relation to time nor space."[34] At the top of the left panel Zeus faces the Titanic hero with an expression of baleful hatred. Beside him in a somewhat confusing forest setting, are the jealous Hera and Io, transformed by her lover Zeus into a white cow and then viciously punished by Hera. To the right—symbolizing the ancient, chaotic, and monstrous order Prometheus toppled by providing mankind with knowledge—appear old, emaciated centaurs, or men not yet in a liberated evolutionary state, seeking refuge on isolated crags to avoid the impulses of the new times. Below, a female centaur struggles to free herself from the fatal embrace of a great serpent, representing the new wisdom and knowledge.[35] Orozco would repeat the basic orientation of his three North American murals, although in somewhat altered form according to the dictates of the architectural settings and in subject matter differing from what he first used with the *Prometheus*. That is, a central or axial allegorical painting addresses the human condition—man's possible salvation, brotherhood, or destruction—while lateral panels depict related themes, though with more descriptive or contemporary comment.[36]

The suggestion for the Promethean theme evidently came from Pijoan but was determined only after Orozco had rejected as unsuitable earlier possible subjects proposed by the art historian. Rejected topics included a Last Supper in a modern context; the conquerors and colonizers of California; "a glorification of modern life with people in the foreground inventing and constructing, watched by great men of the past" (Aristotle, Dante, Newton); founders of North American universities, with ten great figures of North and South America; and a Roman chariot of Victory as the central axis of a classical composition. Finally Pijoan had the notion: "Why not Prometheus, the giant, carrying the fire and burned by his own discovery? Of course Michelangelesque in style. Around him people of different kinds receiving in different qualities the spark of that fire." According to Pijoan's recollections, quite possibly

colored, Orozco smiled and replied, "This has possibilities" and retired to his room.[37]

Orozco's choice of the Promethean myth proved a superb selection in several respects: the motif held particular meanings on various levels for Orozco, and beyond its general suitability for any college or university, the theme held special significance for Pomona College. Students and faculty recognized in the theme of Orozco's mural a metaphor for the task of an educational institution—"The subject is not pleasant: it makes one think, the first duty of any college whatsoever."[38] Also, the mythic legend was an obviously appropriate selection for a college named after the Roman goddess of fruit (Milton's "with fruits Pomona crowned"). Moreover, each spring the school enacted the traditional "Flame Ceremony" —the carrying of lighted candles by teachers and alumni symbolizing the passing on of knowledge, goodness, and mercy to succeeding classes of students. Possibly Orozco created his work knowing of the direct parallel of this college ritual. Students, at any rate, fully grasped the auspicious relationship:

> Those who have eyes, and can see, will appreciate what this fresco means. Take for yourself as much of its conception as you can grasp, then pass it on to those who follow. Pass on that torch that Prometheus first kindled; continue Pomona's traditions as epitomized in her annual flame ceremony.[39]

How did Orozco come to paint at Pomona College (student population c. 800 at this time) in the semiagricultural community of Claremont, California, some forty miles east of downtown Los Angeles, thousands of miles from where he had been living and working in New York City since late 1927? The Mexican artist Jorge Juan Crespo de la Serna, then teaching at the Chouinard School of Art in Los Angeles, had been introduced to José Pijoan by a mutual friend, Professor Manuel Pedro González of the UCLA Spanish Department. Pijoan, anxious to secure a mural decoration for the recently completed Frary Hall refectory, inquired of Crespo if Diego Rivera (i.e., the best

19

19. General view of Frary Hall, 1930s. (*Photo by Robert C. Frampton, courtesy of David Scott.*)

20. *Prometheus*, Pomona College, 1930. Fresco, 20 x 28.5 ft. (*Courtesy of David Scott.*)

See also Plates 1–3.

known of the Mexican artists; Pijoan did not yet know Orozco's work) was available. Crespo, a personal friend of both Rivera and Orozco—and aware that Rivera had forthcoming murals arranged in San Francisco—suggested Orozco for the job.[40]

From this point, the story of the commission primarily concerns the brilliant figure of the Catalonian Pijoan, totally dedicated to art but wildly impetuous and undisciplined in his behavior. Though evidently an exciting and popular teacher (fondly called "El Obispo"—the Bishop—by Pomona students), Pijoan had acquired the reputation of a "wild maverick" not to be trusted by the college administration, and his position at this time was especially delicate because of his demands for increased salary and higher rank.[41] For his part, Pijoan spared no criticism of the administration for failing to appreciate his talents and efforts, such as periodically bringing masterworks in the area to his classes, especially

30

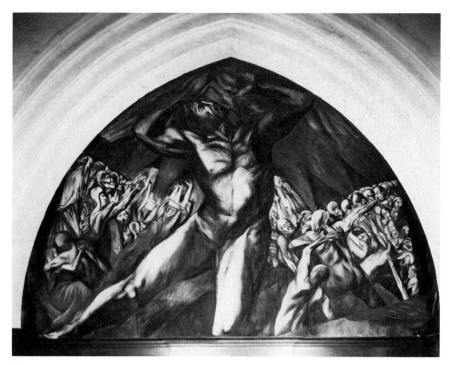

20

important since he had to teach courses in the history of art without lantern slides. Nor did Pijoan hold a high opinion of the intellectual and cultural environment of southern California, where, as he later put it, the Claremont College presidents rose "to the level of sagebrush." "I was surprised," he noted, "that in this refuge of all the loafers in America, Los Angeles and vicinity, there existed so many ignored works of art."[42] According to Pijoan, Sumner Spaulding, the architect of the Pomona College men's dormitories, inquired of him one day during the construction of Frary Hall what could be done to offset "the impression of nakedness and coolness" of the dining room, especially the alcove of the north wall. Pijoan suggested an oil painting, a tapestry, or a fresco. The former two were considered, to the length of installing a tapestry, but the lack of appreciation on the part of students and faculty and prohibitive purchase price ruled this out.[43] Next came the fortuitous meeting with Crespo

de la Serna, which ignited Pijoan's enthusiasm for a mural, particularly one by Orozco, and he raised the topic in a typically spirited talk with the students at dinnertime one night in Frary Hall. Pijoan proceeded on his own initiative throughout the course of his dealings with Orozco, without having the slightest authorization to act in any official capacity from the Pomona College administration. Much to the college's credit, to say nothing of the enjoyment and edification of future generations, the administration would feel honor-bound to accept a commitment in which they had no part.

Of the extant letters and telegrams between Orozco, Crespo, and Pijoan concerning the nature of the commission, the most important single piece of information is Orozco's unpublished letter of January 18, 1930, to his wife in Mexico City, which details his understanding of the situation and expresses his hopes for mural work in this country:

Yesterday I received a letter from a friend who lives in Hollywood, California. . . . His name is Jorge Juan Crespo. . . . He makes me a very nice proposition: he says that he could proceed with a fresco decoration in a new building at the University [sic] of Pomona . . . he tells me it is a sure thing, but as he doesn't have the experience, nor the international fame that I enjoy, he could not undertake the work alone and proposes that I do it with him serving as assistant. The work would pay little, only $2000 dollars, with $500 for him and $1500 for me. Moreover, they would pay my roundtrip ticket, a mason, materials, and other costs. He says the work could be done in a month, and I believe this as it is a wall of 60 square meters, and he will be living there and would be in charge of details. He also says that it doesn't cost much to live there. Last night I answered by telegram that I accept immediately, but that the best thing is that my gallery (that is, the Delphic Studios) acts as my representative, and perhaps therefore, we could obtain a better price and conditions. He says that there are probabilities of obtaining many works of this type in other universities. This would be really magnificent and I would much like this to be the first fresco painted by a Mexican in this country and the beginning of many good things. I await the answer to see what will happen. In my telegram I say that I could go in March, that is, immediately after my exhibition in February. And then I would return to New York or I could go to Mexico. How does this seem to you? By all means New York is my center of operations and it's clear that sooner or later I can work on mural projects but now the opportunity presents itself to begin to do it, if it can be arranged. . . .[44]

The first mention of Orozco in the Pomona College *Student Life* occurs in the March 6 issue, which disclosed that after a meeting with faculty members, Sumner Spaulding proposed a fresco for Frary Hall, and that presently "Diego de Ribere" and "L'Orozco" [sic] were under consideration. On March 19 the newspaper announced that Orozco, "rated by many critics as the outstanding mural painter of the guild that worked with Diego Rivera on the world famous murals of Mexico City's Secretariat and other buildings," would work in Frary Hall, and that undergraduates using the dining hall had pledged $1,000 of the $2,000 needed for Orozco's fee. Their generosity had no doubt been fueled by Pijoan's intense excitement for the project, whose comments in praise of Orozco concluded the article. On March 22 Orozco and Crespo arrived in Claremont, and *Student Life* joyfully welcomed the artists: "The Frary Hall fresco is to be a reality!"[45]

The matter of Orozco's arrival in Los Angeles provides an example of Alma Reed's coloring of events to embellish her picture of Orozco's "campaign" against a hostile world, with Alma Reed at the artist's side. She maintains that a Pomona College student committee met Orozco at the Los Angeles train station and informed him that adequate funds did not as yet exist to cover his fees. Further, she asserts that at this time Crespo volunteered to serve as Orozco's assistant "to show his own faith in a favorable solution." She presents the artist as "saddened and frustrated" at the "abrupt reversal of plans," yet nonetheless "his great dignity, courage, and patience did not fail him for a moment."[46] However, Crespo's son recalls meeting Orozco with his parents (as *Student Life* reported at the time), and that he spent that evening at their Hollywood home. Further, before journeying to Claremont, the Crespos and Orozco viewed the large international mural competition to decorate the projected Mural Hall of the Los Angeles Museum.[47] The German artist Erwin Hetsch won the competition with the theme "The Dynamic of Man's Creative Powers," which would have begun with a treatment of the Promethean legend, but the murals were never executed. Of course Orozco had named Crespo as his assistant weeks before and already knew of the money difficulties. Here he felt, as he maintained throughout the entire period, that the only important matter involved the actual painting of the mural.

President Edmunds's memos from this time reflect his embarrassment and difficult position

as a result of Pijoan's actions and projected a far less enthusiastic outlook than the students' hearty reception. First, Edmunds attempted to establish bureaucratic guidelines for Pijoan, and pointed out to him on March 20 that if the $2,000 represented the artist's fee, additional funds would of course be necessary to cover materials, scaffolding, and living expenses. With sufficient pledges, Edmunds offered to meet with the Dormitory Committee to secure approval of the design and to prepare a contract. Last, "all monies will need to pass through the Controller's hands, as a mere matter of customary procedure."[48] Outright apprehension of Pijoan's actions in the matter, based on previous dealings with him, were directly expressed to President Edmunds by the college controller, George S. Sumner:

> In the light of Mr. Pijoan's remarks at the College Club yesterday and a conference with Mr. Webber it seems to me that we protect ourselves by requiring a cartoon in color showing the fresco before any work in Frary Hall is permitted. Experience with Mr. Pijoan's taste in the past is such to make it imperative in my judgment.[49]

The artists, misled by Pijoan's picture of the situation in Claremont, ruefully found out "on the spot that Mr. Pijoan's following was not as he would have us believe."[50] Despite the administration's attempts to control Pijoan, he got carried away by his impetuous enthusiasm and, acting totally on his own, discussed with Orozco the idea of him painting the entire interior of Frary Hall with a "Hall of Giants" theme during the next eighteen months. Pijoan's "dream" would cost $25,000 and must have horrified President Edmunds, who had agreed to the Prometheus project only. He sent Pijoan a "note of caution," stating that "your public utterances have exceeded the limits of what had been agreed between us":

> Please understand that our consent for your going ahead with the fresco in the alcove on the north wall of Frary Hall does not imply any approval for

an extension of the fresco to other sections of the wall. In fact our Dormitory Committee is unanimously opposed to such a treatment of the side walls though we think a tinting of those walls is desirable.[51]

By the end of May a $1,000 donation had been received from the donor of funds, George W. Marston, for the construction of Frary Hall, with the express understanding that no more decoration be undertaken, and one wonders if the funds were solicited precisely for the purpose of limiting the extent of Orozco's work at Pomona.

> It was my understanding that my contribution should apply on that part of the work [the north wall alcove] and you may hand my check to Prof. Pijoan with this statement, that it is not for any future services of Sr. Orozco nor for the preparation of sketches for the side walls.[52]

If Pijoan's impulsive and vibrant personality ultimately brought about the creation of a masterwork, his unorthodox actions in this matter also proved to be his undoing at Pomona College.[53]

Orozco's mural occupies the niche-like area seen through the arch of the north wall of Frary Hall (a vast interior space of 50 by 100 feet), a total painted surface of approximately 100 square yards. Designed by Los Angeles architect Sumner Spaulding, the Eli P. Clark Dormitories complex comprised eight units: four residence halls, a refectory, a lounge, an assembly room, and a tower. It opened for use by students and faculty in the fall semester of 1929. The general scheme of a large open plaza with fountain surrounded by the cloistered arcades of buildings with white walls and red-tiled roofs had been inspired by Spaulding's firsthand study of Spanish Romanesque monasteries and public buildings. Quite possibly the irrepressible Pijoan, a native Catalan and author of a monograph on Spanish Romanesque painting, influenced Spaulding in the use of this idiom. At the very least he must have ardently reinforced Spaulding's architectural re-

21

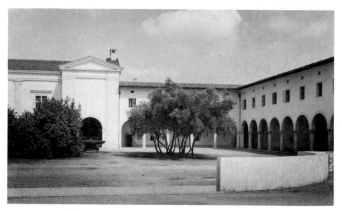

22

21. Plan of Pomona College campus, late 1920s. (*Architectural rendition c. 1952, courtesy of Pomona College News Service.*)

22. Clark Dormitories, 1930s. (*Photo by Fred R. Dapprich, courtesy of Pomona College News Service.*)

solve. Spaulding, at any rate, opted for an authentic adaptation of the Spanish Romanesque motif, choosing to avoid the dreadful adobe-tile pseudo-Spanish style so typically encountered in southern California. His design for the great refectory hall echoed Catalonian medieval and Renaissance monasteries and public buildings with its enormous marching Gothic arches, surmounted by exposed wooden beams instead of vaulting, and walls of exposed concrete. Pijoan greatly admired the architectural environment:

> . . . I will describe the place as the dining hall of a Cistercian monastery. It is a wide room, substantially built with four gigantic arches supporting a ceiling of redwood timbers that only our western forests can supply. There is no fake nor pretense in the entire construction. The monastic architects of the twelfth century will find no fault with its lack of frills and foibles. The floor is of tiles and the sides of simple oak paneling without cheap or gaudy carving or coloring of any kind. The walls are of plain white mortar and there is where we hope to have the frescoes [i.e., the "Giants" series].[54]

Surely the muralist Orozco appreciated the beauty of the austere purity of Spaulding's architectural conception and must have been seized with excitement when he first viewed the interior of Frary Hall, with its magnificent series of arches ending in a chapel-like alcove niche—an area that demanded decoration.

Orozco began work on the mural by producing three general studies, two of which have apparently been lost. The first bore absolutely no resemblance to the actual painting, and Thomas Beggs recalls:

> Yes, I know that it was a figure—dashing horizontally—the body was a horizontal line with the leg extended and one leg supporting him, and the arm outstretched, so that arm and leg and extended torch made a horizontal line that repeated the horizontal of the wainscotting. . . . I made the suggestion, wouldn't it be helpful to have the fall of the arch counter, to direct the attention up and back into

23

the composition where you have a center of interest— the face?

Orozco's design recalls the similarly horizontal figure of the leaping "Youth" in the vaulting of the Preparatory School Franciscan series (1923–24). Here, although adequate in the context of color relationships, Beggs felt the composition to be out of scale with the large surface area to be painted in the alcove space.[55] A second study came much closer to the final design in portraying a huge figure on one knee with arms outstretched, straining the architectonic limits of the wall space, while hints of masses of people appear at the giant's sides. The finished study emerged somewhat later in a drawing that Orozco would use as his general guide during the painting of the mural. Pijoan presented the administration and faculty with Orozco's drawing; they could "make nothing of the sketch and were unwilling to approve the project." To resolve the matter, Spaulding's

23. Second study for *Prometheus*, from *Student Life*, the Claremont Colleges student newspaper, November 4, 1930. Pencil, approx. 12 x 22 in.

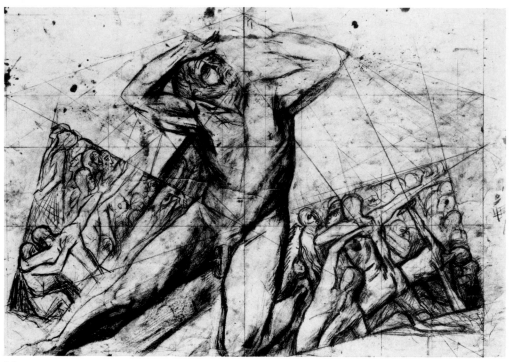

24

assessment of the study—most certainly the second version—was requested, and he made the critical decision that allowed Orozco to proceed with painting his mural: "Each time I looked at it I thought of the Sistine Chapel, and if it could make me think of Michelangelo it was good enough for my architecture."[56]

Orozco's assistant, Crespo de la Serna, had recalled that the artist began work on the project with the sketch already described by Thomas Beggs—"Orozco made a color sketch, but I must say that this sketch had almost nothing to do with the final achievement of the idea. Afterwards he even changed the whole color scheme, as well as the composition." He and Orozco sketched and planned for about two weeks during late March and early April 1930 in a vacant cottage provided by the college for Orozco's use. Working in his typical manner, Orozco first produced a rough lineal sketch that he developed into another one showing the contours of the central figure and the

masses to either side, planning in the proportions of approximately 10:1 for enlargement to the wall. The finished sketch reveals that Orozco employed in a general sense the geometric proportions of "Dynamic Symmetry" to determine his composition. The alignment of the central figure along central subdivision lines and the diagonally arranged and counterbalancing groups of figures to either side indicate Orozco's broad utilization of Hambidge's scheme, similar to Rivera's "guide-line" usage of Golden Section proportions in his North American murals. The general working sketch also incorporated the dozens of figure studies Orozco had made for the Titan and the masses, using as models his assistant Crespo, Mrs. Dorothy Merritt, and students such as John Goheen, since he did not have funds to pay professional models.[57] Orozco used these detailed figure and anatomical studies, exquisitely succinct and strongly sculptural in feeling, as mental notes to enlarge upon or modify as he

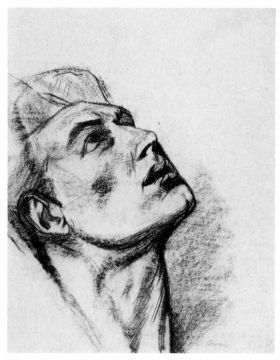

25

26

engaged in the actual act of painting. They were
a "springboard," to use Crespo's term, to the ulti-
mate expression. Some drawings were in fact
enlarged with coordinate lines on the wall, but
at other times Orozco painted figures and heads
directly onto the wall after the example of the
drawing. Mrs. Dorothy Merritt, whose hands
Orozco sketched, recalls that in the relationship
of preparatory drawing to painted image, "Always
in the painting it came out a little bit more dra-
matic . . . in other words, it was a free-hand
thing."

Various drawings indicate the way in which
Orozco could move from study to fresco: two
Prometheus studies, based on portraits of Crespo
and Goheen, reveal that Orozco enormously
revised the sketches in muscular bulk and mon-
umental aspect entirely during the painting pro-
cess, as well as generalizing the face and severely
uptilting the head. Similarly, a sketch of Crespo's
transposed upreaching arms shows that Orozco

24. General study for *Prometheus*, 1930. Pencil,
16.4 x 23 in. (*Courtesy of David Scott.*)

25. Study for *Prometheus*, 1930. Charcoal,
12.9 x 10.9 in. (*Photo by Lucrecia Orozco.*)

26. Study for *Prometheus*, 1930. Crayon,
17 x 12 in. (*Photo by Lucrecia Orozco.*)

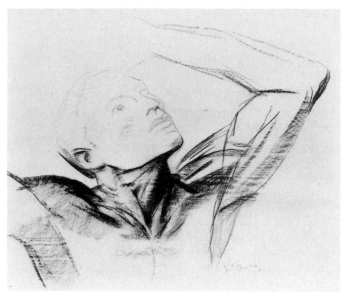

27

28

27. Study for the head of *Prometheus*, 1930. Crayon, 22 x 26 in. (*Photo by Lucrecia Orozco, courtesy of Sr. Juan Crespo de la Serna, who was the model for this study.*)

28. Study for *Prometheus*, 1930. Charcoal, 29 x 22 in. (*Photo by Lucrecia Orozco, courtesy of Sr. Juan Crespo de la Serna.*)

increased their size to Herculean proportions in the painting, as well as making the arms into more two-dimensional design elements echoing the apex of the arch. A sketch for the arm of the person with knife on the right discloses two versions of Orozco's visual note for the painting—only the torso and position of the arm had interest for him, as he barely recorded the hands. Also in this area of the fresco Orozco shifted the position of the body seen from the rear to a more expressive, dynamic pose and greatly distorted the actual length of the poser's arm to suit his painterly and compositional purposes. Yet, on the other hand, he enlarged virtually without change certain elements, such as the raised arm directly next to Prometheus's left (facing the viewer) hip.

With the exception of a Spanish-speaking odd-job person supplied by the contractor, Clarence Stover, Crespo de la Serna served as Orozco's only assistant and worked with him almost every day. Crespo's instruction in fresco advanced so rapid-

ly that within a few weeks Orozco permitted him to undertake details, and he would paint the entire lower section of the Centaur panel. Although preparatory studies demonstrate that Orozco designed the side panels, the restorer Nathan Zakheim has concluded on the basis of his visual examination that

> I do not find any similarity of technique, brushstroke, or compositional expertise such as is evidenced in the front panel. Also upon examining other works of Orozco's I do not find similar lapses of technical capacity in lesser important areas of his other works. So I am left at a loss to understand how the side panels could be ascribed to Orozco.[58]

Expert observation, then, tends to suggest solely Crespo's hand in the artistically inferior side panels, and the confusion of the lower section of the Zeus panel, for example, clearly points to an inexperienced artist at work in these relatively insignificant areas of the mural.

Orozco applied the final *intonaco* coat directly on an "Acousticon" layer covering the alcove walls. Ideally, this material, containing a large percentage of cotton, should have been removed and replaced with several individually applied layers of plaster. Yet, Orozco refused to do this, Thomas Beggs felt, because of the sense of "limited time" and the "urgency of the moment" stemming from the circumstances surrounding the commission and opposition to the artist's presence in Claremont.[59] Orozco himself had little hope for good adherence of the *intonaco* to its synthetic base—an indication of his stated concern that the all-important matter was *painting* the work—and later expressed pleasant surprise that it apparently had remained in perfect condition.[60] Orozco began by "snapping-in" compositional lines, and completed approximately one square yard daily during the fifty-seven-day painting period (presumably Crespo painted the remainder of the 100 square yards) in this order: first, the upper Godhead section, then the main *Prometheus* panel and, last, the lateral mythological subjects.[61] Pijoan has described a typical workday:

> He covered with fresco about one square yard each day; starting early in the morning, ate lunch with the students, and kept going until dark. The first hours made very little impression in the fresh whitewashed space, only at noon did the lime begin to show the color. I thought that the fresco had to be painted much stronger in color than what was expected to remain, but I noticed that the values remained without alteration.[62]

Artist Jean Ames watched Orozco paint one day and recalls that he worked in a spontaneous, improvisational manner directly on the wall from the general sketch of the mural. Orozco was then working on the upper section of the Prometheus figure, and the wall had at this time the major compositional diagonals in charcoal, but very little other drawing. Ames recalled that he used a student-grade watercolor mixing tray, mixing very small amounts of pigments at one time, and student-quality brushes (approximately no. 12 camel hair). The softness of the brush made it easier to apply the pigment, which Orozco did in short, choppy strokes without marring the surface, and since they were inexpensive, the brushes could simply be thrown away rather than cleaned. Orozco confessed his concern with the unfamiliar Canadian lime he had to use and worried that if not properly slaked, it would burn out the pigment colors.[63] Crespo maintained that Orozco had to repaint a few sections, specifically the figures to the left of Prometheus and the section with Zeus, but others recall him revising the head of Prometheus.[64] Orozco's palette for the *Prometheus*, particularly the brilliant combination of cadmium reds, oranges, and yellows to represent fire, introduced a greatly heightened use of pigmentation that anticipated his later coloristic concerns. As David Scott has recognized:

> In its first impact the *Prometheus*, with its flaming reds penetrating the figures, announces the arrival of a color expression heightened beyond that even of the *Trinity* and the *Trench* [Preparatory School murals of 1926]. Although the painting at first glance

39

seems somewhat limited in color range, the total composition is carefully planned in terms of areas which introduce a variety of hues, especially on the side walls. Intense blues and reds dominate, but there are striking passages of black-and-white, and vivid cold blue-green. The *Prometheus* reveals that by 1930 Orozco had entered on the road that was to lead to the chromatic brilliance of the walls at Dartmouth.[65]

One critic noted, "The red of fire is the living color that enrichens the wall." Yet above all, the flaring reds dominate the main panel, and the colors reinforce Orozco's primary theme of purification and salvation by fire. At the opposite edge of the spectrum of color symbolism loom the cold and ghostly gray-whites of those figures who do not respond to Prometheus's bringing of knowledge.[66] Orozco achieved these opaque whites by mixing his pigments with carbonate of lime (or even a bit of that day's plaster), instead of combining the color with pure water, essentially a watercolor technique used, for example, by Rivera to obtain totally transparent effects.[67] Little information exists on Orozco's actual daily progress in painting the mural. *Student Life* of April 19 reports that some twenty of the total one hundred square yards had been completed. An interview with Orozco on May 17 revealed that only a portion of the Centaur panel remained to be painted, and the June 14 date on one of the Goheen studies indicates that Orozco had finished the project by mid-June.[68]

If the actual process of the painting of the *Prometheus* can be coherently traced, some confusion exists regarding the reaction to the mural itself. Principally this involves Alma Reed's version of the formal dedication ceremonies at Pomona College, a dinner in which President Edmunds presented Orozco with a check (albeit for "less than half the originally stipulated five thousand dollars") and fulsomely praised "the moral effect of the artist's stay at Pomona" and "the fine example set by Orozco through his faithful observance to working schedules, his meticulous regard for craftsmanship, rare modesty, integrity, his sim-

plicity and kindliness of manner, his devotion to purpose, and his high standards of personal conduct."[69]

While Alma Reed no doubt would have enjoyed the event she depicted and certainly agreed with the sentiments she has President Edmunds express, her account varies from all contemporary records and later recollections. For example, I have encountered no description of such a ceremony in the local press, a curious matter since dozens of articles on the mural appeared from late March into June. Moreover, the Merritts, who saw Orozco several times each day while he painted in Claremont, unequivocally maintain that *no* formal dedication ceremony took place, and that Orozco simply left when he finished painting. Crespo de la Serna also mentions no official dedication of the mural, only that Orozco spent three or four days in Los Angeles on business matters relating to a set of lithographs he had brought with him from New York.[70] Nor does record of any payment to Orozco exist in Pomona College files, and on two occasions Orozco himself said that he did not receive a cent of the money raised for his modest fee.[71] Reed's account, then, disputed by knowledgeable sources including the artist, apparently represents another of her attempts to color or distort reality for the purposes of her "campaign" for the artist. Moreover, it even contradicts her own contemporary correspondence, as she wrote to the director of the New School for Social Research of "the many months to which Sr. Orozco devoted to mural painting here and in California, without financial compensation."[72]

While easily capable of bending the truth for his reasons, Pijoan asserts in contrast that Edmunds considered the work "an abomination" and refused to take Pijoan up on his dare to whitewash the mural only because "we shall be condemned as the most reactionary people if we cover the fresco."[73] Pijoan's account notwithstanding, widespread opposition to the *Prometheus* came from both within and without the college community. The first published reports of negative reaction came on May 15 when a letter from Har-

old Davis, a young member of the English faculty, noted the objections of some to the subject and its appropriateness for Frary Hall as well as its "harsh" coloring. He urged suspension of judgment until Orozco completed the work. On the same day appeared a letter by Pijoan, no doubt intended to smooth the waters between the "Town and Gown" communities. After urging the "Town" not to shut itself away "from participating in the present thrilling experience of having a masterpiece being made here," Pijoan extolled Orozco's talents, but unfortunately ended on a condescending note that surely must have offended the local townspeople:

> You, lady of Claremont, in your dignified surroundings and your relaxation of tea-parties and bridge parties, be sure that you cannot judge what is being done at Frary Hall. And you, delightful co-citizen, buying groceries and reading the *Atlantic Monthly*, have to give a little time for your soul to receive this new message.[74]

A member of the college's building committee, evidently horrified at the prospect of a possible continuation of Orozco's "ultra-modernist" work, asked Edmunds point-blank to appoint a "competent board of unprejudiced judges, composed of artists of recognized ability" to give their opinion as to whether the painting, "regarded by some as 'a monstrous disfiguration,' " should be allowed to remain as a permanent covering of the wall. Thomas Beggs also recalls the specter of communism being raised, a topic the administration dreaded because of the possibility of loss of funds from the college's conservative supporters—and this in fact happened.[75]

But beyond the responses of local conservatives, cranks, and Pijoan's stereotypical "lady of Claremont," there existed an informed conservative reaction within the academic community, exemplified by Dr. Benjamin Scott, father of David Scott and the chairperson of the speech department. Scott's background included a Ph.D. in philosophy, a period as a minister, and a very

solid grounding in the classics. A professor of English and drama, he felt quite keenly about what he considered the inappropriateness of the mural, that it ran counter to the traditional conceptions of all humanistic culture dating back to the source of Western culture, the civilizations of Rome and Greece. He believed that the "pagan" distortions of Orozco's expressionistic modernism—which derived from European Expressionism and not Mexican art—were at war with the entire classical impulse, and that they destroyed balance, order, and proportion. Dr. Scott's disagreement with his son over the mural reached such bounds that they agreed never to discuss the topic at the dinner table![76] Dr. Scott's reaction typified the situation amid the college sector for whom Orozco's mural had the effect of a traumatic "culture shock," and stands far removed from Alma Reed's more simplistic contention that racism—both in the context of Orozco's Mexican heritage and, by extension, its implication that the artist lacked knowledge of North American customs and beliefs—played a major role in opposition to the murals. David Scott has noted that "in the college community it was the custom to welcome visiting scholars, lecturers, and musicians, and an established foreign painter would have been treated as an equal in the academic community."[77]

Yet Orozco and the mural also attracted support from the very beginning, and foremost among the supporters were the students, spurred on by Pijoan's passionate devotion to the project. They donated and raised funds, posed for Orozco, and brought out a special "Fresco Edition" of *Student Life*. The freshman class president, Bob Brown, saw the creation of the mural as:

> . . . one of the highlights of that first year. I remember that we were impressed by the coincidence of having this wonderful new Commons with its great expanse of unadorned wall and this artist who used a most unusual but very old technique. . . . I remember how thrilling it was to be there at the creation—to see the main theme evolve and then

the subordinate themes and to be impressed as we were by the wonderful symbolism of it all.[78]

The project also had faculty support, particularly from the Merritts, Professor A. E. Dennison of the philosophy department (who had been involved in discussions of the theme), and Professor Morgan Padelford, head of the Scripps College art department. Influential support came from the then-liberal art critic of the *Los Angeles Times*, Arthur Millier, who began coverage of the project shortly after Orozco's arrival in Claremont and highly praised the *Prometheus* on its completion:

> Orozco had energized that wall with his sublime conception of Prometheus bearing fire to cold, longing humanity, until it lives as probably no wall in the United States today. . . . Actually it [the mural] brings to us a bit of the most significant art outburst of our time. The esthetic experiments of modern Paris are trifling matters compared to the Mexican wall paintings of the last nine years.[79]

Last, architect Sumner Spaulding supported Orozco during the painting of the mural and reacted most favorably to the tremendous architectural strength of the mural, commenting, "I feel that the building would fall down if the fresco were removed!"[80]

Orozco seemed as unaffected by the negative criticism toward his work as he had been by not receiving payment, for several months later he wrote to the Merritts: "I don't mind the adverse criticism. It is to be expected. All modern art is and always will be subject to resentment of the conservatives." He also offered his "kindest remembrances to all the friends at Clark Hall," supporting Crespo de la Serna's view that Orozco actively enjoyed his stay on campus and had formed friendships with Pomona/Scripps students and the younger progressive faculty members.[81] Further, he felt no hostility toward the irrepressible Pijoan. Shortly after leaving Claremont Orozco wrote to Crespo, "Really, Pijoan is not to blame for anything," and he maintained an affectionate friendship with the Catalan until Orozco's death in 1949.[82] Although Pijoan was no longer associated with Pomona, Orozco retained hopes for continuing work on the "Hall of Giants" theme, yet the Depression surely cut off any hope for raising the necessary $25,000.[83]

In 1930 the Pomona College administration had been pressured to accept a fresco by an artist unknown in provincial southern California and was probably dissatisfied with the result; today President David Alexander recognizes the mural as a "work of historic importance" and, indeed, a "precious resource of the College."[84]

The New School for Social Research, 1930–31: A Call for Revolution and Universal Brotherhood

Orozco passed the summer of 1930 in San Francisco, where in three months of intensive activity he produced several canvases for the large-scale Mexican Arts exhibition at the Metropolitan Museum that opened in October, before returning to New York to begin work on murals in the new building of the New School for Social Research.[85] The Pomona College newspaper, *Student Life*, had announced on May 1, 1930, that the New School's board of directors had accepted Orozco's "generous offer, through your agent, Mrs. Alma Reed, to honor our new building with your work."[86]

Alma Reed had seen an Architectural League

exhibition in New York that included Joseph Urban's plans for the New School building, and managed to secure an appointment with Dr. Alvin Johnson, the school's director, through an admirer of Orozco's and lecturer at the New School, Lewis Mumford. At their interview Dr. Johnson disclosed his enthusiasm for Orozco's art and stated "he would be very proud to have the Mexican painter share in establishing the New School as a center of modern art."[87] Reed's letter to Alvin Johnson confirms her role as the donor of the murals and reveals her strong association with the imagery of the paintings:

> And it is only right and proper that this cheerfully assumed (though at the time very difficult) responsibility of making it possible for Sr. Orozco to meet his personal and family needs during the progress of the work at the New School, remain my own, since the whole idea of frescoes for the New School originated in my own mind; because the work itself represents profoundly my own point of view and idealism, and because, with the Mexican panel my name will be associated with Mexican history.[88]

Johnson, for his part, charged "each artist [i.e., also Thomas Hart Benton, who painted his first public walls at the New School at this time] to work within the framework of contemporary life." Each was asked to "paint a subject he regarded as of such importance that no history written a hundred years from now could fail to devote a chapter to it."[89] Orozco's New School murals carry forward the structural arrangement of Pomona. Three panels arranged on longitudinal axis present allegories of ideal human orders (respectively, the creative abilities of man, the ultimate success of the proletarian struggle for dignity and happiness, and human brotherhood) flanked by four side panels illustrating the political means by which these ends can be achieved. The cycle would be the most positive of the North American murals, even to the point of being uncharacteristic of Orozco's oeuvre. Here the artist saw the achievement of an ideal human existence as distinctly possible, whereas with the *Prometheus*

29

29. Orozco and unidentified person in front of *Allegory of Science, Labor and Art,* c. 1946. (*Photo by Jerry May courtesy of New School for Social Research.*)

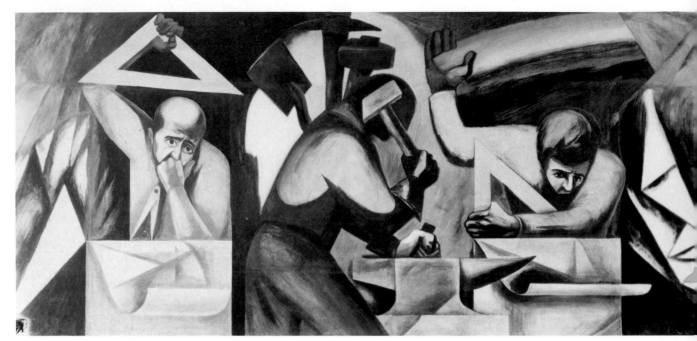

30

30. *Allegory of Science, Labor, and Art*, New School, 1931. Fresco, approx. 6 x 12 ft. (*Photo by Peter Juley, courtesy of National Museum of American Art.*)

31. *Fraternity of All Men*, New School, 1931. Fresco, approx, 6 x 12 ft. (*Photo by Peter Juley, courtesy of National Museum of American Art.*)

32. *The Homecoming of the Worker of the New Day*. Fresco, approx. 6 x 12 ft. (*Photo by Peter Juley, courtesy of National Museum of American Art.*)

he presented only a partial recognition (as opposed to actual steps toward this goal) of the range of human accomplishments offered by the sacrificial act of the heroic rebel. In contrast to the *Prometheus*, however, Orozco's New School murals would depict specific twentieth-century revolutionary struggles that held great meaning for Ashram members, and for Alma Reed personally. Hence the paintings should been seen as the least personal of Orozco's works of this period.

The series begins outside the seventh-floor refectory (at present a classroom) with an allegory of the arts and sciences that serves to introduce the main body of work. Inside, on approximately seventy square meters of wall space on the small, low-ceilinged room, the south wall *Fraternity of All Men*, where the various races and creeds of mankind sit at *The Table of Brotherhood and Ultimate Universality*, stands opposite the north wall *The Homecoming of the Worker of the New Day*. The east wall, concerning the Orient, shows the

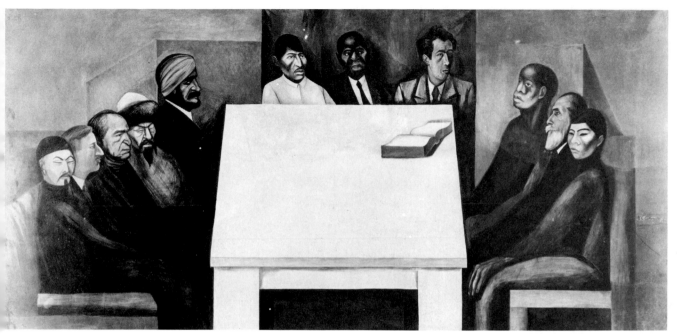

31

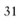

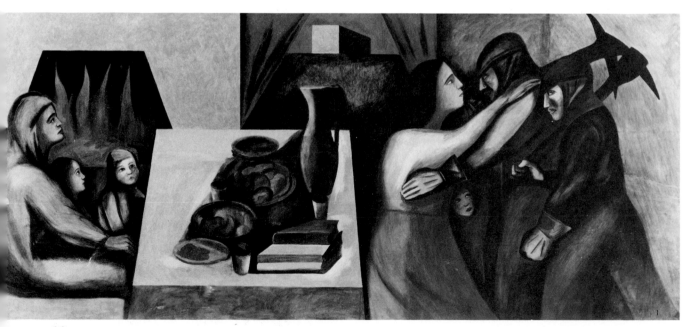

32

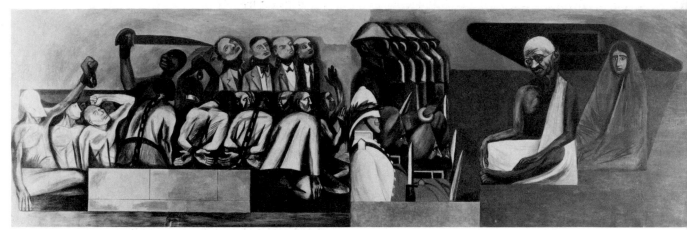

33

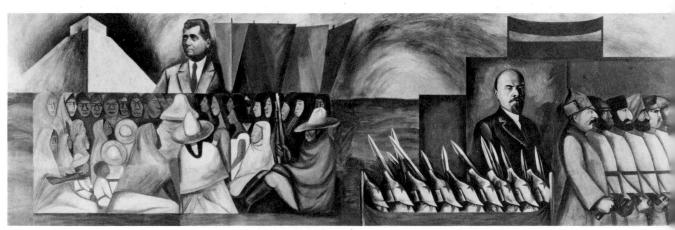

34

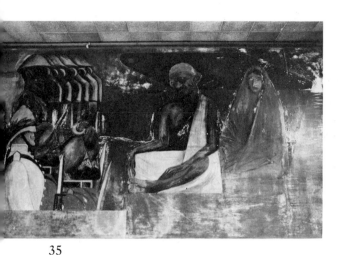

35

33. *The Orient.* Fresco, approx. 6 x 20 ft. (*Photo by Peter Juley, courtesy of National Museum of American Art.*)

34. *The Occident.* Fresco, approx. 6 x 20 ft. (*Photo by Peter Juley, courtesy of National Museum of American Art.*)

35. Detail of the east wall (Gandhi), approx. 6 x 9.3 ft.

ideals personified by Gandhi and a related painting devoted to the freeing of enslaved peoples. The west wall deals with the Occident, as the image of the Mexican political leader Felipe Carrillo Puerto faces Gandhi and appears alongside the "New Social Order" of the Soviet Union.[90]

David Scott has observed in the divine inspiration of the three figures (scientist, artist, and worker) of the introductory allegorical panel a relationship to the Prometheus, who reaches upward for the sacred gift of fire. The scientist, deeply engaged in pondering his world, reaches on high for a triangle (symbol of ideal form) that he succeeds in translating to the measure of his invention, the compass. The artist reaches above for divine guidance (the rainbow), which he transforms into artistic form (the triangle)—an image that may also serve as a reference to Dynamic Symmetry, the compositional system Orozco employed at the New School. Between these figures a worker puts into actual use the theoretical programs of the scientist and artist.[91] These allegories present a universal and hopeful picture of the fraternity of man and are further conjoined, both compositionally and thematically, by two oversized tables. On the south wall, in the *Table of Brotherhood and Ultimate Universality,* various races and creeds of man sit in harmony at the table, chaired by representatives of the "despised races": in the center appears an American black and to his sides a Mexican peon and a Jew. To the left the artist painted (from left to right) a Mandarin Chinese, an Anglo-Saxon, a European Nordic, an Iranian Kurd, and an Indian, while to the right sit an African, a Frenchman, and a Cantonese "coolie." Here Orozco once more drew on his contemporary personal environment and included several portraits of Ashram figures.[92] *The Homecoming of the Worker of the New Day* indicates the artist's hopes for the ultimate beneficial state of the masses as a result of revolutionary struggle. Here two grim-faced workers return from their factory, curiously brandishing pickaxes, to the comfort of home, family, warmth, food, and

36

Gandhi's massive nonviolent movement from discussions with Gandhi's companion and disciple, the Oxford-educated poetess Sarojini Naidu. Mme. Naidu, a past president of the Indian National Congress, was then in the United States to publicize the plight of the Hindu people, and she often read her poetry at Ashram gatherings. Orozco had been deeply touched by her descriptions of her people's abject situation:

> whose condition is inferior to that of the filthiest animal in the way they are utterly deprived of human, civil, and political rights; deprived of the right to work even, to gain an education, to move freely about, to speak, to complain; obliged to burn the widow alive on the corpse of the husband; victims of frightful diseases, starving, helpless, plunged in corruption, with no hope but to die.[94]

The artist presented a generalized image of the enslaved races of mankind as the enchained figures rise in protest against their brutalized state. Between the servile peoples of mankind and Gandhi, Orozco's symbol of liberation through nationalism, obtrude the forces of imperialism and the mechanized forces of modern warfare, represented by a caricature of a British imperial officer, native colonial troops, and the ominous image of a phalanx of faceless troops in gas masks. Confronting this awesome might are the sole figures of the humbly clad Gandhi and a female disciple and symbol of Indian womanhood, while behind them a stylized image of the sun rises over humanity. On this wall Orozco further developed the theme of the suffering masses that he had presented in a universal context in the *Prometheus*, and the New School figures anticipate the fully mature expression of this motif in the Guadalajara murals of 1936–39.

culture. The figures of the three young children represent the theme of "the appealing child," as David Scott calls it, which is quite rare in Orozco's art. Scott has detected an autobiographical note, reference to Orozco's own three young children in Mexico at this time whom he certainly missed.[93] The harmony and tender sentiments of the family scene recall Orozco's third-floor Preparatory School paintings (*The Mother's Farewell*) and are uncharacteristic of the fiercely negative nature of Orozco's subsequent work of this decade, beginning at Dartmouth and becoming especially strident in the Guadalajara murals of 1936–39. Finally, in keeping with the imagery of this panel, decorative worker motifs, the tools of manual labor, appear above the doorways.

On the political aspect of the lateral paintings that treat revolutionary movements of this century, two panels overtly express themes central to the Ashram salon. First, Orozco had firsthand exposure to contemporary Indian problems and

Orozco also had firsthand knowledge from Alma Reed of the "Socialism" section of the west wall, in which the Yucatecan people struggle for justice directed by their extraordinary, though doomed, leader, Felipe Carrillo Puerto. During his brief, but spectacular, twenty-two-month tenure as governor of Yucatán state, Carrillo Puerto

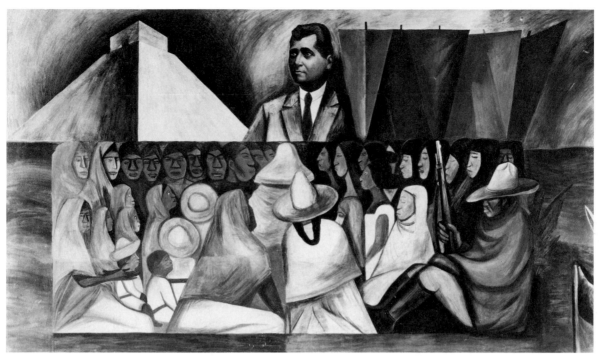

37

had instituted a major program of political, social, and cultural reforms for his people. His policies, aimed at a basic restructuring of Yucatecan society, brought about government control of the state's single crop, sisal, land distribution, democratic elections, extensive school and road construction, an enlightened revision of laws concerning divorce, birth control, alcoholism, and prison reform, and finally, he stimulated an intensive study of Maya culture in all its aspects. In his painting, Orozco portrays Carrillo Puerto in the upper register, flanked by the "Castillo" of Chichén-Itza, symbolizing the indigenes' Maya heritage, and the red flags of the "Leagues of Resistance" organized by Carrillo Puerto in 1915 to combat the ruling aristocratic-clerical establishment. Below, the huddled masses of women and children, protected at the right by an armed guerrilla, recall the auxiliary "feminist leagues" that fought in the areas of improved education, hygiene, and child care.[95]

36. Decorative panel, approx. 4 x 6 ft.

37. *Felipe Carrillo Puerto (of Yucatán)*, New School, 1931. Fresco, approx. 6 x 7 ft. (*Photo by Peter Juley, courtesy of National Museum of American Art.*)

38. (Overleaf) *The Soviet Union*, New School, 1931. Fresco, approx. 6 x 7 ft. (*Photo by Peter Juley, courtesy of National Museum of American Art.*)

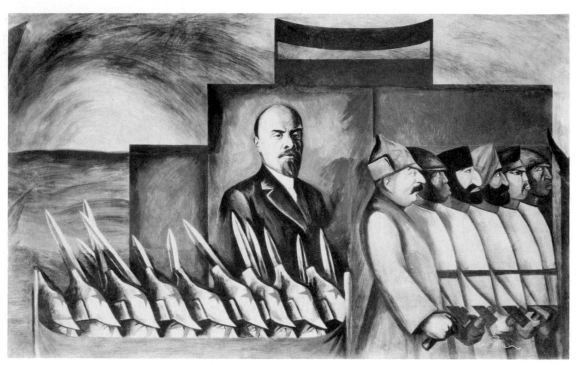

38

The adjoining occidental panel, *Communism*, bears the least imprint of the Reed-Sikelianos "Delphic Movement," for the realities of Marxism apparently went beyond the pale of the Ashram's altruistic liberalism, and this work must reflect Orozco's reading and political point of view at this time. The painting represents the most overt expression of sympathy for the USSR in Orozco's oeuvre, as Orozco adopted the prevailing leftist political point of view of this time. However, his positive interpretation of Stalin's role vis-á-vis contemporary conditions here stands in total contrast to the strident, even raging, anti-Marxism of the Guadalajara murals of the late 1930s. He portrays the past as the silhouette of the old Red Army, marching in battle gear under a banner of Lenin, while now in the present Stalin leads the many races of the USSR in a peaceful demonstration, as each marcher carries a construction tool.[96] In the political panels Orozco further evolved the central theme of the *Prome-*

theus, the sacrifice of the creative rebel for the cause of mankind, this time not in an allegorical sense, but rather in the specific context of twentieth-century revolutionary movements.

Thematically, both the topically popular doctrinaire socialism of the revolutionary panels and the humanitarian idealism of the fraternity of mankind paintings ring false in terms of Orozco's artistic personality. Above all, at the New School one misses the fiercely independent spirit of Orozco. About Orozco's free-willed vision Octavio Paz has observed, "He was a truly free man and artist, and something extraordinary for Mexico, he was not afraid to express his freedom."[97] It appears totally in abeyance in these paintings. One wonders just how much obliged Orozco felt to express his indebtedness to the general milieu of the Ashram and especially to Alma Reed, who not only obtained the commission but also supported the artist during the painting of the murals. Jacqueline Barnitz has written of the New York School

frecoes as "a note of gratitude for his New York hosts,"[98] and this factor must be considered as contributing to the uncharacteristic mood of the imagery. Orozco may also have felt that restraint of his usual gloom was necessary in deference to the progressive sociopolitical community of New York, as exemplified by the New School. He expressed in his murals the liberal idealism of Alvin Johnson, which he seems to have genuinely admired, rather than giving vent to the stormy pessimism and chaos of, say, his *Mexico in Revolution* series.[99]

The paintings are not only unrealistic within the context of Orozco's artistic spirit; they reflect an illusory optimism regarding the economic situation of workers. As his letters to Crespo de la Serna demonstrate, Orozco recognized the terrible gravity of contemporary economic conditions. While he was working on the paintings (December 14) he noted that the general economic situation was "very bad," that "the unemployed have invaded New York," and that the failure of the United States Bank caused a true panic. "All that you see and read in the press about the misery is terribly real."[100] Finally, the mental and emotional pressures involved in painting at top speed in a small, cramped architectural environment amid the noise and confusion of a building under construction and working for the first time in the nation's art center can be cited as other factors contributing to the overall weakness of the paintings.

The composition of the New School panels, to which Orozco painstakingly applied Jay Hambidge's principles of Dynamic Symmetry, stands far removed from his usual manner of working.[101] Preliminary studies communicate the feeling of mathematical plotting and totally lack the sense of spontaneity and freedom of the *Prometheus* anatomical studies. Individual panels, such as *Yucatán*, can easily be divided according to Hambidge's precepts. Orozco constructed a square at the left side of the work, consisting of the Maya peasants below and the "Castillo" of Chichén-Itza and Carrillo Puerto in the upper register and

terminated by a line that runs down the middle of the first banner of resistance and continues down through the rest of the composition. The remainder of this panel, with flags above and an armed peasant below, is the reciprocal of the first section of the panel, making the composition in its entirety a "whirling square rectangle." My proportionally correct diagram illustrates Orozco's dependence on Dynamic Symmetry:

ABCD = square
EFGH = square
ABIJ = whirling square rectangle
CDIJ = reciprocal of ABIJ
FEKL = root-five rectangle
KLIP = root-five rectangle

That Orozco's New School murals had an entirely different compositional rationale from his earlier Mexican murals can clearly be seen by comparing these studies with the drawing for the Preparatory mural, *Franciscan Succoring Indian* of 1923–24. The simplistic structural framework of these designs—sixteen nonroot or "static" rectangles—demonstrates that at Orizaba he worked within the context of arithmetic relationships, in contrast to the geometric associations of commensurable areas of the New School murals. Yet, an unnaturally arbitrary and sterile composition results from Orozco's programmed manner of

working at the New School, and the series can only be regarded as an esthetic failure. Orozco's figures, which depend on Dynamic Symmetry for their existence, have absolutely no life of their own, surely a paradoxical state of affairs for an artist who earlier had proclaimed: "My one theme is Humanity; my one tendency is EMOTION TO A MAXIMUM."

Although the contrived rigidities of Dynamic Symmetry wholly dominated the New School paintings, at least Orozco demonstrated an awareness of the importance of geometric relationships to mural composition, an appreciation not evinced in the earlier Mexican murals. Moreover, Orozco's brief, but total, immersion in Hambidge's theories represented an important learning experience for the artist. If the unfortunate immediate result—an inflexible and lifeless composition—was artistically unsuccessful, Dynamic Symmetry did provide the artist with a significant instrument that he would first employ at Dartmouth: a geometric framework for his essentially spontaneous painting style. Orozco later expressed his recognition of the limitations of Hambidge's ideas:

> After doing the pictures in the New School I abandoned the overrigorous and scientific methods of Dynamic Symmetry, but I kept what was fundamental and inevitable in it and with this I shaped new ways of working. I had the explanation of many former errors and I saw new roads opening up.[102]

In addition to the self-imposed restrictions on subject matter and composition, both deriving from Orozco's association with the Ashram group, he faced other problems at the mural site itself. First, the artist had to contend with an irregular wall space within the confines of the small room. Then the building, still in the process of construction, had not been tested for heating effects, nor had there been time for structural settling, and working amidst the high noise level created added nervous tension for the artist. In addition, Orozco had to work at top speed because authorities want-

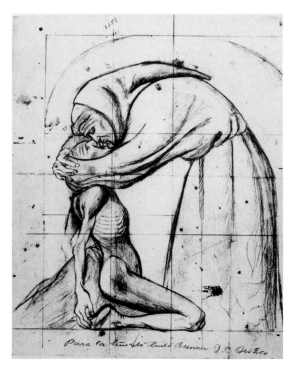

39

ed the building completed by the first of the year.[103]

Orozco began studies for the panels on his cross-country railroad journey in late September and commenced actual painting on November 1. Alvin Johnson described the artist's progress as of January 1: "Orozco had finished only two of his four walls, though the others are well on their way." He required 46½ days' work to complete the frescoes.[104] Orozco made it his practice to show Alvin Johnson his preparatory studies before beginning to work on the walls. He "would ask for nine square feet or fifteen of wet plaster to be available at nine the next morning."[105]

Possibly because of the time shortage, Orozco resorted to short-cut technical procedures and was forced to adopt inconsistent work habits. Mexican restorers who later examined the murals found a widespread use of *fresco secco* (painting in tempera on the dry walls), as in the Yucatán panel

where Orozco overlaid layers of blue and green pigment after completing the fresco section, presumably to heighten the chromatic impact. Orozco's prevailing practice of applying pigments in tempera over the *al fresco* undercoating prompted the restorers' comment that the artist evinced "very little fondness" for the *buon fresco* medium.[106] Also, Orozco at times painted on an extremely dry *intonaco* coat, resulting in an inadequate bond between pigment and plaster, and his typically thick application of pigment similarly failed to adhere properly. Further, Orozco displayed a singularly obvious lack of conern in merging the patches of each day's work with the composition, as in the Lenin portrait, where the line of plaster around the figure produces a jarring visual impact.[107]

In only one panel of the New School series did Orozco follow the manner of "direct expression" so characteristic of the *Prometheus. The Slaves*, with its looseness of painting, slashing brushstrokes, and the tortured, deformed figures—especially in the distorted form of the enchained man at the extreme left with an upraised paw-like hand— marks a tendency Orozco would accentuate to a greater and greater degree in his later work. In, for example, the *False Leaders and the Masses* from the University of Guadalajara mural (1936), Orozco heightened the intensity of the horrible suffering of the masses by means of violent brushstrokes, pulsating color contrasts, and hyperactive, distorted forms. In *The Slaves*, Orozco confined himself to tonalities of black and white, as he had done in the masses section of the *Prometheus*, another anticipation of the University of Guadalajara and the side panels of Jilquilpán, where he purposely denied himself the use of color. Because of the gravely deteriorated state of the painting surface of the New School paintings, it is difficult to assess the general quality of their color.[108] Yet beyond doubt Orozco followed the general scheme of the *Prometheus* and similarly used a "color language" to reinforce the imagery. As Alvin Johnson remarked: "What is past

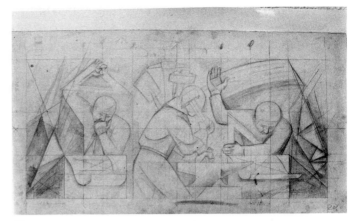

40

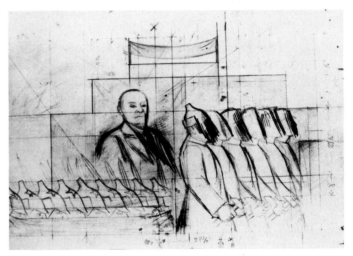

41

39. *Franciscan Succoring Indian*, 1923–24. Pencil, approx. 24 x 16 in.

40. Study for *Allegory of Science, Labor and Art*, 1931. Pencil, approx. 10 x 15 in. (*Courtesy of New School for Social Research.*)

41. Study for *The Soviet Union*, 1930–31. Pencil, 14 x 19 in. (*Courtesy of Lucrecia Orozco.*)

53

or destined for defeat [*The Slaves,* the old Red Army, and Lenin] is in grays: as he approaches reality or promise of realization [Yucatán, Gandhi] his colors brighten and deepen."[109]

Director Johnson wrote enthusiastically of the "deluge of visitors" to the New School and estimated that 10,000 had poured into the building during the first four days of January 1931. Although he noted a general positive reaction, at least one wealthy patron wanted "to raise the devil because Orozco has worked in a portrait of Lenin," and Johnson fully expected a "large-sized fight on my hands over that." Yet he vowed to uphold his decision to allow Orozco thematic freedom: "I am willing to take a good deal of punishment for having done a thing that has shaken New York out of its complacency."[110]

The murals were dedicated on January 19. Later that month, Orozco wrote to Crespo de la Serna that some anxiety had been expressed over the Lenin panel, but that the New School was standing firm behind the artist.[111] The "most violent critics" of the murals were, according to Johnson, New York Trotskyites, who "saw in the picture not merely the glorification of Stalin but approval of Stalin's repudiation of the ideal of a world revolution and his concentration upon the industrial development of Russia."[112] Political considerations would reemerge during the McCarthyite 1950s, resulting in the covering of the Lenin panel because the painting "did not express the philosophy of the faculty."[113]

Critics, including those who admired Orozco's art, found the New School murals unsuccessful.

Edward Alden Jewett, "with genuine regret," judged them "disappointing," and reacted to the panels as "a melée of fragments without—from the standpoint of design—any relationship." He found himself "repelled by the distressing absence of coordination, of rhythm."[114] In a more perceptive review, Lloyd Goodrich realized the reason for the general uneven quality of the paintings, that they represented an uncharacteristic expression on Orozco's part:

> Essentially a mordant critic of society, he is at his artistic best when attacking sham or injustice, as in the devastating satire of his murals in Mexico City, or when he is stirred to indignation by the spectacle of suffering, as in the tragic intensity of his scenes of the Revolution, with their bitter exposé of the horrors of war.
>
> In the present murals, however, these qualities are somewhat in abeyance. It is the constructive side of revolution that is here set forth, and the idealism of the themes offers few opportunities for satire. In Orozco's earlier work the subjects were concrete and close to his emotions, but here they are more generalized and abstract. As a result, one feels in certain of these murals a lack of the emotion shown in his previous work. It is significant that the most abstract of all, the one symbolizing man's creative achievement, is also the one that carries the least conviction.[115]

Yet, despite negative critical opinion (although not a single critic writing at the time comprehended Orozco's utilization of Dynamic Symmetry), Orozco's murals attracted thousands of viewers.[116]

42

42. The west wall in 1980.

43. Detail of the west wall, showing deterioration, 1980.

43

Dartmouth College, 1932–34:
An Epic Interpretive Narrative

In his Dartmouth murals, Orozco abandoned the schematized compositional plan of the New School murals and employed instead a far less rigid geometrical framework to buttress the fundamental spontaneity of his individual painting style. Thematically, the artist continued to develop the motif central to his North American murals, the heroic self-sacrifice of the rebel or artist for the benefit of mankind, here exemplified by the greatest figure in indigenous American mythology—Quetzalcoatl.[117] The Dartmouth cycle continues the New School "continuous wall format," to use David Scott's term, in presenting the subject matter common to all three North American murals—the sacrificial hero, the role of the masses, the overthrow of corrupt orders, the hope for a new and superior civilization based on the hero's higher inspiration. But owing to the architectural environment this series follows only in part the axial arrangements of the Pomona and New School murals. Further, the Dartmouth paintings treat a different theme, Orozco's epic version of the New American civilization. However, what most distinguishes these works is a markedly pessimistic view of human society. This pessimism, seen earlier in Orozco's nonmural art (as in the *Mexico in Revolution* series, the Depression-era oils and graphics), appears for the first time in the North American murals at Dartmouth. It would culminate in the raging nihilism of the later murals of this decade (*Katharsis*, 1934; the "lateral" sections of the Guadalajara series of 1936–39; and Jilquilpán, 1940).

The nature of the commission again runs counter to Reed's later account of the matter, in which the acclaim of the art historian Laurance Schmeckebier, who had written a strongly favorable article on the New School murals, plays a major role in Dartmouth's decision to undertake the mural project.[118] In fact, the Dartmouth College art faculty had been actively pursuing Orozco to paint at Dartmouth even before his work at the New School, as part of an ambitious plan to decorate the college's buildings with a series of murals, and had presented three exhibitions of his easel works, graphics, and mural studies during 1930–32. President Ernest M. Hopkins noted shortly after Orozco began work on the murals that "the members of our Art Department were a solid phalanx of enthusiasm for the scheme in the beginning and in urging that it be undertaken."[119] Moreover, Alma Reed's own contemporary letter refers to Dartmouth's interest in bringing Orozco to Dartmouth:

> Last summer you suggested the possiblity of a mural. . . . I am wondering how such a possibility may be furthered into reality. Orozco is now free for a few months. . . . He has just completed the murals in the New School for Social Research [and] is eager to go on with what he did in Pomona College and which he calls the New World epic painting—taking great traditional themes—such as the "Prometheus" and giving them a meaning for today.[120]

Some three months later she again wrote to answer questions about the artist's fee and subject matter. First, if either square footage or overall figure determined his fee, Orozco felt "confident of the financial side of the question." Regarding the theme, Reed brought forth the Daedalus myth, another topic surely dictated by the predilections of the Ashram Grecophiles: "Orozco has a splendid interpretation and modern application of this myth based upon man's striving to escape from the mechanistic . . . the release of the creative faculties. . . ."[121]

Financial conditions prevented any hope of implementing the project during the rest of the year, and only in early 1932, with the aid of a

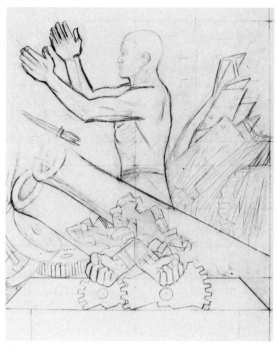 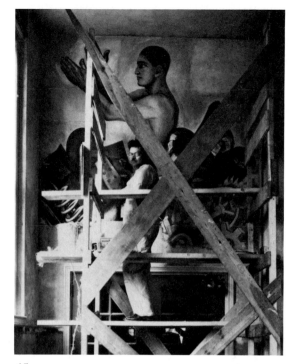

44 45

special Rockefeller teaching fund, did it become possible to invite Orozco to Dartmouth to give a lecture-demonstration on fresco technique. President Hopkins, obviously aware of the current artistic fashion for Rivera and Orozco, notified the college treasurer of his resolve:

> You doubtless have heard that we are bringing the latest sensation in mural painters, or at least one of the two latest sensations, to Hanover in the person of Orozco. I have offered to utilize $500 of the Rockefeller tutorial money to pay for his presence, partly because he may be that useful to the Department of Art and partly because of Mrs. Rockefeller's enthusiasm about these two Mexicans.[122]

Two factors involving this frankly instructional mural would figure prominently in the painting of the American epic. First, additional special Rockefeller funds would underwrite Orozco's salary while he worked at Dartmouth. Second, Orozco would further investigate the general

44. Study for *Release*, 1932. Pencil, approx. 16 x 12 in. (*Courtesy of Dartmouth College.*)

45. Orozco on scaffolding in front of *Man Released from the Mechanistic*, 1932. Fresco, approx. 8 x 6 ft. (*Courtesy of Dartmouth College.*)

theme of this work, man's release from the bondage of warfare and the destructive use of machinery, in the modern-day panels of the later immense mural program. He painted the small panel above the doorway leading from Carpenter Hall, the art building, to the bottom level of Baker Library in approximately a week's time in early May 1932 at the rate of four to five square feet a day.[123] Adapting Orozco's statement on the mural, a Dartmouth press release described the artist's symbolic intent in *Man Released from the Mechanistic:* "In the recovery of the creative use of our hands [Orozco] says he wishes to symbolize the recovery of the integrity of the human soul which is in danger of being lost in the confused welter of modern mechanized existence."[124] Here Orozco depicts a single nude figure reaching for guidance from above, recalling, of course, the *Prometheus,* even though this hero lacks the Pomona figure's expressive strength and seems to regress to the mannered academic tendencies of the first Preparatory School nudes. He emerges from a confusion of mechanical objects, as the artist directly follows the positive symbolism of the New School allegorical panels. However, in the Baker Reserve Room cycle Orozco would reject this overtly positive point of view and call for the total destruction of what he viewed as the abjectly corrupt nature of contemporary civilization. While the specific reasons for Orozco's abrupt change in philosophy remain unclear, that this occurred at Dartmouth, while Orozco worked completely on his own away from the constraints of Alma Reed and her "Delphic Circle," must be taken into account.

Reaction to Orozco's fresco on the part of alumni, primarily in the Boston business sector, anticipated the negative critical tone to the subsequent Reserve Room murals. A typical letter objected to Orozco's "modernism" and purposeful "crudeness" (here a curiously tame example of Orozco's expressionistic tendencies) and pleaded for "something that gives pleasure and satisfaction and that appeals to my senses." The writer also felt the work completely inimical to the neo-Georgian architectural environment, another element in the subsequent protests to the Baker Library murals, and described his reaction to viewing a photograph of the mural: "I felt that Baker Library had been ravished—that violence of some sort had been done to it.[125] In his first rebuttal to adverse criticism of Orozco, President Hopkins emphasized above all the essential instructional task of the artist and his mural, which he staunchly defended as a concrete expression of the fundamental purpose of any educational institution:

> His original panel, which people are criticizing so vigorously, was designed to give the widest possible illustration of how murals are prepared and the effects achieved. That panel was a pure and unadulterated piece of demonstration for the instruction of our art students with regard to the technique used by a great artist.[126]

During his preliminary visit to the campus in mid-March 1932 to inspect possible sites for the *Release* panel, Orozco happened to pass through the lower-level Reserve Room of Baker Library on the way to attend a lecture. He paused, quietly thunderstruck at the vast unadorned wall space of almost 3,000 square feet, and announced: "These are the walls for my best mural, my epic of America."[127] Moreover, Orozco's enthusiasm for these walls, which led him to formulate and present his plan for his American civilization cycle to Dartmouth officials, also suited the administration's desire to decorate this area:

> It has been a matter of great concern to the building committee ever since the library was built that we had no decoration of any sort in this room. . . . However, on his own initiative Orozco figured out exactly the amount of wall space that was available in the room, and that this was broken by the basement windows into panels of exactly the size he had in mind for the development of his subject. Thereupon he presented to us the formal proposal to develop his major theme, the desirable space for which he had long sought.[128]

Alma Reed recalled witnessing the signing of a contract between Orozco and Professor Artemas Packard of the art faculty, the college's primary go-between with the artist, stipulating a period of approximately two years to paint the murals, but this document has disappeared. The only extant contractual documentation bears a date after Orozco had begun actual work on the walls of Baker Library.[129] However, Reed again creates a mistaken impression concerning Orozco's financial situation during this time: "Two years at Dartmouth on the modest salary of a visiting lecturer provided the painter with only a bare living."[130] Actually, Dartmouth authorities budgeted Orozco's salary, gauged from the official title of "visiting professor of art," at $7,700 (with an additional $2,177.05 for materials), placing the artist in the upper 20 percent bracket of college salaries during 1933–34.[131] The funds to pay Orozco did not come from the college's strained budget; rather, as President Hopkins wrote to a critic of the murals, they were a "special gift" from a party specifically interested in sponsoring Orozco's presence at Dartmouth:

> . . . my original interest in Orozco arose from the suggestion of one of the wealthy patrons of the College [surely the Rockefeller family] that in our teaching of the various eras of art and the various cycles of art it seemed that the College ought to give something in the way of instruction about Mexican art and about mural painting, both of which could be combined in the person of Orozco.[132]

Alma Reed and Orozco had been informed that Mrs. Rockefeller's contribution *alone* made the mural project possible, given the difficult economic picture at Dartmouth: ". . . Orozco and I were given to understand that the murals would not have been realized at that time without Mrs. Rockefeller's financial support, as Dartmouth faced a large deficit and was appealing to its alumni for funds."[133]

Admittedly not a connoisseur of the arts, President Hopkins saw the murals primarily as a highly significant educational tool, as Orozco would "teach by doing" as well as direct an art department course in fresco technique.[134] Hopkins intended the murals as a visual expression of his independent and progressive educational policies, whose "radical" nature had drawn protests from various groups: "We have gone on the assumption that any cause that commanded a large following in the world was proper meat for the undergraduate mind to feed on in its attempts to get intellectual nourishment and understanding of what life is all about."[135] Similarly, the college felt the responsibility to provide Orozco with complete artistic freedom to express his theme, in providing the opportunity for "one of the outstanding artists of our time to do the best work of which he is capable without any official restrictions as to the character of his expression; in other words, in extending the principle of academic freedom to public art."[136]

Finally, the murals completed the decorative scheme for the cultural complex constructed in Hanover during the late 1920s—Baker Library (1928), Carpenter Hall (Art, 1929), and Sanborn House (English, 1930)—and reflected the revitalization of the art faculty under the progressive leadership of Professor Artemas Packard, who so strongly advocated Orozco's presence at Dartmouth.[137] In fact, President Hopkins noted that the intensity of the art department's lobbying for the Orozco mural had reached "the extent where they were willing to cut down on the work of their department and to forego necessary facilities in order to carry out the painting of the murals."[138]

Orozco called the immense undecorated area of the basement level of Baker Library "the walls of my dreams."[139] The nearly 3,000 square feet of surface comprises two great walls on the north side of the hall, measuring 150 feet long by 26 feet wide, flanking the centrally situated reserve book circulation desk. In fourteen pictures approximately ten by thirteen feet and ten smaller ones, the artist intended to paint his conception of the development and current state of civilization in *America, the "New World."* Above all, he did *not* propose a historical narrative to treat this

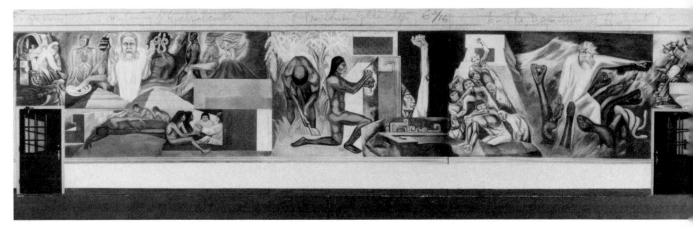

46

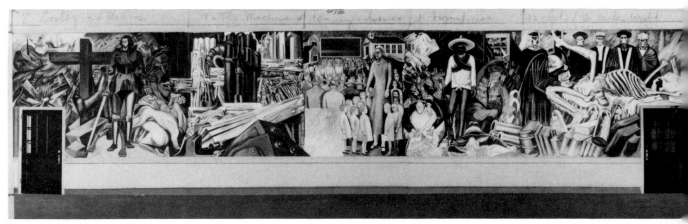

47

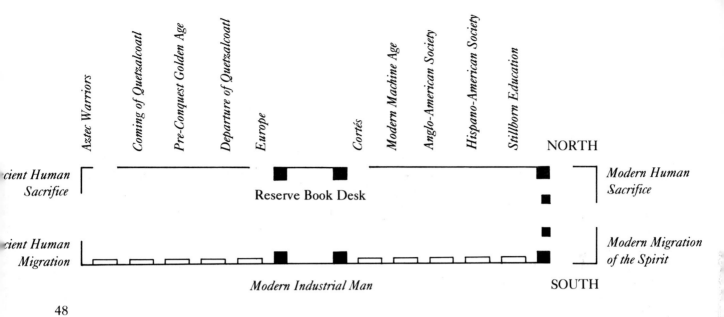

Aztec Warriors

Coming of Quetzalcoatl

Pre-Conquest Golden Age

Departure of Quetzalcoatl

Europe

Cortés

Modern Machine Age

Anglo-American Society

Hispano-American Society

Stillborn Education

NORTH

cient Human Sacrifice

Reserve Book Desk

Modern Human Sacrifice

cient Human Migration

Modern Industrial Man

Modern Migration of the Spirit

SOUTH

48

theme, a point missed by most contemporary critics of the mural cycle. Rather, a specifically American (involving the entire American continent, not solely the United States) *idea* would underlie his frescoes:

> In every painting, as in any other work of art, there is always an *idea, never a story.* . . . The important point regarding the frescoes of Baker Library is not only the quality of the idea that initiates and organizes the whole structure, it is also the fact that it is an American idea developed into American forms, American feeling, and as a consequence, into American style.[140]

Orozco would use what he termed the "living myth" of Quetzalcoatl as the fundamental image in his depiction of the indigenous American civilizations and their relationship to European culture transported to this continent in the early sixteenth century. He saw the "prophetic nature" of the myth as clearly pointing to "the responsi-

46. View of the west section of the north wall. (*Courtesy of Dartmouth College.*)

47. View of the east section. (*Courtesy of Dartmouth College.*)

48. Diagram of Baker Library mural program, 1932–34. Total painted area approx. 3,000 sq. ft.

See also Plates 4–6.

bility shared equally by the two Americas (the indigenous and European cultures) of creating here an authentic New World civilization."[141] Further, he saw Dartmouth College, founded in the late eighteenth century for the express purpose of educating the native American population, as a particularly relevant environment for his theme. As the artist wrote to President Hopkins on the college's acceptance of his mural proposal: "The resolution of your college is in line with its traditions that connect it with the Indian races of America."[142]

Alma Reed asserts that Orozco "had already developed an epic interpretation of civilization on the American continent" by the time of his fresco demonstration-lecture, without, however, supplying any information regarding Orozco's involvement with this theme.[143] In any case, he drastically revised his preliminary plan for the mural, a confusing admixture of six groupings of indigenous, European colonial, and contemporary themes in the same sets of panels that ended with the depiction of various aspects of immigration to the New World.[144] Orozco resolved the chronological discrepancy and thematic hodgepodge of his original by treating several millennia of American indigenous culture on the walls of the western section of the Reserve Room, and post-Cortesian civilization on the eastern part of the great north wall. Yet the artist continued to make alterations in his imagery even as he painted. While the pre-Conquest panels had reached their definitive state running in the thematic order of *Ancient Migration, Ancient Human Sacrifice,* and the three Quetzalcoatl panels flanked by the smaller *Aztec Warriors* and *Europe,* the plan of the post-Cortesian panels retained at this time a largely historical emphasis.[145] A later plan reveals a thematic restructuring of the post-Cortesian panels, and a more powerful program emerges that portrays a greatly heightened sense of sociopolitical commentary on these topics: the Spanish Conquest, twentieth-century machine technology, Anglo and Hispanic society.[146] However, even at this stage Orozco had not completed his revi-

sions: the last panel of this wall, entitled at this time *The End of Superstition—Triumph of Freedom,* surely had nothing in common with the completed painting on education, *Gods of the Modern World.* Finally, the walls opposite the reserve desk, originally intended to depict explorers, settlers, and founders of Dartmouth College, would come to represent images of modern industrial man and serve as a contemporary epilogue or coda to the main body of the mural cycle.

The Dartmouth murals further ramified the central theme of Orozco's North American murals—the creative individual's heroic self-sacrifice for the benefit of humanity—here epitomized by the "American" Prometheus, Quetzalcoatl, and a pendant figure to him in the last of the post-Cortesian panels, a militant Pantocrator-Christ. Orozco struck the initial chords of his mighty epic in *Ancient Human Migration,* his vision of the murky primeval origins of indigenous American civilization, the first of two paintings on the western wall inside the main entrance to Baker Library. Here he illustrated the various roles individuals play in any society, much as he had earlier done in the masses section of the *Prometheus* mural:

> Here are the essential tests by which you may measure the prospects for survival or decline of any human society; the zeal and competence of the leaders; the numerical strength and the ability to persist of those who are willing to follow; and negatively, the degree of resistance and dead weight of those who are apathetic.[147]

Next, in *Ancient Human Sacrifice,* the artist shows the social institutions that have evolved from the nomadic form of life, specifically in this case the sacrifice of an enemy warrior to Huitzilopochtli, the Aztec god of war. Ignoring the subtle intricacies of Nahuatl thought and culture, Orozco considered the act in distinctly *human,* and not historical, cultural, or religious terms. That is, he saw the event—in which the almost amorphous hulk of the god, with his necklace of human hearts, looms malevolently over the cer-

emony of the tearing out the heart of a living warrior—in terms of the essential conditions of a society that serve to control or regiment human behavior.[148] Here the ultimate sacrifice is demanded: the destruction of human life to support what Orozco believed to be the brutalizing institutional needs of civilization. Hence the ceremonial participants are masked, indicating the total impersonality of the act. Throughout the series of paintings that treated ancient indigenous cultures, Orozco continued to be primarily concerned with what he saw as universal human factors, and the resultant loss of historical accuracy did not particularly trouble him, an important fact practically all contemporary critics failed to comprehend. In these two panels Orozco spans ancient Mexican culture from its very beginning until its last civilization, the Aztec (1325–1521), a society in which Orozco saw death as the overriding concern. That is, while Orozco would paint the earlier positive achievements of pre-Cortesian Mexican civilization (of the Teotihuacán, Toltec, and Maya cultures) in the Quetzalcoatl panels, he makes horribly clear his belief that ancient Mexican society ended on a basely inhuman level. Thus Orozco establishes his pessimistic point of view regarding American culture at the outset of the cycle. Moreover, he discerned a human parallel between the slaughter of man by the forces of state in both ancient and twentieth-century American civilization. In the former it was under the aegis of religion, in the latter (in *Modern Human Sacrifice*, facing the Aztec version some 150 feet distant on the far eastern wall) from political nationalism.

On the western section of the long north wall of the Reserve Room, Orozco pictured his version of the Quetzalcoatl legend flanked by two smaller panels that serve to encapsulate the larger panels in time. *Aztec Warriors* begins this section. As Orozco painted one reconnoitering ocelot warrior and three vanguard eagle troops in their battle guard, he ignored the fact that the Aztecs came to power in the mid-fourteenth century, or hundreds of years after the Toltec and Maya cul-

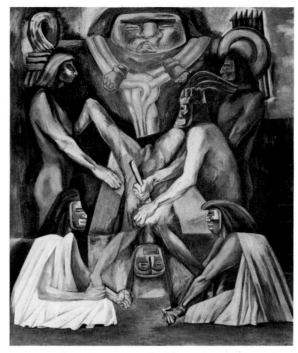

49

49. *Ancient Human Sacrifice*, 1932–34. Fresco. (*Courtesy of Dartmouth College.*)

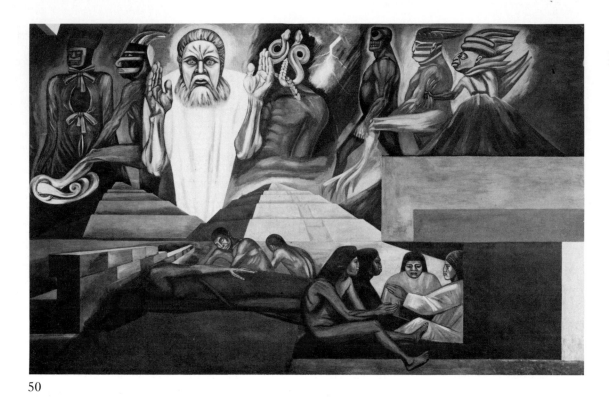

50

50. *The Coming of Quetzalcoatl*, 1932–34. Fresco.
(*Courtesy of Dartmouth College.*)

tures portrayed in the following panels. However, Orozco retained historical accuracy in the last painting on this wall, *Europe,* which depicts armed forces of the Spanish Renaissance. The central paintings celebrate the positive achievements of indigenous American civilizations and revolve about the figure of Quetzalcoatl, whose humanistic philosophy one scholar has termed "the foundation and cause of Mesoamerican civilization."[149] Quetzalcoatl originally appeared millennia ago as a sea and wind divinity on the eastern Mexican coast, and the cult around him gradually moved inland to central Mexico where it established itself at Teotihuacán (a site dedicated to Quetzalcoatl), the first great Mesoamerican city. After the fall of this civilization (c. A.D. 600) he reappeared as the major deity of the Toltecs, who had located their capitol at Tula by the tenth century A.D. The Toltec line of priest-kings adopted the use of the god's name, the last of whom, Topiltzin Quetzalcoatl, proved to be

the greatest of the lot, and his reign is celebrated as an age of peace, abundance, and splendor.

The name combines elements having supreme significance for ancient American cultures: *quetzal* refers to the seldom-seen green-feathered bird of the Chiapas and Guatemalan highlands, while *coatl* translates from the Nahuatl as snake. The plumed-serpent god thus represents a duality—earth and air symbolizing the union of opposites, matter and spirit—that pervaded many ancient Mesoamerican religions. The name also translates as the "Precious Twin," another fusion of unequal qualities, alluding to Quetzalcoatl's role as Venus (in its aspect of the Morning Star), while his fearsome, deformed, and thoroughly repellent monster twin, Xólotl, represented the planet as the Evening Star. The mythic figure Quetzalcoatl provided, therefore, cosmic associations with the realms of earth, air, and the heavens: "Quetzalcoatl was thus a composite figure describing the many orders of matters in creation: a kind of ladder with man at the centre, but extending downward into animal, water, and mineral; and upwards to the planets, the life-giving sun, and the god creators."[150]

In his role as the "Precious Twin," with his passage across the sky as an eagle and his departure from it as an ocelot, followed by his reemergence each morning, Quetzalcoatl presided over the era of the present-day Fifth Sun (*Nahui-Ollin*, or *Four Movement*), an age characterized by the fusion of elements of the four earlier ages (earth, air, fire, and water). Moreover the god had created man of the present age, *macehual* ("those who are worthy of the gods through penitence") by his act of self-sacrifice, as he poured his blood on bones gathered from the underground regions, creating life from the remains of death. He also performed crucial acts of beneficence for his creation, including inventing the arts and discovering maize, the primary foodstuff of Mesoamerica:

The Toltecs, the people of Quetzalcoatl,
were very skillful.
Nothing was difficult for them to do.

They cut precious stones,
wrought gold,
and made marvelous ornaments of feathers.
Truly they were skillful.
All the arts of the Toltecs,
their knowledge, everything came from Quetzalcoatl.[151]

In presenting his personal interpretation of the indigenous American civilizations, Orozco chose to depict Quetzalcoatl not in exotic raiment alluding to his godly properties, but rather in the image of man. In the first panel of this series, Quetzalcoatl ascends like the sun of a new day in the act of blessing mankind and uses his immense power to dispel the hitherto dominant evil gods. The god instills a new and positive energy into mankind, shown awakening from a lethargic torpor, and great acts of creativeness result, exemplified by the construction of the pyramids at Teotihuacán and education of the people. Orozco includes the two primary edifices, the Temples of the Sun and Moon from around the second century B.C. The vital civilizing force Quetzalcoatl symbolizes overcomes the malevolent, unproductive qualities represented by the other gods, and mankind now lives and works in a more meaningful and creative manner. Advocating such ideals as humanism, work, unity, loyalty and honesty, wisdom, dynamism, and hope, Quetzalcoatl offered what has been called "the adventure of the man who turns himself into light and sun." He represents "an epic of light and liberation, and therefore proposes an active and conscious hope of transcending death: this hope is a spiritual state translated into action, into movement toward an ideal."[152] Surely in his search for specifically American forms and themes, the creative rebellion of Quetzalcoatl—an American counterpart to the Promethean legend—must have held enormous thematic significance for Orozco.

In the next panel, the painter summarizes the achievements of the Toltec and Maya cultures in the areas of agriculture, the arts, and scienc-

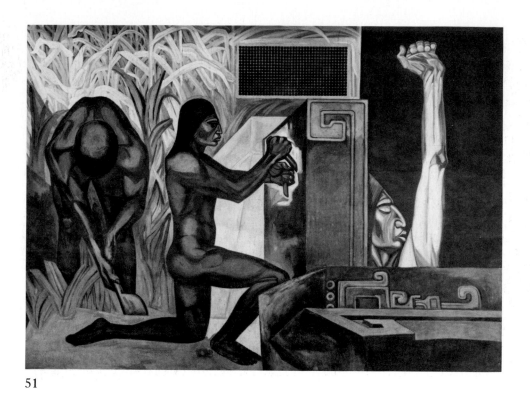

51

51. *Pre-Conquest Golden Age*, 1932–34. Fresco.
(*Courtesy of Dartmouth College.*)

es, all directly related to Quetzalcoatl's role as benefactor of mankind. First, Orozco pictures the cultivation of maize, whose most precious gift from the god ensured man's existence on earth. Next, the act of the indigenous sculptor carving in stone immediately brings to mind the magnificent stelae at Quiriguá, Tula, and Chichén-Itza, and this particularly American art form again derives from Quetzalcoatl's largesse as bestower of the arts to mankind.

Finally, in the quintessential image of the single figure with arms upraised to the heavens, Orozco sums up the scientific aspirations and accomplishments of the Toltec-Maya peoples. In his aspect as supreme ruler of the upper celestial regions, Quetzalcoatl assumed patronage of the sciences of the heavens. These sciences held enormous significance for ancient American societies, whose preoccupation with time and its measurement can be gauged by the example of the Maya calendar, closer in accuracy to the solar

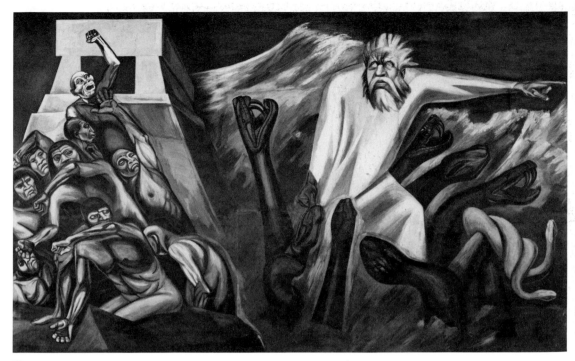

52

52. *Departure of Quetzalcoatl*, 1932–34. Fresco. (*Courtesy of Dartmouth College.*)

year than our own is, and by the precise dating that occurs on sculptural pieces and stelae. León-Portilla has characterized this all-pervasive concern with time: "For them to assign a date was to know, perhaps even to identify with, the ever-changing nature of the universe. Time was not an abstract concept; it was a living reality, a deity, a cosmic substratum of everything."[153]

The concluding panel of this series portrays the opposition of evil magicians to Quetzalcoatl's determination to change the course of his, and by extension man's, existence by following his own mandates instead of those established by others. In this, of course, he mirrors the act of the great rebel of the Pomona mural, Prometheus. The magicians, devotees of Texcatlipoca, ("Smoking Mirror"), represented the irrational unconscious aspects of the human mind, as opposed to the purposeful, rational conscious intelligence of Quetzalcoatl. They emerged successful in a Toltec internecine struggle and over-

threw Quetzalcoatl and his followers sometime near the end of the tenth century. According to one chronicle, the evil priests made the priest-king drunk and sexually incontinent, a sinner or "eater of filth." Thus, the Quetzalcoatl sect suffered a spiritual and ideological breakdown of their values and left Tula, finally arriving at Yucatán where they constructed Chichén-Itza. The parallel legend has Quetzalcoatl condemned to leave his beloved people, and Orozco follows the version of the myth in which the god sailed off on a raft of serpents to the "regions of Tlapallán: the red dominion of the sun his royal master."[154] In another variant he commits self-immolation, his ashes rise to the sun to become the Morning Star, and the celestial path of Venus eternally recreates the sequence of Quetzalcoatl's birth, death, and rebirth. The god's never-ending journey—associated with Venus because of the planet's brilliance in the Mexican latitude and its mobility in the heavens—demonstrates, as one scholar puts it, "the collective dream of his people: that evil is innate, permanent, while good depends on the will, resulting from man's actions, from his invigorated movement toward self-betterment aimed at the fulfillment of himself as the ideal of perfection."[155] All versions of the myth agreed that Quetzalcoatl would someday return, specifically on his birthdate, Ce Acatl (One Reed), which appeared once every fifty-two years in the Aztec calendar, and that this would take place only in the lifetime of the last Aztec leader, Mocteczuma, ironically enough in the spring of 1519—the date of Hernan Cortés's arrival in Mexico. The god's turbulent, wrathful departure provides an ominous note for Orozco's conception of his return, as he prophetically points to an image of a new civilization, the European, represented by an armored soldier bearing a cross, and in the background a powerful new military weapon unknown to the Aztecs—the horse.[156]

Orozco's treatment of indigenous American civilization emerges as an independent effort in interpreting ancient American history and mythology, divorced from both his earlier work and that of

53

53. *The Conquest*, 1932–34. Fresco. (*Courtesy of Dartmouth College.*)

other artists. As Orozco emphasized: "It is to be understood that there is no literary or other record of the exact implications of this ancient myth of Quetzalcoatl and that this interpretation grows out of the inspired idealism and creative imagination of Orozco."[157]

The dynamic expressive element of the Prometheus and Baker murals demonstrates Orozco's artistic growth from his earlier mytho-allegorical panels from the Preparatory School. In contrast to the completely uncoordinated subject matter of these paintings at Dartmouth Orozco created a coherent and meaningful relationship among the panels portraying indigenous American culture. Further, in the pre-Conquest paintings he rejected the precedent of Diego Rivera's mural *Legend of Quetzalcoatl* (1929), a part of his vast national epic at the National Palace in Mexico City. Rivera stresses above all historical, cultural, and mythological accuracy, to the extent that his painting achieves the faithfulness of a pre-Conquest codex. To note a few of the particularized images in his visual retelling of the myth: the blond-haired god assumes the center position of the wall, as acolytes offer him the sacred beverage *pulque*. To the right, natives make cloth and pottery and perform the ritual harvest dance. To the left are scenes of Aztec tribute and ceremonial warfare (or indifference to the teachings of Quetzalcoatl). In the upper register the serpent emerging from a volcano symbolizes the beginning of a new fifty-two-year Aztec cycle of time, and to the right, the god, clad in brilliant ceremonial garb, departs from his people on a stylized flying serpent.

Orozco's point of view is different here, with his emphasis on what he saw as the universal factors at play in an eternal cycle of sin, rejection, and redemption—corrupt orders of man, the actions of a divinely inspired sacrificial hero, the concomitant struggle of mankind for a perfect existence—in his portrayal of indigenous American society. Finally, in the portentous figure of the departing Quetzalcoatl Orozco supplies a sense of linkage between the pre- and post-Cortesian panels, and his "return" in the guise of Cortés and Christ.

In the second major segment of the murals, Orozco treated various aspects of post-Cortesian and twentieth-century civilization as they related to American society: the machine, Anglo and Hispanic culture, education, and the dual horrors of nationalism and war. In the first panel of the eastern sector of the north wall, Orozco depicts a brutal picture of the invasion of the Spanish conquistadores (1519) led by Hernán Cortés. The Spaniard was at first believed to be Quetzalcoatl, whose coming had been prophesized to Moctezuma by many celestial and visionary omens, until his greed and other all-too-human frailties convinced the Aztecs otherwise. The unrelieved destruction of the Conquest scene initiates the pessimism that dominates this section, where, in total contrast to the New School murals, Orozco would paint a savage indictment of the values and institutions of twentieth-century society.

To the side of Cortés a Franciscan missionary holds a cross, another reference by Orozco to the church's ideological reinforcement of the military force of the invaders. In the background Orozco illustrates Cortés's single-minded purpose, as he burned his own ships to forestall his troops' talk of leaving Mexico. Cortés's act linked his capitalistic opportunism to the religious values of the Catholic Church and the political ideology of Renaissance Spain. His defiant act against his superior, Diego Velásquez, governor of Cuba, ultimately brought him vast rich properties (some 25,000 square miles) to the immediate south of Mexico City, if little lasting political power. Orozco seemingly admits a sense of admiration for Cortés's resoluteness and indomitable will, as expressed in the image of the flaming ships, which also points to the totally distinct sense of European values and customs:

For the Spaniards, on their part, were making "total" war: there was only one possible state for them, the monarchy of Charles V, and only one possible religion. The clash of arms was nothing to the

54

54. *Cortés* (left) and *Modern Machine Age* (right) panels, 1932–34. Fresco. (*Courtesy of Dartmouth College.*)

clash of ideologies. The Mexicans were beaten because their thought, based on a tradition of pluralism in both the political and religious aspects of life, was not adapted to contend with the dogmatism of the monolithic state and religion.[158]

This panel reflects the great change in Orozco's emphasis from the favorable portrayal of Cortés's and the church's role in the Conquest (National Preparatory School, 1923–24). There, incredibly enough in the context of his later work, he presented Cortés as the protector of the Indian races, personified in the figure of Malinche, his Indian translator and mistress, generally considered by Mexicans to be a traitor to her people. The Franciscans, who succor the diseased and starving indigenes, apparently indicate Orozco's opinion of the state of the native races at the time of the Conquest. After Dartmouth, Orozco would further intensify his vision of the brutality of the Conquest in the mural program of the Hospicio

Cabañas (Guadalajara, 1938–39), where Cortés appears as a mechanized robot wreaking destruction on the Indian peoples, and the cross of the Franciscan missionary becomes an arrow-like weapon, with both figures receiving "inspiration" from machine-like angels above them. Indicating the greatly intensified pace of the discordant, even strident, nature of the imagery of the post-Cortesian paintings, Orozco parallels the killing and barbaric ruthlessness of the Conquest, symbolized by the destruction of the indigenes, with twentieth-century industrial society. Social critic Lewis Mumford saw the relationship between the Conquest and Orozco's specter of a totally dehumanized and threatening twentieth-century industrial landscape scene:

> The two are graphically connected—*as they were in history*—by the prostrate figures of Cortés' captives, who are represented as being fed into the maw of the machine, their arms twisting into stumps as they are gripped by the steel. Orozco demonstrates the fundamental kinship of both types of power production and regimentation, that of the soldier and that of the new capitalist.[159]

The machine panel does not represent a recognizable industrial environment like the one Rivera painted at Detroit, for example. Rather, Orozco attempted to present the *idea* of contemporary mechanization:

> He gives its glitter, its bulk, its automatism, its suppression of the personality, and even, in the splintering metallic forms, the piercing whir and whine of machines in operation. There is not a single identifiable contrivance in the whole pattern: it is just cold metallic hell.[160]

The next two pendant works depict Orozco's conception of the wholly distinct character of Anglo- and Hispanic-American society. The figure of a tall, stern-visaged "school-marm," a strong, even overbearing agent of control, typifies Anglo society for Orozco. He visualized a strict regimentation of individuals in the expressionless youngsters grouped in an orderly fashion about their teacher, and in the strict arrangement of adults at a New England town meeting. The perfectly ordered grillwork of the ventilator reflects the sense of a totally controlled human environment. Yet, at the same time, Orozco recognized positive aspects of the Anglo world: the schoolhouse symbolizes the desire for universal education, and the town meeting illustrates cooperation in reaching decisions affecting society at large. Although Orozco liked his stay at Dartmouth and appreciated New Englanders and their customs, beyond the order and cooperation he detected a basic sense of dullness in Anglo society.[161] Yet the conformity Orozco saw in the culture constituted a recent trend, a by-product of "cultural lag," or the tension that intellectuals saw developing in the 1920s as artistic considerations held little importance for society in relationship to developments in the more material-oriented areas of science, technology, and industry. This tension produced during the 1920s what Pells calls "an orgy of civic boosterism":

> The outburst of "school spirit," the Babbitt-like camaraderie of the Rotary Club, the transformation of religion from a set of beliefs to a social occasion, the hostility to criticism of any kind, all testified to the need for shared values and purposes which modern America seemed unable to provide.[162]

This group ideology differed from the nineteenth-century heritage of rampant individualistic competition (mainly involving the acquisition of wealth) that writers such as Van Wyck Brooks had termed the fundamental disease afflicting our civlization.

In contrast, the Hispanic-American panel screams in chaotic disorder and rampant destructive individualism. The total ruin of the Hispanic landscape acts as a disruptive foil to the order and peace of the Anglo panel, as do the actions of buffoonish generals and politicians, wildly looting their country's wealth for their own personal gain. Against these figures Orozco posits a single armed

55

55. *Hispano-American Society*, 1932–34. Fresco.
(*Courtesy of Dartmouth College.*)

56. *Gods of the Modern World*, 1932–34. Fresco.
(*Courtesy of Dartmouth College.*)

rebel peasant—a universal symbol of the collective might of the people—who must contend with the reactionary native establishment as well as with the fatal dangers of imperialist aggression. The artist evidently held intense feelings about this work and apparently was inspired by the toppling of the government of the Cuban dictator Machado in the summer of 1933.[163] Concerning the Hispanic-American rebel, Orozco said this to Dartmouth College authorities:

> The best representation of Hispanic-American idealism, not as an abstract idea but as an accomplished fact, would be, I think, the figure of a rebel. After the destruction of an armed revolution (whether against a foreign aggressor or local exploiter or dictator) there remains a triumphant ideal with the chance of realization. If there is any need for expressing in just one sentence the highest ideal of the Hispanic-American rebel, it would be as follows: "Justice whatever the cost."[164]

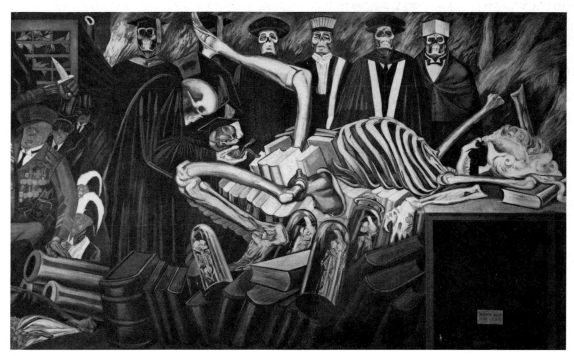

56

In the last panel of the long north wall, *Gods of the Modern World* or *Stillborn Education*, Orozco savagely denounced what he believed to be the sterility and meaninglessness of modern institutional education in a grotesque scene in which a skeleton, prone on a bed of books, gives birth to a dead fetus. Cadavers in academic garb preside in the background where the flames of Cortés's ships reappear, now a reference to the intellectual impotence and absence of purpose resulting from the dissemination of false, useless knowledge. This painting made specific reference to the stated educational aims of Dartmouth College as they related to the real issues of the outside world.

President Hopkins has stated that he believes that no college has the right to exist unless it feeds directly into the carrying on of world affairs, unless its curriculum is cued to an intelligent realization of present needs. This panel represents dead minds concentrating on futile things instead of live subjects.[165]

At the same time, one suspects that Orozco's inflammatory and totally negative tone may have far exceeded what the administration would have considered a suitable expression of the theme.

Early in his career Orozco had expressed "his opinion about the effectiveness of academic training because of the driveling lack of *Doctors of Learning*"—the title of his cartoon in which five fools of various shapes and sizes parade in academic gowns.[166] In this panel, Orozco explicitly referred to his experience with academic officials at Pomona College by including caricatures of the president and dean of students among those witnessing the ceremonial birth of dead wisdom.[167] He had evidently shocked some 200 Yale art students in 1933 with the assertion that they painted with "the dead hand of Academy."[168]

Thus, the topic appears to have been uppermost in Orozco's mind and perhaps reflects the reason for the dramatic change in theme from the originally intended *The End of Superstition—Triumph of Freedom.*

In the two panels of the far west walls concluding the main body of the mural cycle, Orozco turned from education to other areas of sociopolitical commentary, the interlocking topics of nationalism and armaments and, to Orozco, their inevitable result, "scientific destruction by modern warfare."[169] In *Modern Human Sacrifice* Orozco provides an overt thematic link between the two ages of American civilization, as both the contemporary and ancient scenes refer to the institutional sacrifice of the individual for false, useless ends. Here the villain is modern nationalistic war. The Aztec sacrifice directly faces this panel some 50 yards away. Orozco pictures a generalized "Unknown Soldier" ceremonial display, which includes the various trappings of nationalism—flags, wreaths, marching bands, and a pompous speech-making politician. In the center, partially covered by wreaths and a flag, lies the skeleton of a soldier still clad in military uniform: a representative victim of nationalistic warfare. At right angles to the painting, over the doorway leading to the northwest reading room, Orozco included a flanking decorative panel replete with helmets, lions, eagles, and other nationalist symbols to reinforce the meaning of the large painting. Despite the relevance of its theme, nationalistic war, to contemporary society, the painting lacks the expressive impact of the other major Dartmouth panels, largely owing to Orozco's overdependence here on overtly caricaturist imagery reminiscent of the cartoons from his earlier Mexican and New York periods.

In the last of the major Baker Library panels, *Modern Migration of the Spirit*, a majestic, though horribly mutilated Pantocrator-Christ provides the final thunderous crescendo for the series.[170] He returns to destroy His cross, a modern Last Judgment illustrating Orozco's theme here, the abject failure of modern American society. By His act of self-sacrifice, Orozco's Christ calls for the liberation of twentieth-century man from the bondage of the counterproductive forces of industrialism, the confines of institutionalized education and religion, and the terrible human and material waste of nationalism, which is indicated by the mountainous junkheap of weapons and the useless remnants of outworn creeds and religions. In this ravaged, yet wrathful and all-powerful figure of destruction, Orozco draws parallels to Quetzalcoatl.[171] Both represent higher forces that attempt man's salvation through purification by self-sacrifice, yet here, in contrast to the positive achievements of mankind made possible by Quetzalcoatl's actions, Orozco's concern lies solely with the realm of violent destruction. In fact, all prevailing forms of civilization are totally destroyed. The pervasive cynicism of Orozco's view of contemporary American society culminates in this painting, and it is this pessimism that so distinguishes the post-Cortesian paintings from those of the indigenous American section. As David Scott has asserted, however, there remains at least a degree of hope for man's future in the Christ image, a force capable of standing in judgment of good and evil: "a new image of spiritual force, ravaged, archaic, hieratic. He destroys the old orders, as did Prometheus, to prepare for the 'Modern Migration of the Spirit.' "[172] This work recalls similar imagery in the earlier Preparatory School murals, *Christ Destroying His Cross* and the caricature *Social and Political Junkheap* and anticipates Orozco's acutely heightened involvement with the themes of the destructive capabilities of militarism and nationalism in his later Mexican murals (such as *Katharsis*, 1934; the panels *Revolutionary Fratricide* and *The Contemporary Circus*, Governmental Palace, Guadalajara, 1937).[173] A small decorative panel at right angles to the *Migration*, crammed with symbols supporting Orozco's theme of man's spiritual bondage (chains, weapons, keys, and vultures), reinforces the message of the larger work.

A small set of paintings, *Modern Industrial Man*, opposite the delivery desk of the Reserve Room

57

and thus isolated from the main body of the
murals, serves as a somewhat problematical epi-
logue to the post-Cortesian panels. Orozco origi-
nally intended this area for murals concerning
exploration and settling of North American and
the founding of Dartmouth College, which would
have related the epic narrative to the locality.
When well into the painting of the post-Cortesian
section, however, he decided to devote this
area to both a more modern and more universal
topic. Here Orozco seems to imply that a new
culture will emerge from the Pantocrator's de-
struction of contemporary civilization, but his
meaning is ambiguous. Four scenes of industrial
construction flank the curious figure of a work-
er, at rest and reading, in front of the girders of a
building in progress, a sledgehammer at his side.
Was Orozco proposing that a new order of soci-
ety would emerge from the destruction of con-
temporary civilization? He appears to concede the
possibility of an enlightened new order, but one

57. *Modern Industrial Man*, 1932–34. Fresco,
approx. 3 x 12 ft. (*Courtesy of Dartmouth
College.*)

wonders if it would be wholly proletarian. Or does Orozco have in mind Lewis Mumford's vision of "neotechnical civilization," an intelligent and organic utilization of mechanization to create additional meaningful leisure time for man? In any case, Orozco's savage attack on the institutions of twentieth-century society in the main body of the series simply overwhelms the tentative possibilities these paintings present.

The sentiment of the panels lies totally at odds with the artist's later brutal indictment of both Marxism and the masses in the *False Leaders* (Marxist labor leaders) and their subhuman henchmen at the University of Guadalajara; the *Contemporary Circus*, his nihilistic attack on all political ideology at the Government Palace; and finally the Jilquilpán murals of neighboring Michoacán, where the revolutionary masses appear as faceless, howling agents of wanton destruction.

As if to demonstrate the importance the message the Christ panel had for the artist, his next mural, *Katharsis*, repeats the theme of the Dartmouth painting: purgation by violent destruction. Unlike in the Dartmouth murals, Orozco does not even attempt to predict what will result from the final devastation of modern society.

Perhaps one should bypass the tentative and unconvincing nature of these paintings,[174] and propose to relate *Modern Migration of the Spirit* to its earlier indigenous counterpart. That is, Orozco's last major panel relates to the first, as Orozco concludes that man must once again begin the long, arduous, and painful journey—"this burning search," as Díaz Infante puts it—toward human perfection.

Orozco's negative view of contemporary civilization, tempered only by his belief that there still exists a higher force capable of distinguishing good from evil, contrasts greatly with Rivera's Marxist picture of modern Mexico in his National Palace cycle, *Mexico of Today and Tomorrow* (dated November 1934). As he did in his Quetzalcoatl panel, Rivera treats his topic with much descriptive detail. At the very top Karl Marx points to the future communist utopia of Mexi-

co; the scroll he holds delineates the struggle necessary to this end: "it is not a matter of reforming the society of today but rather of forming a new society." Orozco would have had no quarrel with this sentiment, but he repudiated Rivera's picture of a class war with the final—and wildly unrealistic, as history has demonstrated—victory of the Mexican proletariat. At the bottom of the panel Rivera depicts violence against the working class, directed by reactionary Mexican forces, such as ex-President Calles, the church, and the military, who collaborate with North American capitalists (Mellon, Vanderbilt, Morgan, Sinclair, Rockefeller) placed in adjoining compartments on this wall. Above, a worker exhorts his comrades to revolt, while the forthcoming result looms in the distance, Mexico City in flames.

If Orozco rejected both Rivera's Marxist indictment and prophesies his Baker Library murals also reflect a thoroughly different historical approach from North American artists who painted thousands of murals for various New Deal art projects during the 1930s. The historical iconography that typically prevailed in these murals utilized the idea of what one New Deal project director called the "usable past." Regarding this notion, Francis V. O'Connor has observed:

> The fall from economic grace which so shocked the American people and induced in so many millions a profound sense of self-doubt and inadequacy engendered a turning back to the past when men presumably did things right. Dos Passos stated the situation this way: "We need to know what kind of firm ground other men, belonging to generations before us, have found to stand on."[175]

Instead of depicting the horrors around them, these artists tried to find solace and inspiration in the American historical experience in order to deal with the disrupture of the present. They turned to local history and customs, such as scenes describing the pioneer existence, or hardship overcome by the united effort of the people, or the founding of towns and cities. Another common image, identical landscape views spanning vari-

ous centuries, stressed the survival of America's centers of population. These murals provided a sense of security and continuity with their basic premise that history holds hope for the future. As a New Deal art historian has put it:

> The sensibilities of the 1930s, as revealed by the artistic archetypes of the decade, are mythic: "the essential tendencies of the human mind" rejected political realism in favor of hopes and dreams. The mythology of the decade acknowledged the existent terrors of the present by indirection, by the very fervor with which that myth transmuted fear into faith. Depression America believed passionately in a verifiable, usable past of happiness and plenty, and in a future that would once again fulfill the primal needs of the forgotten man.[176]

Orozco, in contrast, gives us no sense of linkage between the magnificent cultural and scientific achievements of indigenous American civilization and the present day. Rather, he shows that twentieth-century America has abjectly failed to emulate the accomplishments of the pre-Conquest era and posits not only an unobtainable past but also an unusable, meaningless present. The apocalyptic nature of Orozco's vision in *Modern Migration of the Spirit* finds a parallel in the contemporary novels of Nathaniel West, Dalton Trumbo, Horace McCoy, and Henry Roth, which offered a similar view of the necessity of the cataclysmic destruction of American civilization. Of these, West's *The Day of the Locusts* comes closest to Orozco's negativism in its call for a "terrible holocaust." As Pells observes: "West had delivered a funeral oration over the remains of the old society, but there was no redemption, no rebirth, no renewal. What he saw in the convulsions of the 1930s was simply the end of the world."[177]

At Baker Library Orozco liberated his composition from the confines of Dynamic Symmetry, employing only a broad armature he termed a "geometric skeleton," on which he painted directly. This "skeleton" provided a generalized com-

positional basis for his essentially spontaneous painting style, for within each painting he produced a relatively simple calculated subdivision: "the principal points of the lesser divisions are determined by means of coordinated rectangles that use as axes the nearest perpendiculars." Dartmouth provided the first instance of a loosely ordered geometric arrangement that would govern the composition of the artist's later work, "an organization of living forms in free movement, yet at the same time controlled and precise."[178] However, if Orozco worked in a much freer manner at Dartmouth, he nonetheless exercised meticulous working habits. Assistant Leo Katz observed:

> My first impression of Orozco at work was that I had never encountered a more dependable, split-second punctuality or a more calmly controlled sense of long-and-short strategy in planning and preparation. We stayed at the same inn, we appeared at the same minute in the morning for breakfast; we arrived at a certain time in front of the scaffold, and then everything went as clockwork as is necessary in fresco. He worked until the daylight gave out, ate some supper, and the rest of the evening was devoted to preparations for the next day.[179]

While none of Orozco's colleagues in the art department recorded the number of painting sessions or the dates when Orozco completed the various panels, neither did they keep photographic record of the work-in-progress and the preparatory studies, a generalized account of the progression of the painting can be established. Photos of the pre-Cortesian work-in-progress demonstrate that Orozco completed the last panel of the series, the small *Europe, first*, indicating that he must have had the entire set of panels definitely planned before he actually began to work on the walls. Alma Reed recalls "hours we spent discussing points of North American history and Maya legend [Kukulcán, the Maya version of Quetzalcoatl]," and that she contributed research on the history of Dartmouth College and supplied Orozco with documentation concerning

58

Maya culture. During the first weekends of the Dartmouth project in May 1932 the artist returned to New York for "intensive preparations for the murals," including life sketching. For example, he worked on drawings of the snakes of the last Quetzalcoatl panel during a Sunday outing at the Bronx zoo.[180] According to *The Dartmouth*, Orozco came to Hanover on May 2, 1932, for the *Release* demonstration piece, and left in the third week of June for a three-month European trip (having by this time completed *Europe*, part of *The Prophecy*, and *Ancient Human Sacrifice*).[181] At this point the irrepressible Pijoan again emerged to assist Orozco in planning his trip, the only time he would travel to Europe, and to give the artist a day-long tour of the great Florentine monuments when they met in Italy. Orozco spoke of two great impressions, one a tantalizing reference to the Pompeiian frescoes—"Pompeii and its Villa of Mysteries, in which I learned much, much, of the art of painting."[182] The other was a reference

to Orozco's "supreme Spanish experience," Toledo and the works of El Greco.[183]

After Orozco's return to this country, he painted the rest of *The Prophecy*, the small *Aztec Warriors*, the remaining panels devoted to the Quetzalcoatl legend, and last, *Ancient Migration*, the first painting in the chronological order of the pre-Cortesian series. During her visit to Hanover in May 1933, Alma Reed described Orozco as working on the panel of the indigenous agriculturist, artist, and astronomer. Apparently, Orozco remained at work in Hanover through the summer of 1933, for by early November he had completed *Cortés* and *Machine Age* and had interrupted work on the *Anglo* panel to paint *Hispano-America*.[184] Yet, even this late, Professor Packard understood that the walls across from the Reserve Book Desk would be illustrated with the founding of Dartmouth College and images of North American missionaries, explorers, and settlers, indicating Orozco's more free-wheeling approach

to subject matter in the post-Cortesian section.[185] In fact, his assistant during this period, Gobin Stair, was not at all certain that even Orozco knew what would come next at this stage:

> I remember wondering as we went along from panel to panel what he was going to do next. He was supposed to have it all planned out before he started, but I don't think he always knew what was going to turn up. So he would go away for a week or ten days to that wonderful world that was Greenwich Village of 1932–33, to the Jumble Shop or Romany Marie's, but he would be working too and planning and making drawings, and he would come back to paint furiously.[186]

59

Finally, Orozco completed the side "industrial totem" panels (where he signed his work), and painted last the decorative snake panel over the west wing entrance. Here he used the heightened palette of the twentieth-century panels to balance the coloristic elements of the two main sections. The placement of the work emphasized the axial orientation of the room.[187]

In undertaking the mammoth task of painting the enormous area of the Reserve Room by himself (which would take approximately one year's time), Orozco stressed the difficult practical considerations he faced at Dartmouth in a letter to a would-be apprentice, noting also the protracted dedication required of practitioners of the mural art form:

> The mural I have been painting here in the College is a work done under especial and unusual circumstances. It has to be finished in the shortest possible time, and for that reason it is not possible to have apprentices of any kind. All my effort and attention have to be concentrated on the mural.
>
> There has been much misunderstanding among the public and art students about fresco painting. As a medium it is simpler and easier than any other used by artists and it can be learned by any student in just ten minutes, and then by personal research and experiment it is possible to get some skill to use it effectively. Now, mural conception and practice is quite another matter, one that

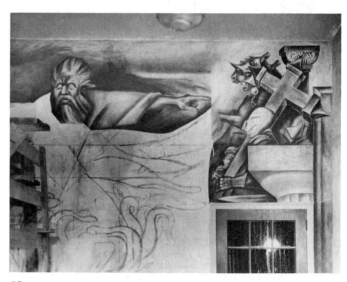

60

58. Leo Katz (left) and Orozco in front of *Departure of Quetzalcoatl.*

59. Work in progress, west wall. (*Courtesy of Dartmouth College.*)

60. Work in progress, *Departure of Quetzalcoatl* and *The Conquest.* (*Courtesy of Dartmouth College.*)

61

62

61. Study for *Ancient Human Sacrifice*, 1932–34. Pencil, 20 x 14 in. (*Courtesy of Lucrecia Orozco.*)

62. Anatomical Study for *Ancient Human Sacrifice*, 1932–34. Pencil, 5 x 12 in. (*Courtesy of Lucrecia Orozco.*)

requires a lifelong study of the most complex problems.[188]

Studies for the mural reveal a gradual loosening of Orozco's style from the bondage of Dynamic Symmetry to a much more freely ordered and visually exciting manner of working.[189] The preliminary sketch for *Ancient Human Sacrifice* shows Orozco's continuing dependence on the schematized orientation of Hambidge's ideas, although at the same time he executed several freely done anatomical studies—apparently of Dartmouth athletes—much in the manner of the *Prometheus* studies.[190] A mathematical precision, including the noting of specific dimensions, continues in studies of *The Prophecy* and *The Coming of Quetzalcoatl*, yet sketches for the achievements of the native races and especially the last panel to be executed, *Ancient Human Migration* (both of which also had full-size detail studies), indicate Orozco's path to a more simple, generalized, and freely

63

64

65

63. Study for *The Departure of Quetzalcoatl*, 1932–34. (*Courtesy of Lucrecia Orozco.*)

64. Study for *The Departure of Quetzalcoatl*, 1932–34. Crayon, 32¼ x 28⅛ in. (*Courtesy of Museum of Modern Art, New York, gift of Clemente Orozco.*)

65. Study for *Ancient Human Migration*, 1932–34. Pencil, 23 x 18 in. (*Courtesy of Lucrecia Orozco.*)

66

67

66. Study for *Cortés*. Pencil, 18 x 17½ in.
(Courtesy of Lucrecia Orozco.)

67. *Study for Cortés*. Pencil, 17½ x 18 in.

68. Study for *Cortés*. Tempera, 17.6 x 17.6 in.

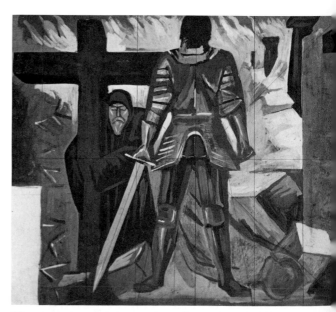

68

69

70

rendered compositions. Orozco followed this
open and discursive manner of working in prepar-
atory studies for the post-Cortesian paintings in
which he freely charged his original image to a
drastically different one. The preliminary draw-
ings for the Cortés panel show only the general
compositional guidelines sketched in and a de-
tail of Cortés's head. Studies for the other paint-
ings, obviously quite early in the genesis of the
imagery, reveal the extent of the alteration in
conception from original visual idea to completed
painting.

Anglo-America at first included a portrait of a
male pioneer (perhaps a historical personage?) in
the background, and a sign of affection between
teacher and student (holding of hands). From this
stage Orozco would emphasize the matriarchal
tone of the scene and intensify the "school-
marm's" hardness of personality. The inclusion
of golden wheat symbolizes the importance of
agriculture to the region. While the central peas-

69. Study for *Anglo-American Society*, 1932–34.
Pencil, 18 x 21 in. (*Courtesy of Lucrecia Orozco.*)

70. Study for *Hispano-American Society*,
1932–34. Pencil, 19½ x 13¾ in. (*Courtesy of
Lucrecia Orozco.*)

71

71. Study for *Gods of the Modern World*,
1932–34. Crayon, 18½ x 25⅛ in. (*Courtesy of
Museum of Modern Art, New York, gift of Clemente
Orozco.*)

ant figure in the *Hispano-America* panel remains
the same, Orozco changed the entire feeling of
the work, for in the study the peasant appears
victorious in his battle, as he steps on the heads
of dead opponents and grasps another by the hair.
Yet, in the painting the rebel-peasant leader falls
victim to the greed of corrupt native politicians
and to military oppression, and one wonders about
the reasons behind this dramatic reversal of
Orozco's position. If the successful revolt against
Machado did indeed serve as his immediate Lat-
in American frame of reference, surely the pre-
liminary sketch expressed a more appropriate
visual image.

In a marvelously energetic, though barely
defined preliminary draft for *Gods of the Modern
World*, Orozco included the prone figure (here
with mortar board) across the center of the pan-
el, with indications of academic personages in the
background. Gobin Stair, a student-assistant to
Orozco during the painting of the post-Cortesian
section, recalls his role in the artist's search for
relevant visual images for the work:

I remember when he was preparing the drawings
on the education panel. For some reason this was a
difficult time. I guess there was some reluctance
or perhaps lack of enthusiasm around for what this
section might "say." I was not involved in that
higher-level concern but I was involved in the mate-
rial, and he conveyed to me that I was to do some
research. So I got him medical books with illustra-
tions of skeletons, but also he wanted some baby
skeletons and that was difficult. Luckily I found a
bell jar with a skeleton of a fetus, and that, as you
can see by the painting, was just what he wanted.
He dealt with opportunity, and I began to see that
this was an important part of being an artist.[191]

Stair also noted the nature of Orozco's prepara-
tory studies and his various manners of working,
particularly in relation to the later section of the
murals:

Orozco prepared drawings ahead of time. For some
faces and most hands he made the drawing full size

and pressed the lines through on the wet plaster with a brush handle. He also perforated the paper and tamped dusted color through the holes, but he sometimes created the design directly on the wall. He was so confident that he did it anyway he wanted to do it, and this still gives me the feeling of the immediacy of the painting. It is more noticeable in the later part—the east wing; the earlier painting is more studied.[192]

In addition to an ever-increasing spontaneity of drawing and design, the Baker Library murals, beginning with *Ancient Migration*, mark the appearance of a new, bold, and much looser handling of the brushwork, having the effect of more coherently carrying the imagery to the spectator over the great distances involved. This broader, more direct, and rapid manner of working anticipates the brushwork of the Guadalajara mural cycles (1936–39), when Orozco at times splattered pigment on the walls. At Dartmouth he more effectively coordinated the relationship between the daily work patches (*giornate*) and the composition by painting over two adjoining sections in *fresco secco* to create an accentuated sense of surface unity and heightened coloristic emphasis. As with the Pomona and New School murals, Orozco adopted a functional approach to color and compositional matters: "Orozco says he wishes to convey the feeling [by means of plastic form and color] of a morning and an evening in these Quetzalcoatl panels, the rising and setting of the sun."[193]

He planned his compositions in a similar pragmatic vein, as his designs for the indigenous American panels generally echo the architectural environment. *Ancient Migration* and *Ancient Human Sacrifice* parallel the verticality of their walls, while the Quetzalcoatl paintings reflect the fundamental horizontal nature of the eastern section of the lengthy north wall and its architectural features. Here Orozco composed with an overall geometric emphasis: pyramidal forms (the structures of Teotihuacán, the agriculturist, the temple and arrangement of the evil magicians) play

against rectangular shapes (the abstracted house in the first panel, the sculptural stelae), indicating Orozco's desire to maintain the architectural integrity of the Reserve Room walls, rather than to work within the context of traditional Renaissance perspective and depth illusion. The post-Cortesian paintings follow a more abrupt horizontal division between panels. This arbitrary partitioning of the more individualized motifs and the clashing, dissonant colors acts graphically to project the cataclysmic upheaval Orozco saw in American civilization in the centuries after the Spanish conquest.

The paintings bear Orozco's signature and completion date of February 13, 1934, providing the final irony to his North American period vis-à-vis Rivera, whose RCA murals were destroyed almost to the day that Orozco finished at Dartmouth. This event resulted once again in Rivera garnering media coverage at the expense of Orozco's art.[194]

Dartmouth College foresaw negative criticism of Orozco's murals:

> That the Orozco murals should arouse controversy was anticipated and desired. Passive acceptance has no legitimate place in the educational process, and the double-edged incisiveness of controversy is one of the major educational values to be derived from work as positive and vital as Orozco's.[195]

The college's expectations proved fully justified; in fact, President Hopkins stated bluntly in 1935 that "there is nothing regarding College policies nor College actions that has aroused the bitterness of controversy or made the College the recipient of vitriolic comment as these murals have," and later admitted that this was the only occasion during his close to three-decade tenure as president that he failed to enjoy solid alumni support.[196] Opposition to the murals rested on several grounds, two of which—Orozco's Mexican heritage and supposed leftist political inclinations—appeared linked together. Harvey Watts, a director of an eastern art school and a

vociferous conservative opponent of the current Mexican "craze," as he called it, railed:

> That the Mexicans should develop their vernacular is all right, whether it be Spanish or Aztec, Toltec, or Mayan, or just plain Mexican, but that we should grovel in it and fill our museums and colleges and banks with the crude message of radicals and visionary patriots of an alien civilization seems too ridiculous to be possible, even though it is in permanency at Dartmouth.[197]

Opponents saw in Orozco's expressive distortions in the Reserve Room murals a "deformed" or "grotesque" modernism:

> Pity the art that can find no other means of stimulating the beholder than that of giving offense to reason and normal sensibilities by the conscious distortion of things which in natural and reasonable form and relation we enjoy seeing. Weak indeed the artist who must substitute crudity for strength and by the manner and matter of his work achieve merely sensation and evoke distaste, if not disgust. . . .[198]

Moreover, this writer, among many others, disapproved of the presence of the murals in the neo-Georgian architectural environment of Baker Library:

> The very fact that any supporter of modernism lauds these things should be sufficient reason to bar them from the building they occupy. The idea of fitness to purpose in art and design is axiomatic. How then reconcile the measured dignity, simple and refined, of Baker Library with the strident, jarring, jumbled masses of these decorations?[199]

As an illustration of the tenor reached by the letters of protest from Dartmouth alumni, who included many members of the Boston business community, was the charge that the murals endangered the students' mental health. Dr. George Van Ness Dearborn (class of 1890), a neuropsychiatrist, stated that he was "a bit concerned, mentally," and feared the effect created by viewing the murals, particularly the education panel, on "unsophisticated, naive, impressionable lads":

> This protest represents an idea, yes a conviction, that college students are positively entitled to have in their daily academic surroundings for four years real values, valid age-tried things, influences, and objects that will make them neither jeer nor wonder nor doubt if academic education after all is not an outworn fallacy. . . .[200]

At the national level, the conservative North American artists' organization, the National Commission to Advance American Art (whose governing board came primarily from the National Academy of Design), formed only weeks before to protest the selection of Diego Rivera to paint at Rockefeller Center, "indicted" Dartmouth College on the charge of foreign art preference and placed the school on its "regret list" to "call attention to inconsiderate blows being dealt American artists by important national institutions."[201] Dartmouth answered the commission's charges in a reasonable fashion, noting that since Orozco had himself proposed the theme and locale for the murals, no competition had been held.[202] President Hopkins maintained his adamant position regarding what he saw as the educational value of the murals in the face of both alumni and national conservative opposition:

> My own sentiments in regard to the whole matter are that I would bring in anybody to espouse any project that would be as intellectually stimulating to the undergraduate body as these murals have proved to be. The very fact that opinion is so definitely divided among the students is in itself, I think, a far better effect than could be accomplished by something in which everyone was agreed.[203]

Student reaction ran from the opposition President Hopkins noted to apathy, yet also included the strongly supportive position held by radical student leaders, such as Budd Schulberg, who felt Orozco "was painting a view of history that we felt was urgently needed."[204]

86

Liberal writers, particularly E. M. Benson (Dartmouth, 1927) and Lewis Mumford, offset negative reaction to the murals. Writing in journals such as *The American Magazine of Art* and *The Nation* during the work-in-progress, Benson spoke of Orozco's "broad social vision, the ability to relate man to mankind" and judged the Baker Library epic as "the most important contemporary document of its kind."[205] Mumford found in Orozco's work—"probably the most impressive mural in North America"—"the realities of human mind and passion, the realities of the world in which we live and dream and plan and act."[206] Mumford also spoke at the ceremonial dinner honoring Orozco on February 16, citing the murals' "disturbing quality that is the vitality of really living art which must be appreciated not only with the mind, but also the emotions and viscera of man."[207] Orozco spoke at the conclusion of the festivities, and his graceful remarks indicate his complete satisfaction with his time in Hanover:

This is an excellent occasion for me to acknowledge publicly the cooperation, the kind assistance and encouragement that I have received from many persons of the community. I am particularly indebted to the members of the Art Department under the leadership of Prof. Artemas Packard, whose influence on the whole educational plan of the College is truly remarkable in its attitude and results. . . . My own work will be, I hope, only the first step toward a more sustained accomplishment. The walls of Dartmouth will have, no doubt, in the future many other paintings. The way is open to other artists who will come to Hanover with the certainty of finding a place where Art can fully develop and flourish.[208]

The murals rapidly gained acceptance from the general populace as important works of art, a surprising occurrence given the intensity of contemporary opposition toward them. President Hopkins noted that during the summer of 1934 some 250 people visited the library daily, and that "practically everyone" he saw during his vacation made their approach to the Maine seacoast by way of Hanover in order to view the murals.[209] The Boston newspapers, which had published vitriolic attacks on Orozco's work during 1932–34, wrote in early 1935 that "people from all over the United States the past year have been apparently more interested in the great mural painting by a Mexican artist—José Clemente Orozco—than in any other one thing in the college."[210]

By 1940 the murals had become famous and played an important role in a burgeoning art program, with some 400 students a year enrolled in art and archeology courses.[211] In 1941, one writer asserted that "history has caught up with [the murals]" and saw the realization of a prophetic note in Orozco's work at Dartmouth:

What Orozco depicted in 1932 seems no more brutal nor horrifying than many of the cartoons or photographs to which we are subjected in the news today. . . . Orozco is not thinking of the machine as an implement of war alone, but as the cause of over-industrialization and nationalistic acquisition describing the vicious circle that produces nationalism and war. These pictures are full of that ingredient that is subject to didactic argument today—social significance.[212]

Since that time the murals have come to be accepted, as was the case with the *Prometheus* at Pomona College, as the single most important artistic and cultural resource of Dartmouth College. They have been the topic of two recent symposia in Hanover (1980 and 1984), the last to celebrate the fiftieth anniversary of the completion of the cycle. Today, in superb condition, the paintings proclaim their "idea" as brilliantly as they did half a century ago.[213]

DIEGO RIVERA

Rivera's Mexican and European Background, 1886–1930

In contrast to Orozco and Siqueiros, Rivera arrived in the United States a fully mature artist and highly accomplished mural painter whose prodigious creation of frescoes on thousands of square meters of Mexican walls during the 1920s included the first masterworks of the twentieth-century Mexican mural movement. If the North American murals of Orozco and Siqueiros should be seen as a dramatic "breakthrough" regarding style, content, and, in Siqueiros's case, technique, the significance of the murals Rivera produced in this country lies rather in his interpretation of the North American industrial environment and capitalism. Although treated differently in the various works, these themes were common to the murals he created here from 1930 to 1933. Both the topics of Rivera's early years and the Mexican murals of the 1920s merit monographic studies in their own right and are beyond the scope of this investigation.[1] However, as a means of introducing the reader to Rivera's pre-North American art I would like briefly to discuss three interrelated influences on his mural production: Positivism, which provided the underlying methodology for his art; Cubism, which supplied basic compositional and stylistic components of his art; and the ancient Mexican belief in a highly complex system of life-balancing dualities that governed the basic organization of Rivera's thematic motifs in his murals.

Positivism, the earliest of these influences on Rivera, reflected the fundamental focus of education in Mexico during the Porfirian era (1876–1910). Rivera should be seen as a typical, if unusually talented, product of the strictly ordered, "scientific" educational system devised by the student of Auguste Comte, Gabino Barreda (1818–81), during the 1860s and 1870s. Positivism was intended above all to provide intellectual emancipation for Mexico (and Latin America in general) in its rational categorization of thought to combat what were seen as the pervasive theological tendencies from the colonial era or metaphysical viewpoints inherent in the liberalism of the nineteenth-century Independence movements. In much the same fashion the Comtian system aimed to supply the antidote to the anarchy of the French Revolution. Thus, between 1880 and 1900 Latin intellectuals viewed Positivism as a means of liberation, even sal-

vation, from the regressive tyranny of earlier periods. A new Latin American order seemed to arise, based, as the leading Mexican scholar of this movement, Leopoldo Zea, has put it, "on science, an order concerned with education of its citizens and the attainment for them of the greatest material comfort."[2] In Mexico, Positivist education would be used to transform a "weak" and "inferior" Mexico of the mid-nineteenth-century (who had lost much territory to the United States during the war of 1846–48) to a more organized and practical race, along the lines of the United States and England. Justo Sierra (1848–1912), one of the leading Mexican Positivists, went so far as to insist that in accepting Positivism—and in doing so completely breaking away from the colonial heritage—an attempt was aimed at "Saxonizing" Mexico and converting Mexicans into "Yankees of the South."[3] The aim of the Positivist generation of 1880–1910, then, focused on the formation of a national consciousness and on progress outside the realm of foreign domination.

In attempting to bring Mexico into the modern age, Barreda and the Mexican Positivists adopted Comte's ideas of organic social evolution and the primacy of society. From the English Positivist Spencer they took his emphasis on the importance of the individual. In so doing Barreda changed Comte's motto of "Love, Order, and Progress" to "Liberty, Order, and Progress." Ironically, "Liberty"—except as it would later come to mean the freedom of the individual to accumulate wealth—would have the least importance in Barreda's goal to rid his country of its "chaotic" and "anarchistic" character. One Positivist called for "fewer rights and fewer liberties in exchange for greater order and peace! . . . No more utopias! I want order and peace even if it be at the expense of all the rights that cost me so dearly."[4] Barreda's mission to restore order in Mexican society, which would ultimately result in the Positivists' ardent support of the authoritarian Díaz regime, utilized sweeping changes in the country's (more specifically, the Federal District's) educational program to implement his goal.

Criticizing the prevalent education of the 1850s and 1860s as "theoretical," Barreda proposed seeking "a common fund of truths" for all Mexicans vis-à-vis Positivist education. To this end knowledge would be based on *experience,* in the "spirit of investigation and doubt," rather than on authority. These new beliefs common to all Mexicans were, as Zea says:

> to be supported by positivist demonstration. To attain a new social order, it was necessary that the individual abandon every interpretation based on scepticism and intolerance and subordinate these interpretations to demonstrated truths. The purpose of schooling was to offer Mexicans demonstrated truths and to eliminate ideas based on fantasy and scepticism. The new beliefs were to be based on scientific demonstration.[5]

In the late 1860s Barreda completely reorganized the National Preparatory School according to Positivist principles, using science as what he hoped would be the bond to bring together all Mexicans. Thus his program, meant for all students regardless of their interests, included all the positive sciences, with the most important being mathematics. Next, the natural sciences would be studied in this precise order: cosmography, physics, geography, chemistry, botany, and zoology. The study of modern languages followed: French, which Barreda felt had replaced Latin in primary importance, English, and German. Spanish would not be studied until the third year. Logic would be studied last, since only after the students had an understanding of how science works could they comprehend its theoretical bases. In contrast, the earlier system had begun with two years of Latin before one could be admitted to the philosophy course. Previously, students had first studied logic, then metaphysics (in three sections—"the divinity," "the angels," "the human soul"), and finally morality. The second course had included algebra, plane and solid geometry, and trigonometry, complemented by a short study of geography, chronology, and

French, deemed necessary only to translate next year's physics course textbok for which no instruments were provided.[6]

Barreda had both an organic and encyclopedic intent for his program as he sought to guide, even order, the minds of his Mexican students. Yet his program had further social functions. First his system brought forward a coherent and pervasive ideology for the triumphant class of this period, the bourgeoisie. Indeed, Zea has maintained that "the ideal of order of the Mexican Positivists was the ideal of peace of the Porfirian regime."[7] Overt Positivist support for the Díaz administration—in their terms a necessary "social dictatorship" or "benevolent tyranny"—is exemplified by the Liberal Union Party's 1892 manifesto calling for Díaz's fourth consecutive term. The party spoke of "scientifically" analyzing Mexico's social situation, hence they became known derisively as "los científicos" by the opposition. They appealed for the granting of liberties to Mexican citizens. These liberties, however, primarily involved a national "freedom of commerce," or the freedom to accumulate private wealth. Hence Barreda's slogan of progress came to mean the assurance of individual enrichment within the context of the order of the Díaz government.

As Ramón Favela has shown, Rivera's years at the San Carlos Academy of Art, 1898–1906, were typical of this period in their "rigorous control" and "positivist orientation."[8] Nicknamed as a child the "engineer," Rivera displayed an early interest in investigating and portraying natural phenomena and in the workings of mechanical objects. He was practically a born Positivist. In technical courses at the San Carlos School of Architecture he studied mechanical and advanced geometry, while the art school curriculum included coursework in descriptive geometry, mechanical drawing, and physical geography. Rivera spoke with revealing reverence of the "mathematical security" with which one of his instructors, José María Velasco, constructed the appearance of "everything that architectonic forms and surfaces have to offer in the way of representable

surfaces. . . ."[9] The texts Rivera studied, such as Eugenio Landesio's *Foundations . . . Compendium of Linear and Aerial Perspective, Shadows, Reflections and Refractions with the Necessary Rudiments of Geometry*, the required text for Velasco's perspective theory class, had a strong mathematical bent that reflected their Positivist orientation. *The Foundations* presented in geometric terms the rendering of shadows and showed the artist how to calculate "scientifically" the depiction of reflections and refractions. These sections included Velasco's illustrations with superimposed geometric diagrams. Rivera's rigorous training in geometry and the laws of optics—a Positivist demonstration in the "science" of presenting the visual world on a two-dimensional surface—had enormous significance for the artist's European period. The influence of Velasco's teaching can be seen especially in Rivera's early European paintings of water reflections (e.g., *Reflections* of 1909–10), and a reappearing motif is abstracted reflections of the Tagus River. Ramón Favela has observed that because of "Rivera's familiarity with Landesio's text and Velasco's teaching the Cubist concept of a subjective perceptual space composed of tactile and motor sensations would later be easily comprehended by him."[10]

Rivera's training in the Positivist method had overwhelming importance in his approach to both the Mexican murals of the 1920s and the North American murals. That is to say, although Rivera rejected the conservative *message* of Positivism inherent in its slogan of "Liberty, Order, and Progress" in favor of a Marxist point of view, he remained a devout follower of the Positivist *method*. The words of a "typical" Positivist from the late nineteenth century mirror Rivera's artistic procedure in his murals: "We do not recognize truth at first sight, to be sure. To reach it we need to make long journeys into the regions of science, painstaking and constant work, and laborious and patient investigation."[11]

Beginning with the Education murals (1923–28) Rivera's artistic method may be termed fundamentally Positivist, characterized by direct obser-

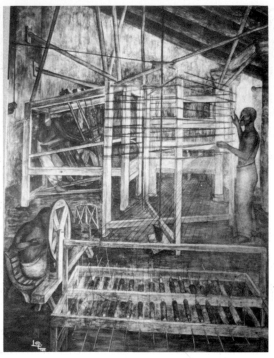

72

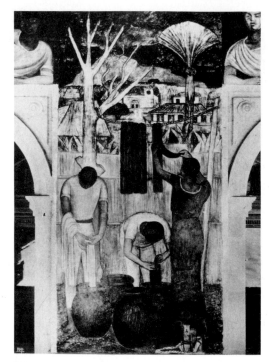

73

vation of facts, a spirit of practical investigation,
and above all an encyclopediac and organic
approach to his subject matter. In the hundreds
of square meters of his first-floor and stairway
murals for the Secretariat of Public Education
Rivera took as his theme the entire fabric of con-
temporary Mexican society, depicted in relation-
ship to the causes and achievements of the
Mexican Revolution. In the stairway murals Rive-
ra painted a faithful geographical portrait of Mex-
ico, beginning at the bottom of the stairs with
the tropical coastal regions and ending at the top
of the stairwell with the highland plateau. Here
he celebrated the triumph of the revolution and
dramatic advances for the masses of Mexico in
the areas of agriculture, industrial development,
and education. Commenting on his aim to pres-
ent Mexican reality, Rivera stated at this time:
"I had the ambition to reflect the genuine essen-
tial expression of the land. I wanted my pictures
to mirror the social life of Mexico as I see it, and

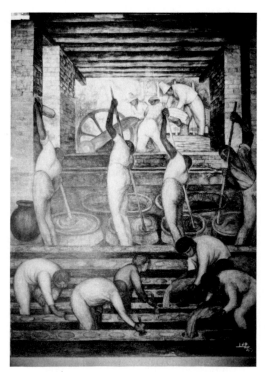

74

75

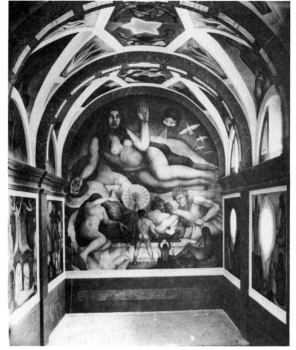

76

through the reality of arrangement of the present the masses were to be shown the possibilities of the future."

In his next works at Chapingo (1926–27) Rivera followed Positivist thinking in his application of biological laws to human conduct. The Positivist Manuel Ramos drew an analogy between society and biology: ". . . nothing resembles a society as much as an organism. . . . Biological phenomena are, then, the best source of comparison for sociologists."[12] Although the Positivists presented a class ideology favoring the increasingly powerful Mexican bourgeoisie in their call for the survival of the fittest in society, Rivera opted at Chapingo to portray in an orderly, rational manner the organic development of revolution, in this case the twentieth-century Mexican agrarian movement, paralleled by various stages of biological growth.

In his final Mexican mural of this decade, the Palace of Cortés murals (1929–30) at Cuernavaca

72. *Weavers*, Secretariat of Public Education (Court of Labor), 1923. Fresco mixed with nopal (cactus) juice, 15.5 x 12 ft.

73. *Dyers*, Secretariat of Public Education (Court of Labor), 1923. Fresco mixed with nopal juice, 15.5 x 7 ft.

74. *Sugar Factory*, Secretariat of Public Education (Court of Labor), 1923. Fresco mixed with nopal juice, 15.8 x 12 ft.

75. General view, loggias of Secretariat of Public Education, 1923–28. Fresco, total painted surface approx. 5,200 sq. ft.

76. Chapingo murals, general view of the former chapel, Universidad Autonoma de Chapingo (Mexico State), 1925–27. Fresco, total painted surface 2,324.5 ft.

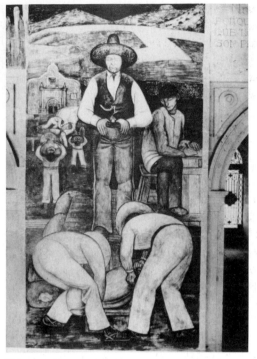

77

78

77. *Foreman*, Secretariat of Public Education (Court of Labor), 1923. Fresco mixed with nopal juice, 15.7 x 7 ft.

78. *Peasants*, Secretariat of Public Education (Court of Labor), 1923. Fresco mixed with nopal juice, 15.7 x 8.1 ft.

the artist presented in specific detail the history of the state of Morelos from the sixteenth-century through the colonial era—documented in all its brutal detail—ending with what Rivera saw as the only possible rational conclusion, the triumph of the twentieth-century Zapatista revolution. To buttress the didactic intent of the main panels he included small paintings in grisaille underneath and also arranged this series of paintings geographically: the panels run from north to south, as Cortés invaded from the north, and Zapata attacked Mexico City from the south.

In North America Rivera continued both to mirror Positivist logic and method and to reject the bourgeois mentality of this school, as his three most important murals in this country clearly reveal. In Detroit the artist spent months of rigorous preparatory investigation, producing by his count thousands of sketches in his study of the automotive industry. He not only achieved a factual accuracy in his Institute of Arts murals that

workers praised, but also managed to synthesize a mass of individual images and details into a single coherent whole, portraying his view of the "struggle of the worker" within the context of the twentieth-century capitalist industrial environment. Rivera also specifically evoked the Positivist analogy between biology and society in referring to his "biological function" as artist: "I am not merely an 'artist,' but a man performing his biological function of producing paintings. . . ."[13]

At Rockefeller Center and the New Workers School Rivera proceeded to work in the vein of social function stressed by Positivism, although here he turned the Positivists' political position upside-down by injecting these works with an overt Marxist message. Using both macroscopic and microscopic vision and the theme of capitalism versus socialism, Rivera demonstrated at Rockefeller Center the role of technology for the (socialist) future, controlled by the imposing symbolic figure of a worker. The New Workers School panels were full of the artist's oppositional-Marxist rhetoric, but they nonetheless retained a distinctly Positivist-oriented didactic method in their detailed history of the United States, replete with hundreds of characters, from the point of view of the anti-Stalinist Communist party opposition. In his *Portrait of America* he again presented his subject matter in a rational and clear-cut manner. The paintings of the east wall, for example, the seventeenth to nineteenth-century *Historic Causes*, are integrally related to the twentieth-century *Later Day Effects* panels of the west wall.

Rivera rejected Parisian Cubism as a nonviable approach for his Mexican murals of the 1920s, instead creating a representational public art integrated with the functions and needs of society and intended to enhance aesthetically architectural environments. Yet he still retained stylistic and compositional elements of Cubism. He said to the North American critic Walter Pach in 1923, "I am ten times as much a Cubist today" [than I was in Paris]. Rivera's first mural, *Creation*, owes its existence to his extensive study during 1920–21

of Italian public art from the Early Christian, Byzantine, and Renaissance epochs, but the arbitrary flattening of the figures and the emphasis accorded the picture plane represent extensions of the artist's Cubism of 1913–17. Rivera's mistress of these years, the artist Angelina Beloff, has recalled his great interest in the construction of his paintings: "Diego evidences a broader viewpoint [than his fellow Cubists], being chiefly preoccupied with the building of the picture."[14] His fellow muralist in Mexico Jean Charlot also noted the strongly architectonic nature of Rivera's Cubist paintings: "In Paris Cubist Rivera treated each easel painting as architecture, building it patiently up from the initial rectangle of the canvas. Muralist Rivera did not have to change his point of view, only the scale of his work."[15] Rivera's first Mexican murals, then, fused Cubism with sociopolitical commentary and the monumental architectural space of government buildings. The underlying Cubist frame of reference for the Education murals can be seen in a flat two-dimensional surface treatment and the interlocking planes in which the Cubist grid appears, at times disguised as architectural and structual elements (*Weavers, Dyers, Sugar Factory*). Later at the Palace of Cortés (the panel *Constructing the Palace of Cortés*) and the California School of Fine Arts, Rivera painted the grid in the form of architectural imagery, treated figures as massive geometric forms encased in their painted and actual architectural environment and positioned for compositional purposes (*Peasants, Descent into the Mine, Foreman*), and depicted simultaneously different scenes within the same panel (the stairway Education Ministry series). Rivera controlled the stylized aciton and movement of the figures at all times by a two-dimensional planar arrangement and the mathematical harmony of the compositions as in the frieze-like panels such as *Fiesta of the Flowers* and *Xochimilco*.

Rivera had thoroughly assimilated Cubist practices, which would provide the stylistic basis for his murals, in his art, through group meetings and viewing other artists's work. Of great significance

in this last area was the Puteaux Group. Their *Section d'Or* exhibition of October 1912 was a "declaration of independence," in historian Douglas Cooper's words, from the art of Picasso and Braque and their perceived lack of interest in humanity. Instead, the Puteaux Group called for predetermined mathematical harmony in art that led them to take the ancient visual proportions of the Golden Section as their motif.[16] Moreover, in their effort to indicate the importance of architecture to the arts, the Puteaux artists had earlier that year jointly exhibited a Cubist House at the Salon d'Automne. Along with Jacques Villon's interests in Pythagorean and Renaissance theory that inspired the mathematical subdivision of his canvases—a practice Rivera followed in his murals—must be added the influence of Gris in his similar "rich interplay between a predetermined vocabulary of perfect parallels, perpendiculars, and diagonals."[17] Like Gleizes and Metzinger, Rivera concerned himself with the philosophical basis for Cubism and related matters such as the representation of the time-space elements of the fourth dimension. The Italian Futurist Severini noted with approval Rivera's experimentation in this area:

> As the painter Rivera, following Poincaré, justly observed, "A being living in a world with varied refractions instead of homogeneous ones would be bound to conceive a fourth dimension." This milieu with distinct refractories is realized in a picture if a multiplicity of pyramids replaces the single cone of Italian perspective. Such is the case with certain personal experiments made by Rivera, who sees in Poincaré's hypothesis a confirmation of some intuitions of Rembrandt, Greco, and Cézanne.[18]

Aspects of the art of those art historian Robert Rosenblum terms "the Parisian satellites" also held great interest for Rivera. For example, Picabia's depiction of folkloric subject matter in the Cubist vocabulary (*Dances at the Spring,* 1912) anticipates Rivera's use of popular Mexican imagery, although Rivera painted much more realistically in the Education murals. The literary

intentions of Duchamp surely attracted Rivera's attention as well, as did his portrayal of sequential motion derived from Analytic Cubism, Futurism, and motion photography. Rivera later used this manner of working in the *Commercial Chemicals* panel of the Detroit Institute of Arts mural program. The enormous size of some paintings of this time, such as La Fresnaye's *Conquest of the Air,* further hinted at the mural potential of Cubism.

In the work of Fernand Léger we see a parallel to Rivera's drift toward monumental public art. In several areas Léger's geometrically oriented art of the 1910s directly presaged Rivera's murals of the 1920s and later. These areas include "the activities of the human body and the machine" (the Education Ministry and Detroit murals), "the public experience of the contemporary industrial world" (most notably Detroit), and "the impersonality of a classic monumental style" (a term equally applicable to Rivera's murals in general).[19] Especially relevant here is the dense compression of geometric forms in Léger's paintings such as *Nudes in the Forest* (1910) that immediately brings to mind various murals of Rivera's filled with human figures and mechanical forms. Again, however, Rivera uses a more naturalistic rendering. See, for example, the Mexican carnival scene and the political demonstrations of the first floor Education frescoes, the third-floor Education *corrido* series, the vast National Palace cycle, and the automotive panels at Detroit. Rivera saw the world in a much more specific and detailed fashion than Léger, whose universe of basic architectonic forms comprised figures, landscape, and objects alike. Rivera also painted a more precise geography (Mexico) and political position (Marxist). The art of the Purists Le Corbusier and Ozenfant also looked forward to the architectonic concerns of Rivera in his murals.[20] Rivera would prove to be the only artist trained as a Cubist whose mature work was devoted primarily to the mural, an art form—as Rivera's murals irrefutably demonstrate—inherently linked with the architectonic plastic language of Cubism.

The ancient Mexican belief in a system of dualities that governed the existence of man and the gods appeared last among the fundamental influences on Rivera's art, deriving from the artist's extensive study of pre-Conquest culture and society, which he first depicted at the National Palace (*The Ancient Indigenous World*, 1929) and Cuernavaca (1929–30). Rivera's profound interest in his country's history and art would lead him, in fact, to collect some 60,000 pre-Cortesian ceramic and sculptural pieces that rival in quality those housed at the National Museum of Anthropology in Mexico City.[21]

One scholar terms the concept of duality "the dialectic of the opposites, of the contradictory forces whose function is to animate life and create a vital balance."[22] It played an extremely important role in the metaphysical aspect of ancient Mexican life. This concept seems to date back to Preclassic times, as evidenced by small two-headed clay figures expressing the two basic facts of human existence: life and death. This notion became more fully defined in the person-god of Quetzalcoatl, the plumed serpent, whose person symbolized the cosmic and eternal struggle between matter and spirit. Quetzalcoatl represented the fundamental Nahautl principle "that everything is dual, men and gods, heaven and earth, life and death."[23] Rivera, of course, had painted his idea of the Quetzalcoatl legend as the first panel of his vast National Palace cycle of Mexican history in 1929 and was thus intimately familiar with Nahuatl history and thought. The principle of duality permeated all aspects of Nahuatl life, extending even to a manner of speech known as "di-phrasing," or expressing an idea by means of complementary words (in English we have "bread and water," "fire and brimstone," "come hell or high water"). The principle of duality appears also in the opposing Rivera's use of the four cardinal directions, all related to the path of the sun through the heavens. The west (red, home of the Lord of Jewels) contained the house of the Sun; opposite, to the east (white, home of the Morning Star) was the area of light and fertility; opposed to the south (blue, home of the Mother Earth), placed to the left of the Sun, lay north (green, home of the maize seed awaiting rebirth), the country of the dead.

Rivera's Chapingo murals also have a strongly marked Italianate character, including scenes of good and bad government, *trompe l'oeil* partitions between the ceiling paintings, and decorative grisaille passages. Rivera's *Flowering of the Revolution* is similar to Giotto's Arena Chapel *Lamentation*. Here for the first time Rivera composed the panels in sets of contrasting dualities, a thematic grouping anticipating his mural program at the Detroit Institute of Arts (1932–33). Francis V. O'Connor has termed Rivera's personal and contemporary adaptation of the indigenous Mexican principle, as well as his relating his panels to the cardinal directions, "directional symbolism."[24] To provide transition from general to specific in the Chapingo murals, Rivera contraposes two images of "Seeds of the Revolution" in the two large panels of the vestibule. On the south wall, underground, lie the martyred agrarian heroes Zapata and Montaño, while on the north wall farmers and miners spread the call for revolution. The inner archway of the west wall depicts the *Virgin Earth* (after a pose by the photographer Tina Modotti), grasping a phallic bud emerging from the soil, and below, sleeping children. The opposite panel, largest of the series, is *Fecund Earth* (Rivera's pregnant wife at this time, Lupe Marín, inspired the nude figure), while below *The Producer, Man* gains the benevolent assistance of the other elements, air, fire, and water. On the long north and south walls, in six panels on each wall, are the themes of natural evolution and social transformation, or the process of growth in nature paralleled by Rivera's view of the organic process of revolutionary political (in this case, agrarian) development. Hence the panels of natural growth—from west to east, fertilization and terrestrial chaos, germination, flowering, and fructification—find their political counterparts on the opposite wall: *The Earth Oppressed by Capitalism, Militarism, and Clericalism* (two panels), *Social Ger-*

mination (or *Agitation*), *Flowering of the Revolution,* and *Fructification of the Revolution,* the final union of farmer, soldier, and worker. Allegorical figures in the vaulting reinforce these natural and political themes and run from west to east in this order: the elements sun, wind, and rain; builders; the "Red Star"; workers with hammer and sickle.

In his most important North American murals (Detroit Institute of Arts, Rockefeller Center, the New Workers School) Rivera continued to work in terms of dualities; in Detroit the east and west panels contrast life and agriculture with industry and the possibility of death, while the north and south paintings present the opposed operations of the internal motor block assembly and the external body manufacture. Rivera also used the actual play of sun and shadows to further emphasize the symbolic dualities of his paintings. At Rockefeller Center Rivera contrasted the physical properties of the telescope and microscope while commenting on the political duality of capitalism and socialism. Finally at the New Workers School, where Rivera painted the most stridently Marxist mural series from this time, he stressed inherent dualities in panels portraying eighteenth- and nineteenth-century American historical events that anticipate paralleling themes on the opposite twentieth-century wall.

California, 1930–31:
The Worker in the Context of Modern Industry

In San Francisco Diego Rivera introduced the themes of twentieth-century industry and North American capitalism to his murals, albeit in an undigested manner and with a curiously muted political point of view. These murals lack the ideological programs of the Mexican work, such as the murals at Chapingo (agrarian revolution) and at Cuernavaca (the history of Morelos state from the Conquest to the twentieth century), and present instead a pastiche of industrial motifs rather than any intelligibly planned subject matter. Yet, the relative weakness of these works seems only natural. Although Rivera had been pursued by Bay Area collectors of his art to paint murals in San Francisco since 1926, his herculean work schedule in Mexico during 1926–30 and a trip to the Soviet Union in 1927–28 had prevented any systematic investigation of North American industrialism.[25] At the same time, however, Rivera's consuming interest in all things mechanical must have been aroused by what he saw around him, and he recognized in a matter of weeks a highly desirable subject for his North American murals. He expressed to Detroit Institute of Arts Director William Valentiner (whom he met at a San Francisco cocktail party) his wish to study and paint the industrial world of Detroit. Although Rivera first painted modern industry at San Francisco, he would not come to terms with this theme or develop his political philosophy in this context until later, in Detroit, where he examined the worker's role in the industrial environment and the possibility for creating good or evil with machine technology, at Rockefeller Center, where he prophesied a future socialist society, and at the New Workers School, where he presented a particularized Marxist version of United States history from colonial times to the present.

Rivera arrived in San Francisco in early November 1930, preceded by his enormous popu-

larity and critical acclaim. Architect Timothy L. Pflueger, patron of Rivera's first San Francisco mural, welcomed him as "the world's greatest muralist." One critic noted at the time:

Mexico's foremost painter has been a curious case here—famous, and at the same time practically unknown. Ten years ago few people had even heard Rivera's name. Then, with the completion of the now celebrated frescoes in the Ministry of Education, Mexico, and the simultaneous general awakening of interest in Mexico, his name and work were widely and enthusiastically broadcast, so that today everybody knows that the ancient art of fresco painting has a great new exponent on this continent. However, we have had to take this art and this eminence more or less on faith, having had little but the fanfares of writers and the inadequacies of printed reproduction to go on.[26]

North American museums had known about, admired, and purchased his nonmural art years before Rivera arrived in this country, however, and the artist had several exhibitions in California during the 1920s, the largest of which was his 120-work exhibition at the California Palace of the Legion of Honor in late 1930.[27] Local artists, such as Ray Boynton and Ralph Stackpole, who studied fresco technique in Mexico with Rivera in the mid-1920s, helped greatly to stimulate interest in Rivera in their city through their championing of his art and by bringing his mural studies to California for exhibition and sales. Rivera noted this assistance in a letter to a local patron of the arts, businessman Albert Bender: "Stackpole, in one of his letters, spoke of a mural that had been offered to me and which I shall paint with great pleasure when I return (from the Soviet Union)."[28]

By June 1929 opposition to Rivera's presence had developed in San Francisco from the conservative Labor Council at San Francisco. It was the first expression of hostility toward Rivera's art and politics, which prefigured controversies in Detroit and New York. Rivera's leftist politics were responsible for the denial of his request for a six-month visa in 1929, although his influential San Francisco patrons managed to have the State Department decision reversed.

Before the reversal, Rivera wrote to Bender, saying that because of the visa denial he would begin work on the three large walls of the National Palace of Mexico. "I am developing there in synthesis the history of Mexico from its remotest past to the present and a vision of the possibilities of the future," he said but promised to interrupt this work "during the time necessary for my trip" [to San Francisco]. The announcement by Timothy L. Pflueger in late September 1930 that Rivera had been chosen to decorate the stairway of the recently constructed San Francisco Stock Exchange Luncheon Club generated media tirades against Rivera.[29] Newspaper headlines screamed "Colony Raps Selection of 'Red' Artist," "Radical To Do Exchange Mural," "Will Art Be Touched in Pink?" and included a composite photo of Rivera's pantagruelian picture of Wall Street leaders from the Secretary of Public Education Ministry fresco series superimposed into the site of the Luncheon Club mural.

Actually, Rivera had been expelled from the Mexican Communist Party in 1929, ostensibly for his support of the rightist Calles administration, a fact apparently unknown by any San Francisco newspaper reporters. Local conservative artists such as Maynard Dixon, Frank Van Sloun, and Otis Oldfield criticized the selection, not because of Rivera's politics, but because they felt that only an artist born in the United States should have been considered for the commission. Concerning the commission, Beatrice Judd Ryan, director of the Galerie Beaux-Arts and very much involved in the San Francisco art world at this time, has recalled:

Several years after [Rivera's 1925–26 Beaux-Arts exhibition], when the Stock Exchange mural came up, several of the Beaux-Arts members were asked to make sketches. But Bertram Alanson [club president] did not care for what they produced, and he and Tim Pflueger finally decided on Rivera.[30]

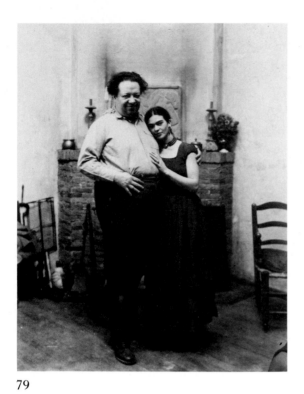

79

79. Diego Rivera and Frida Kahlo in San
Francisco, c. 1930. (*Photo by Peter Juley,
Courtesy of National Museum of American Art.*)

80. Interior of San Francisco Stock Exchange
Luncheon Club. (*Photo, 1980.*)

81. Interior of Luncheon Club. (*Photo, 1980.*)

Pflueger noted that the mural site "is a private
club, and what they choose to put on the walls is
their own business" and stated his intent to curb
any radical political content in Rivera's mural: "I
hold a contract with Rivera. And I hold the
pursestrings for the job. Should he attempt any
of the caricaturing for which he is famous . . .
well, there's power in pursestrings."[31] The con-
troversy seems to have been quickly defused on
Rivera's arrival in mid-November, as his warm
personality and earthy appearance provided news-
papers with much good copy. Rivera was de-
scribed as "a jovial, big jowled 'paisano', beam-
ing behind an ever-present cigar, his clothes bulki-
er than his big frame, a broad-brimmed hat of a
distinctly rural type on his curly locks" and his
new wife, Frida Kahlo, as "a contradistinct liv-
ing picture, the charming, thin-waisted, high-
heeled, nugget-beaded señorita."[32] The exotic
appearances of the pear-shaped 300-pound giant
Rivera and the diminutive Kahlo, dressed in floor-
length Mexican Indian wedding dresses and pre-
Conquest jewelry, evidently intrigued the local
populace. Viscount John Hastings, one of Rive-
ra's assistants in San Francisco and Detroit, recalls
that one night when the three of them were on
the Oakland Bay ferry, a person approached and
asked, "What circus are you people with?"[33]

On his arrival, Rivera explained that his mural
would "represent California with the three bas-
es of her richness—gold, petroleum, and fruits.
Transportation, rail and marine, will be motifs
stressed, and on the ceiling, energy and speed."[34]
Using Ralph Stackpole's borrowed studio, which
was large enough for Rivera to work on full-sized
cartoons, he had completed the preliminary stud-
ies for the mural by mid-December. At this time,
he began to paint on the stairway between the
two floors of the Luncheon Club. He would fin-
ish his mural, the largest and most important of
the various works intended for the extensive dec-
orative scheme commissioned by Pflueger, on
February 14.[35] In explaining his plan for the dec-
oration, the architect noted that "all the other art-
ists [i.e., besides Rivera] who have joined in

80

81

decorating the club have tried to illustrate with their work the business man at play, with golf, hunting, feasting, and the like as their motif. This is the type of thing Rivera will do in his mural here. . . ."[36]

Pflueger apparently spared no expense in decorating the two floors with a wide variety of woods (ebony, pear, Philippine mahogany), metals (copper, bronze and gold leaf, silver, and modern alloys), inlays, and marbles. Michael Goodman, the artist-designer responsible for the interior decoration, superbly integrated the various materials and works of art throughout the club's two floors. Today these Art Moderne rooms, which fortunately have been kept in excellent condition, look almost exactly as they did when Rivera's mural was dedicated on March 31, 1931.[37]

Rivera began painting, assisted by Clifford Wight and Lord John Hastings, with plastering done by Matthew Barnes. Hastings recalls, "We worked to grind the colors, trace the drawings, and very occasionally to paint unremarkable parts of the painting. We also tidied up and generally helped to keep everything in order. . . . The theme was decided by Rivera."[38] Before painting, however, Rivera had spent weeks viewing and sketching the northern California landscape, as well as preparing eleven studies for the mural and a full-scale cartoon. Rivera worked in several ways on the sketches, probably beginning with the generalized studies for the entire wall and ceiling areas. His delicate pencil studies of Ralph Stackpole's son, Peter, holding an airplane, the diver Helen Crelenkovitch, the prone nude, and the studies of miners and the naturalist Burbank recall his early period of study with the Ingrist Santiago Rebull (1829–1902) in the Academy of San Carlos.[39] These pencil sketches, and the portraits in pastel taken from life, particularized the stylized "types" of the preliminary wall and ceiling sketches, while the miners and Burbank drawings indicate Rivera's study of source photographic material. Rivera then created one monumental study for the central figure, the allegory of California, for which the tennis champion (and ama-

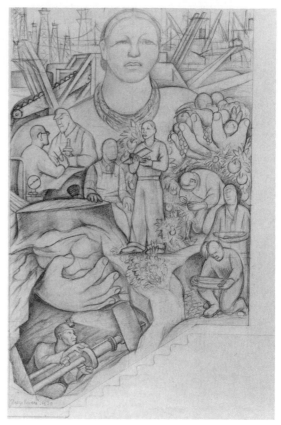

82

teur artist) Helen Wills Moody posed. Rivera had been introduced to Mrs. Moody by William Gerstle and sketched her several times playing tennis. He also did profile studies. He said, "Miss Wills has classical Grecian features. Since I feel that California is a second Greece, I think that Miss Wills typifies the young womanhood of this state." Mrs. Moody recalled the way Rivera worked: "He sketched in sanguine chalk before my astonished eyes, on a colossal scale, while standing on a soap box. . . . The likeness was unmistakable, although somewhat stylized as the fresco demanded." Objections were raised to using the specific portrait of Mrs. Moody in the mural by those who thought they should represent California or that the head "be made typical of womanhood, but not a portrait of any

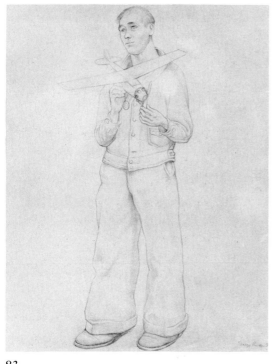

83

84

85

82. Study for mural, Luncheon Club, San Francisco, 1930. Pencil, 22½ x 11¹¹⁄₁₆ in. (*Photo by Phillip Galgiani, courtesy of San Francisco Museum of Modern Art, William L. Gerstle Collection.*)

83. Study for *Youth* [Ralph Stackpole's son], 1930. Pencil, approx. 24 x 18 in. (*Photo by Phillip Galgiani, courtesy of San Francisco Museum of Modern Art, William L. Gerstle Collection.*)

84. Study (*Luther Burbank*), 1930. Pencil, 24⁷⁄₁₆ x18⁷⁄₈ in. (*Photo by Phillip Galgiani, courtesy of San Francisco Museum of Modern Art, William L. Gerstle Collection.*)

85. Study (*Miners Panning Gold*), 1930. Pencil, 24¼ x 18⁷⁄₈ in. (*Photo by Phillip Galgiani, courtesy of San Francisco Museum of Modern Art, William L. Gerstle Collection.*)

86

87

88

86. Study, 1930. Pencil, 13³⁄₁₆ x 18 in. *(Photo by Phillip Galgiani, courtesy of San Francisco Museum of Modern Art, William L. Gerstle Collection.)*

87. Study (nude figure standing), 1931. Pencil, 31³⁄₄ x 18⁵⁄₈ in. *(Photo by Phillip Galgiani, courtesy of San Francisco Museum of Modern Art, William L. Gerstle Collection.)*

88. Study (reclining nude), 1931. Pencil, 18⁷⁄₈ x 24¹⁵⁄₁₆ in. *(Photo by Phillip Galgiani, courtesy of San Francisco Museum of Modern Art, William L. Gerstle Collection.)*

89

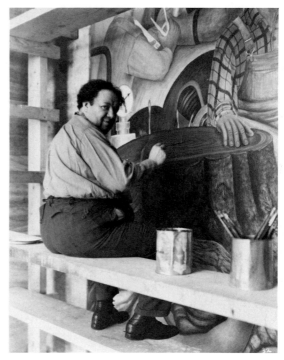

90

89. *Mrs. Helen Wills Moody*, 1930. Sanguine and pastel, 89¾ x 63⅛ in. (*Courtesy of Tate Gallery, London.*)

90. Rivera on scaffolding, 1931. (*Photo by Peter Juley, courtesy of National Museum of American Art.*)

individual."[40] Whether he did it to mollify these protestors or not, Rivera further generalized the sketch in the painting, though one can still detect an obvious resemblance to Mrs. Moody.

Michael Goodman determined the location and area proportions for the mural and spoke with Rivera several times a week concerning technical problems. The size of the modular units of travertine marble dictated the space available. The extension of the mural across the ceiling—"which baffled Rivera, but he didn't protest," according to Goodman—derived from a situation Goodman had seen in Germany in the 1920s in which a batik hanging, too long for the wall, was simply carried into the ceiling area. Rivera considered the mural proportions "perfect," since they fell within the formula for Dynamic Symmetry. Goodman recalls that Rivera worked quickly and continuously for hours, until that day's fresh plaster section was finished.[41] He closely followed the general sketch for the wall,

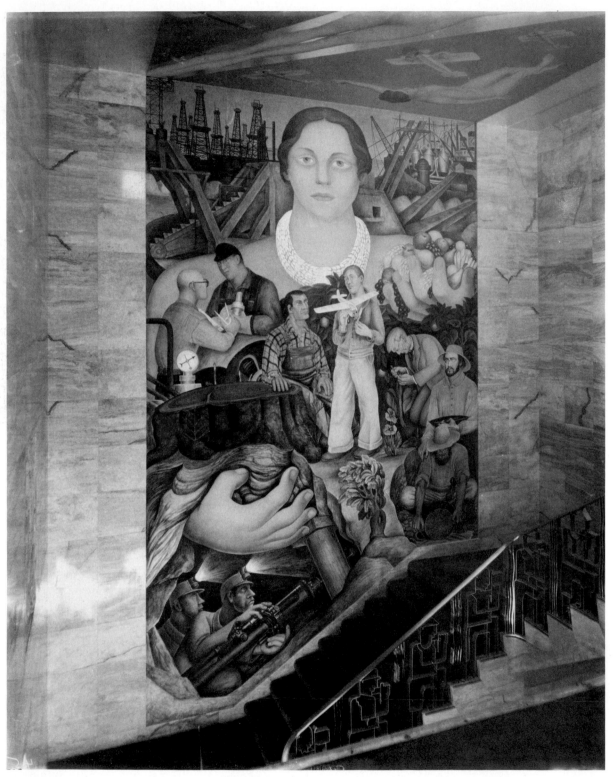

91

substituting the individualized portrait studies, slightly changing the position of the boy with airplane and the kneeling miner, and adding another coal miner.

Rivera chose not to glorify capitalism as Pflueger had specified ("the business men at play, with golf clubs, swimming, hunting, feastings, and the like"). The chrome and polished brass balustrade running up the stairs alongside the mural uses three stylized motifs in this vein—men in business suits, golf clothes, and full dress. Instead, Rivera honored the workers' liberation of California's material resources. He represented the worker in his multiple roles: not only the manual laborer but also the nineteenth-century gold miner and twentieth-century coal miner, the lumberman, the factory worker, the engineer-inventor with slide rule and compass, and the creative scientist. In a contemporaneous article, Emily Joseph, Rivera's friend, translator, and a local art critic, wrote what probably reflected conversations with Rivera on his mural:

> The significance of the Californian mural is plain. The heroic figure of California, the mother, the giver, is dominant. She gives gold and fruit and grain. California and her riches are here for all. Without the genius of her sons, however, her riches would be dead matter. Under the earth, over the earth, and above the earth, man's will and spirit transform gold, wood, metal, into goods that are to liberate the life of man. This idea of liberation is involved in the entire fresco.[42]

Using the figure of California as the central thematic element—the allegorical origin of the mineral and vegetable resources of the state—Rivera painted the various workers' activities predicated by California's resources. In the subterranean level coal miners drill a shaft; just above ground John Marshall and another miner pan for gold; above them Luther Burbank works surrounded by local flora. To Burbank's left the "American Boy" holds an airplane; he is both symbol of the inventive gifts of mankind and a reference to the

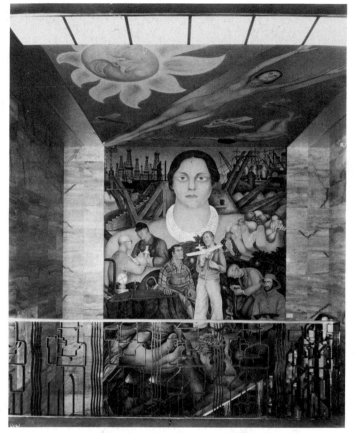

92

91. *Allegory of California*, Luncheon Club mural (view from top of stairway), 1931. Fresco. (*Photo by Peter Juley, courtesy of National Museum of American Art.*)

92. *Allegory of California* (general view), 1931. (*Photo by Peter Juley, courtesy of National Museum of American Art.*)

See also Plate 7.

107

then youthful aviation industry, which originated in the Bay Area. Gazing at the dreaming youth sits the lumberman (a stylized portrait of the artist Victor Arnautoff, who had worked on Rivera's National Palace project and would paint murals in San Francisco during the 1930s), with his hand resting on the stump of a redwood tree, which was of enormous importance to industries such as mining and construction. To the left stand the engineer-inventor and the mechanic, a partnership of imagination and manual labor, and between them a project in blueprint form. Above these two figures, on either side of the head of California, appear the tangible products of their partnership: oil rigs, derricks, cranes, ships, and other conventionalized mechanical apparatus. On the uppermost ceiling level, a stylized female nude soars within a band of gold, an allegory of energy and man's creative spirit, surrounded by airplanes, the sun, and a female at rest. Rivera's proletarian theme of the necessary, productive activities of the worker is central to all three San Francisco murals at this period. We do not know if he chose not to depict more volatile aspects of twentieth-century labor activities in California (for example, the IWW's role in the Wheatland Strike and the Mooney-Billings case) from deference to the commission or from his possible ignorance of California labor history. He nonetheless subtly hints that this system, over which capitalistic control is minimally indicated by the small dollar signs on the ships' smokestacks, faces a crisis situation. Note the "hidden" symbol of the red arrow in the machine gauge below the engineer-inventor, which has passed far beyond the "safety level indicator." Thus, in a seemingly innocent yet artfully contrived image, which evidently escaped everyone's attention, Rivera alludes to his belief that a capitalist explosion (revolution) will soon occur.

The wall portion of the Luncheon Club mural represents Rivera's most successful work from the 1930–31 San Francisco period, and meaningful compositional and iconographic parallels can be

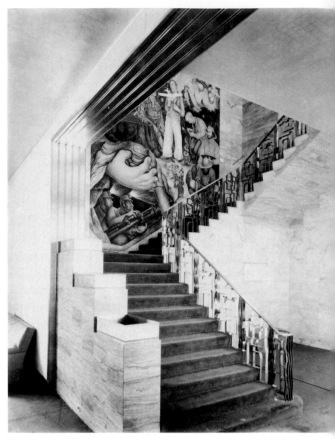

93

93. Luncheon Club mural (view from below). (*Photo by Peter Juley, courtesy of National Museum of American Art.*)

drawn to his earlier Mexican murals of the 1920s. In both color and the overall design, Rivera recreates the actual topographical features of California. In viewing the mural, one's eye ascends from the subterranean activity of coal mining to aboveground labors—panning for gold, lumbering, agriculture, and factory work—to the assorted cranes and derricks silhouetted against the sky, and finally, on the ceiling, to the celestial sphere. Rivera's treatment of color mirrors his composition—it progressively lightens from the dark, murky region of the mines, to the earth colors and ochers of the terrestrial level, to the brighter flesh tones of the allegorical figure and her brilliant golden necklace of wheat, and finally to the delicate golds and blues of the ceiling.

Rivera's ability to synthesize naturalistic and allegorical elements in a flowing, yet rigorously controlled, all-over pattern here was first demonstrated in his works on the staircase walls, ascending three floors, of the Secretary of Public Education. In these murals Rivera depicted a geographical "portrait" of the Mexican nation, a panoramic view of Mexico from the ocean depths and the tropics of Tehuantepec, to the plains and arid upper northern regions, including his celebration of the Mexican Revolution and its subsequent achievements (modern agrarian practices, rural education) in the latter geographic levels. Similarly, at the Palace of Cortés Rivera painted a "unified progression of events within a continuous frieze-like design" in which he achieved a "naturalistic unity between action, time, and space," portraying the history of the state of Morelos from the sixteenth to twentieth centuries in a geographically accurate manner.[43]

While similarities can be seen between the compositions of the earlier Mexican murals and the Luncheon Club painting, the Mexican murals described outright revolutionary subject matter. In contrast, the Luncheon Club mural presents much more muted political commentary. Yet within the particularly restricted nature of the commission Rivera succeeded in synthesizing the visual details he selected into a cumulative image that projects his Marxist political position. The irony here was that Rivera's painting perfectly satisfied his capitalist patrons.[44]

The Stern Mural

Rivera painted his next mural, the smallest and most charming from this period, in the Atherton home of a prominent member of the Bay Area business and cultural community, Mrs. Sigmund Stern. Mrs. Stern recounted in an interview that Rivera visited her in early April 1931 and was greatly impressed with the beauty of the landscape, especially the almond trees, then in full bloom. His enthusiasm prompted Mrs. Stern to ask him if he would consider painting a fresco in her home, to which he agreed at once, and selected the niche in the outdoor living room as the site for the work. The sketch accepted by Mrs. Stern showed a tractor working the soil, men digging, and a small boy sowing seed, and in the front a basket filled with fruit was placed on a stone wall, with three small children grouped around the basket.[45]

Rivera created a composite, idealized landscape scene based on his impressions of the Atherton environment, yet he intended something more than merely a lyrical, bucolic scene for, as with the Luncheon Club mural, he again depicted the productive labor of the workers. In fact, the workers, aided by the tools of twentieth-century industrial technology (the tractor), demonstrate

94

94. Approved sketch, 1931. Pencil, approx.
12 x 20 in. (*Photo by Don Beatty, anonymous
collection.*)

See also Plate 8.

their ability to order nature's agricultural resources for the benefit of mankind, which Rivera symbolized by the image of the children around the basket of fruit. Here, too, Rivera certainly purposefully underplayed his proletarian message, or masked it in imagery unobjectionable to his patron. The subtle visual irony, which I'm sure Rivera would have vastly enjoyed, retains its impact today, for the third Stern grandchild, Walter, shown as a common laborer sowing seed, is the present chairman of the board of Levi-Strauss, Inc.

The fresco marked Rivera's first use of a "portable" mural format; he painted on a separate frame of galvanized metal lath especially constructed for the project. This allowed removal of the mural from its original site, which took place in 1956 after Mrs. Stern's death, when the fresco was installed at the entrance to the dining room in Stern Hall at the University of California, Berkeley. Fortunately, all seven of the prepara-

95

96

tory studies have survived, and through these one can trace the development of the mural from the original (rejected) sketch to the completed work. Faint compositional lines in the accepted sketch clearly show that Rivera's first trees and the placement of figures follow general Golden Section proportions. Revisions would include the portraits of Mrs. Stern's grandchildren and the addition of two stylized worker-gardeners, taken from sketches of Mrs. Stern's gardeners, at the time engaged in putting in a new lawn. Recent restoration has revealed that Rivera completed the work in eight work sessions, each portrait requiring one session, but he was able to cover much more area at one time in the less difficult landscape areas. However, possibly owing to weather conditions or to Rivera's spending too much attention on his hostess and her friends, the upper left area dried too rapidly and the colors did not adhere permanently.[46]

95. Rejected sketch, 1931. Pencil, approx. 12 x 20 in. (*Photo by Don Beatty, anonymous collection.*)

96. Preliminary study, 1931. Pencil, approx. 8 x 10 in. (*Photo by Don Beatty, anonymous collection.*)

97

98

99

97. Stern grandchild, 1931. Pencil, approx. 8 x 10 in. (*Photo by Don Beatty, anonymous collection.*)

98. Stern grandchild, 1931. Pencil, approx. 10 x 8 in. (*Photo by Don Beatty, anonymous collection.*)

99. Child, 1931. Pencil, approx. 8 x 10 in. (*Photo by Don Beatty, anonymous collection.*)

100. Rivera painting in the Sigmund Stern home, Atherton, California, 1930. (*Photo by Ansel Adams, courtesy of the Trustees of the Ansel Adams Publishing Rights Trust. All rights reserved.*)

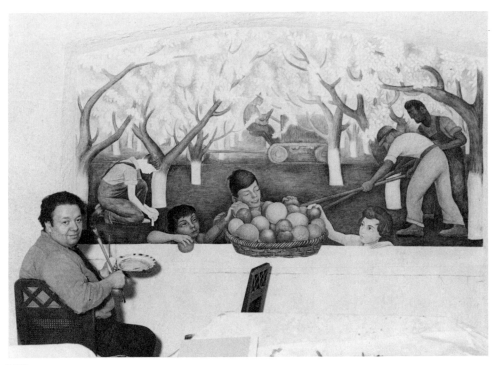

100

California School of Fine Arts

Immediately after completion of the Stern mural, Rivera began work at the (then) California School of Fine Arts on the largest and least successful mural of his San Francisco period, which dealt with various forms of artistic and manual labor in progress. Again he stressed the productive role of the worker in contemporary society, symbolized here by the central, many times larger than life-sized, figure of a laborer at work, in turn shown being painted in fresco by Rivera and his assistants. Although covering some seventy square feet more than the Luncheon Club mural, this mural was completed in approximately half the time.[47] Rivera found it necessary to work night and day and behind locked doors because of the increasingly urgent requests from high-ranking public officials in Mexico that he return to finish the National Palace murals. No doubt the higher-paying San Francisco public and private commissions played a role in his procrastination. Rivera had his patron Gerstle write to President Ortíz Rubio to request a further extension and explained his situation in San Francisco to New York critic and art dealer Carl Zigrosser:

I have formal engagements to paint seven other frescoes here, but I must first return to Mexico, which I expect to do in a few days, to finish my decoration in the National Palace. It is impossible for me to come to New York now, but when I return to San Francisco which I expect will be early September next, I hope to come via New York.[48]

113

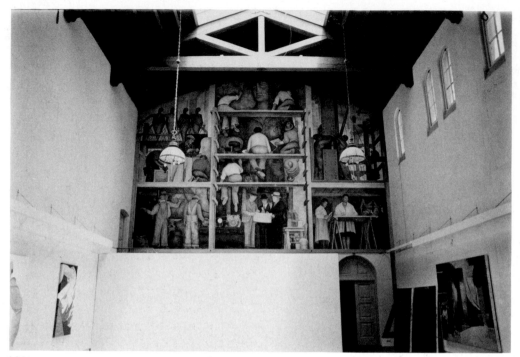

101

101. General view, California School of Fine Arts mural, *Construction*, 1931. Note that the room is used now as an art gallery. *(Photo 1980.)*

Extant documentation—especially Rivera's notes on the architectural plans of the school, which opened in 1927, and the nineteen studies of the mural—reveals the process of the creation of the mural from the originally proposed commission to the completed painting. In late May 1929, a month before Rivera's expected arrival, an acquisitions committee of the San Francisco Art Association met and proposed the forty-foot-long outdoor loggia as the site of the mural. The group made clear that they expected a nonpolitical work: "The character of the mural might have a very wide choice of subject matter—anything but of a political nature— of course suitable to an art institution."[49] Rivera rejected as unsuitable this long, fractured architectural space in favor of the large open walls of the art gallery. While both areas represented more or less the same wall space, Rivera opted for the unbroken gallery walls where the spectator would be able

See also Plate 9.

CALIFORNIA SCHOOL OF FINE ARTS, SAN FRANCISCO *Vue du sud.*
BAKEWELL AND BROWN, ARCHITECTS

La grande galerie à peu près 10 metres × 16 m.

102

102. Photograph of the California School of
Fine Arts with Rivera's notes. From *The
Architect and Engineer*, June 1927.

to view the mural completely in a single glance.[50]

Curiously, Rivera first selected the south wall of the gallery, its surface broken by a circular window. At this time, he had already decided on the general compositional device of scaffolding, as well as artists (a sculptor to the left, muralists to the right, and easel painters below to the right and left). The second sketch, for the north wall where Rivera would finally paint, depicts subject matter more akin to the completed fresco—sculptors, muralists, and architects work, with their patrons studying the artists' plans. The sketch also indicates how the composition has been generally determined by Golden Section proportions. The central image of the fresco-within-a-fresco has become a large, completely apolitical, allegorical female, recalling the figure in the Luncheon Club mural.

In contrast to these complete studies, other drawings of two markedly different types were used as models for specific areas of the fresco. Rivera sketched his subjects actually at work—Clifford Wight sharpening a tool, dropping a plumb line, measuring; Matthew Barnes plastering; John Hastings with plumb line; steel construction workers erecting a building; Albert Barrows sketching. The sketch of Michael Goodman, in architect's smock with slide rule, illustrates Rivera's approach to sketching subjects to be incorporated into his murals. "A model of an architect-designer" to Rivera, Goodman posed for the sketch (made at the Luncheon Club, where possibly Rivera also originally sketched his assistants at work) in the traditional architect's blue smock, holding an architect's scale. For esthetic reasons, Rivera changed the smock to white and gave him a slide rule "because the slide rule has all the answers to great proportions."[51] The other sketch type comprises specific, detailed portraits in pencil of the patron Gerstle, the architects Brown and Pflueger, the draftsman Barrows, and the sculptor Ralph Stackpole.

Timothy Pflueger prepared notes at the time on the technique and rationale of "furring" the

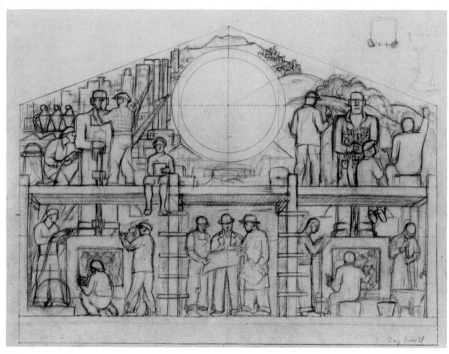

103

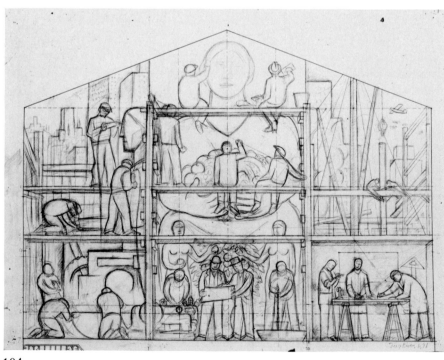

104

116

105

106

103. Sketch, first plan of mural, 1931.
Pencil/ink, 18.3 x 24.2 in. (*Courtesy of Sotheby's.*)

104. Sketch, second plan of mural, 1931.
Pencil/ink, 17.6 x 23 in. (*Courtesy of Sotheby's.*)

105. Sketch, Clifford Wight sharpening a tool,
1931. Charcoal, approx. 24 x 18 in. (*Courtesy of
Sotheby's.*)

106. Sketch, Clifford Wight dropping a plumb
line, 1931. Charcoal, approx. 24 x 18 in.
(*Courtesy of Sotheby's.*)

107

108

109

110 111

107. Sketch, construction workers, 1931.
Pencil/ink, 9 x 12.1 in. (*Courtesy of Sotheby's.*)

108. Sketch, Clifford Wight measuring, 1931.
Charcoal, approx. 24 x 18 in. (*Courtesy of
Sotheby's.*)

109. Sketch, Matthew Barnes plastering, 1931.
Charcoal, 23.8 x 18.3 in. (*Courtesy of Sotheby's.*)

110. Sketch, Michael Goodman standing
working, 1931. Sanguine/charcoal,
22.2 x 17.1 in. (*Courtesy of Sotheby's.*)

111. Sketch, *The Draftsman* (Albert Barrows),
1931. Sanguine/charcoal, 24.2 x 18.3 in.
(*Courtesy of Sotheby's.*)

112

113

112. Portrait of William L. Gerstle (patron), 1931. Pencil, approx. 24 x 18 in. (*Courtesy of Sotheby's.*)

113. Portrait of Arthur Brown, Jr., 1932. Pencil, 23.8 x 17.9 in. (*Courtesy of Sotheby's.*)

114. Portrait of Timothy Pflueger, 1931. Pencil, approx. 24 x 18 in. (*Courtesy of Sotheby's.*)

115. Portrait of Albert Barrows, 1931. Pencil, approx. 24 x 18 in. (*Courtesy of Sotheby's.*)

116. Ralph Stackpole cutting stone, 1931. Pencil, 23.8 x 17.9 in. (*Courtesy of Sotheby's.*)

114

115

116

wall before Rivera painted, which became standard practice for Rivera during his North American period. Pflueger also recorded his innovative ideas concerning the artist's scaffolding. "Furring," or the installation of runner bars at two-foot intervals tied to vertical metal studs at twelve-inch centers, followed by the wiring of galvanized metal lath to this armature, was deemed necessary because of the possible dangers of an incomplete bond between the plaster and concrete wall, moisture seepage from the exterior wall, and expansion cracks in the wall that might show through the fresco coats. This procedure made possible (if still difficult) the removal of the fresco, given the approximate life-span of thirty to forty years of most twentieth-century buildings in the United States. Regarding the scaffolding: first, the placement of the vertical supports along Rivera's compositional lines allowed the maximum degree of observation of the work-in-progress. Moreover, the design of the scaffolding system permitted the artist to break down easily both vertical and horizontal members to view the entire work at a glance and replace the scaffolding should he desire to revise the work.[52]

A gigantic figure of a "hard-hat" laborer operating machinery—a much more political figure than appeared in the initial studies— forms the dominant central image of the mural.[53] This figure itself is being painted in fresco by Rivera and his associates, Hastings and Wight, in the upper level of the scaffolding, with Rivera (his ample behind protruding over the edge of the scaffolding) and Barnes in the middle, and Wight again shown on the lowermost level. At the bottom, the architects Pflueger and Brown flank the patron Gerstle and hold study plans for an architectural project. In the left segment of the mural, surrounded by several assistants, the sculptor Ralph Stackpole works with a pneumatic hammer on a monumental sculptural piece. (Stackpole was almost certainly actually engaged at this time on the pair of large-scale sculptural groups for the San Francisco Stock Exchange, *Mother Earth* and *Man and His Inventions*, each twenty-one feet high,

unveiled on December 31, 1932.) Above, Rivera again depicted industrial exhaust fans, devices he found esthetically intriguing, though they have little to do thematically with the sculptor's labor. They also occur in the upper right-hand section of the Luncheon Club mural. To the lower right, the architects and designers Goodman, Frickle, and Barrows sketch and plan, while above, laborers install steel girders of a building under construction.

The scaffolding motif forms the compositional and thematic core of the mural, yet it is also ultimately responsible for the mural's artistic weakness. Compositionally, the work comprises an arbitrary tripartite design in which no visual relationship exists between the various self-contained sections. Further, within the individual lateral sections Rivera failed to achieve a sense of compositional and visual unity. At the left, for example, there is no meaningful association, either compositional or thematic, between the Stackpole workshop and the fans and buildings above. In the architectural section to the right, the absolute lack of compositional and visual linkage between the architects and construction laborers appears even more glaringly; one design seems peremptorily tacked atop the other. In sum, then, Rivera's composition is overly rigid, even boxlike, and simply fails to function as an esthetic totality, in marked contrast to the wall of the Luncheon Club and his earlier Mexican murals.

Thematically, the mural treats not only the sculptor, painter, and architect at work, but also, and more important, their involvement with twentieth-century industrial technology. Rivera had clearly become enthralled with North American industrial developments during his time in California and urged the esthetic appreciation of these elements: "Become aware of the splendid beauty of your factories, admit the charm of your native houses, the lustre of your metals, the clarity of your glass. . . ."[54] In spite of Rivera's enthusiasm, he lacked at this time the familiarity and knowledge—to say nothing of sufficient time to prepare himself adequately for painting this mural—necessary to comment meaningfully on the industrial imagery. Here Rivera painted a hodgepodge of his observations of industry— the exhaust fans, the construction laborers, and the machinery operated by the worker—a series of industrial images that fail to achieve any overall associative meaning. However, Rivera's involvement in the industrial milieu and the possibilities this held for his art, prefigure his immersion in the mass production environment of Detroit and his brilliant use of the theme of twentieth-century technology in the murals at the Detroit Institute of Arts in 1932–33.

Formal dedication ceremonies, organized by the board of directors of the San Francisco Art Association, took place before a select gathering of members of the San Francisco cultural and artistic community on August 11, 1933. The local press devoted prominent space to the event—one account spoke of "the continuous murmur of enthusiastic praises for the fresco' "—and Gerstle declared his satisfaction with the work: "The fresco is a beautiful work and a credit to the genius of Diego Rivera."[55] As a sign of the dramatic change in art styles and appreciation that occurred in this country during and after World War II, Rivera's mural was concealed behind a false wall sometime around 1947 and was not uncovered, cleaned, and rededicated until the spring of 1957.[56] At some later date, the building of a storage room into the lower register covered the *trompe l'oeil* scaffolding, and one views the mural today in this partially obscured condition.

Rivera arrived in New York in mid-November 1931 to work on fresco panels to be included in his forthcoming one-man Museum of Modern Art exhibition, after having painted the large central wall of Mexico's National Palace from June through October. Rivera's immense popularity in the United States at this time can be demonstrated by the fact that the exhibition, a high-powered "media event," broke all museum attendance records in drawing 56,575 spectators, some 20,000 more than had viewed the museum's only other one-man show— Matisse's, held the same year.[57] Moreover, in addition to great critical and popular acclaim, Rivera enjoyed the patronage of the Rockefellers, the primary power behind the Modern. Abby Aldrich Rockefeller had purchased in September 1931 the artist's series of forty-five watercolors done in Moscow on May 1, 1927, for the sum of $2,500—the highest sum Rivera had received for nonmural works.[58] The exhibition, held in the museum's quarters on the tenth floor of the Heckscher Building (730 Fifth Avenue) from December 2, 1931 until January 27, 1932, comprised fifty-six easel works, eighty-nine watercolors, drawings, and mural studies, and eight fresco panels especially executed for the exhibition. Rivera's current fashionableness and critical repute derived from his previous work in Mexico and had preceded him to the exhibition. As one critic commented: "The exhibition was inevitable, since Rivera is the most talked-about artist on this side of the Atlantic. . . ."[59]

The Modern exhibition, organized by Rockefeller staffer Frances Flynn Paine, reflected the contemporary North American interest in Mexico and particularly in twentieth-century Mexican art, exemplified in the critical and public eye by Rivera. Rivera's exhibition, according to the *New York Times* "the outstanding event of the week," opened with great fanfare, as interest focused on what one critic called "the exact quality of the famous frescoes." During several weeks after his arrival in New York, Rivera executed eight "portable" fresco panels (each six by eight feet and weighing over 1,000 pounds), five dealing with Mexican imagery and three reflecting his observations of contemporary New York City life. He worked with three assistants (Clifford Wight, Ramon Alva, and Lucienne Bloch), regularly putting in fifteen-hour working days in an unheated room (with heat the plaster would have dried too quickly) on the sixth floor of the Heckscher Building.[60] Rivera worked from memory, from small sketches, and from, at times, full-scale cartoons, on plaster coats applied to an armature of steel netting on a securely supported steel framework.[61] The five Mexican panels, finished by the opening date of the exhibition, were derived from his best-known Mexican murals at the Secretary of Public Education and the Palace of Cortés. The scenes, carefully chosen to depict not only various aspects of Mexican history but also Rivera's political commentary on these events, included *The Conquest* (Cuernavaca; Spaniards battling indigenous forces), *Sugar Cane* (Cuernavaca; Spanish colonial exploitation), *The Agrarian Leader Zapata* (Cuernavaca; the twentieth-century revolution), *Liberation of the Peon* (Education Ministry; the liberating aspect of the revolution for the peasant class), and *Uprising* (Education Ministry; the necessary struggle against oppression). Later, during the first week in January, Rivera added three paintings with specific New York City content to the exhibition, which further investigated the theme of twentieth-century industry.[62] Two, *Pneumatic Drillers* and *Power*, depict in Rivera's words "the rhythm of American workers"— activities that he saw as directly related to his conception of the artist's role and to the physical labor of fresco painting:

For me the artist is a worker, and unless he expresses his work as a worker, he is not an artist. I must remain with the people; I must live with them,

123

117

otherwise with me there is no expression. By work-
er I mean anyone who contributes physically or men-
tally, I do not discriminate. Perhaps, though, I do
mean especially the man who creates with his
hands.[63]

Power, based on Rivera's observations during a
sketching trip to a General Electric power plant,
depicts his pictorial synthesis of repair work there.
To the left an electric welder works beside a dyna-
mo, in the center two men work inside a steel
boiler, and to the right a man mends cables. In
Drillers, the most visually successful of the New
York panels, Rivera captures in the foreground
the sensation of two men, one of them as corpu-
lent as Rivera and writhing in intense activity,
drilling into Manhattan's bedrock, rock chips and
dust flying, while in the background other exca-
vation work is going on at the Rockefeller Cen-
ter construction site. In the remaining panel,
Frozen Assets, Rivera made his most direct politi-

117. Rivera in front of *Liberation of the Peon*, 1931.
(*Photo by Peter Juley, courtesy of National
Museum of American Art.*)

118. *Power*, 1931. Fresco, 4.7 x 7.8 ft. (*Photo by
Peter Juley, courtesy of National Museum of
American Art.*)

119. *Drillers*, 1931. Fresco, 7.8 x 6.2 ft. (*Photo
by Peter Juley, courtesy of National Museum of
American Art.*)

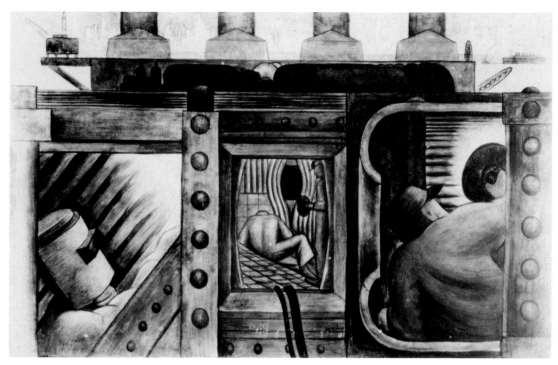

118

119

cal commentary thus far in his art created in the United States. As he later said,

> The most ambitious of these frescoes represented various strata of life in New York during the Great Depression. At the top loomed skyscrapers like mausoleums into the cold night. Underneath them people were going home, miserably crushed together in subway trains. In the center was a wharf used by homeless unemployed as their dormitory, with a muscular cop standing guard. In the lower part of the panel, I showed another side of this society: a steel-grilled safety deposit vault in which a lady was depositing her jewels while other persons waited their turn to enter the sanctum.[64]

Rivera claimed the work as the "most ambitious" of the New York paintings. It was based on first-hand observation of municipal sleeping quarters, banks, and subways, as well as sketches of the New York skyline. Yet the panel is the least suc-

120

121

120. Study, *Frozen Assets*, 1931. Charcoal on paper, 98¾ x 77¾ in. (*Courtesy of Sotheby's.*)

121. *Frozen Assets*, 1931. Fresco, 7.8 x 6.2 ft. (*Photo by Peter Juley, courtesy of National Museum of American Art.*)

cessful in compositional terms. Rivera arbitrarily tacked on three diverse scenes, separated by horizontal framing elements (the rush-hour subway patrons and the underground electrical conduits and water and sewage pipes), which have no visual relationship to each other.

In generally favorable reviews of the exhibition, critics made two major and valid points. First, they felt that only after the long years of art study and apprenticeship from 1897 to 1921, when Rivera worked under wide-ranging influences (as the exhibition made clear), and after his return to Mexico did it become possible for him to synthesize his diversified visual experiences into an individual, and particularly Mexican, expression. As one critic noted in this vein, speaking of the Mexican murals:

These frescoes represent the climax of a restless and ever-searching career. They are the work of a man who has found himself in technique and in

sympathy with his subject matter. They are profoundly Mexican, revealing a deep social life which they commemorate. In these frescoes soldiers attack, generals stand beside the beautiful white horses, peasants move at their labors, with the great rhythmic swing, above all with the superb color which characterizes all great fresco painting from the days of antiquity. It is a calm won at the expense of unending trial and rejection, however, and is by no means naive.[65]

Curiously, even in the most jingoistic of reviews, critics who felt that Rivera lacked substantial knowledge of New York so that his paintings of the locals seemed "unofficial and second hand," declared themselves "not outraged," or even bothered by Rivera's political commentary.[66]

One critic maintained that, however successful Rivera had been in achieving a hard-won triumph of technique, form, and content within a specific Mexican context, the exhibition frescoes failed to give an adequate sense of the nature of monumental fresco art, especially the important relationship of the mural to its architectural environment:

> Grateful as we are for the effort, we must admit that it is not the whole mountain which has been moved, but only isolated peaks. For the samples of frescoes, torn from their companions and from the original settings, which must mean so much to them, remain "samples" out of place and isolated in their present environment.[67]

Indeed, the New York City paintings appear as individual industrial scenes or "snapshots," lacking a larger iconographic program in which to function coherently.[68] Only with the Detroit Institute of Arts massive mural cycle, Rivera's masterwork of these years, was the artist able to develop an overall design that would present his observations and commentary on the phenomenon of twentieth-century North American industrial technology, exemplified primarily by Detroit's mass production automotive industry.

The Detroit Institute of Arts, 1932–33: The Contemporary Industrial Environment of Detroit

Helen Wills Moody inadvertently played a pivotal role in the commissioning of the Detroit murals, as she introduced the director of the Detroit Institute of Arts, William R. Valentiner, to Rivera during his trip to California in December 1930. As Valentiner later recalled:

> I soon discovered that Rivera's interest in economic and industrial development was at least as great as his interest in nature, if not greater. He wanted to hear all that I knew about industry in Detroit, and he explained that he had a great desire to see that city and study its extraordinary growth. Nothing would have pleased me more than to have Rivera represented in the Detroit museum, but I did not want to make promises until I was sure of finding work for him in Detroit. It seemed indeed a coincidence, though, that I should meet Rivera, for I had always hoped to have on my museum walls a

series of frescoes by a painter of our time—since where could one find a building nowadays that would last as long as a museum?[69]

Valentiner's enthusiasm for Rivera originated with an exhibition of his paintings and drawings held at the museum in early 1931. In a letter to Rivera, Valentiner spoke of the "great success" of the exhibition and the sale of several drawings; yet, prospects for Rivera painting murals in Detroit seemed unpromising: "I tried all I could to interest people here in town to make the proposition to you to come here some day to execute some frescoes, but so far I have found considerable difficulty."[70] However, Valentiner persevered with Edsel Ford and other members of the Arts Commission, and by the end of May the situation had changed dramatically. Valentiner expressed "delight" that after two meetings the Arts Commission offered Rivera the opportunity to paint murals at the museum. At this time Valentiner noted stipulations concerning Rivera's fee, the probable site of the paintings, and the theme of the murals. The Arts Commission could offer no more than $10,000, with the museum covering material and plastering costs, which Valentiner calculated as approximately $100 a square yard for some fifty square yards on the large central panels of the north and south walls of the "Garden Court." Valentiner indicated that the commission

> would be pleased if you could possibly find something out of the history of Detroit, or some motif suggesting the development of industry in this town; but at the end they decided ι ιeave it entirely to you, what you think best to do, although they would be pleased to see the sketches for the paintings and approve them before they are executed.[71]

Although exactly what occurred between April 2 and May 27 remains unclear, Edsel Ford undoubtedly assumed the key role in extending the offer to Rivera. In accepting the directorship of the museum in 1924, Valentiner shrewdly "put all my hopes on the second [i.e., the younger] generation, on Edsel Ford particularly." In fact, he believed the future of art in Detroit depended on Edsel Ford's role as collector, and in an important preliminary move in this direction, Ford was appointed to the Arts Commission in early 1925.[72] In his autobiographical *Remembering Artists*, Valentiner states that "Edsel Ford generously offered to pay ten thousand dollars for two large murals," and the Institute's Education Curator, E. P. Richardson, explicitly understood that the project came about because "Mr. Ford was going to pay for it, and Valentiner was very enthusiastic. They [the four-person Arts Commission] had to act officially to approve the decoration of the court, and the acceptance of the frescoes, but that was a formality."[73]

Rivera submitted two sketches using the automotive industry as subject to the Arts Commission for their May 23 meeting. Although they are preliminary drawings, they are meticulously rendered and represent two months of study and sketching on Rivera's part at the River Rouge and Dearborn plants. Identical in all compositional respects to the completed fresco, the north wall sketch differs only in the predella panels; here Rivera depicted mining in the first segment and "Raw Products Arriving at the Factory by Boat" in the remaining seven panels. The south wall sketch, on the other hand, would undergo substantial revision in the lower right-hand corner before Rivera designed the enlarged cartoon. Also, the predella panels show stages of steel production, necessary, of course, for the making of the automobile body, which Rivera subsequently moved to the north wall panels.[74]

In his enthusiasm for the project, Rivera created a new and enlarged decorative scheme, in which he would paint all the walls of the Garden Court. As Valentiner recalled:

> A few days before the end of May, he suddenly asked me what I would think of his enlarging his

project by covering not only the two large walls in the court but also the smaller walls. . . . Rivera's idea was to use these additional spaces to represent the elements out of which the automobile and other Detroit industries grew. The space covered would thus amount to twice as much originally planned. Rivera would need another five thousand dollars.[75]

122. Sketch for north wall panel, 1932. Charcoal on paper, dimensions unknown, whereabouts unknown. (*Henry Ford Museum and Greenfield Village, Dearborn, Michigan.*)

Valentiner successfully persuaded Edsel Ford to increase the commission before Valentiner left for Europe at the end of May, and the final contract signed on June 10 came to $20,899.[76]

Rivera would paint in the deepest throes of the depression, in a city particularly devastated by it. In Detroit people faced, as E. P. Richardson noted in a personal recollection of the times, "a disaster such as no one could have conceived." "Detroit was just one big factory, and it was by no means easy to like, especially as it began falling apart. It was a terrible human situation we

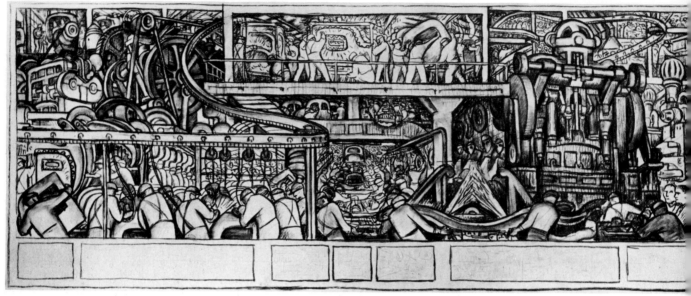

123

were living in while the fresco was going forward—the whole world was collapsing around us."[77]

At the Detroit Institute of Arts, the staff barely scraped by on a budget in 1933 of some $40,000, down from $400,000 in 1928, and Valentiner was forced to take an unpaid leave of absence of several months.[78] Yet, Rivera did not concern himself with depression Detroit in his mural program. He focused instead on the spectacle of the ultramodern and technically sophisticated River Rouge complex and the effect this working environment had on the worker. Construction began on the Rouge factories, a pioneering North American industrial accomplishment, in 1918–19 on some 2,000 acres of remote farmland. From the first, Henry Ford envisioned his creation of a superplant, which grew during the 1920s at the expense of Ford's Highland operation, and its construction signaled a new era of large-scale and intensive industrialization. At its maturity in the mid-1920s the Rouge boasted 93

separate structures (23 "main buildings"), 95 miles of railroad track and 27 of conveyor belts, and 75,000 employees, including a cleaning work force of 5,000 in continual activity. It was "an industrial city, immense, concentrated, packed with power."[79] Henry Ford described the basic operational concept of the Rouge plants as "vertical integration"—an interrelated system of company-owned mines and forests (the raw materials), factories, foundries, and steel-mills (production), and railroad and shipping fleets (transportation). In the emphasis on the control and transportation of materials, the Rouge plants lay at the center of a circle of interconnecting rail and water routes. Ford's system also emphasized large-scale operation and a carefully planned interrelationship of production units. As the saying went, "the work moves and the men stand still."

The latest in technological advances—for example, forty-three machine-tool operations were involved in the manufacture of the cylinder block—

124

123. Small sketch for south wall automotive panel, 1932. Charcoal on paper, dimensions unknown, whereabouts unknown. (*Courtesy of Henry Ford Museum and Greenfield Village, Dearborn, Michigan.*)

124. Rouge Plant, 1931. (*Courtesy of Henry Ford Museum and Greenfield Village, Dearborn, Michigan.*)

125. Interior of Power House No. 1, Rouge Plant, 1931. (*Courtesy of Henry Ford Museum and Greenfield Village, Dearborn, Michigan.*)

125

126

126. Stamping Presses, Pressed Steel Building, Rouge Plant. (*Courtesy of Albert Kahn Associates, Architects and Engineers, Detroit.*)

127. Beginning of Final Assembly of Ford V-8, "B" Building, Rouge Plant, 1932. (*Courtesy of Detroit Institute of Arts. Founders Society Purchase, Edsel B. Ford Fund and Gift of Edsel B. Ford.*)

represented another central factor in creating the integrated automotive assembly envisioned by Ford. The result of this intensely efficient operation was that the iron ore arriving one morning by boat would emerge as a finished motor on the conveyor assembly line some thirty-three hours later. Rivera sketched at the Rouge during what historian Allan Nevins characterizes as the years of maximum effective size, 1929–36, and incorporated into his murals not only an accurate picture of the technology of the Rouge, but also a brilliant condensation of the general flow of manufacture and transportation that governed the entire factory.

What were general working conditions at this time? Henry Ford's paternalistic attitudes gave Ford employees undoubtedly more favorable working conditions than other automobile workers. Ford's desire to take "drudgery off flesh and blood and lay it on steel and motors" led to efficiently designed worker operations. Heavy loads were handled by machines, not men, and each worker task involved the minimum of physical movement. Ford strongly emphasized safety, cleanliness, and expert care of machinery, and he also offered an English language school, a plant hospital, the Henry Ford Trade School for underprivileged boys, and a social welfare plant department. Moreover, Ford exercised enlightened policies toward employment of the physically and mentally handicapped and in racial relations and, in contrast to most industrialists, favored the five-day week, which he instituted in 1922.[80]

Other factors, unfortunately, offset the superb physical plant and Ford's treatment of his employees and created an overall atmosphere of sullen depression, reflected in the grimly resigned faces of Rivera's workers. Rivera recognized what he called "the struggle of the worker," fighting for his dignity, even existence, against enslavement by the machines and brutal labor conditions— even before the depression.[81] Rivera quickly became aware of the harsh physical restrictions imposed on the men during his many sketching tours at the Rouge and Highland Park plants.

Ford demanded complete silence from his employees, and he allowed no sitting down at any time. Strict time limits were imposed—fifteen minutes for lunch, for example—and company "spotters" guarded against those workers designated by the company as "time-stealers." Violations meant immediate firing. During the 1920s and 1930s the workers endured a lack of job tenure and seniority rights and were completely at the mercy of foremen. During the depression foremen engaged in rampant favoritism, with bribery common in hiring. A factory espionage system existed to obtain information on worker attitudes toward management, union activities, and Communism. Factory spying and worker treatment worsened considerably with the rise to power in the late 1920s of Harry Bennett and his "Service Department." In fact, Nevins maintains that Bennett's emergence "introduced an element of arbitrary brutality previously unknown."[82] These factors, along with the ever increasing work speed-ups, combined to keep the plant functioning at peak level, but the limited space and carefully gauged work assignments inevitably produced tension among the tens of thousands of Ford employees. Rivera captures this tension, the strain of performing repetitive tasks at maximum speed—relentless, even hateful labor—on the sullenly determined faces of the workers in his panels.

These conditions represented the predepression situation at the Ford factories. In the early 1930s matters became much worse. The deteriorating economy, the challenges of competitors, and a disastrous new Ford dealer policy that created more dealerships with lower individual profit ratios, resulted in Ford shutting down production of the four-cylinder Model A in August 1931. The economy continued to spiral downward in 1932, the worst depression year for the automobile industry, as production lagged to 20 percent of 1929. Unemployment in Michigan increased 50 percent, from 500,000 to 750,000 in the first eight months of 1932. By 1933 the Ford payroll had shrunk to $32.5 million (down from

127

$181.5 million in 1929), and the company lost $125 million during 1931–33. In the midst of this dreadful economic picture, Ford decided to go ahead with the revolutionary V-8 design, and on March 31, 1932—three weeks before Rivera arrived in Detroit to paint the production of the new Ford V-8—the new automobile went on nationwide display. Conditions at Ford, aggravated by the depression, led to worker protests, such as the March 7, 1932, Communist-led unemployment march of some 3,000 on the Ford Dearborn plant. This demonstration, brutally repressed by the Dearborn police, left four workers dead, while the wounded were arrested and chained to their hospital beds. Later that year unemployed Ford workers reacted to the Ford Company letter they received in fall 1932 urging them to vote for Hoover by voting primarily for Roosevelt and Foster, the Democrat and Communist party candidates. After Roosevelt's election, Henry Ford staunchly defied the NRA worker right-to-or-

128

128. Sinopia on brown coat of north wall automotive panel, 1932. (*Courtesy of the Detroit Institute of Arts. Founders Society Purchase, Edsel B. Ford Fund and Gift of Edsel B. Ford.*)

129. South wall with unfinished automotive panel, 1933. (*Courtesy of the Detroit Institute of Arts. Founders Society Purchase, Edsel B. Ford Fund and Gift of Edsel B. Ford.*)

See also Plates 10–11.

ganize stipulation, and the company fired any worker suspected of belonging to a union.[83]

The fundamental point here is that Rivera, who sketched for a period of months in the Ford plants and presented himself as an avowed Communist (although he was expelled from the Mexican Communist Party), did *not* depict contemporary Detroit in his fresco program, *Detroit Industry*. Rather, he painted a more generalized and permanent picture of twentieth-century industrial technology and its relationship to man within the framework of Detroit and, more particularly, the industrial microcosm of the Ford Company River Rouge plant.

As originally conceived, Rivera intended two paintings for the large central panels of the north and south walls. The production of a contemporary automobile, the 1932 Ford V-8, begins in the north wall, where Rivera presents the significant operations involved in the manufacture and assembly of the motor and transmission housing—

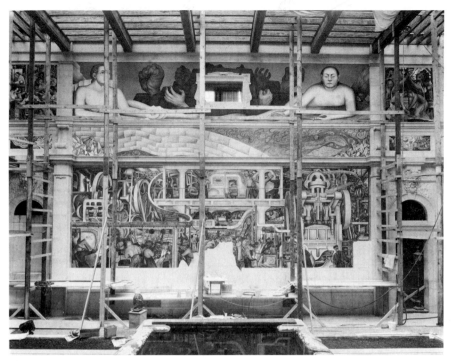

129

the fundamental interior elements of the automobile. In the upper register, center, the artist shows the blast furnace operations, or the reduction of iron ore, coke, and limestone by heat to make iron. Below sits the open hearth furnace, a further reduction process of molten iron and steel scraps to produce steel. Rivera devoted most of this panel, however, to foundry operations, which run sequentially:

a) The upper half, left to right: various operations in the production of, first, the mold for the engine block and, then, the pouring of the steel for the block itself.

b) The lower half, left to center: the actions of deburring, spindling, and honing.

c) Right, lower section: the foundry and drilling work necessary for the production of the transmission housing.

d) Center, between Rivera's oversized multiple spindles: the motor-assembly production line.

e) Lower register, original designs for the monochrome predella panels: (1) "Mining," (2) "Raw Products Arriving at the Factory by Boat." The south wall panel describes the basic series of operations involved in body production—the exterior element of automobile manufacture—though in this case not in actual factory sequence.[84] The production of body parts begins at the right, where gigantic presses stamp out fenders; several stamping presses also appear in the upper left section. At the lower left, a conveyor belt brings body parts to the next process, the bumping and grinding of these elements, supervised by a foreman. In the upper left corner, painters work next to baking ovens, while in the upper central section the welding buck attaches the various body parts. Below the welding buck, the motor is lowered to the final assembly line, the site of the motor, body, and chassis assembly. The finished automobiles, driven off far in the background, appear only as miniscule objects.[85]

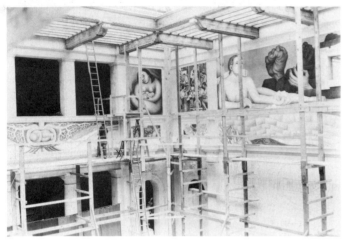

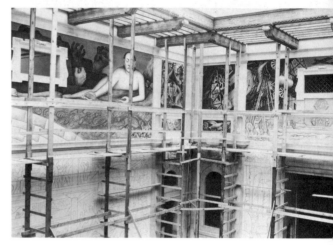

130 131

As Rivera continued to sketch in various Detroit factories, he evolved the final conceptual scheme for the murals, entailing twenty-five more (though considerably smaller) interrelated panels, which would more fully develop Rivera's "portrait" of contemporary automotive manufacture into an integrated interpretive study of Detroit industries and, ultimately, what Rivera saw as the relationship between men and machines. Underlying his complex iconographic program was an overall wave-like movement through the panels, unifying the paintings and representing, in Rivera's words, "the continuous development of life." Thematically, Rivera painted an involved system of corresponding dualities that he saw as inherent in nature, man, and technology. In their serpentine flow and interconnection, Rivera's murals paralleled actual operations at the Rouge plant, as did his use of the same raw materials—limestone and sand for plaster, and minerals for pig-

ments. Further, each assistant had a specific task, as was true on the assembly line.[86]

The walls of the museum's Garden Court (the glass-roofed hall measures sixty-seven feet long, forty-nine feet wide, and thirty-eight feet high), designed in the Roman Baroque manner by the French architect Paul Crêt, posed a difficult decorative problem for Rivera, since Crêt's plan subdivided the walls into twenty-seven panels of widely varying sizes, from 12 to 781 square feet and situated anywhere from 4 to 30 feet off the floor.[87] On a far larger scale than the San Francisco mural, the assistants had constructed special false walls to eliminate the possibility of damage by water seepage. Although Rivera's painting schedule varied according to temperature and humidity (he had anywhere from eight to sixteen hours before the plaster set), he generally began late at night: "He underpainted in black and white and towards dawn he would begin

132

133

mixing color and as the light grew brighter he would add the color over the underpainting."[88]

In spite of Rivera's technical mastery of the medium, he encountered setbacks and became depressed over aspects of the painting process, as this entry from assistant Lucienne Bloch Dimitroff's diaries reveals:

August 19: This morning Art [Niendorf] came to give the news to Diego, who had worked 23 hours on the airplane panel and had been very happy with the results, that the whole drawing couldn't be used because Jack [Hastings] had made a mistake with the dimensions. For the first time I saw Diego really desperate. He said, "What's the use of continuing this work?" But then he got underway better than ever. Now he is working on the front panel making large planes.[89]

These diary entries mention tasks of the assistants (seven altogether for this project), such as

130. Southeast corner with scaffolding, 1932–33. (*Courtesy of the Detroit Institute of Arts. Founders Society Purchase, Edsel B. Ford Fund and Gift of Edsel B. Ford.*)

131. Southwest corner with scaffolding, 1932–33. (*Courtesy of the Detroit Institute of Arts. Founders Society Purchase, Edsel B. Ford Fund and Gift of Edsel B. Ford.*)

132. Garden Court, view from east entrance, c. 1927. (*Courtesy of the Detroit Institute of Arts. Founders Society Purchase, Edsel B. Ford Fund and Gift of Edsel B. Ford.*)

133. Garden Court, view from west entrance, c. 1927. (*Courtesy of the Detroit Institute of Arts. Founders Society Purchase, Edsel B. Ford Fund and Gift of Edsel B. Ford.*)

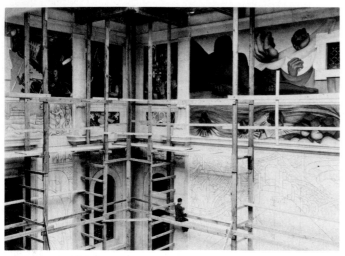

134

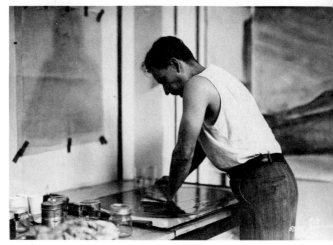

135

plastering and enlarging Rivera's preliminary drawings to be transferred to the walls. Clifford Wight acted as chief assistant, as he had done in San Francisco, and in this capacity had responsibility for most of the plastering, as well as drawing the sinopia (the red ocher outline) and pouncing the sketches, a method of transferring the sketch to the wall. Viscount Hastings seems to have worked primarily with enlarging sketches before he left the group in November 1932, at Rivera's urging, to accept a private mural commission in Chicago.[90] Lucienne Bloch Dimitroff became an assistant at the end of May 1932 when she arrived in Detroit on the way to teach sculpture at Frank Lloyd Wright's Taliesin workshop, and Hastings instructed her in enlarging Rivera's sketches of the large female nudes to the walls.

Stephen Pope Dimitroff came to Detroit in late November 1932, and apparently Frida Kahlo, in sympathy for his impoverished plight, convinced

Rivera to take him on. He ground pigments under Andrés Sanchez-Flores. Sanchez-Flores had been employed as a chemist at the Ford Company and personally approached Rivera for employment on the mural project. Ernst Halberstadt met Rivera in New York in the fall of 1932 and was hired after Rivera examined his portfolio. At Detroit, Halberstadt built scaffolding and under the instruction of Clifford Wight assumed responsibility for the physically arduous and lengthy process of preparing plaster. He usually worked from noontime to midnight for twelve dollars per week. Art Niendorf assisted with plastering. Halberstadt recalls a very hard-working group of artists:

All the assistants put in many long hours rushing the Detroit job so that he [Rivera] could get to New York. . . . Frequently I put in 18 hour days—and on more than one occasion put in two 18 hours days, one on top of another, for a total of 36 hours straight away. . . . [However] I found him intensely human,

138

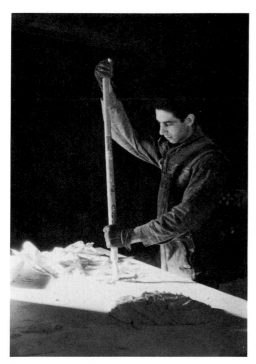

136

137

138

134. Clifford Wight, assistant to Rivera, reinforcing sinopia with paint, 1932. (*Courtesy of the Detroit Institute of Arts. Founders Society Purchase, Edsel B. Ford Fund and Gift of Edsel B. Ford.*)

135. Andrés Sanchez-Flores grinding pigments, 1932–33. (*Courtesy of the Detroit Institute of Arts. Founders Society Purchase, Edsel B. Ford Fund and Gift of Edsel B. Ford.*)

136. Ernst Halberstadt preparing plaster, 1932. (*Courtesy of the Detroit Institute of Arts. Founders Society Purchase, Edsel B. Ford Fund and Gift of Edsel B. Ford.*)

137. Frida Kahlo, wife of Rivera, and Andrés Sanchez-Flores, 1932–33. (*Courtesy of the Detroit Institute of Arts. Founders Society Purchase, Edsel B. Ford Fund and Gift of Edsel B. Ford.*)

138. Lord Hastings (?), Clifford Wight, Diego Rivera, Dr. William Valentiner, 1932. (*Courtesy of Henry Ford Museum and Greenfield Village, Dearborn, Michigan.*)

139

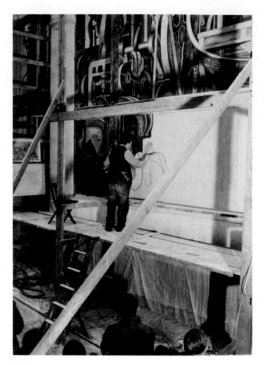

140

139. Rivera posing with dog in front of north wall, 1932. (*Courtesy of the Detroit Institute of Arts. Founders Society Purchase, Edsel B. Ford Fund and Gift of Edsel B. Ford.*)

140. Rivera painting south wall automotive panel in monochrome, 1933. (*Courtesy of the Detroit Institute of Arts. Founders Society Purchase, Edsel B. Ford Fund and Gift of Edsel B. Ford.*)

141. Rivera cartoons found in 1979. (*Courtesy of the Detroit Institute of Arts. Founders Society Purchase, Edsel B. Ford Fund and Gift of Edsel B. Ford.*)

very likable, and a very good man to work for. I admired the hard work he put in himself, and nobody would have worked as hard as we did if he hadn't set the example.[91]

In addition to their labors for Rivera, the assistants also posed for him, and the automotive panels include portraits of Dimitroff, Halberstadt, Niendorf, Wight, and Sanchez-Flores, as well as Ford Company employees Rivera sketched. Lucienne Bloch Dimitroff and Rivera's maid at the Wardell Hotel inspired the features of his figures for the white and black races: "The other two were invented. Diego did not like to invent people in his frescoes. He said one easily found a formula, so he preferred to have people pose for him."[92]

Besides the sketches of his assistants and others, Rivera made "literally thousands" of preliminary drawings for the Detroit murals during the period from April 20, his arrival in Deteroit, to

141

July 25, 1932, when he began to paint.[93] Sketching at the Rouge plant and elsewhere seems to have totally captivated Rivera. As Lucienne Bloch Dimitroff has recalled:

> I was there when he [Rivera] was still going to the factory [Rouge] almost every day to make sketches. Edsel Ford took him there and gave him absolute freedom to wander all over. To him, those were the happiest days of his life, he told Edsel Ford later, because he had always loved machinery from the time he was five years old. . . . To be there and see the creation of automobiles was something so wonderful to him, he really felt it and he let it absorb him, so that it became a part of him.[94]

Edsel Ford put a Ford Company photographer, W. J. Stettler, at Rivera's service; he took study photos at the Rouge plants and later documented the painting of the mural in both still and cinematic film. Rivera's sources also included other Detroit plants and the Detroit Public Library. Lucienne Bloch Dimitroff writes that his "little library" at the Hotel Wardell had specialized scientific magazines.[95] When the sketches, photographs, reference study, and preliminary designs were completed and approved by the Detroit Arts Commission, Rivera turned to executing cartoons, or large drawings the exact size of the wall to be painted. In determining how the image appeared in relationship to the architectural environment, a matter of critical importance to Rivera, he first affixed the finished drawings (in charcoal with some red and brown pastel) to the wall.[96] If he considered the result satisfactory, assistants then traced the design and transferred this to the wall where Rivera would paint. The cartoons were transferred to the wall by tracing the outlines on transparent paper, perforating them and dusting the perforations with red ocher to create a dotted outline of the general design on the wall (pouncing). Rivera then could begin to paint.

142

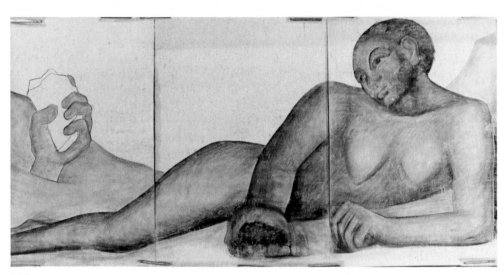

143

142. Study for north wall, white race. (*Courtesy of the Detroit Institute of Arts. Founders Society Purchase, Edsel B. Ford Fund and Gift of Edsel B. Ford.*)

143. Study for north wall, black race. (*Courtesy of the Detroit Institute of Arts. Founders Society Purchase, Edsel B. Ford Fund and Gift of Edsel B. Ford.*)

From her examination of the panels and the records of the Valentiner-Rivera-Wight correspondence, Linda Downs has compiled a chronology of pertinent dates concerning the painting of the murals:

- April 20, 1932 Diego Rivera and Frida Kahlo arrive in Detroit

- May 1932 Rivera tours the Rouge plant

- May 21, 1932 Contract for erecting scaffolding (to cover all four walls) signed

- May 23, 1932 Arts Commission approves sketches for the two automotive panels

- End of May 1932 Rivera requests to paint all twenty-seven panels of the Garden Court

- June 10, 1932 Contract between Detroit Institute of Arts Founding Society and Rivera signed for fresco project

- July 25, 1932 Rivera begins painting allegorical nudes of south wall upper register

- August 1932 East wall *Woman with Fruit* signed and dated

- September 20, 1932 South wall *Pharmaceuticals* panel signed and dated

- November 29, 1932 North wall *Embryo* panel signed and dated

- January 1, 1933 North wall *Automotive* panel signed and dated

- February 1933 West wall *Steam* panel signed and dated

- March 13, 1933 South wall *Automotive* panel signed and dated on paper held by Valentiner.[97]

Two basic factors determined the composition of the mural program. The first was Rivera's all-over serpentine pattern that linked together the upper registers of the four walls and the conveyor-belt system of the automotive paintings:

As [the] basic plan for the mural decoration of the garden court of The Detroit Institute of Arts I chose the plastic expression of the undulating movement which one finds in water currents, electric waves, stratifications of the different layers of the earth and, in a general way, throughout the continuous development of life.[98]

The second basic organizing factor was the Golden Section.

In its fully developed conception, Rivera's mural program began on the east wall, yet, as commonly occurred in the Detroit cycle, Rivera introduced wide-ranging modifications into his original designs. Here Rivera first intended a strictly agricultural theme, as evidenced by his preliminary sketch of a family harvesting fruit flanked by men on tractors. A later sketch focused specifically on the Michigan sugar beet industry. While the final version retains agriculture, the first industrial operation of man, Rivera deepened the symbolism with the inclusion of a child, so that the program now began with the origins of human life itself:

This germ—a child, not an embryo—is enveloped within the bulb of a plant which sends its roots down into fertile soil deposited in the hollow bed of an ancient lake, above strata of sand, layers of water and salt, and deposits of iron, coal and limestone—which constitute the actual geological composition of the soil of Michigan and the primordial reason for the existence of the city of Detroit.[99]

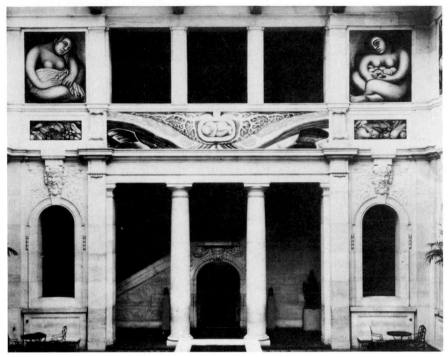

144

144. *Detroit Industry*, east wall, 1932. Fresco. *(Courtesy of the Detroit Institute of Arts. Founders Society Purchase, Edsel B. Ford Fund and Gift of Edsel B. Ford.)*

145. (Overleaf) Cartoon of woman holding fruit, 1932. Charcoal on paper, 101½ x 84 in., whereabouts unknown. *(Courtesy of the Detroit Institute of Arts. Founders Society Purchase, Edsel B. Ford Fund and Gift of Edsel B. Ford.)*

146. (Overleaf) Two cartoons for the east wall showing the germ/child motif and the sugar beet industry, 1932. Charcoal on paper, 74.8 x 311 in. *(Courtesy of the Detroit Institute of Arts. Founders Society Purchase, Edsel B. Ford Fund and Gift of Edsel B. Ford.)*

Of Rivera's symbolism here regarding human and plant life, Professor Dorothy McMeekin has observed:

> The embryo linked by veins to its host is functionally parallel to the roots of a plant and the soil. Thus the final composition is an elegant analogy that is more than the sum of its parts: it dramatically represents the universal idea of the interdependence of all living and non-living things.[100]

The image of a child may have derived from the agonizing miscarriage suffered by Frida Kahlo in early July. As a child she had been severely damaged in a trolley-car accident in Mexico City, "suffering a fractured spinal column, pelvis, and leg, and an iron rod pierced her body in the intestinal area. Doctors advised her not to conceive, but Kahlo—desperately wanting to bear Rivera's child—became pregnant in Detroit, and endured the first of four painful miscarriages." Thus, Rive-

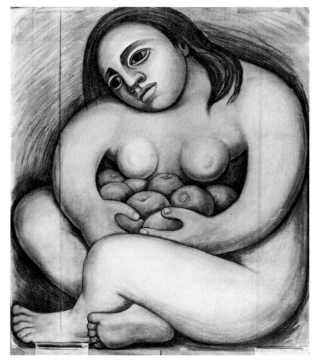

145

146

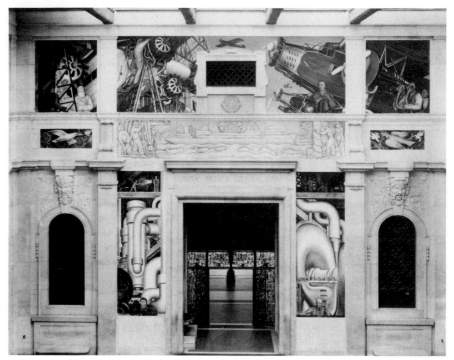

147

147. *Detroit Industry*, 1932–33. Fresco.
(*Courtesy of the Detroit Institute of Arts. Founders Society Purchase, Edsel B. Ford Fund and Gift of Edsel B. Ford.*)

ra painted the form of Frida Kahlo's lost child in the panel initiating the series, and charged it with profound symbolic import.[101] On either side of this central image are two female allegorical figures holding fruit and grain, images repeated below. Here, then, Rivera stated the two major themes of the mural cycle: first, the relationship of man to nature, symbolized by the "germ-child" as the culmination of the lengthy geological-organic process of nature, and second, technology, or the transformation of the raw materials of nature into products of use to man. All the other walls ultimately derive from this small but complex scene. In these paintings Rivera presented in dichotomous images the possibilities for man's positive and negative uses of technology.

On the west wall, directly opposite the symbolic "germ-child," Rivera depicted a specific and factual view of Detroit's water transport indus-

try. He considered the area's system of navigable rivers and lakes the geographical reason for the founding of Detroit. Transportation by water, as Rivera explained, "facilitated commerce between the industrial city and the far distant lands which produce the raw materials and consume the finished products." Above this panel the artist addressed the topic of aviation; on the left, welders and mechanics construct an airplane, demonstrating man's positive mechanical capability. However, Rivera shows the plane's actual use as negative, as pilots prepare for a military mission in the right-hand panel. The middle register contains the only panel of the series besides the smaller predella paintings to be painted in grisaille, as here Rivera attempted to create a sense of harmony between his paintings and the monochromatic Roman Baroque style sculpture of the court.[102] Here he juxtaposed the industrial port of Detroit with Brazilian rubber plantations, Ford Company's source of raw material. Rivera chose not to portray the Marxist position of imperialist exploitation of the nonindustrialized world, but instead spoke for mutual interdependence between the producing capitalist countries and Latin American and Asian suppliers of raw materials. Rivera took the port image to the left from the actual Rouge factory boat slip; at the far left stand a pipefitter and a man working a chain pulley, while to the right of these figures Rivera presents a composite view of major buildings from the Rouge and downtown Detroit plants. In the center, the long, slender forms of two merchant vessels echo the horizontal architectural moulding of the entranceway; below, Rivera contrasts the primary industrial use of the river with smaller recreational craft.

At the very center of the panel, in the exact location of the "germ-child" of the east wall, Rivera painted the heraldic device of a star, to the left, half a human head, and to the right, half a human skull. Photos of the work-in-progress reveal that Rivera did not conceive of this interrelated visual scheme until very late, in fact, after the sinopia had already been applied. These alterations strengthened the underlying dualities Rivera saw in nature and man's use of technology. Using the star (whether alluding to the traditional Christian symbol of divine guidance or the Communist Red Star), flanked by symbols of life and death, Rivera pictures what he viewed as the next stage in the evolution of man's production skills. For Rivera, the skull had rich associative meaning in a strictly Mexican context. It is the central image in Mexico's celebration of Day of the Dead. Moreover, José Guadalupe Posada, whom Rivera considered his artistic "father," used the skull frequently in his political graphic art of the late nineteenth and early twentieth centuries. Rivera possibly intended the skull to represent capitalism, and the half-face as the "new man" of socialist society.

From the picture of agrarian capability on the east wall, man has progressed to machine technology; in the upper register Rivera depicts the manufacture of modern means of transportation, the airplane and steamship, and below, the production of immense quantities of steam and electric power required by twentieth-century industrial complexes exemplified by the Rouge plants. As man's manufacturing technology has increased, he now faces a choice in his use of it—for good or evil. Directly above the star, Rivera painted a negative symbol, a compass that points to death and devastation in this register— the skull and military warfare. The compass points north, or in traditional Mexican geographical symbolism, to the "country of the dead."

In contrast to Orozco at Dartmouth, who saw twentieth-century machine technology as an impersonal, all-powerful agent of destruction, Rivera agreed with writers such as John Dewey and Lewis Mumford that technology could be used for the benefit of mankind, provided that man asserted control over his creation. As Mumford wrote:

Our capacity to go beyond the machine rests on our power to assimilate the machine. Until we have absorbed the lessons of objectivity, impersonality, neutrality, the lessons of the mechanical realm, we cannot go further in our development toward the more richly organic, the more profoundly human.[103]

Yet at Detroit Rivera would not address himself to what Dewey and Mumford believed to be the major obstacle our civilization faced vis-à-vis industrialization—the fact that a "money culture" now controlled North American technology. Mumford called for a "wholesale devaluation of the bourgeois civilization upon which our present system of production is based," and urged a "socialized political control of the entire process [of industrial production]."[104] If Rivera did equate the destructive use of machinery with capitalism in his *Detroit Industry* panels, not until his next mural project, at Rockefeller Center, would he propose that capitalism is the fundamental obstacle facing twentieth-century man and posit socialism as the only rational answer to the problems confronting our civilization.

The lower two west wall panels illustrate Rivera's conception of two different kinds of mechanical and human power. To Rivera's image of the production of steam power and (below) a generalized "worker-type" on the left, he counterposed on the right of the entranceway the production of electrical power and a similar collective type, the "manager-engineer," here a composite Henry Ford/Thomas Edison portrait.[105] In these paintings Rivera introduces the theme of automotive industry with his stylized representation of the Rouge power center, "Power House No. 1." Rivera's visual interpretation begins in the small upper left section where coal produces steam in boilers and is transported by large pipes to the dominant image of the right panel, the turbine generator. The generator produces electricity, which is relayed to the multifactory Rouge complex by the control center at the upper right. Here Rivera again reworked his composition, to achieve a cleaner, more simple design in which

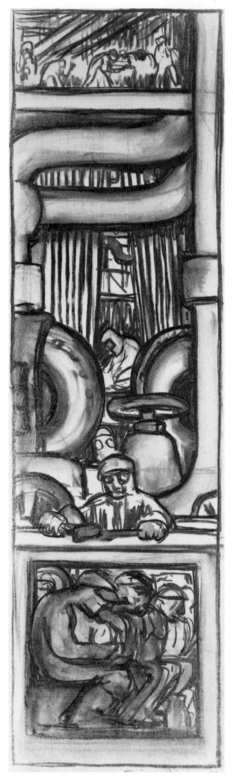

148

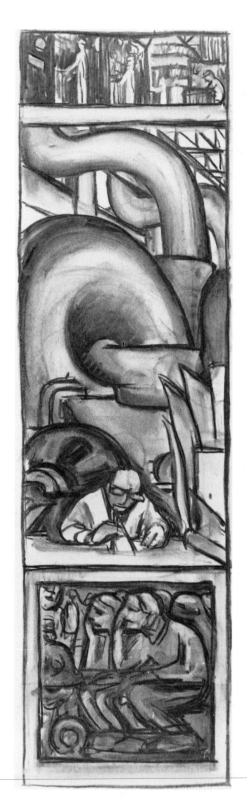

148. *Steam Produced by Coal*, sketch for west wall automotive panel, 1932. Charcoal on paper, 20¼ x 5¾ in. (*Courtesy of Courtauld Institute of Art, London.*)

149. *Steam Turbine Generating Electricity*, sketch for west wall automotive panel, 1932. Charcoal on paper, 20⅜ x 5¾ in. (*Courtesy of Courtauld Institute of Art, London.*)

149

the machine shapes assume male and female sexual shapes, thus completing the west wall paintings with an explicitly organic visual duality.

With the inclusion of twelve supplementary panels on the north and south walls, Rivera was able to address other themes in his mural program, such as the origins of raw material—the ultimate source of Detroit's mass production industries—and other subsidiary industries of the city. These additional panels continued Rivera's commentary on the duality involving nature, man, and technology that he established on the east and west walls. In this sense Rivera not only contrasted the symbolic female figures—the dark nudes of the north wall representing materials deep beneath the soil (coal, oil) against the lighter figures standing for the more surface minerals (limestone, sand)—but he also paralleled the basic internal (motor block assembly) and external (body manufacture) operations pictured on the respective walls. Rivera underscored a key thematic relationship between raw materials and modern technology in the image of the volcano and its industrial counterpart, the blast furnace, in which "the earth culminates in a volcanic cone, below which, in the large panel, is the blast furnace, an industrial equivalent of the volcano, which amalgamates the raw materials that enter into the composition of steel.[106] Rivera painted the corresponding figures on the south wall, as he said, "in contrasting colors, Limestone and Sand; and in like manner protruding hands which symbolize the hard metal and strength of the workers, the direct human expression of terrestrial energy."[107] He supplied overall compositional unity in the middle registers by various geological strata, whose general forms are echoed in the waves of the east wall water transportation section. Throughout, the long, narrow architectural bands dictated a basic horizontal design emphasis.

In the eight small panels of the north and south walls Rivera painted industries and other themes outside the realm of the automobile industry, displaying a sophisticated awareness of contemporary scientific developments that he fused with religious symbolism and, in one instance, sexual satire.[108] Here he portrayed his thoughts on the possibilities of the positive and negative uses of science in interrelated imagery. For example, he created a thematic connection between the west and north walls by linking the military aspect of the west wall to wartime production of poisonous gases, the horrible weapon that had been used in World War I (and was as greatly feared in its time as nuclear arms are today). Workers in protective uniforms and masks, measure out the lethal ingredients for aerial bombs, in their seemingly lifelessness, eerily anticipate the effect of their labor. Below, poisonous gases destroy healthy cells already in various stages of degeneration, and the static, though potentially dangerous, mineral coal, which produces sulfur dioxide (SO_2) when burned and sulfuric acid when combined with water, appears at the center bottom of the panel. Yet Rivera also depicted the beneficial potential of modern chemistry in a vaccination scene on the opposite north wall. In this panel he updated a traditional nativity scene with contemporary elements; in the background doctors of different religious creeds vivisect an animal to obtain life-saving serum. The symbolic mammals in the foreground are also those used to obtain antisera. In the center W. R. Valentiner, in the guise of a doctor and assisted by a nurse, innoculates an infant. Rivera included more contemporary references here; he modeled the nurse after the stereotypical Hollywood blond movie star and the infant after the kidnapped Lindbergh child.[109] Below, Rivera painted a healthy human embryo (top center) and underneath an egg, red blood cells, and the crystals of hallite (cubes) and calcite (triangular shapes). To the right and left of center in the light areas are microscopic images of sperm, bacteria, and chromosomes. In the dark area below Rivera included cells seen by means of dark phase (left) and bright field (right) microscopes. In their salutary picture of twentieth-century science, these two panels relate to the animating aspect of agriculture on the adjacent east wall.

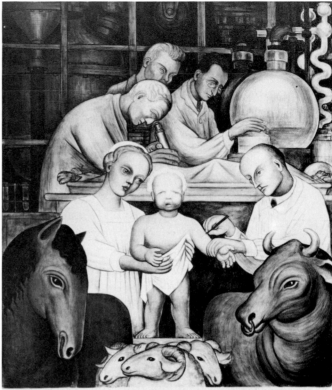

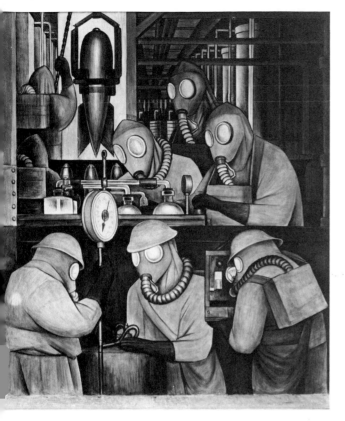

150

151

150. *Manufacture of Poison Gas* and *Cells Suffocated by Poison Gas*, north wall. (*Courtesy of the Detroit Institute of Art. Founders Society Purchase, Edsel B. Ford Fund and Gift of Edsel B. Ford.*)

151. *Vaccination* and *Healthy Human Embryo*, south wall. (*Courtesy of the Detroit Institute of Art. Founders Society Purchase, Edsel B. Ford Fund and Gift of Edsel B. Ford.*)

Directly across from *Vaccination* on the south wall Rivera painted the most complex of the small panels, ostensibly a picture of the pharmaceutical industry. In the center a scientist directs the operation, surrounded by the technology of business and science. Laboratory technicians dissecting endocrine glands for hormone extraction flank the director, while above, two women process capsules (center), a man operates a filter press (extreme right) to remove crude drugs from their extract, a woman runs a meat grinder (top center), and a man puts chopped extracted glands and concentrated extracts into a Bufflovak Pan Dryer (left).[110] Rivera painted a realistically observed industrial environment in this panel, but he also included his own political and social commentary. First, in illustrating the discovery of life-saving drugs degenerating into a large, impersonal capitalist business operation, Rivera gives the *Vaccination* panel a negative side. Rivera included a sly sexual reference as the burrow-browed scientist struggles to stay with his text and not to observe the women with their skirts above their knees. The standardized dresses (rather than the required lab coats) and hairstyles are Rivera's commentary on what he viewed as the monotonous sameness of North American fashion.[111] Finally, Professor Dorothy McMeekin has detected here Rivera's ironic allusion to the broadcasting of a contemporary religious service, a development of the early 1930s. Hence, in addition to the obvious radio of Gothic design, the scientist (in front of microphone) becomes the preacher, the lab technicians the choir, the covered tools sacred objects on the altar, and the woman to the rear the organist.

Below, Rivera shows a brain operation in progress, as a surgeon removes a tumor in the center scene using hemostats to stop the flow of blood from the arteries and veins. Above, an X-ray top view of the brain shows a three-lobed tumor. To the right, Rivera depicts separate organs of digestion and to the left, those of reproduction (female above and male below). Here the artist worked in a didactic manner to commemorate modern

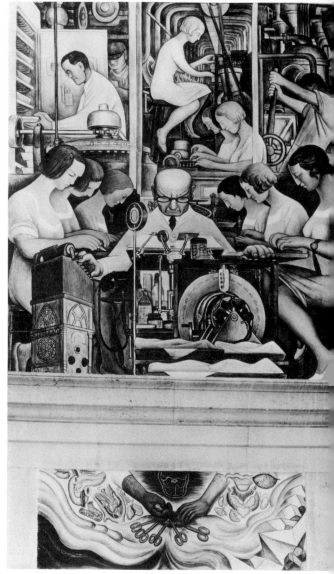

152

152. *Pharmaceuticals* and *Surgery*, south wall. (*Courtesy of the Detroit Institute of Art. Founders Society Purchase, Edsel B. Ford Fund and Gift of Edsel B. Ford.*)

advances in the treatment of diseases. The pancreas referred to the control of diabetes (insulin), the intestine to advances in the field of nutritional diseases (the treatment of pellagra with the B vitamins), and the reproductive organs to symbolize the discovery of hormones. He depicts human abnormalities in the form of an intestine (right, next to surgeon's arm) looped back on itself (intususception), which if not treated will result in death, and a hydatidiform mole (left, the bead-like forms next to the uterus), an aspect of uterine pathology. Dorothy McMeekin believes Rivera intended in these paintings to link religion and sexuality and to show that religious concepts residing in the brain (in Rivera's symbolism, tumors) can be removed by twentieth-century science (the surgeon).[112]

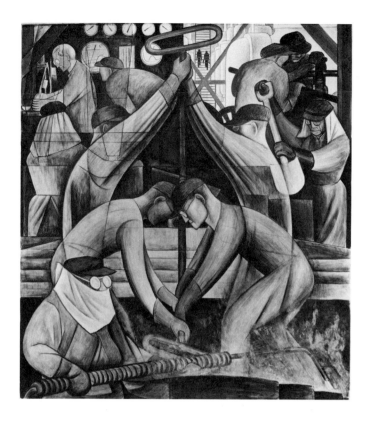

The last of the small panels, *Commercial Chemicals*, refers to the thriving alkali ("salt bed") industry of Detroit.[113] A worker in the foreground heats drums of coal tar products with a steam lance, while in the center two men raise and lower a "scrapper" to recover coke and ammonia from a recuperative oven. Rivera presents a dual image of the same operation. At the upper right men shovel finished products into drums and manually operate related controls (with processing towers above them), while at the left a worker brings an engineer a sample for quality control analysis. Again Rivera includes religious symbolism, here in the "mandorla arch" formed by the outstretched arms of the workers with the "scrapper" and the crucifix shape within, which is especially obvious to the viewer from the museum floor. The lower panel represents the basic raw materials of the chemical industry: sulfur (yellow; orthorhombic) and potash (white; cubical). Rivera also accurately represented the chemicals necessary to produce poison gas (the fumes in the center of the panel), a specific reference to the *Poison Gas* panels directly across the courtyard.

In these small panels, overtly scientific in subject matter though interwoven with religious symbolism, Rivera posits the coexistence of science and religion (*Vaccination, Commercial Chemicals*) for

153

153. *Commercial Chemicals*, south wall. (*Courtesy of the Detroit Institute of Art. Founders Society Purchase, Edsel B. Ford Fund and Gift of Edsel B. Ford.*)

the mutual benefit of mankind at the same time as he includes religious satire (*Pharmaceuticals*) and calls for the extirpation of religion (*Surgery*). To further reinforce this byplay in his imagery, Rivera—in an arrangement unique in his mural oeuvre—used the physical play of light and dark through the glass-topped roof to enhance the symbolic dualities of his paintings. As McMeekin has observed:

> The murals are designed and placed in a very polarized arrangement; polarized between light and dark, good and evil, and life and death. Those parts of the room that receive direct sunlight (*Vaccination, Surgery, Pharmaceuticals*, the symbolic agricultural figures of the east wall), even in winter, reflect the themes of life being renewed and hope based on the positive achievements of science. The murals in the light emphasize warm colors, brown and reds. There are many curved lines and individual people can be recognized. Those parts of the room that are not exposed to direct sunlight (the military section of the west wall, *Poison Gas*) contain representations of the negative aspects of science. The colors are predominantly blue to gray, the lines are straight, the people are impersonal.[114]

In painting his Detroit mural cycle Rivera synthesized for his stylistic and thematic purposes three epochs of art history: first and most important, the indigenous American, and the Italian Renaissance and Cubism. In both central panels of the north and south walls Rivera purposely distorted the appearances of certain machines to refer to indigenous American art and culture. These visual references were central to Rivera's fundamental thematic intent. For example, on the north wall Rivera dramatically enlarged the multiple spindle machines, which he called "as beautiful as the masterpieces of the ancient art of pre-columbian America"—not only to establish the basic tripartite composition of the painting, but more important, to establish the importance of Rivera's ominous view of the contemporary factory environment vis-à-vis mankind.[115] Max Kozloff also has noticed the similarity, both with

154

regard to image and content, of Rivera's machines to the Toltec sculpture pieces at Tula:

> Yet, one divines another aspect of him [other than the superb technician who describes the factory scenes with extraordinary accuracy] that senses in a factory a kind of gorgeous inferno, unnoticed by all within it. Everything that occurs there is subject, and possibly sacrificed, to an unknown, inexorable will. Lording over the toiling masses are giant multiple drill presses that could invoke the ancient warriors of Tula.[116]

However, Kozloff apparently did not realize that Rivera had substantially increased the actual size of the spindle machines to fulfill his compositional and thematic needs and that he also followed the same procedure on the south wall with the stamping presses. If the latter are not as effectively deployed in the composition, they—especially the one to the right—loom frighteningly over the masses of workers. Here, both in terms

155

156

of image and iconography, Rivera evokes by physical similarity and his anthropomorphizing (the "head" and "ears") of the press perhaps the greatest single pre-Conquest work of art, the fifteenth-century Aztec masterpiece *Coatlicue*. This colossal monolith summarizes the complexity of Aztec cultural and religious beliefs. As art historian Justino Fernández has written, "These ideas relate to the cosmic order, to humanity, a concept of the above and beneath, the four cardinal directions, and the primary principle of the life and death of everything."[117]

The work, an inseparable unity of form and symbolism, depicts the deity (the "Goddess of the Serpent Skirt") as related to elements of the Aztec cosmology. To the rear a large appendage of thirteen leather braids on two levels hangs from waist to ground, a reference to the thirteen Aztec heavens presided over by the dual masculine-feminine principle of Ometecuhtli and Omecacihuatl. On top of the braids is the shield of the

154–56. *Coatlicue*, Aztec, late 15th century/early 16th century. Height: 136.5 in. (*Courtesy of the National Museum of Anthropology, Mexico City.*)

war god Huitzilopochtli, which hangs from a skull at the figure's waist. At the top, two serpent heads appear, recalling the related divinities Quetzalcoatl and Xótotl (symbols of the morning and evening stars). Coatlicue appears in the skin of a flayed woman (to symbolize spring) with a collar of hearts and hands, recalling religious sacrifice. The female aspect of the goddess can be seen in the skirt of interwoven serpents, the tortoise at the rear (symbol of childbirth), and the pendant breasts, yet the twin masculine element appears as a serpent between the legs of the figure. The principle of duality not only appears in specific instances, but on a deeper level pervades the entire meaning of the work. As Fernández maintains:

> In effect Coatlicue symbolizes the earth, but also the sun, moon, spring, rain, light, life, death, the necessity of human sacrifice (to offer to the gods the precious *chalchihuitl*, blood), humanity, the gods, the heavens, and the supreme creator: the dual principle Coatlicue, then, is a complete view of the cosmos carved in stone. Many different gods participate but all are rendered mythically to enter into one ordering religion.[118]

For the magnificent *Coatlicue,* the artistic synthesis of the Aztec concept of the universe deriving from a never-ending struggle between opposites, Rivera drew from his Mexican heritage the pictorial and thematic analogue for *his* set of dualities involving man, nature, and technology in his muralistic commentary on the world of twentieth-century industry. That Rivera had *Coatlicue* specifically in mind when he painted at Detroit is confirmed by this recollection of critic Walter Pach at the mural site:

> . . . the painter called my attention to certain gigantic machines [the stamp presses] and asked me what they represented. It did not occur to me initially to think in other than the meticulous study carried out by the artist to realize each detail of that modern miracle. But it was not a question of details, but of

groupings and I saw the point when Rivera reminded me of the sculptures in the Museum of Anthropology in Mexico City, and especially one of them, the most impressive one, the *Coatlicue.* The spirit of life and death was evident in the fresco— and in an extraordinary resemblance—in the vibrant machine which symbolized to a high degree life today.[119]

Rivera included a cross-section of the racial and ethnic types of Detroit in his paintings—those who labor in a strictly controlled, and even brutally determined, manner in the otherwordly milieu of the factory scenes, highlighted by the glowing oranges of the blast furnace and the iridescent greens of the lower registers. In the automotive panels emerged the final set of opposites of the mural program: that man, the inventor of the exceptionally intricate mechanical system, found himself completely enslaved by his own creation. Although artist-engineer Rivera found the automotive technology tremendously appealing in both the visual and mechanical senses, he recognized on the human level man's debased, robotlike existence because of the machine. His assistant Ernst Halberstadt felt that while Rivera had a profound admiration for the superbly designed and crafted "steel environment" of contemporary industrial Detroit, he also recognized the "degrading" nature of the situation in which man must labor at the mercy of his creation, the machine.

An unpublished Rivera manuscript, "America Must Discover Her Own Beauty," confirms that he had formed his ideas regarding the machine and the man-machine relationship before coming to Detroit. Writing in mid-1930, Rivera called for a "New Order of Beauty" deriving from the industrialization of the American continent, rather than from imitating obsolete European models:

> There is more beauty in an electrical plant, with its frank outline and its nervous system of steel transmitting the electric fluid indispensable to social life, than in the redundant Baroque imitations of Euro-

pean architecture that have contaminated the soil of America and has served solely for the purpose of transporting bad taste.

At the same time as Rivera the artist celebrated the beauty of the North American industrial environment, as sociologist he detested the machine's inherent fundamental danger to man and the necessity of man's prevailing over the machine: "Machinery does not destroy, it creates, provided always that the controlling hand is strong enough to dominate it."[120] In Detroit, Rivera encountered just the reverse of this position that man must govern technology, and his paintings made it abundantly clear that the industrial worker had been reduced to a dehumanized existence, both by the tools he invented and the production system devised to operate this machinery. Although Rivera had acute awareness of the industrial conditions of Detroit, he did not moralize here. Rather, in the ultimate duality of these paintings, he presents a grim *ballet méchanique* in which the workers move with a resolute harmony established by the tyranny of the machine.[121]

Rivera's portrait of the contemporary industrial world of Detroit owed little to faddish notions such as technocracy, the horrible economic condicitions of 1932, or the brutal factory conditions common at this time. His position was surprisingly devoid of Communist ideology.[122] At Detroit Rivera emerged as an independent artist, sociologist, and political humanist, the creator of an enduring, visual representation of the worker and the industries of Detroit. He wrote:

> The frescoes were inspired by a belief in things even broader than Communism. They were inspired by a belief in the worker. I am a worker myself. I know the worker. And I have painted him as I know him and see him. I understand the struggle of the worker. And I have tried to put in these frescoes that struggle as I understand it.[123]

In addition to the influence of indigenous American art and culture on the Detroit murals,

Rivera drew to a lesser extent on his wide-ranging knowledge of the art of the Italian Renaissance, which strongly permeated his Mexican murals of the 1920s. He borrowed the *buon fresco* technique, though he improved it with twentieth-century advances such as higher quality pigments and a specially prepared wall of metal lath for the actual painting. He made use of monochrome predella panels and also included traditional donor portraits of Edsel Ford and W. R. Valentiner on the south wall. Other Renaissance elements include the carryover of assimilated *quattrocento* practices from the Cuernavaca murals, characterized by one scholar as the use of "solid, overlapping figures" and "the representation of two or more related events in a compositional frame or stage unified in extended time and space [e.g., the north and south automotive panels], similar to that of Masaccio in the *Tribute Money*."[124] Various motifs at the very heart of the Italianate Chapingo murals—the organization by contrasting sets of dualities, the emphasis on organic development (both natural and political)—anticipate the arrangement by dualities in the Detroit murals and the organic representation of the "germ-child." Moreover, Rivera would adapt specific symbolic images he initially employed at Chapingo—the monumental nudes of the west and east walls, the hands in the lunettes of the last three north wall panels (from west to east, *Aspiration, Struggle, Peace*), to perform very similar functions at Detroit. Despite the significant organizational and visual similarities in these murals, one should note that at Detroit Rivera would entirely omit the fundamental Marxist message of the Chapingo frescoes, painted before Rivera's disillusioning trip to the Soviet Union in 1927–28 and his expulsion from the Mexican Communist Party in 1929.

More than 86,000 people, an unprecedented number, flocked to the Detroit Institute of Arts in March 1933 to view Rivera's murals (they were officially opened to the public on March 19).[125] While museum surveys indicated that most of the viewers reacted positively to the murals, some sec-

tions of the press, religious groups, and political factions sparked a heated, if brief, controversy in protest against Rivera's paintings. Objections to the murals centered on the alleged Communist imagery, religious disrespect in the *Vaccination* panel, and the unsuitability of the paintings for their architectural environment. These objections entirely failed to take into account Rivera's thematic intent in the murals, his fundamentally negative reaction to the impact of industry on man. In one radical reaction, the Rev. H. Ralph Higgins called for the whitewashing of the *Vaccination* panel since "it inevitably must impress the spectator as a satire of that family dear to religion." He failed to grasp Rivera's lack of satirical intent here as well as his veiled portrayal of a contemporary media liturgical service in the *Pharmaceuticals* panel. A leading editorial in the *Detroit News* placed "the blame for this unhappy condition" on Valentiner, and opined that "*all* the murals should be whitewashed." The editor of Detroit's other major daily, the *Free Press*, voiced jingoistic objections toward both Rivera and Valentiner: "An art director is brought from Germany to commission a Mexican artist to interpret the spirit of an American city. Why not hire a French director to find us a Japanese muralist to tell us what he thinks we look like?"[126]

The violent objections to Rivera's murals at times came close to physical confrontation between detractors of the paintings and the museum staff, but the institute's resolve was firm; in E. P. Richardson's words, "we just fought back." Richardson and others spoke at the mural site and on the radio in favor of the "Detroit Industry"

panels, published a broadside on the paintings, and organized the People's Museum Association to help reverse negative public feeling. Valentiner issued statements to periodicals stressing the importance of Rivera's frescoes as works of art. He said, "In their gigantic conception the murals would seem to be the most important addition in the field of modern art that has been made at the museum since its opening."[127] With Edsel Ford's approval, the Art Commission decided tactfully, "to leave the final decision to coming generations."[128]

In his final statement on the mural controversy, Rivera echoed the fundamental organic approach of his paintings:

> If my Detroit frescoes are destroyed, I shall be profoundly distressed, as I put into them a year of my life and the best of my talent; but tomorrow I shall be busy making others, for I am not merely an "artist," but a man performing his biological function of producing paintings, just as a tree produces flowers and fruit, nor mourns their loss each year, knowing that the next season it shall blossom and bear fruit again.[129]

The paintings have, of course, survived. Indeed, they are today the most popular work in the museum collection, and their existence over a fifty-year period underscores the quotation from Hippocrates, part of which ("vita brevis, longa ars") is carved into the west wall portal: "Life is short, but art is long, the opportunity fleeting, an experiment perilous, the judgment difficult."[130]

Rockefeller Center, 1933

In his next United States mural at Rockefeller Center Rivera would continue to develop subject matter derived from technology, but here, in contrast to the Detroit mural program, in the most frankly Marxist work he had yet created in this country, Rivera predicted the liberation of man from the tyranny of the machine by the socialist transformation of society. Diego Rivera first met Nelson Rockefeller in late 1931 after his Museum of Modern Art exhibition opened. Soon afterward, Todd-Robertson-Todd Engineering Corporation, the development manager, asked Rivera to paint murals in a conference attended by Rockefeller, who supported the request.[131] The mural would occupy the most choice location in all of Rockefeller Center's buildings, the three walls of the ground floor elevator bank in the RCA "Great Hall" and would be viewed by incoming workers and visitors. Companion murals would be painted by Frank Brangwyn and José María Sert on the same "New Frontiers" motif, providing the general theme for the dozens of artworks (sculpture, painting, mosaics, photomurals) commissioned for the center's buildings.[132]

In a lengthy and somewhat pompous synopsis of his proposed mural Rivera delineated the subject matter. In *The Frontier of Ethical Evolution* (left wall) he would show "human intelligence in possession of the forces of Nature," expressed in the image of lightning striking the hand of Jupiter and then "transformed into useful electricity that cures man's ills." In *The Frontier of Material Development* (right wall) Rivera illustrated "the Workers arriving at a true understanding of their rights regarding the means of production," in depicting a statue of Caesar in pieces and the "Workers of the Cities and the Country inheriting the Earth." On the far larger central wall Rivera developed the theme of macrocosm (the telescope) and microcosm (the microscope) and industrial energy "controlled by the Worker," and

showed various scenes relating to the "New Generation" of human society, joining in the center Man in his fraternal triple aspect of Peasant, Worker of the City, and Soldier.[133]

Rivera departed from the original large-scale mural sketch in a new design created in Detroit sometime before he arrived in New York in late March 1933. His conception of the contrast between macrocosm and microcosm developed from conversations he had with Lucienne Bloch on a proposed filmic collaboration involving music Ernest Bloch would have written for a text by Romaine Rolland. As part of retelling the Promethean legend Bloch envisaged the depiction of the utter destruction of contemporary society and the planet Earth itself by explosion and fire, while in space the general pattern of existence remained unchanged. The film would move from this telescopic view of the universe to examine the earth's surface microscopically and detect in a crack in a rock the reemergence of life at the level of cellular division. Rivera became greatly enthusiastic about the graphic possibilities of this motif and began his visual adaptation, in which macrocosm and microcosm appeared as two intersecting ellipses picturing the contrasting fields of vision of the telescope and microscope.[134] The resulting sketch indicates Rivera's marvelous synthesizing powers, here seizing and developing for his own purposes imagery created by artists working in a completely different medium. At the same time, this sketch reveals the other fundamental dichotomy of the altered conception of the mural—the contrast between the opposing political systems, capitalism and socialism, which Rivera saw in conflicting moral and technological terms:

> As I see it: man at the crossroads of life—man looking out on the world as it is and what the future has in store, sees that the individualistic scheme of things existing has brought the world to chaos—war

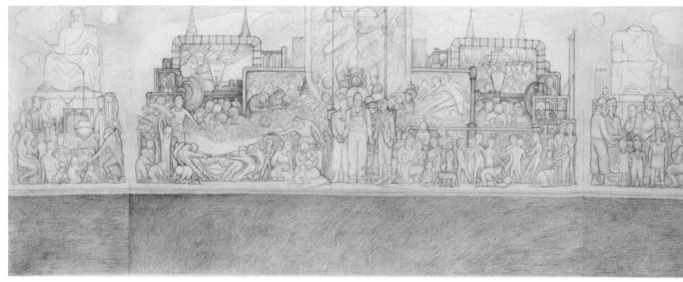

157

157. Original study for Rockefeller Center mural, *Man at the Crossroads*, 1932. Pencil on brown paper, 31 x 71¼ in. (*Courtesy of Museum of Modern Art, New York.*)

and unemployment—and that the hope of the future lies in the organization of producers into harmony and friendship and the control of the natural forces through high scientific knowledge and the development of the skilled worker. Socialism, if you like.[135]

Although one of the building's architects, Raymond Hood, wanted the artists to work in monochrome to achieve an overall harmony of color, if not of style, Rivera lobbied from the beginning for bright hues. On this issue Rockefeller, expressing himself "entirely in accord" with Rivera's request, notified Rivera in October 1932 as contract negotiations continued that architects Hood and Harrison were "quite agreeable, in fact very enthusiastic, about your suggestion of using some color in your mural."[136] Rivera appealed other restrictions relating to technical matters and wrote to Mrs. Rockefeller *after* the contract had been signed, requesting to work in fresco since

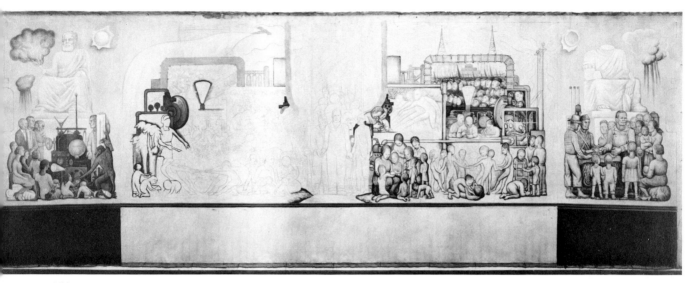

158

the result "will be a thousand times better than the hateful lined canvas."[137] An assistant present when Rivera signed the contract in Detroit on November 2, 1932, recalls that Rivera simply signed the contract without reading it, a typical action on his part.[138] Thus, even before the project began, two factors prefigured patron-artist difficulties. On one hand, the architects, acting at the behest of the building managers and the Rockefellers, revealed their artistic insensitivity in requesting Rivera, generally acknowledged as the greatest practitioner of the fresco technique then much in vogue, to work on canvas and in monochrome. Rivera, for his part, displayed total carelessness in contractual matters. The key point is that Rivera's RCA mural design would evolve organically before the final step of painting took place, as had occurred at San Francisco and Detroit; here he would dramatically revise his composition for the main wall of the mural. However, in contrast to the earlier murals, in New York

158. Enlarged color version of original sketch, 1932. Approx. 3 x 12 ft. (*Courtesy of the Detroit Institute of Arts. Founders Society Purchase, Edsel B. Ford Fund and Gift of Edsel B. Ford.*)

he would not be dealing with an understanding patron. Actually the Rockefellers, surrogate sponsors, seem to have been sympathetic to Rivera's Marxist intentions, while the true patron, Todd-Robertson-Todd, was not.

In view of the widely held notion that Rivera's Marxist political position, and particularly the inclusion of a portrait of Lenin in the mural, provided the impetus for the Rockefeller Center controversy, it is revealing that contemporary sources contend that the Rockefellers, especially Abby Aldrich Rockefeller, not only knew of Rivera's intended use of Marxist subject matter but even encouraged him in this respect. The earliest, and most startling, indication comes from a letter by assistant Clifford Wight:

> Diego has been riding rough-shod over the hardest-boiled bunch of architects in the world . . . and he has them all licking his boots. I was afraid that his sketches would not be approved by the Rockefellers but Mrs. J. D. Jr. said that he didn't give Communisn *enough* importance and asked him to include a portrait of Lenin.[139]

Ernst Halberstadt, just hired by Rivera to assist on the Detroit project, happened to be outside Nelson Rockefeller's office when the original sketch was approved. He recalls Rivera's overjoyed reaction, and later that day his informing Frida Kahlo that "everything is just fine; they have approved everything." She inquired, "Even the heads?" and Rivera, grinning, replied, "Yes. They have no objections to the heads of the Communist figures" [the May Day celebration in the right "television screen"].[140] Lucienne Bloch Dimitroff remembers Mrs. Rockefeller visiting Rivera, even spending time with him on the scaffolding, and praising the Soviet section, taken directly from Rivera's sketchbooks of the May Day 1927 celebrations in Moscow, as one of the most beautiful sections of fresco work he had ever done.[141]

Muralist Edward Laning recalls that Nelson Rockefeller often visited Rivera at the mural site and watched the artist work. One night at dinner (Rivera evidently consumed one gargantuan meal each day) Rivera was asked, "Nelson Rockefeller sits up there beside you night after night while you paint. What does he talk about?" Rivera replied: "Tonight he said, 'I'm of the last generation in which a great fortune will be in the hands of a single family.' "[142] Rivera made no attempt to mask his leftist political intent, either in his mural design or in public statements. Two weeks before being ordered off the RCA scaffolding, he explained to a reporter:

> I am a worker. I am painting for my class—the working people. If others like my painting, that is all right. To be useful, that is my object. But I am not a prostitute with the workers. I am not a bourgeois worker nor bourgeois painter nor bourgeois thinker. I am a man who works for my own interests and my interests are those of the working class.[143]

Apparently, that the Rockefellers went beyond mere acquiescence to active encouragement of Rivera's Marxist subject matter was a factor in his revision of the central panel, now to depict a socialist onslaught against capitalism in a citadel of capitalism. Some have alleged that another factor in the increased political intensity of the mural was the attacks of the strident Communist Party of the United States of America (CPUSA) on Rivera which "goaded" the artist into presenting subject matter that would demonstrate that he was not an "opportunist" (the primary charge against Rivera), but that he could, in fact, function as a Communist artist in capitalist society. Ben Shahn, assistant to Rivera on this mural, maintains that Rivera craved above all else positive criticism from CPUSA organs, the *Daily Worker* or *New Masses*, which had not been forthcoming.[144] The building's scheduled opening date had been designated as May 1, providing further impetus for Rivera to strike back at CPUSA charges of his cooptation by the forces of U.S. capitalism and imperialism. At the same time, Rivera included a portrait of Lenin, who

symbolized for him true Communism, instead of Stalin, whom he abhorred as a false and dangerous representative of Communism.[145]

Yet even in the drastically altered plan for the main wall (the side panels, to be rendered in diminished color, remained the same), Rivera adapted some elements of the initial sketch into the more politically explicit and far more visually dynamic revision. He retained the two lateral scenes from the large television screens (with cathode tubes in front); to the left is an infantry attack supported by airplanes and tanks, and one gasmasked soldier sprays what was then termed "liquid fire." In contrast to the dull grays and greens of this picture of contemporary chemical warfare, Rivera juxtaposed the vibrant reds and joyous activity of a Communist May Day celebration. These two scenes still appear in the upper lateral registers, though now outside the arbitrary confines of the television, and the May Day festivities have been enlarged, with the female track hurdlers placed immediately below. The overall visual effect of the new design for this section brings more clearly into focus Rivera's thematic emphasis on the options he saw confronting society: Fascism or Communism. The major compositional elements placed in the central, boxlike section of the original design become a much more exciting interplay of circular and elliptical visual elements. Foremost here are the great contrasting ellipses of images from the field of view of a microscope and telescope depicting Rivera's set of biological symbols referring to capitalist and socialist society. At the lower left in the telescopic ellipse, beneath Rivera's portrait of decaying capitalism—drinking, card-playing, and dancing in a nightclub—is the moon, a dead planet, and the earth, soiled. In the upper left portion of the microscopic ellipse, directly above the nightclub scene and reinforcing the idea of decay and corruption swim microbes given life by chemical warfare. Below these Rivera pictured other microbes (syphilis, gonorrhea, gangrene, and tetanus) he saw as resulting from the debilitating life-form of capitalism. The images from the socialist sec-

tion stand opposed to their capitalist counterparts; the upper right telescopic ellipse portrays constellations and nebulae in ascending evolution, highlighted by the glowing red star of Mars. A photographic detail of the latter reveals an example of Rivera's "hidden" political symbolism, here a faintly imposed hammer and sickle apparently noticed by no one at the time. The lower microscopic segment begins with cancerous cells, another disguised image, in this case symbolizing the state of Stalin's contemporary position of leadership in the Soviet Union, and continues with images concerning the generation of human life (shown are the womb and cervix, spermatoza, and healthy cells in subdivision).[146] At the intersection of microcosm and macrocosm appears the mural's imposing central figure, "Contemporary Man, represented by the skilled worker controlling manual labor and natural forces by means of high scientific knowledge, and looking toward the future from the center of the crossed roads."[147] This worker controls a huge dynamo-like machine of Rivera's invention, and to the rear appears his adaptation of enormously enlarged slotted television discs. Superimposed on the worker in the exact center of the panel is a crystal sphere representing another of the artist's prophecies, the splitting of the atom, controlled by a gigantic hand symbolizing man's latent mechanical and scientific capabilities. Below Rivera's image of atomic fission would have appeared plants providing nourishment for the earth, specifically with "a representation of the earth as an open book, with the chief elements of organic life in geological strata on its pages and plants sprouting on the soil surface."[148]

Beyond the thematic importance of the contrapositioning of the images of macrocosm-microcosm, Rivera also intended to allude to the specific architectural environment of the RCA building, the tallest and most important of the Rockefeller Center complex, through the telescope-microscope motif. He employed the telescope to express the seventy-story height of the building, the microscope to refer to the teeming

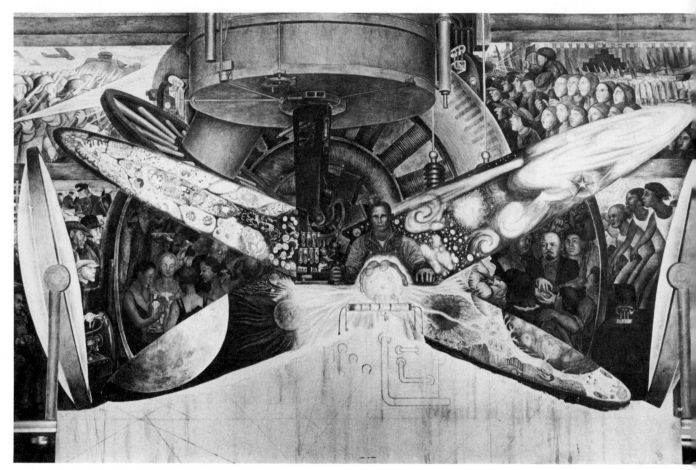

159

164

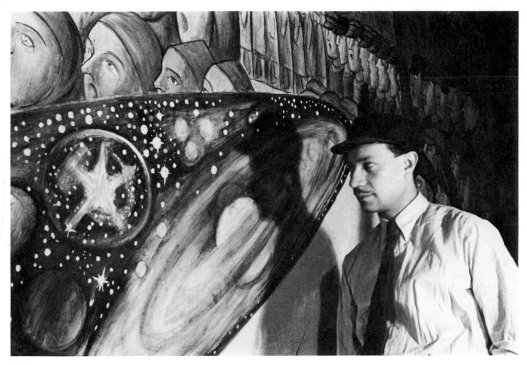

160

metropolis with its vast numbers of people, and
the intersection of macrocosm-microcosm in the
worker and atom to establish the central axis of
the building.[149] Completing Rivera's picture of
the other primary duality of the central panel—
capitalism and socialism—are, on the left, an
unemployment demonstration in the Wall Street
area with Trinity Church in the background.
Mounted police forcibly break up the demonstra-
tion, dotted with workers' banners reading "We
Want Work, Not Charity," "Down with Imperi-
alist Wars," and "Free Mooney." On the right,
opposite the frivolity and corruption of capital-
ism, Rivera shows Lenin joining the hands of a
soldier and a white and black worker. In view of
the controversy surrounding the mural, ostensi-
bly caused by the inclusion of Lenin's portrait,
Rivera's modification of this aspect of the pre-
liminary design should be noted. In the only
change Rivera made from the enlarged sketch to
finished painting, he transferred the position of

159. Central panel, at time Rivera was
dismissed. (*Courtesy of Lucienne Bloch Dimitroff.*)

160. Assistant Andrés Sanchez-Flores standing
before "hidden" hammer and sickle symbols in
telescopic section. (*Courtesy of Lucienne Bloch
Dimitroff.*)

See also Plate 12.

the women athletes and the adjoining section of a "leader-figure" (shown with a cap) between two men clasping hands. This alteration, in which the "leader-figure" emerged indisputably as Lenin, greatly strengthened both composition and content, since Lenin became the central socialist image, whose heroic presence confronts, to use Marx's term (which Rivera knew), "the overflowing scum of capitalist decay."[150]

Heralded by Rockefeller press releases, Rivera arrived in New York on March 20, 1933, ready to begin work on the mural. Two assistants, Arthur Niendorf and Stephen Dimitroff, had been engaged for a month on "furring" operations, or constructing the false walls necessary to shield the mural from elevator vibrations, and Rivera had made several brief inspection trips from Detroit during this period. Rivera had emerged clearly triumphant in his battle to work in fresco and color. A Rockefeller Center press release explained the fresco process in detail and even listed the fourteen colors Rivera would use during the estimated four to five weeks it would take him to complete the work. Full of enthusiasm for his first large-scale New York mural project, Rivera plunged headlong into his labors, working as much as twenty-four consecutive hours (with breaks only for eating and leaving the scaffolding to examine his work from a distance) and covering up to four square yards at a single stretch. Before painting on a given section of the wall, Rivera would sketch his final design in red ocher over the original lines in charcoal on the third plaster coat. Next an assistant traced the area he designated for the next day's work, and others applied two more coats of plaster, the last being the smoothly polished *intonaco* coat on which Rivera would actually paint. Wall preparations took as long as twelve hours and generally were carried on during the night. Plastering and tracing accomplished, assistants would grind colors, make sure that Rivera had everything he required for work on the scaffold, and perform tasks such as carrying out research errands to find illustrative material for details of the macrocosm-micro-

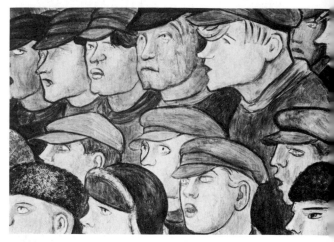

161

cosm fields. After beginning a section, Rivera was obliged to finish that area completely in one work period before the water evaporated and the lime set, binding the pigment to the plaster. Since correction could only be carried out by physically cutting away the entire section and repeating the time-consuming and difficult process of preparing the wall to receive pigment, Rivera made sure of his complete satisfaction before leaving the scaffold. Following a work session, assistants moved the scaffold to the next area to be painted, applied the final plaster coats, and pounced the design outlines from the tracing to the wall, the only visual guidance Rivera would have as he began to paint. If Rivera found the wall in less than perfect condition, assistants report, he could become enraged.[151] Beaumont Newhall observed Rivera at work on the chemical warfare segment of the mural and described his absolute mastery of fresco technique:

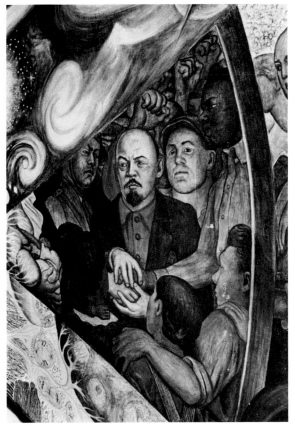

162

163

161. Detail, May Day section. (*Courtesy of Lucienne Bloch Dimitroff.*)

162. Detail, Lenin section. (*Courtesy of Lucienne Bloch Dimitroff.*)

163. Sketch on east wall. (*Courtesy of Lucienne Bloch Dimitroff.*)

Deliberateness characterized these proceedings. Before every part he painted, Rivera paused, gazing at the blank surface and its relation to its surroundings. Having definitely decided on the direction of the line he was to paint, he then applied the brush to the wall and, without a second's hesitation, yet without haste, traced its contour. There was no guess work, no false step.[152]

From his observation of Rivera at work, Newhall raises two significant technical matters: first, he noted that the "design grows on the wall itself." Newhall observed that Rivera would, if he felt it necessary, change the design on the wall and reject earlier preparatory sketches. For example, a transposition of the "worker-leader" and female athlete areas occurred after the second general sketch had been enlarged onto the wall. However, Rivera did not "invent" the Lenin group directly on the wall; rather, he worked from a rough sketch done on scrap paper in his RCA workshop.[153] Second, Rivera did not proceed in traditional fashion directly across the wall from left to right, but rather, during the following day's work session, proceeded to complete the upper register Soviet area. Last, as the photo of the unfinished central wall makes clear, Rivera's compositional design was derived as usual from his intimate knowledge of the dictates of the Golden Section.

Rivera followed his usual procedure in employing models for figures in the mural; these included construction workers, assistants, and passersby. He based the figure of the central "Contemporary Man," for example, on a night watchman who happened to be around at the time. As Rivera had done at Detroit, he devoted himself to meticulous study of scientific matters, especially bacterial cultures that he observed at local hospitals, where he received staff assistance.[154]

Shortly after he began to paint at Rockefeller Center, Rivera acknowledged that he fully expected negative criticism of the sociopolitical content of his murals.[155] Yet surely he could not have anticipated the nationwide publicity the controversy—the "Battle of Rockefeller Center" in media jargon—aroused, nor his dismissal from the project, the immediate cancellation of other planned North American commissions, and, almost a year later, the physical destruction of his mural.

For their part, the Rockefellers knew of Rivera's Marxist intent, as they surely knew of his earlier anticapitalist Mexican murals, one of which depicts John D. Rockefeller, Sr., at dinner with friends, consuming money. Moreover, they encouraged Rivera in his leftist political sympathies; for as he said afterwards, "Through this all I received nothing but praise and encouragement."[156] Rivera made absolutely no attempt to disguise his political position and asserted unequivocally at this time that "[Communism] is the ultimate form of social life among civilized people."[157]

To be sure, the second preparatory study went much further in presenting both a positive view of socialism, and a negative one of capitalism, but Rivera maintained that he had sent this second drawing to Raymond Hood, and he did have the drawing enlarged in its entirety on the wall before beginning to paint.[158] How, then, given Rockefeller support of Rivera's clearly expressed aim and the artist's repeatedly publicized statements of his belief in Marxism, as well as the content of his previous murals in Mexico, did patron dissatisfaction come about?

Two incidents—one entirely innocent and one decidedly not so—appear to have ignited the controversy. Ben Shahn recalled inadvertently revealing Lenin's presence in the mural:

We were late, the other contractors were ahead of us, and as they were painting the ceiling splotches of paint hit the fresco. I called the attention of the fellow in charge of the building to it. He paid no attention so I called the architectural firm and a Mr. Hood came over. And I had him on the scaffold to show him these greasy spots of oil paint. . . . And

he was very upset. As he looked around he said "Who's there?", very casually as he looked down and sort of directed, "Who's that, Trotsky?" And I said, "No, Lenin." And then the fun began.[159]

Surely far more influential in calling public attention to the content in Rivera's mural would have been Joseph Lily's inflammatory headline in the *World-Telegram*, "Rivera Perpetrates Scenes of Communist Activity for RCA Walls—and Rockefeller, Jr., Foots the Bill," in late April. Accurately terming Rivera's mural "a forthright statement of the Communist viewpoint, unmistakable as such, and intended to be unmistakable," Lily noted correctly that it would be "likely to provoke the greatest sensation of his career." The reporter went on to describe the mural in detail, curiously omitting any mention of the "leader-figure" who would shortly change into Lenin.

In view of Rockefeller enthusiasm for Rivera's project, one is hard-pressed to explain Nelson Rockefeller's letter of May 4, 1933, the first public expression of patron disapproval of the mural:

> While I was in the No. 1 building at Rockefeller Center yesterday viewing the progress of your thrilling mural I noticed that in the most recent portion of the painting you had included a portrait of Lenin. The piece is beautifully painted but it seems to me that his portrait appearing in this mural might very easily seriously offend a great many people. If it were in a private house it would be one thing, but this mural is in a public building and the situation is therefore quite different. As much as I dislike to do so, I am afraid we must ask you to substitute the face of some unknown man where Lenin's face now appears.
>
> You know how enthusiastic I am about the work which you have been doing and that to date we have in no way restricted you in either subject or treatment. I am sure you will understand our feeling in this situation and we will greatly appreciate your making the suggested substitution.[160]

Rivera explained the Lenin portrait in this fashion:

> When I gave them my (revised) sketch of the panels, I told them I would depict a leader standing between a soldier and a worker. When I began to paint, the head of Lenin appeared, for he was the symbol of the one great worker-leader I had ever known. So it became Lenin, whom I loved, who became a composite of great leadership. It was my conception of the leadership and so I painted it.[161]

Rivera's contention that "the head of Lenin appeared" on the wall as the result of artistic and political inspiration must be considered disingenuous, given his desire to gain CPUSA support and the fact that the artist worked from a preparatory sketch. In any case, Rivera's reply of May 6 to Nelson Rockefeller stated that the drawing in Hood's possession included "a general and abstract representation of the concept of leader, an indispensable human figure," and that he "merely" changed its placement in the painting. Rivera continued that a person offended "by the portrait of a deceased great man" would be offended "by the entire conception of the painting." Inexplicably, Rivera next placed himself in an extremely difficult position, maintaining that "rather than mutilate the conception I should prefer the physical destruction of the conception in its entirety, but preserving, at least, its integrity." Thus having cornered himself, Rivera proceeded to suggest what he termed "an acceptable solution"—to place opposite Lenin in the section denouncing capitalist society a great figure from American history. He suggested Lincoln, surrounded by Abolitionist leaders and important inventors of the nineteenth century, such as McCormick.[162] Assistant Lucienne Bloch Dimitroff recalls that Rivera, as an artist, desperately wanted to finish the mural; at the same time he ardently desired to prove his political integrity, both to his patron and to his CPUSA detractors. He maintained the hope, which would not materialize, that his

patrons would let him complete the mural, either at this time or at a later date. He simply could not conceive of the possibility that his murals might face physical destruction.[163]

At this point the Rockefellers withdrew from the fight, and all further correspondence was directed to the Rockefeller Center managing agents, Todd-Robertson-Todd Engineering Corporation. Writing to Rivera, the firm omitted any praise of the mural and presented a more intransigent position, referring only to the original sketch and the November 2 agreement, which they maintained did not authorize "any portraits or any subject matter of a controversial nature." Hugh Robertson believed Rivera had "taken advantage of the situation to do things which were never contemplated by either of us at the time our contract was made." Although Robertson offered the artist the opportunity "to conform the mural to the understanding we had with you," that very evening another letter terminated the project, when Robertson (in the company of a dozen uniformed guards) presented Rivera with a check for $14,000, completing payment of his $21,000 fee.[164]

When the order to cease work became known, Rivera's assistants immediately mobilized a protest campaign. Stephen Dimitroff and Lucienne Bloch painted on Rockefeller Center windows "Workers Unite" and were unable to finish "Help, Protect Rivera Mural" before guards stopped them. Within two hours several hundred sympathizers gathered outside the RCA building with similar banners and signs. Mounted police broke up the rally, a scene ironically enough, paralleling Rivera's painted depression scene in the mural. Various left-wing groups supported Rivera's position, and the CPUSA, caught in an ideological bind between the Rockefeller Center capitalists and the "opportunist" communist Rivera, denounced the denial of artistic expression to Rivera. At the same time, the party attempted to straddle both sides of the leftist position: while the CPUSA would "join in the struggle," it could not "allow itself to appear to support the politi-

cal position of Rivera, nor to withdraw from its well-known stand toward him." Robert Minor, writing in the *Daily Worker*, approved of Rivera's image of "a worker, a Negro, and a soldier—their hands being united by the symbol of the revolutionary world Communist Party—Lenin," without having detected Rivera's "hidden" cancerous reference to Stalin. At the same time he denouced Rivera, "no longer a revolutionist," for having sold his talents to the imperialist-capitalists Morrow, Ford, and Rockefeller, while envincing total disregard for the contradiction in his position. How could an "opportunist-nonrevolutionist" possibly create a valid "revolutionary" image? Parroting official Soviet dogma, soon to prove wildly unrealistic, that this incident "was one of the lightning flashes in the stormy skies of the present decline of capitalism," Minor closed: "Not too long after the German masses will hang the butcher Hitler, many men of the class and role of Rockefeller will face a revolutionary tribunal of American workers, soldiers, and Negroes. It may be in the same great hall at Rockefeller Center."[165] For his part, Rivera spoke to gatherings at Irving Plaza, the Art Students League, and the New School for Social Research, terming Nelson Rockefeller's objection to the Lenin portrait a "pretension"—a seemingly valid claim, given Rockefeller's and his mother's expressed interest in Rivera's approach to the mural. The respected establishment critic Walter Pach, a friend of both the Rockefellers and Rivera, attempted personally to bridge a compromise between the two parties and wrote to Mrs. Rockefeller, urging that Rivera be allowed to finish his mural. Further, Pach raised a critical issue:

> I understand that the decision to put the mural out of sight after sending Rivera away was largely the doing of the agent for the building [Todd-Robertson-Todd]. It seems to me that it is on this score that Mr. (Nelson) Rockefeller can step in to remedy a mistake, for I believe it to have been one.[166]

John D. Rockefeller, Jr., determined not to reply

164

164. Covered wall. (*Courtesy of Lucienne Bloch Dimitroff.*)

to Pach's temperate suggestions, but instead to refer his and any other communications on the dispute to Todd-Robertson-Todd.[167] Pach again wrote to Mrs. Rockefeller in September 1933, informing her that on three occasions Todd-Robertson-Todd officials had told him that no decision had been reached on Rivera's mural, and prudently appealed to her to consider allowing the artist to complete the mural. A secretary replied that "Mrs. Rockefeller is most anxious that she should not become in any way involved in the controversial question mentioned in your letter."[168] The Rockefeller family, then, decided to evade any responsibility in the matter.

Pach's comment on Todd-Robertson-Todd's activities raises the issue of their participation in the mural controversy. Several knowledgeable contemporary sources maintain that the firm opposed Rivera's painting from the very beginning. First of all, Todd-Robertson-Todd demonstrated their artistic insensitivity in attempting to

impose a dreary "harmony," as they put it, on the interior decorative scheme by insisting that the three sets of murals be done in monochrome on canvas, and on "imaginative" topics. Rivera had, of course, managed to circumvent these stipulations. Also, they nowhere made reference to the second preparatory sketch, which according to Rivera had been sent to Raymond Hood. Both Hood and another Rockefeller Center architect, Harvey Wiley Corbett, stated that they had not been informed of disapproval of the mural. Rivera's dismissal seems to have been handled entirely by Todd-Robertson-Todd, whose final statement found Rivera's painting "artistically and thematically incongruous," without explaining precisely what this meant.[169]

Ernst Halberstadt recalls a great deal of friction between Todd-Robertson-Todd and the crew working on the mural, involving matters such as the plaster and sand droppings that littered the lobby of the almost-completed building. Rivera's mural was running late with regard to the general construction work. Other mural assistants remember that the scaffolding for the side panels interfered with the workers' tasks and that work on the fresco created problems for the installation of the terrazzo floor.[170] However, beyond these mundane problems—seemingly minor irritants that could have been easily remedied had a decent relationship existed between the two parties—loomed the almost palpable feeling of opposition to the mural project in general, which those close to the situation recognized as a very serious factor. Todd-Robertson-Todd's fundamental objections to the mural, although never publicly acknowledged, surely stemmed from the profoundly anticapitalist nature of Rivera's subject matter. The firm, after all, was attempting to rent office space in this seventy-story building, the keystone of the entire Rockefeller Center plan, during the depths of the depression. Rivera's mural portraying the future in socialist terms ran totally counter to the underlying conception of the complex and must have been objectionable to Todd-Robertson-Todd for economic considerations alone. One wonders, as did the *Nation* after the controversy erupted, why the building management did not candidly admit "that most businessmen object to renting space in a building where they and their customers must look at Lenin."[171] One wonders indeed how the mural progressed as far as it did since—notwithstanding the genuine esthetic merit of the work. The work must be considered as singularly inappropriate for its site. Perhaps this provides the ultimate illustration of the exceptional contemporary popularity and influence Rivera enjoyed, in that he came close to completing a work flouting his particular Marxist point of view in the most accessible viewing site of a monument to capitalism costing hundreds of millions of dollars.

By far the most highly publicized event surrounding the Mexicans' activities in the United States, "The Battle of Rockefeller Center" generated dozens of front-page articles in New York alone. The situation elicited a poetic commentary from E. B. White, the best-known and single most witty account of the affair, which hints at the ultimate fate of the mural:[172]

I Paint What I See

[A Ballad of Artistic Integrity]

"What do you paint, when you paint on a wall?"
　Said John D.'s grandson Nelson.
"Do you paint just anything there at all?
"Will there be any doves, or a tree in fall?
"Or a hunting scene, like an English hall?"

"I paint what I see," said Rivera.

"What are the colors you use when you paint?"
　Said John D.'s grandson Nelson.
"Do you use any red in the beard of a saint?
"If you do, is it terribly red, or faint?
"Do you use any blue? Is it Prussian?"

"I paint what I paint," said Rivera.

"Whose is that head that I see on my wall?"
　Said John D.'s grandson Nelson.

"Is it anyone's head whom we know, at all?
"A Rensselaer, or a Saltonstall?
"Is it Franklin D? Is it Mordaunt Hall?
"Or is it the head of a Russian?"

"I paint what I think," said Rivera.
"I paint what I paint, I paint what I see,
 "I paint what I think," said Rivera,
"And the thing that is dearest in life to me
"In a bourgeois hall is Integrity;
 "However . . .
"I'll take out a couple of people drinkin'
"And put in a picture of Abraham Lincoln;
"I could even give you McCormick's reaper
"And still not make my art much cheaper.
"But the head of Lenin has got to stay
"Or my friends will give me the bird today,
 "The bird, the bird, forever."

"It's not good taste in a man like me,"
 Said John D.'s grandson Nelson,
"To question an artist's integrity
"Or mention a practical thing like a fee,
"But I know what I like to a large degree,
 "Though art I hate to hamper;
"For twenty-one thousand conservative bucks
"You painted a radical. I say shucks,
 "I never could rent the offices—
 "The capitalistic offices.
"For this, as you know, is a public hall
"And people want doves, or a tree in fall,
"And though your art I dislike to hamper,
"I owe a *little* to God and Gramper,
 "And after all
 "It's *my* wall . . ."

"We'll see if it is," said Rivera.

With coast-to-coast reportage and editorial commentary, the controversy wreaked catastrophe for Rivera's North American career, as other blue-chip patrons immediately and irrevocably withdrew support for his mural projects. Albert Kahn cabled from Detroit: "I have instructions from General Motors executives to discontinue with the Chicago mural. This is undoubtedly due to the notoriety created by the Radio City situation."[173] According to those close to him, Rivera fully understood the magnitude of his career loss, and, though typically a pleasant, outgoing personality, he now became bitter and depressed at the realization of his suddenly acquired *persona non grata* status among North American capitalists.[174]

The final, unfortunate, and totally unnecessary phase of the Rivera-RCA controversy concerned the physical destruction of the murals on the weekend of February 10–11, 1934. As an arrangement had seemingly all but been concluded to transfer the murals to the Museum of Modern Art, the decision to destroy Rivera's art becomes difficult to understand. In mid-December 1933, John Todd informed Nelson Rockefeller that "the managers see no objection to Rivera's work being given to the Modern Art Gallery [*sic*]" but stipulated that the museum remove the work at its own expense and that an agreement be signed with Rivera to finish the work before making a formal request to Todd-Robertson-Todd. Now more sensitive in the area of public relations, Todd commented: "If this is to be done the publicity must be handled carefully and fully so that the public reacts as we would want."[175]

With efforts to move the murals from their original site thus under way, and agreement seemingly a certainty, one wonders why the two parties did not implement the arrangement? Moreover, why were the murals literally chopped off the walls when the entire "furred" false walls could have been removed?[176] Again, however, opposition does not seem to have come from the Rockefellers, for as W. R. Valentiner commented: "Yet even so [despite the inappropriate nature of Rivera's imagery], the New York frescoes would not have been destroyed, Mrs. Rockefeller told me, if the architects had not insisted upon it."[177] A terse press release from Rockefeller Center following destruction of the frescoes stated that "their removal involved the destruction of the mural." The incident resulted in another Rivera-related

public relations disaster for the Rockefellers and the center, as charges of artistic "vandalism" and "barbarism" filled the New York press. John Sloan, head of the Society of Independent Artists, and many other artists vowed not to exhibit at the Municipal Art Exhibition scheduled that spring for the RCA building, and various protest marches and demonstrations took place—the largest, a gathering of some 1,000 at Irving Plaza, featured Suzanne LaFollette, John Sloan, and Walter Pach among the speakers. Rivera, at this time in Mexico, issued a statement personally denouncing the Rockefellers as having perpetrated "an act of cultural vandalism": "The Rockefellers demonstrate that the system they represent is the enemy of human culture, as it is of the further advance of science and the productive power of mankind."[178] Rivera gained some artistic revenge later in 1934, as he painted a far smaller version of the RCA mural on a flat wall of the National Palace of Fine Arts (Mexico City). In addition to painting in a vastly different architectural and cultural environment, Rivera introduced some thematic variations, notably a portrait of John D. Rockefeller, Jr., in the nightclub scene, very close to the venereal microbes.

Decades later, in a lecture at the New School for Social Research on his activities as a collector and patron of the arts, Nelson Rockefeller presented his recollections of the RCA mural controversy. In a self-serving account, Rockefeller departed from factual accuracy in several crucial matters either to favor his family's role in the incident or to criticize Rivera's. He began with the sheer fantasy that Frida Kahlo—in her early twenties and without any significant political experience—persuaded Rivera "to incorporate the most unbelievable subjects [both political and sexual] into the mural." After claiming to have kept close watch on Rivera's work and enforcing thematic changes, Rockefeller again alleged Frida Kahlo's disruptive intervention: "I had pretty well threshed this out, I thought, and I periodically peeked in the door to keep check on developments. But it turned out that whenever I went out, Frida came in." Next, Rockefeller conveniently "forgot" a key image in the work: "Then he had Stalin—or was it Lenin? I've forgotten—featured in the center of the mural." Finally, in the last and most blatant factual misstatement, Rockefeller maintains that, in fact, Rivera had been allowed to complete the mural: "Well, we made two installments on the payment and Rivera worked twenty-four hours without stopping to get the mural finished. Then we gave him his final check and thanked him, and just took the mural down. It was a little rough for awhile." Particularly appalling here is Rockefeller's contention that Rivera received permission to finish his painting, since at the time artists who did not necessarily agree with Rivera's political views objected to his being summarily dismissed from the work-in-progress. Also, a fresco, of course, cannot "just be taken down," as Rockefeller surely knew.[179]

174

After the debacle of the Rockefeller Center project, Rivera decided to use the remainder of his fee to work on a set of murals that he would donate to the citizens and workers of New York City. Rivera and his assistants inspected several possible sites in offices and schools of various leftist and radical associations (they were denied entrance at the CPUSA Workers School), and finally settled on the "Communist Party Opposition" center, the New Workers School at 51 West 14th Street.[180] Rivera took as his theme the group's interpretation of United States history:

> I have been strongly impressed by their insistence upon rooting their movement in the American soil and building upon the revolutionary traditions of the country in which they live and struggle, as well as upon international revolutionary traditions. The painting will consist of sixteen panels on the side walls of the main hall of the School and a central panel on the rear wall. . . . Beginning with the first panel, which represents the colonial period, the painting will reveal the class conflicts in the very foundations of the country's economic structure, which growing with its development, caused the attempt to complete the bourgeois revolution during the Civil War and makes necessary the proletarian revolution today, i.e., communism.[181]

For the first time during his career Rivera would paint for a workers' organization, so that his murals were intended for a particular audience and not the general public. What specific leftist position, then, did the "Communist Party Opposition" (hereafter CPO) hold, how was the group formed, and what function did the New Workers School fulfill? The group, whose leader, Jay Lovestone, and others had been purged from their majority position in the "official" Communist Party (CPUSA) during the June 1929 "Enlightenment Campaign," fundamentally believed in an international form of communism, placing them in diametric opposition to Stalin's rigid control of the Communist International. Several reasons existed for their ultimate break with Stalin:

1) The group believed that the Communist International should have a genuinely international and independent collective leadership, with the Soviet Union allowing other national parties to make their final decisions because they possessed greater knowledge of their own particular situation and problems. Above all in this area, Bertram Wolfe and others advocated a specific set of *American* conditions (history, traditions, a national temperament and psychology), for which they were denounced in Moscow as "American Exceptionalists."

2) The group believed, in agreement with Marx, Engels, and Lenin, in "American backwardness" regarding socialist tradition and native radicalism. Thus, they directly opposed the Soviet position that at this time the American economic system had entered its final crisis stage, to be followed by imminent revolution.

3) In his call for "dual unionism" Stalin proposed that the CPUSA break with the American Federation of Labor to form their own independent "revolutionary unions," which would have meant the loss of arduously earned Communist influence in industries such as coal, steel, and textiles.

4) Finally, the group strongly disagreed with Stalin's theory of "Social Fascism," which held the Socialists to be the primary enemy of Communism.

After the Lovestone-led faction gained a resounding victory over the minority opposition led by William Z. Foster at the 1928 Sixth Congress of the CPUSA, the Executive Committee of the Communist International strongly rebuked the Lovestone majority for unexplained reasons, and gave the unequivocal impression that Moscow preferred the Fosterites. In response, the then CPUSA majority sent its leaders to "reason with Stalin" and attempt to convince him that the Unit-

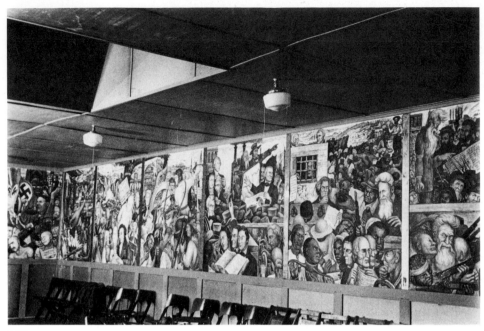

165

ed States remained outside the scope of his proclaimed "Third Period" (the end of capitalist stabilization and a surge of new revolutions throughout the world). In answer, Stalin denounced the American "exceptionalists," who were soon after expelled from the party, and the CPUSA underwent an "enlightened" restructuring under directives issued by the Soviet-controlled organ, the Communist International.[182]

As a result, these declared "renegades and counterrevolutionaries," among the first leftists in this country to voice their opposition to Stalin, formed the splinter "Communist Party U.S.A.—Majority Group" and began publishing their semimonthly *Revolutionary Age*. Wolfe, primarily an educator and administrator rather than an activist, founded the New Workers School along the model of the CPUSA Workers School he had earlier established and lectured on Marxist theory and practice. Rivera's fame and presence—in addition to painting on the walls of the lecture hall, he gave several talks—drew overflowing crowds to the school. Rivera, nominally a Trotskyite at this time, did not belong to the CPO but worked at the New Workers School in the spirit of "Communist unity."[183] The CPUSA responded to the new independent Marxist organization with physical assaults during its open meetings, "stink bomb" attacks, and further accusations against Rivera, including a vicious prearranged attack on Rivera's character and politics after he accepted an invitation to speak at the party's John Reed Club.[184]

Rivera designed the imagery of his murals in accordance with the specific Marxist position of the New Workers School, and as such they represent the most dated subject matter of Rivera's North American public art. They presented "alternative" history to the several hundred members of the group, decidedly not the brand of history appearing in contemporary textbooks. Frankly propagandistic in tone and firmly dia-

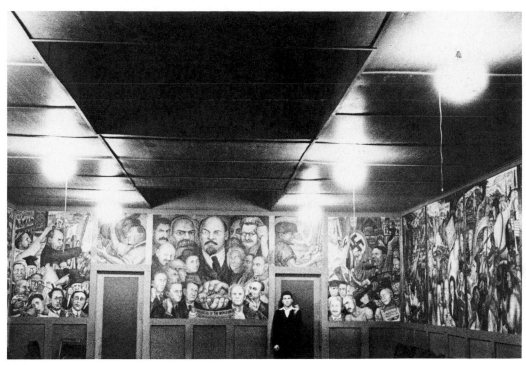

166

lectical in character, the paintings issued a call
to revolutionary action in twenty-one panels teem-
ing with hundreds of characters and a sweep of
almost 200 years of United States history. Rive-
ra's mural cycle, *Portrait of America*, maintained
that revolution in this country must develop from
native traditions, ideas, and customs and not
derive from Soviet models; at the same time Rive-
ra pleaded for the cause of Communist accord.
Rivera's thematic organization rested on conflict-
ing currents of American life. The negative
aspects he saw revealed in capitalist exploitation
of Indians, blacks, and workers; racism; and
expansionist and imperialist wars culminating in
fascism. Rivera identified the positive aspects of
American history as the Revolutionary War and
Shays' Rebellion, the abolitionist movement, the
achievements of the Transcendental thinkers and
writers as well as scientists and inventors, the
struggles of labor, and the possible beneficial
function of American industrial technology. The

165. Wall I. (*Courtesy of Lucienne Bloch Dimitroff.*)

166. Central wall with assistant Stephen Dimitroff. (*Courtesy of Lucienne Bloch Dimitroff.*)

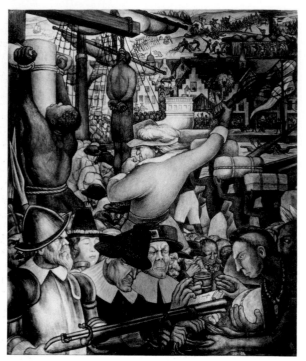

167

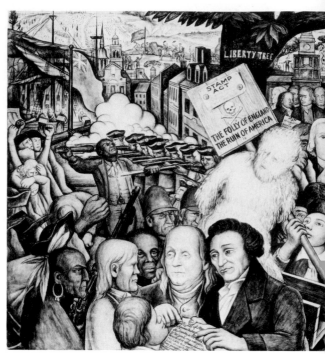

168

optimistic current in Rivera's narrative peaked
with his eloquent, if wholly unrealistic, entreaty
for Communist solidarity in the largest single pan-
el of the series, the central *Proletarian Unity*.
Another duality, this involving time, governed the
organization of the side wall panels; the paint-
ings of the east wall were titled *Historic Causes*
and the west wall *Later Day Effects*. Underlying
Rivera's vast Marxist panorama of American his-
tory, which "reads" as a mammoth revolution-
ary comic-strip, and providing the final ideological
basis for Rivera's denunciation of capitalism stood
Marx's dictum, "The history of all human soci-
ety . . . has been the history of class struggles."[185]

The panels, intended to instruct the Ameri-
can worker in making his/her revolution, began
with *Colonization*. The larger-than-life figures in
the foreground represent the forces of conquest
and exploitation of the American indigene, as the
soldier with blunderbuss, the trader taking animal
skins, the missionary, and the bulbous-nosed

whiskey vendor all prey on the Indian. In the
center the slavemaster scourges a slave, while
another—in an extreme form of punishment since
slaves represented invested capital—has been
hanged. Indentured whites unload the slave ship,
while Indians carry aboard the products of their
own labor. In the near background slaves are
counted and sold, while the rudiments of mod-
ern industry—weaving, carpentry, forging—ap-
pear. Still farther in the distance colonizers bat-
tle the Indians.

Next, in *Revolutionary Prelude*, creole and
native colonials struggle against the metropolitan
ruling class for possession of the land they work.
In the foreground Benjamin Franklin, the title
figure of "Populist Leader of the American Revo-
lution," and Thomas Paine (holding a scroll with
representative quotations) instruct a slave, worker,
Indian, and young pioneer of the necessity of rev-
olution. Directly above Crispus Attucks, a fugi-
tive slave, dies during the Boston Massacre; to

178

his left the "Sons of Liberty," protesting trade taxes and the Stamp Act, dump tea into Boston Harbor. Above Paine, a captured tax collector has been tarred and feathered, and a youth, symbol of the future, holds aloft a revolutionary banner. Beyond, the boy Samuel Adams, "the People's Tribune," and man of the town meeting, shows the way to the future. Above Adams stand the signers of the Declaration of Independence and in the far distance, George Washington, playing the role of "Kulak," is shown at his Mount Vernon estate. On the other side of "The Liberty Tree," Washington appears again, this time as a loyal colonial officer, planting the British flag after defeating the French.

The *Revolutionary War* panel features Shays' Rebellion (1786) as its central image, as Shays, the militant leader of poor farmers dispossessed of land, leads his undermatched men—with sprigs or fir in their hats, their red "Dont' Tread on Me" flag, and armed with the rifles they used against the English—against the more powerful federal forces symbolized by Washington and foreign supporters of the American Revolution. In a triangular arrangement around Shays' head loom the "temples" of the new conservative establishment: the courthouse, slave market, and Masonic Lodges control the society and economy of the new republic. To the left of this scene, Thomas Jefferson, the "aristocrat with agrarian-populist tendencies," provides the rationale for Shays' rebellious action. Only in the upper background register does the actual revolution appear. To the left Rivera shows revolutionary headquarters; in the center the revolution is fought in city and country; and to the right the Battle of Yorktown takes place. Shays' failed rebellion resulted in strengthened federal control and capitalist development, as Rivera illustrates in his next phase of American history, *Westward Expansion*.

To the left, at the apex of heads stands the conservative, Alexander Hamilton, founder of the National Bank. Below him appear John Jacob and William D. Astor, who anticipate the "future supermillionaire capitalist rulers of America," and

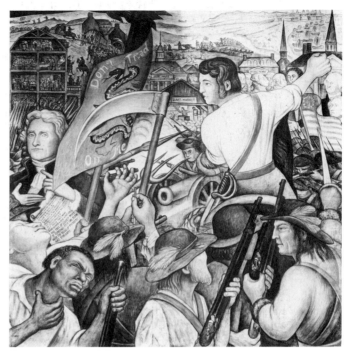

169

167. *Colonization*, 1933. Fresco. (*Photo by Peter Juley, courtesy of National Museum of American Art.*)

168. *Revolutionary Prelude*, 1933. Fresco, 6 x 5.9 ft. (*Photo by Peter Juley, courtesy of National Museum of American Art.*)

169. *Revolutionary War*, 1933. Fresco, 6 x 5.9 ft. (*Photo by Peter Juley, courtesy of National Museum of American Art.*)

179

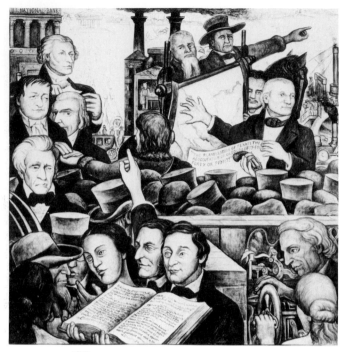

170

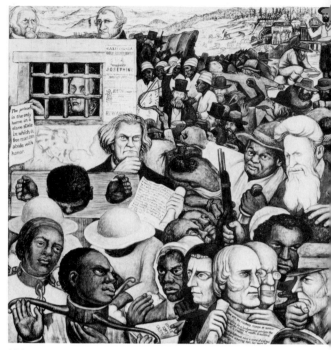

171

their "appointee," Andrew Jackson. To the right, another triangular grouping of figures, dominated by Polk with his hand on a map and holding his "54-40 or fight" banner, represents agents of expansion, along with Sam Houston, Stephen F. Austin, and Brigham Young. Below appear positive, creative, but ultimately ineffectual or co-opted forces—the Transcendentalists Fuller, Emerson, and Thoreau—to the left pointing the way to a socialist utopia (represented by the model of the Parthenon in the rear). Rivera shows that the products of inventor-artists, such as Morse, including the sewing machine, the telegraph, the railroad and steamboat, the Colt revolver, had been taken over for detrimental purposes. (From the sewing machine came the sweatshops of Lowell, pictured above Houston and Austin.)

Houston points to the "fruits" of expansion presented in the *Slavery and the Mexican War* panel, symbolized by the bloody hand print on the map, in which the heads of the generals Scott and

Taylor appear above the imprisoned Thoreau, foe of the Mexican War. From the war came California gold (shown in the upper right area) and the mineral wealth of the Rocky Mountains, but achieving industrial development cost staggering human misery, illustrated in the treatment of black slaves and Chinese workers. In the struggle against slavery Rivera depicts Nat Turner; John Brown in the midground opposes the forceful apologist for slavery (yet at the same time the opponent of capitalist "wage-slaves") John C. Calhoun. Below, in the foreground, stand enchained slaves and proponents of abolition, Sojourner Truth, H. B. Stowe, Wendell Phillips holding a scroll, William Lloyd Garrison, and Frederick Douglass. The scene pits the equally inhumane plantation slave system against northern industrialism. The clash between these two orders explodes in *Civil War*, where Rivera's hero, John Brown, figures prominently, below in the Harper's Ferry raid, and above, separated by

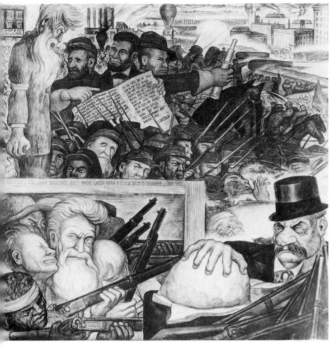

172

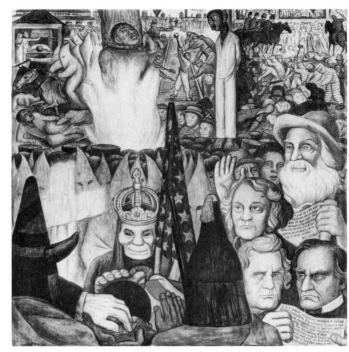

173

Marx's quote on slavery, hanged—a martyr for antislavery. Yet northern efforts, depicted alongside Brown in Lincoln's freeing of the slaves and the battles of the war, would ultimately lay the foundation for the domination of the forces of industrial capitalism, which Rivera saw as controlling the country since this time.

J. P. Morgan, gold speculator and dealer in substandard rifles (shown exploding in the soldiers' faces), personifies this trend and provides the crucial link to the next panel, *Reconstruction*, as he funds the activities of the Ku Klux Klan. The *Konklave* panel highlights scenes of the new and more severe types of postwar slavery, represented by burned and hanged blacks, nightriders, and the forced labor of Chinese and white workers. To the right stand counterforces to this more general form of enslavement, Walt Whitman and the Radical Republicans, Thaddeus Stevens, Benjamin Wade, and Charles Sumner. This opposition to the excesses of capitalistic development

170. *Westward Expansion*, 1933. Fresco, 6 x 5.9 ft. (*Photo by Peter Juley, courtesy of National Museum of American Art.*)

171. *Slavery and the Mexican War*, 1933. Fresco, 6 x 5.9 ft. (*Photo by Peter Juley, courtesy of National Museum of American Art.*)

172. *Civil War*, 1933. Fresco, 6 x 5.9 ft. (*Photo by Peter Juley, courtesy of National Museum of American Art.*)

173. *Reconstruction*, 1933. Fresco, 6 x 5.9 ft. (*Photo by Peter Juley, courtesy of National Museum of American Art.*)

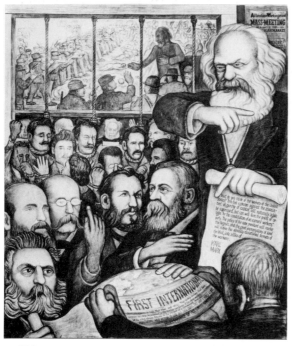

174

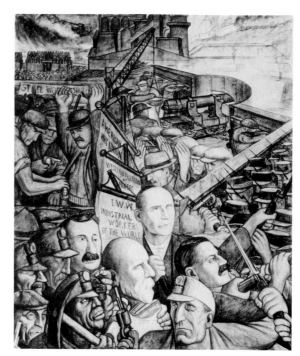

175

174. *The Labor Movement*, 1933. Fresco, 6 x 5 ft.
(*Photo by Peter Juley, courtesy of National
Museum of American Art.*)

175. *Labor Fights During the '90s*, 1933. Fresco,
6 x 5 ft. (*Photo by Peter Juley, courtesy of
National Museum of American Art.*)

176. *Modern Industry*, 1933. Fresco, 6 x 5.9 ft.
(*Photo by Peter Juley, courtesy of National
Museum of American Art.*)

peaks in the concluding panel of this wall, *The
Labor Movement*, in which Rivera portrays the
new set of class struggles, those of industrial labor,
resulting from the triumph of capitalist industri-
alism in the Civil War. Below, the labor leaders
Johann Most (anarchism), Henry George (anti–
land monopoly), Terrence Powderly (Knights of
Labor), and William Silvis (National Labor Union)
illustrate the confusion of many voices and creeds
that characterized the American labor movement
in the 1860s and 1870s. An indication of the new
and violent mood of workers and employers was
the latter's philosophy "hang first, investigate lat-
er." Above them Rivera depicts the Chicago
McCormick-Harvester demonstration of May 1,
1866 (the origin of International May Day), and
the following one at the Haymarket resulting in
the deaths of thirteen workers and the subsequent
hanging of the city's labor leaders. The impos-
ing figure of Marx, with Engels and pertinent
quotations alongside, dominates this scene, a por-

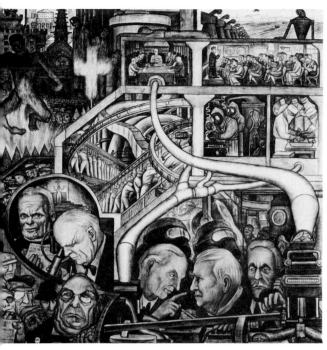

tent of the necessity of a united Communist struggle to achieve "the forcible overthrow of the whole existing social order."

The facing panel on the west wall, *Labor Fights During the 90s*, portrays the enormous sharpening of the class struggles from this era of lockouts, blacklists, injunctions, industrial spies, armed guards, and the attacks on labor by militia and troops. Rivera telescoped into one image the Homestead (steel) and Pullman (railroad) strikes. In the midst of labor violence appears a triad of great labor leaders from these years, Eugene Debs (the apex of the triangle, he formed the American Railway Union), "Big Bill" Haywood (facing the bayonet, of the Western Federation of Miners), Daniel De Leon (armed with a volume of Marx, one of the founders of the American Communist Party). Next, *Modern Industry* (opposite the reactionary period of Reconstruction) illustrates a time of capitalist consolidation, as the great trusts and heavy industry prepared,

in Rivera's view, for World War I and overseas imperialist ventures. The process of "trustification" involves the channeling of workers' labor, students' education, and scientific investigation for the immense monetary benefit of a board of directors, shown by the direct connection of the curved money pipe to the capitalist Mellon and "two American geniuses perverted by trust capital," Ford and Edison, in the foreground. Outside the pipes exploiting the labors of man into a continuous flow of gold are fanatics and quacks spawned by capitalism, exemplified by Millikan, Bishop Manning, and Aimee Semple MacPherson. Below, next to broken men and women emerging from factories, Samuel Gompers betrays the labor movement in an act of class collaboration by accepting capitalist funds. In the upper left, the Ku Klux Klan lynches and burns a black amidst the capitalist "sanctuaries" of church, bank, courthouse, and armory. From capitalist domination over industry, state power, and productive labor flow the consequences in the succeeding and increasingly violent panels concerning war, imperialism, racism, depression, and unemployment.

World War faces the *Civil War* panel and parallels it in the image of another mighty capitalist, here John D. Rockefeller, to link capitalism with war, as Wilson's pointing arm similarly indicates the origin and causes of the war. The tribunal from which Wilson speaks, dove on shoulder and backed by the monuments of capitalism, also serves as a jail for labor leaders incarcerated for war opposition: Haywood, Debs, and Ruthenberg. The war's famine victims and the maimed surround the jailed, while in the left and right foregrounds the Rockefellers and J. P. Morgan begin their speculation in war, lending funds to Clemenceau and Lloyd George, respectively, who are surrounded by other European leaders. Although Gompers's A.F. of L. pledged not to strike during the war period, active opposition arose from the Socialist Party and the I.W.W. as hundreds of their numbers were jailed, and Rivera depicts the lynching of Frank Little, a leader

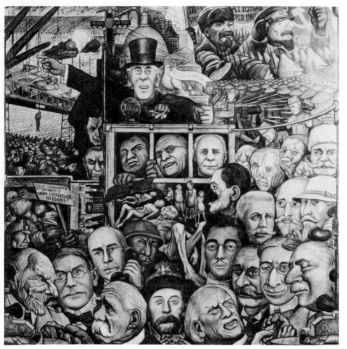

177

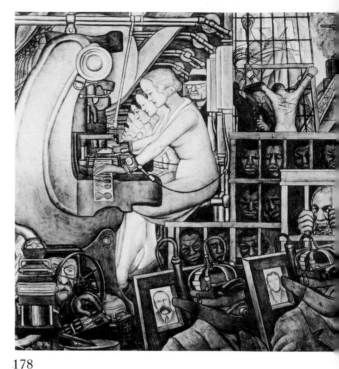

178

in the Montana copper strike, in the far middle left. In the only positive note of the panel surges the banner of the Soviet Third International, led by Trotsky and Lenin, while below American troops mutiny against their leaders at Archangel following the Allied victory. Rivera symbolizes United States aid to counterrevolutionary Russian forces by the portraits of Kerensky and Kolchak under the protective "wing" of Wilson.

Postwar repression in the area of labor, politics, and race occupies Rivera in *The New Freedom*, which has its historical antecedent in the *Slavery and the Mexican War* panel. Here he presents various methods of enslavement, dominated by the image of workers literally handcuffed to their punch press machines, their operations brutally controlled so as to prevent injury and to regulate the rhythm of work (Rivera adapted his scene from advertising copy). In this era of severe attacks on labor organizations and employers driving for "open shops," a guard flogs a work-

er, and the Statue of Liberty can be seen only through bars. Directly below are the Scottsboro Boys and Tom Mooney (both still in jail when Rivera painted), symbols of racism and capitalism's aggressive campaign against organized labor. Mooney, in his modern steel cage, occupies the place of Thoreau in the earlier panel. Instead of the slave's iron collar, Sacco and Vanzetti, victims of the anti-Communist hysteria that swept the country after World War I, are strapped to electric chairs, as Harvard's President Lowell gives his "academic blessing" to their execution.

Capitalism's repression of workers and leftists on an international level follows in *Imperialism*, the latter-day corollary of *Colonization*. The frame of Mooney's cell continues as the portal of the New York Stock Exchange, and the executed Sacco and Vanzetti become transformed into murdered Latin Americans, portrayed as a representative Caribbean black and the Cuban Communist Julio Antonio Mella (assassinated in

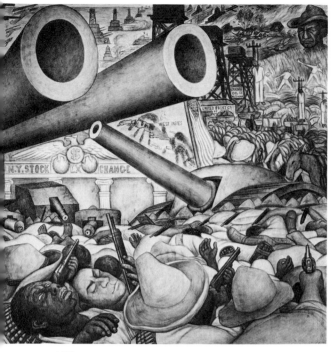

179

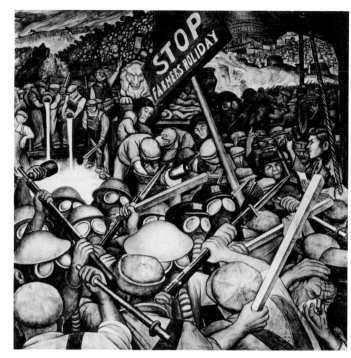

180

Mexico by agents of Machado). The United States fleet, supported by bombers, steams to Latin America, while cannons of a ship and tank together with the American flag enclose a blood-stained map of the Caribbean area, a reference to the thirty Latin American invasions made by United States forces during the first quarter of the twentieth century. The Nicaraguan rebel leader Augusto Sandino, symbol of resistance to United States imperialism, looks down from the upper right onto United Fruit, Standard Oil, sugar cane operations, and rebels hanging from telegraph poles.

Violence continues, in this case class warfare between American workers and troops, in *The Depression*; however, these twentieth-century workers lack the arms of their forebears in the Shays' Rebellion panel. Rivera pictures, in the "fatal and inevitable result" of the entire capitalist system, want in the midst of plenty as farmers dump their milk, plow under cotton, and set

177. *World War*, 1933. Fresco, 6 x 5.9 ft. (*Photo by Peter Juley, courtesy of National Museum of American Art.*)

178. *The New Freedom*, 1933. Fresco, 6 x 5.9 ft. (*Photo by Peter Juley, courtesy of National Museum of American Art.*)

179. *Imperialism*, 1933. Fresco, 6 x 5.9 ft. (*Photo by Peter Juley, courtesy of National Museum of American Art.*)

180. *The Depression*, 1933. Fresco, 6 x 5.9 ft. (*Photo by Peter Juley, courtesy of National Museum of American Art.*)

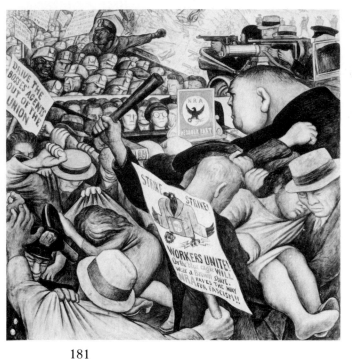

181

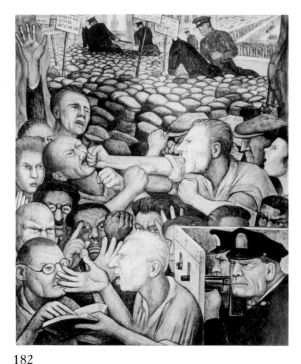

182

wheatfields on fire, while in the cities the unemployed scavenge from garbage cans. To the right a rigged foreclosure sale takes place, with one bid and a noose as warning to the auctioneer, while above the *Bonus Expeditionary Force* marches on Washington. In *The New Deal*, opposite *Revolutionary Prelude*, Rivera portrayed the "great waves of strikes by workers who are determined not to live any longer under the intolerable conditions of slavery." In the upper register armed police and "Pinkertons" attack miners, while in the foreground militant dressmakers are shown on the picket line and being sentenced en masse for violating an injunction against picketing a shop showing the National Recovery Act logo. (Rivera used the corrupt Judge Ewald, convicted of accepting bribes at this time, as his model.) The picket signs equate Roosevelt's labor reforms with fascism.

In the final, ineluctable step—in Rivera's opinion—of the process of capitalism, the last pan-

el of this wall, *Division and Depression*, depicts workers standing in endless breadlines, and, without work or organization, they are driven like cattle by mounted police. In the foreground Rivera illustrates the proletarian dissension preventing the working class from uniting in their struggle, basing his case on an actual physical confrontation that occurred between CPUSA and CPO supporters, while in the foreground two opposing Communists draw divergent opinions from the same passage, one so carried away with his argument that he has inadvertently backed up against an armored car.

Rivera painted what he saw as the inevitable result of the general state of labor's disorganization and disaccord on an international scale in the flanking "Fascism" panels of the central wall. To the left, scenes of torture, execution, the burning of labor headquarters, and military might appear in the background, as Mussolini, the recipient of papal favor and English funds, addresses

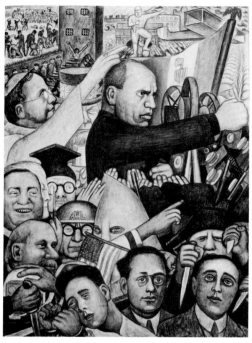

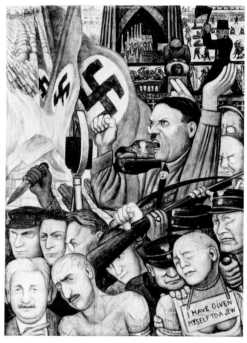

183

184

a mass rally. Below, Rivera portrays various fascist aspects of American life: an admiring university professor, a wealthy society woman, Father Cox, the KKK, the American Legion, and, again, J. P. Morgan. Much similar theatrical pageantry fills the Nazi panel to the right, as Hitler also addresses a demonstration. Book burning and various images of torture and execution fill the background. Einstein points to a tortured Jew, while a stormtrooper and the maniacal Göring surround a shaven, abused Christian girl, and a bloody knife looms over the German Communist leaders Thaelmann, Törgler, and Brandler. Workers in the smaller pendant panels attempt to halt the fascist onslaught. To the left an elderly white and a black youth break the *fasces* and strangle the Roman eagle (also alluding to the NRA, Rivera painted the eagle blue), while to the right a worker holds back a bloody dagger.

The largest painting of the series, the central *Proletarian Unity*, presents Rivera's plea for

181. *The New Deal*, 1933. Fresco, 6 x 5.9 ft. (*Photo by Peter Juley, courtesy of National Museum of American Art.*)

182. *Division and Depression*, 1933. Fresco, 6 x 5 ft. (*Photo by Peter Juley, courtesy of National Museum of American Art.*)

183. *Mussolini*, 1933. Fresco, 6 x 5 ft. (*Photo by Peter Juley, courtesy of National Museum of American Art.*)

184. *Hitler*, 1933. Fresco, 6 x 5 ft. (*Photo by Peter Juley, courtesy of National Museum of American Art.*)

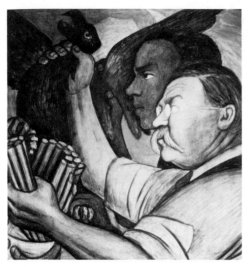

185

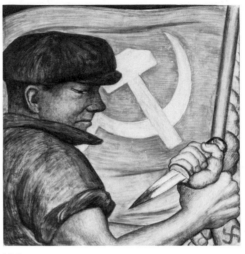

186

185. Resistance to Mussolini, 1933. Fresco, 3 x 2.7 ft. (Photo by Peter Juley, courtesy of National Museum of American Art.)

186. Resistance to Hitler, 1933. Fresco, 3 x 2.7 ft. (Photo by Peter Juley, courtesy of National Museum of American Art.)

Communist and working-class accord as the antidote to the barbaric cruelty and torture of fascism. In contrast to the violent activity of the twentieth-century and fascist panels, Rivera here creates a sense of monumental solidity and dignity by grouping together portraits of revolutionary leaders, most prominently the massive, rock-like head of Lenin, who joins in his outsizes hands the fraternal handclasp of American workers, black and white, a farmer, and soldier. Marx and Engels appear to either side of Lenin, and beside them Rivera represents three divisionary tendencies in the Soviet Union, personified by the steadfast Trotsky, the devious Stalin (looking away from the viewer), and the impish Bukharin. Two women, Rosa Luxemburg (to Lenin's right) and Clara Zetkin, complete the order of international Communist leaders, and below Rivera portrays leaders of American factions, here in theory, at least, presenting a unified front (from left to right), William Z. Foster (CPUSA), Jay Lovestone (CPO),

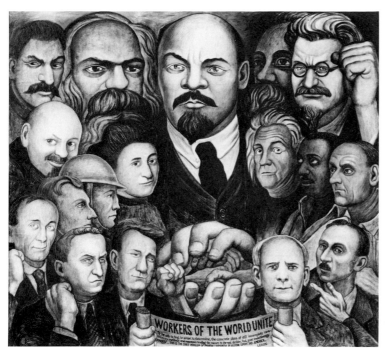

187

James P. Cannon (Trotskyites), and Charles E. Ruthenberg (American Party). Rivera's political mentor, Bertram Wolfe, points to the hands joined in unified embrace, symbolizing the message of this panel—proletarian accord.[186]

Despite the strong narrative emphasis of the panels and the mass of factual detail crammed into the nearly 700 square feet of wall area, Rivera saw his paintings as neither "anecdotal nor literary," but rather as rationally composed "plastic elements." And in fact most critics failed to comprehend Rivera's intricate and exceedingly well-planned compositional designs.[187] Limited by the hall space and the temporary site of the New Workers School, Rivera was forced to work in smaller dimensions, on moveable panels around five by six feet.[188] Within this framework, Rivera began by dividing the panels into two "harmonic triangles" (utilizing again the Golden Section) meeting on the hypotenuse. Throughout the series, the upper register served to sug-

187. *Proletarian Unity*, 1933. Fresco, 6 x 7.1 ft. (*Photo by Peter Juley, courtesy of National Museum of American Art.*)

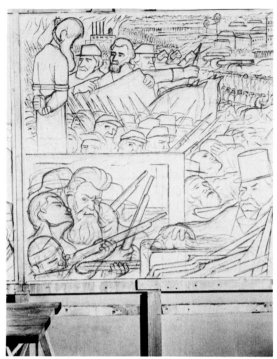

188

189

188. Wall sketch for *Civil War*, 1933.
(*Courtesy of Lucienne Bloch Dimitroff.*)

189. Constructing panels, 1933. (*Courtesy of
Lucienne Bloch Dimitroff.*)

190. Installing panels (Ben Shahn in center),
1933. (*Courtesy of Lucienne Bloch Dimitroff.*)

190

gest landscape or distance to allow the viewer's eye to "escape" from the detailed narrative to a background and also to unify the panels visually. Rivera contrasted the diminutive scale of the background with the larger-than-life-sized heads of the foreground, designed to reflect the presence of an audience in the hall but at the same time preserving their identity as painterly objects. Further, the muralist's sensitivity to his architectural environment reinforced the feeling of support generated by the walls by designing a substantial and solid object in each panel to bring together the foreground and background registers. Rivera employed a wavelike surge in his compositions to relate his paintings horizontally as well as to indicate movement in time, and this device is readily apparent in the first three paintings of the series.

In *Colonization*, a strong vertical runs along the entire extreme left (tortured slave and soldier), rebounds along the rifle to the instruments of conquest, and returns to the top of the panel by the diagonal line of indentured slaves beyond the slavemaster's elbow and then runs vertically upward (the ship's mast). The hanged black and the outstretched arm of the master form a smaller "harmonic triangle," and the sensation of movement is suggested by the curved arm and lines of the whip. Another diagonal descends the line of loading the slave ship, and continues into the center of the next panel (the quotations of Thomas Paine). The general ascending diagonal movement in *Colonization* (soldier's head through master) becomes downward in *Revolutionary Prelude* (the flag, soldiers, banner), and ascends again in *The Revolutionary War* (rifles, scythe, Daniel Shays), exemplifying Rivera's wavelike movement throughout the panels. Moreover, he created a sense of visual linkage here, as the rigging of the English ship echoes the lines of the scourge and the repeated Indians in the foreground. Between the second and third panels the branches of the "Liberty Tree" overflow into *Revolutionary War*. Jefferson mirrors Samuel Adams's instructional pose, and the diagonal staff

of the banner terminates and ascends, in the black's arm. In the uppermost register, the tiny landscape scenes portray contiguous battle scenes from the period, the early colonizers against the Indians, the French and Indian Wars, and the Revolutionary War. [189]

Technically, the New Workers School murals are unique in Rivera's career, as here Rivera worked out his compositions directly on the panels in charcoal on the third or "rough" coat of plaster with no preliminary sketches or full-scale cartoons. Photographs reveal the wall sketches to have been worked out in detail, although Rivera made some adjustments when he painted. In *Slavery and the Mexican War* the artist added the heads of Scott and Taylor above Thoreau's jail and the figure of William Lloyd Garrison to the abolitionist group. In *Civil War* he adjusted the position of the hanged Brown, emphasized the slavery motif by placing a slave dealer's building next to Brown, and greatly increased the size of Morgan's pile of gold as well as the satirical aspect of Morgan's portrait. This manner of working, made possible because of the comparatively small dimensions of the individual panels (he could not have sketched in this fashion on the large Detroit or RCA walls), provides yet another example of Rivera's enormous synthesizing talents and compositional mastery in the medium of fresco.

> By drawing and studying directly on the rough coat, elaborate studio-made paper cartoons are eliminated in whole or part according to the methods of the artist. But more important, such rough coat studies give a much truer relationship to the architecture of the painting that will follow than a paper cartoon seen in the studio or transplanted like a hot-house flower and hung in place. [190]

He worked on a scaffold about three feet from the floor, surrounded by books on various historical topics, the source material for his portraits, and he sketched in charcoal after his assistants had "snapped-in" basic geometric proportions. If dissatisfied, he would simply wipe out the charcoal lines with a rag, revise, and when satisfied,

would trace over the lines with a permanent solution of red pigment and water. Assistants would begin early in the morning with the day's plastering labors by tracing the precise section Rivera would paint that day, and applying the fourth coat, and then the final *intonaco* layer after a short wait.[191] Next the traced section would be pounced onto the *intonaco*, and all was ready for Rivera, who began by outlining the perforations from the tracing. Then Rivera applied values in black and white, and, after lunch, he began to "float" his pigments over the black and white. Finishing in the late afternoon, he would inform the assistants of what parts, if any, displeased him and must be removed, and the entire cycle began again early the next morning. The work routine varied occasionally, as when Rivera became entranced with the compositional structuring of the panels and sketched several at one time.

Rivera began painting on July 15, and by August 19 had completed four paintings and sketched two more of the east wall panels and was working on the seventh of the east wall panels. Each panel took approximately ten days, and by October 1 he had completed the east wall, half-filled the west, and had just begun the large central wall. Rivera's assistants, the Dimitroffs, have also noted his rather random manner of working, apparently dictated by whatever topic spurred his interest and his emotions at a particular moment. A case in point is *Division and Depression*, chronologically the last panel of the west wall, but painted first in this sequence after Rivera heard Bertram Wolfe's account of the altercation between CPUSA and CPO members.[192]

Reaction to the New Workers School murals, which generated much publicity and drew large crowds to the school to watch Rivera paint and hear him and Wolfe lecture on their view of American history, was predictably mixed. The school's members proclaimed Rivera as the country's first "People's Artist" and held a three-day celebration of public viewing and lectures concerning the murals in early December. Establishment press reaction to the murals and book took a general jingoistic and anti-Communist tone in denounc-

ing this aspect of the "Mexican Invasion," typified by phrases such as "complete distortion of United States history," and "textbook for incipient Communists."[193] A rare sensitive review came from the politically conservative Frank Jewett Mather, Jr., an art historian who disagreed with Rivera's political position and questioned much of the imagery. However, he recognized that the nature of the environment dictated Rivera's approach: ". . . it is the true portrait as seen by the Communist Opposition. In their meeting place, any other portraiture would be untruthful." Mather felt that the "propagandistic element" represented an "indispensable element" of the series' "greatness." Mather also addressed himself to matters such as color, composition, the balance of three-dimensional forms, and the purely esthetic merit of the murals and went so far as to term the murals "the greatest effort of artistic invention that our time has seen." Another informed response came from Anita Brenner, who characterized the works as "without question the peak of his achievement to date" and believed, much more in agreement with the murals' content than Mather, that Rivera had made a solid case in his depiction of labor history for the "vicious cheating" of American citizens' rights. However, she reacted negatively to the final image of *Proletarian Unity* as hooking "a wish-fulfillment conclusion to conflicting reality, thus 'resolving' into relief the anger, fear, distress, and other fighting emotions at first aroused"—a most perceptive contemporary observation, as history has proven Rivera's prophecy the sheerest fiction.[194] Whereas the capitalist press attacked Rivera on the grounds of "class prejudice," the CPUSA organs attacked him on "faction prejudice," the most obstreperous being Siqueiros's raging diatribe, "Rivera's Counter-Revolutionary Road."[195]

When wreckers pulled down the CPO's 14th Street headquarters in mid-December 1936, Rivera's panels underwent their first move uptown to 131 West 33rd Street.[196] With the later dissolution of the New Workers School and its parent organization, the panels, donated to the Interna-

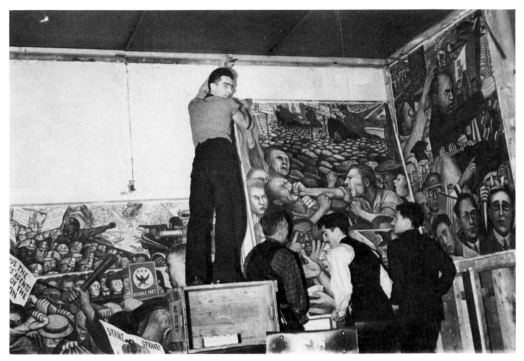

191

tional Ladies Garment Workers Union (many of whose Local 22 workers had been charter CPO members), went on "permanent exhibition" in the lounge room of Unity House, the group's non-profit summer vacation quarters in Forest Park, Pennsylvania. More accurately, the International Ladies Garment Workers Union exhibited most of the series, since the union refused to display several panels, objectionable either because of political (anti–New Deal or excessively Communist) and ethnic reasons.[197] The murals remained on view at Unity House until their destruction by fire in 1969, with the exception of five of the "censored" panels previously donated to the International Rescue Committee.[198] Rivera fulfilled his North American political obligations to the local Trotskyite group by completing two small panels in fresco for it in *The Communist League of America* (depicting Trotsky's role in the Soviet Revolution and the Fourth International). He finished by mid-December and returned to Mexico at this time.

191. Removing panels. (*Courtesy of Lucienne Bloch Dimitroff.*)

3

DAVID ALFARO SIQUEIROS

Mexico and Europe, 1911–32: Political Militancy and the Call for Revolutionary Art

Political considerations were so important to David Alfaro Siqueiros that they threatened to engulf his artistic pursuits during the years 1911–32. In fact, the first notable events in the artist's life involve politics, not art. In 1911, while enrolled at the Academy of San Carlos, the fifteen-year-old Siqueiros participated in a student strike, a protest against the school's traditional academic teaching methods, and a demand for the dismissal of the school's director, Antonio Rivas Mercado for his reactionary political stance. In 1913 he enrolled in the newly established "open-air schools" of Santa Anita (a Mexico City suburb), whose program stressed working outdoors, self-teaching, spontaneity, and improvisation, in contrast to the rigid artistic traditionalism of the academy.[1] Also during this year Siqueiros took part in the "Alardin" conspiracy against Victoriano Huerta, who usurped the presidency after killing Francisco I. Madero.

After the discovery and quashing of this protest movement, Siqueiros joined the forces of Venustiano Carranza in 1914 and worked with Dr. Atl on the revolutionary periodical *The Vanguard* published in Orizaba (Veracruz state). In 1915,

he received an appointment to the official staff of General Manuel M. Dieguez, head of the Western Division of the revolutionary army, and rose to the rank of second captain. During the period 1917–18, Siqueiros became associated with the Guadalajara-based "Centro Bohemia," whose members included José Guadalupe Zuno, Amado de la Cueva, and Xavier Guerrero. The group's program called for the creation of a national art rooted in the indigenous Mexican artistic tradition, a monumental public art, and art at the service of the Mexican Revolution.[2]

With the end of the military phase of the revolution (1910–18), the new government offered study-trips to Europe to Siqueiros and other artists who had actively participated in military action. Siqueiros would nominally serve as cultural attaché in Spain and Italy. During his European period, 1919–22, Siqueiros became aware of contemporary European art, viewed monumental Italian art, spent time in Paris, and published in 1921 the pioneering text of the twentieth-century Mexican mural movement that anticipated his future artistic search for a contemporary revolutionary mural form. He evidently produced

195

much art in Europe, for his acquaintance and fellow artist Jean Charlot, has written:

> On arrival [in Mexico, 1922] Siqueiros unpacked a trunkful of pictures, unstretched and rolled. Displeased with his European output, Siqueiros repacked his trunk, sparing only a small loosely-brushed hilly landscape once praised by Picasso "because it looked like a piece of liver. . . ."[3]

Unfortunately, Charlot did not describe Siqueiros's European work. From his comment on the "liverish" landscape, however, it would seem to have been highly varied, since what is maintained to be the only extant work from the 1919–22 period, the small pencil drawing *Portrait of W. Kennedy* of 1920, lacks the spontaneity and painterly handling of the landscape.[4] In Italy, Siqueiros would have seen the work of the Futurists and that of the Metaphysical School. The rigidly controlled *Kennedy* drawing shows the influence of Carlo Carrá's post-Futurist paintings of 1917–18, especially with what Carrá called his preoccupation with "*concrete forms* . . . placed in space."[5] Like Carrá's paintings, Siqueiros's drawing contains large basic forms, including a mannequin reminiscent of the paintings of Giorgio de Chirico, although Siqueiros uses it in an interior setting. The drawing documents at least one aspect of Siqueiros's study of modern European art and looks forward to Siqueiros's call for a more architectonically oriented art in his 1921 manifesto.

In Europe Siqueiros met frequently with Diego Rivera, who introduced him to artists then working in Paris and shared with Siqueiros his comprehensive knowledge of European art, past and present. Siqueiros brought Rivera up to date on Mexican events, particularly those surrounding the cataclysmic upheaval of the revolution. While much of their talk and correspondence concerned Mexican topics, such as art forms, peoples, and folk art, more relevant for the future were their discussions regarding the possibilities for a postrevolutionary artistic program in Mexico. In for-

mulating these ideas they became increasingly attracted to monumental art, particularly the murals of the Italian Renaissance and Baroque. However, the artists had entirely different preferences and ended by having only one point of agreement: to return to Mexico and paint monumental works inspired by Mexican themes.[6]

Siqueiros's Barcelona manifesto of 1921, "Three Appeals of Timely Orientation to Painters and Sculptors of America," would lead directly to the first postrevolutionary murals of 1922–24, as well as presage many of Siqueiros's later artistic concerns as a revolutionary muralist.[7] In the first of the manifesto's "appeals," Siqueiros criticized the "pernicious influence" of Art Nouveau and the resultant "marked decadence" of Spanish art (excepting such artists as Picasso and Gris) from the end of the nineteenth century until the present time. On the other hand, Siqueiros praised new positive developments—the achievements of Cézanne, Cubism, and Futurism—and proclaimed his enthusiasm for the "new subjects and new aspects" of the twentieth-century machine age:

> We must live our marvelous dynamic age! love the modern machine, dispenser of unexpected plastic emotions, the contemporary aspects of our daily life, our cities in the process of construction, the sober and practical engineering of our modern buildings. . . . Above all, we must remain firmly convinced that the *Art of the Future* is bound to be, barring unavoidable transitory decadence, ascendingly *Superior*.[8]

Second, Siqueiros observed in language strongly reminiscent of Cézanne's theories, that "we draw silhouettes, filling them with pretty colors; when modeling, we remain engrossed with skin-deep arabesques and overlook the concept of great primary masses: cubes, cones, spheres, cylinders, pyramids, the scaffold of all plastic architecture. . . ." Following his praise of Cubism, he called for Mexican artists to learn from the "clarity and depth" of their own indigenous American artistic tradition:

An understanding of the admirable human content of "Negro art" and "primitive art" in general has oriented the plastic arts toward a clarity and depth lost for four centuries in an underbrush of indecision: as regards ourselves, we must come closer to the works of the ancient settlers of our vales, Indian painters and sculptors (Maya, Aztec, Inca, etc.). . . . Let us borrow their synthetic energy, but let us avoid lamentable archaeological reconstructions so fashionable among us, "Indianism," "Primitivism," "Americanism."

In the least important "appeal," Siqueiros brought together unrelated matters, such as his call for the rejection of purely nationalistic art and for artistic education, and his exhortation that Latin American artists embrace the esthetic advances of Cubism and reject narrative painting. In this manifesto, then, Siqueiros recapitulated his European period, when he first became aware of mainstream developments of twentieth-century European modernism and rejected his earlier Art Nouveau–inspired Mexican art. Even more significant, it indicated the general direction of his future artistic concerns, particularly his desire to borrow the forms of indigenous American art for his own contemporary expression.

Siqueiros returned to Mexico at the repeated urging of the education minister, José Vasconcelos, in mid-1922 to join his ambitious program for a Mexican "plastic renaissance." Siqueiros eagerly endorsed Vasconcelos's plans for an art program:

Before all, I must sincerely confess that the enthusiasm that your letter breathes intensified my own great desire to return to my *patria*, there to share in the common work with all my strength.

I find myself in total agreement with your basic idea: "To create a new civilization extracted from the very bowels of Mexico," and firmly believe that our youth will rally to this banner. . . .

When I asked you for a prolongation of my pension for one year, I meant to study part of the time in Italy and part in Spain before coming back to Mexico, but a DESIRE TO RETURN SOONER TO MY *PATRIA* TO WORK THERE (a desire that I owe specifically to your own intelligent initiative concerning art) led me to modify this program. . . .[9]

In December 1922 Siqueiros joined the group of painters engaged in painting the walls of the National Preparatory School. His series of unrelated murals containing bewildering imagery seems to have been dictated by a totally intuitive compositional approach. Siqueiros later acknowledged the compositional failure of these murals and his own lack of understanding of the relationship of mural painting to its architectural environment; he characterized this period as "one of window-painting, of the easel picture simply enlarged and stuck on the wall, without any breadth of conception or real comprehension of the true problem of modern fresco."[10] The murals, situated in a cubical stairwell of three levels of the "Colegio Chico" of the school, cover an area of vaulting sidewalls and ceiling of some 200 square meters.[11] Siqueiros painted *The Elements* in the vaulting of the first stairwell and a small scroll symbol directly beneath it. A curious painting follows on the wall of this stairway: two painted windows look out onto a landscape scene, with a painted column placed between them. At the first landing, portraits of a male worker (three-quarter length) and a woman peasant (half length) face each other. A woman's portrait occupies one of the two smaller, lateral panels of the landing, surrounded by four generalized shell shapes similar to those in *The Elements*; in the other panel the shell shapes occur but the central area is indistinguishable. A full-length generalized woman worker (in a coffin?) covers the vaulting of the second stairway, on each side bordered by the shell shapes of the previous paintings, and the lateral wall repeats the painting of the first stairway wall. There is nothing on the lower area of the third stairway, while the upper area comprises disparate elements: a hammer and sickle between two windows and, above, two floating figures. Siqueiros painted the incompleted *Burial of the*

197

192

193

194

192. *The Elements*, National Preparatory School,
1922–23. Encaustic mural.

193. *Portrait of Woman*, National Preparatory
School, 1923–24. Fresco, approx. 20 x 6 ft.
(*Courtesy of Siquieros Archives.*)

194. *Burial of the Martyred Worker* (unfinished),
1923–24. Fresco. (*Courtesy of Siqueiros Archives.*)

195. General view of upper stairwell, National
Preparatory School, 1923–24. (*Courtesy of
Siqueiros Archives.*)

195

Martyred Worker and *The Call to Liberty* on the final stairway wall, and a repeated spiral motif covers the ceiling.

Siqueiros's first Preparatoria mural, *The Elements,* clearly derives in its composition and figural style from his study of the Italian Renaissance (the powerfully rendered female form immediately recalls Michelangelo). He also introduces here in embryonic form a motif that would distinguish his later work—a supermuscular human form, "activated" by compositional distortions on a concave surface, hurtling toward the spectator. Surrounding the powerful form, Siqueiros's primary interest, are traditional Christian elements, "wings" above and a "crescent moon" below, and more-or-less abstract symbols whose only function appears to be the filling of wall space. The actual painting of *The Elements* caused Siqueiros great problems. Despite the small dimensions of approximately eight square meters, Charlot says that painting the vault in encaustic took some eight months, from around late December 1922 until July 1923, and that Siqueiros "did over and over again the same stretch of wall," all in secret behind a high fence. Siqueiros's snail-like work pace, surely based on his inexperience with compositional and technical facets of mural painting, angered his patron Vasconcelos. "I was patient with Siqueiros who, during all that time," Vasconcelos noted, "failed to finish some mysterious sea-shells in the stairway of the small patio of the Preparatoria."[12]

The artist's first mural reflected the curious thematic aspect not only of his set of Preparatory School murals but also of the entire mural program, so strongly affected by the humanist-classicist orientation of Vasconcelos's education policies:

> Upon beginning the artists tried to give form to the neo-classicist ideals of Vasconcelos. They painted allegories . . . in which they used Christian myths and occult signs. Before orienting themselves toward a popular, national, political and revolutionary art,

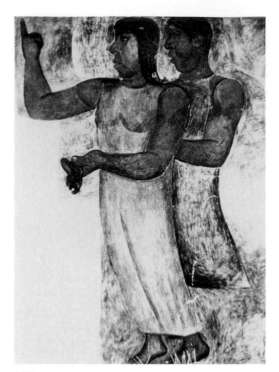

196

196. *Call to Liberty*, 1923–24. Fresco. (*Courtesy of Siqueiros Archives.*)

200

the painters affirmed the known and hallowed: religious art.[13]

The Elements, then, should be seen as no exception to the general thematic pattern for the first murals at the Preparatory School. Siqueiros has described the painting's traditional iconography: "I, for my part, painted the elements: water, fire, wind, etc., and above and controlling these—the figure of an angel in the style more or less of colonial Mexico."[14] As a representative first effort of Vasconcelos's mural projects, *The Elements* does not portray conditions in postrevolutionary Mexico, but it is curious that the work contradicts the express spirit of Siqueiros's letter to Vasconcelos in which he had written enthusiastically of his desire to work for his *patria* to create a plastic Renaissance for the postrevolutionary Mexican civilization.

Although Siqueiros's Preparatory School murals were artistic failures, they were an important part of his long and arduous development as revolutionary muralist. In the incompleted murals of 1923–24, *Burial of the Martyred Worker* and *Call to Liberty*, he abandoned the Italian Renaissance aspects of *The Elements* and successfully assimilated the forms of pre-Conquest Indian art—specifically Olmec and Aztec sculpture—for the purpose of contemporary Mexican political commentary. Siqueiros emphasized the revitalization of the indigenous heritage by twentieth-century Latin American artists in the 1923 manifesto he wrote for the artists' union, the Syndicate of Technical Workers, Painters, and Sculptors:

Not only the noble labor but even the smallest manifestations of the material and spiritual vitality of our race spring from our native midst. Its admirable, exceptional, and peculiar ability to create beauty—the art of the Mexican people—is the highest and greatest spiritual expression of the world-tradition that constitutes our most valued heritage.

Siqueiros adopted the forms of Mexican pre-Conquest art and the basic monumental treatment by drawing on the physiognomic character of Olmec sculptural figures. He used the same high forehead and cheekbones, slanted eyes, large protruding nose and lips. His appropriation of the Olmec style epitomized the flowering of interest in this area on the part of Mexican artists around 1920. One of the first statements indicative of this trend came from Carlos Mérida (born in Guatemala of Maya stock) in the catalog for his 1920 Mexico City exhibition, devoted in large part to Maya subject matter:

My painting is fired with an intimate conviction that it is imperative to produce a totally American art. I believe that America, possessed of such a glorious past, with both nature and race original in character, will doubtless breed a personal artistic expression. This is a task for the prophetic vision of the young artists of America.[15]

Diego Rivera, who would later incorporate pre-Conquest art into his vast National Palace cycle, spoke in a kindred vein on his return to Mexico in 1921: "I could tell you much concerning the progress to be made by a painter, a sculptor, an artist, if he observes, analyzes, studies, Maya, Aztec, or Toltec art, none of which falls short of any other art in my opinion."[16] The Mexican artists' keen appreciation of the esthetic values of pre-Conquest art stemmed directly from their exposure to modern European art, particularly Cézanne and Cubism, and their awareness of basic similarities between modern European and indigenous Mexican art, which originated with a European interest in "primitive" art.[17] Diego Rivera had been primarily responsible for the importation of Cubism to Mexico and served as the tireless proselytizer for the Cubist cause in Mexico during the 1920s. Siqueiros called for the creation of "great primary forms" in his 1921 Barcelona manifesto, and it became evident to the Mexicans that Aztec sculptors, to use only one example, had worked in this manner, using monumental form, geometrical structure, and a complex system of interlocking sculptural planes. In

one of the massively beautiful masterworks of Aztec art, the *Coatlicue*, the Mexican artists recognized the essential "plastic purity" of indigenous Mexican art.

In *Burial of the Martyred Worker* and *Call to Liberty* Siqueiros abandoned the neoclassical ideals and nonpolitical theme of *The Elements* for the plight of the oppressed proletariat, a topic he would treat with increasing specificity and currency during the 1930s. The transformation in Siqueiros's work from traditional Christian allegory to paintings dealing with contemporary Mexican conditions typifies the trend of the mid-1920s for muralists to include overt political commentary in their art.[18] The artists also became more involved in radical politics; Siqueiros and Xavier Guerrero became members of the Executive Committee of the Mexican Communist party in 1923 and were instrumental in organizing the artists' Syndicate. The Syndicate's manifesto urged the overthrow of an "old and inhuman system" by the "worker and Indian soldier," exalted the pre-Conquest Indian artistic tradition, and called for the creation of monumental public art. "We repudiate the so-called easel art and all such art which springs from ultra-intellectual circles, for it is essentially aristocratic. We hail the monumental expression of public art because such art is public property."[19]

Siqueiros was also in charge of the art produced for the Syndicate's broadsheet publication, *El Machete*, pasted on public walls to speak to the masses:

> *El Machete* was our "presentation card" to the great number of organized workers in the country. . . . We became militant politically and this militancy brought with it inevitable differences with the government—patron of our murals—this government [the rightist administration of Plutarco Elias Calles] who initiated at this time a period of contraction in the Mexican Revolution that was to last until the advent of Cárdenas to power.[20]

Siqueiros's radical political activities of this peri-

197

197. Portrait of Ione Robinson, 1931. Oil on gunny-sack, 34½ x 23 in. (*Courtesy Zeitlin and Ver Brugge, Los Angeles.*)

198. *Proletarian Mother*, 1930. Oil on jute, 8.2 x 5.9 ft. (*Courtesy of Siqueiros Archives.*)

199. *Peasant Mother*, c. 1930. Oil, approx. 8 x 6 ft. (*Courtesy of Siqueiros Archives.*)

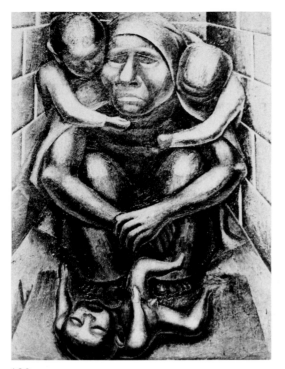

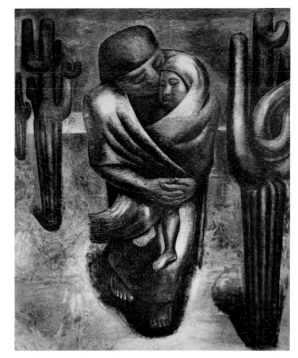

198 199

od found their artistic expression in *Burial of the Martyred Worker* and *Call to Liberty*. In these paintings he exhorted the worker, and more particularly the Indian worker, to rise against his oppressors and present a unified, unyielding front through the Communist party. The hammer and sickle on the worker's coffin signals his resistance to capitalistic violence against his class.

After forced cessation of work on the Preparatory School murals in 1924, largely owing to the protests of the reactionary press, students, and faculty, Siqueiros seems to have withdrawn completely from painting until 1930.[21] During this period he engaged in union organizing, primarily with the miners of the western Mexican states, and in related leftist political activities. As a direct result of his jailing after the tumultuous May Day 1930 demonstrations in Mexico City and his confinement to the outlying village of Taxco from late 1930 until early 1932, Siqueiros produced a

substantial body of easel and graphic work—some 150 paintings, including commissioned portraits to alleviate his desperate financial condition.[22] The subject matter of most of this work was drawn thematically from his political experiences of 1925–30 and intended to appeal to a mass audience. Stylistically, these socially oriented paintings continue in the monumental vein of the 1923–24 Preparatory School murals and show, in the solid, rocklike forms, strong light and dark modeling, the increased influence of Aztec sculpture. As was the case with the earlier murals, however, Siqueiros desired to infuse the indigenous style with contemporary political meaning. Despite their large proportions the ample, even bulky, forms resemble mural details cramped within the picture frame, especially in the *Proletarian Mother* and *Peasant Mother*. Reinforcing the uncomfortable visual sensation created by confining the mural forms to the easel format was

Siqueiros's painting technique, the rough-textured surfaces, and dark, somber coloration. Part of his new look resulted from use of the thick local fiber *henequén*, instead of canvas. Also, Siqueiros experimented with pigments, combining a native resin, *copal*, and oil to obtain a greater impasto effect. Deliberately "ugly" paintings resulted from Siqueiros's form and technique, and he meant these works to deny traditional esthetic response and speak directly to a popular audience.

Siqueiros summarized his politico-esthetic views of this period in a lecture he gave at the closing of his first Mexican one-man exhibition in Mexico in 1932.[23] The lecture, "Rectification About the Plastic Arts in Mexico," included Siqueiros's view of the contemporary Mexican artistic situation and his call for the militant political commitment of the artist. He criticized postrevolutionary art education for continuing the basic academic pedagogy of the Porfirian era and advocated instead a return to the workshop-apprenticeship system directed by a master artist. While Siqueiros saw the great contemporary interest in Mexican popular art as a "natural reaction" against aristocratic Porfirian art, he condemned popular art "as a degraded manifestation of a race of people enslaved for centuries," during which time they had lost the ability to express themselves in the monumental terms of the past. Further, Siqueiros believed that the interest in popular art paralleled the development of foreign tourism, one of the effects of the "penetration of North American imperialism in Mexico," and had produced a fetish-like admiration of "Mexican curious" art. A great danger to professional artists—here he cited Diego Rivera—was their concession to this trend and the creation of "typical Mexico" works for folkloric export. In opposing this fashion, Siqueiros said: "We must be modern and international above all things; but we must contribute to the universal aesthetic the plastic values that are in our hands." At the same time, however, Siqueiros also opposed the "snobbish" reaction of some Mexican artists to "Mexican curious" art, and their imitation of European formal models whereby they completely abandoned "the physical reality of the geographic region in which we live." Against these contemporary trends, Siqueiros posited the future role of mural painting and the return to "formal painting," or the fully completed work of art in the Renaissance tradition as opposed to the contemporary importance given "initial works" (drawings and sketches). Here Siqueiros advocated the cause of social art, given the historical condition that "the present age is the age of the struggle of exasperated classes, the age of imperialism, last stage of the capitalist regime." He hoped for an art that would express the "revolutionary ideology of the masses" but also be a "great art, plastically speaking." He believed that the artist could not remain indifferent "to the struggle which will liberate humanity and art," but, rather, he must "collaborate aesthetically and individually with the class historically predestined to change anew our present society."

The primary political thrust of the Casino Español speech found its visual expression in the works shown in the exhibition. Siqueiros's "proletarian votives," while they adopted the popular religious art form, stood in opposition to the folkloric "Mexican curious" art. The socially oriented Taxco paintings derived from Siqueiros's labor and political activities of 1925–30 and reflected his personal experiences and observations during those years. Rather than the more positive, even wish-fulfilling, tone of the Preparatory School murals, these works are devoted to the actual suffering of the Mexican masses at this time. In keeping with Siqueiros's primarily rural activities, many comment on rural conditions, such as a mine accident, the imprisonment and torture of farmers, and the resultant misery of shattered families, abandoned and dead children, and other similar images of social repression and ongoing suffering. These paintings illustrate Siqueiros's ability to create a twentieth-century

Mexican art form neither strongly influenced by foreign capital, nor resulting from the imitation of abstract European models. The larger works, in effect "portable" murals, such as *Proletarian Mother* and *Peasant Mother,* exemplify Siqueiros's appropriation of indigenous Mexican forms—"the monumental terms of the past"—for the purposes of twentieth-century political commentary. Also, the mass-oriented media of the "proletarian votive" and portable mural, and their unflinch-ing sociopolitical criticism, demonstrated Siqueiros's firm commitment to an art that would express the "revolutionary ideology of the masses."

Finally, although the Casino Español speech indicated the political stance of Siqueiros as artist, it remained mute concerning the technico-formal means to achieve these political ends: this search would be Siqueiros's major esthetic problem for the rest of the 1930s.

Los Angeles, 1932: Technical Innovation at the Service of Radical Politics

Siqueiros's North American years, 1932 (Los Angeles) and 1936 (New York), represent an entirely new approach on his part to politico-artistic questions. In Los Angeles, for example, he first employed the instruments of North American industrial technology and utilized collective, or "team," painting. His Los Angeles murals marked Siqueiros's first, if unsuccessful, attempt to create large-scale exterior murals, in his words, "the great uncovered mural painting—in the free air, facing the sun, facing the rain, for the masses."[24] The political imagery of his art became increasingly specific during these years. In Los Angeles Siqueiros commented on the contemporary Mexican political situation and in New York illustrated the political aims of the Communist Party of the United States of America. These years represent a radical departure in Siqueiros's artistic exploration, with the art he produced bearing little or no relationship to his earlier Mexican work. Yet the artist's quest during this period to produce unreservedly experimental art would not bear fruit until the execution of the mural for the Mexican Electricians Union in 1939–40, the first fully developed work in Siqueiros's manner of "dialectical realism."

· · ·

Exiled from Mexico following his Casino Español exhibition, Siqueiros's concentrated artistic activities in Los Angeles from May to November of 1932 resulted in the completion of three murals and formed a decisive period in his evolution as revolutionary muralist.[25] The Los Angeles murals contain elements totally new to Siqueiros's art: technical experimentation with the tools of North American industrial technology and strident sociopolitical criticism against racism, United States imperialism, and the current political situation in Mexico. These murals were Siqueiros's first, albeit tentative, expressions of an alternative mural technique that would dramatically differentiate his mature murals from the traditional technical means employed by Orozco and Rivera.

Grace Clements, artist and executive committee member of the Hollywood John Reed Club, discussed Siqueiros's Los Angeles activities in a letter to Louis Lozowick of the New York John Reed Club:

Comrade Siqueiros is at the present time in L.A. and has completed a fresco of revolutionary subject matter at the Chouinard Art School where he has also had a class in fresco painting—the members of which he claims to have "propagandized" under his tutelage and should supply at least a few possible members for the club and perhaps the school [the proposed John Reed Club Art School]. Siqueiros is eager to work with us while he is here and is scheduled to give a lecture in about three weeks. We have been waiting to hear word from Joe Freeman [a Communist party member who had previously denounced Diego Rivera and his art] regarding Siqueiros' present standing since he tells us he has had some difference with the party in Mexico.[26]

Siqueiros entitled his John Reed Club lecture (noted by Clements in her lecture) "The Vehicles of Dialectic-Subversive Painting." Here Siqueiros spoke in quite specific terms regarding his "technical revolution" in painting (discussed in Appendix A), but the particular nature of his "dialectical-subversive" art was less clear. In language certainly owing to his conversations with the Soviet filmmaker S. M. Eisenstein in Taxco (1930–31) on the character of twentieth-century revolutionary esthetics, Siqueiros proposed, albeit imprecisely, the establishment of predetermined psychological reactions by means of art forms:

> The Bloc [Siqueiros's "Bloc of Mural Painters"] tries to determine the psychological nature and measure of colors, tones, values, forms, volumes, spaces, textures, combinations, rhythms, equilibria, and the mechanics of motion, which are by nature active or passive, depressive or impulsive, reactionary or subversive in their essence and psychologico-plastic interplay. General psychology has already touched the question of colors from a medical standpoint and for the service of applied medicine. There is need now to carry this science over into the field of plastic arts and into aesthetics in general. This enterprise is of immense importance to art as an absolute human product, but even more so is it to the dialectical art of the modern era.[27]

In the concluding section Siqueiros came closer to defining his new art form:

> The daily march on the road to its final objective, the passage of a revolutionary aesthetic through the period of illegality, will give to the plastic of propaganda and agitation the dialectic subversive style which it requires; to the corresponding style its own language, its own methodology, its own form, that is to say, the plastic form of the epoch of the final proletarian struggle against the capitalistic state; a form which will have nothing in common with the dry forms of the past, nor with eccentric "snob" forms of the present. This form will be neither academic nor modernist; it shall be dialectic and subversive, that is to say, logically materialistic, objective, dynamic.

Although Siqueiros failed here to interpret the "style" or "language" of his "dialectic-subversive" art, this art would be overtly Marxist in content: "the plastic form of the epoch of the final proletarian struggle against the capitalist state." Siqueiros devoted his art of the 1930s to this end as he depicted specific causes and issues supported by the United States and Mexican Communist parties and Popular Front organizations in both countries.

By the middle of June Siqueiros had begun mural instruction at the Chouinard School of Art with several students who would work with him as the "Bloc of Mural Painters" on the first of the experimental Los Angeles murals, *Workers' Meeting*.[28] According to Siqueiros, commissioning of *Workers' Meeting* resulted from the invitation he had received in Taxco from Mrs. Nelbert M. Chouinard to teach a mural course at the Chouinard School of Art. Siqueiros believed that he had been invited primarily as a representative of the then-popular "Mexican School," and that Mrs. Chouinard "was not interested in my own work, she simply wanted to pay me a small salary to teach the painters the procedure of painting *al fresco*."[29] The mural was completed in two weeks on the twenty-by-twenty-five-foot wall of the school's sculpture court, a surface broken by three

windows in the upper register and a door in the lower.

The use of waterproof cement, spray gun, and stencils marked a significant advance in Siqueiros's mural technique from the 1922–24 Preparatory School murals. Siqueiros's decision to use white, waterproof cement and the spray gun for pigment application because of the difficulty in working in traditional *buon fresco* on an exterior site came about after consultation with the architects Richard J. Neutra and Sumner Spaulding.[30] According to Siqueiros's companion, Blanca Luz Brum, he used stencils for the first time to produce the shadows cast by the workers in the top register. Also, photographs taken of actual labor meetings and construction sites visited by the Bloc painters replaced traditional preliminary sketches.[31] In addition to the vastly more rapid work pace made possible by the new technology, in *Workers' Meeting* Siqueiros achieved a sense of visual continuity lacking in the Preparatory School murals.

The two horizontal tiers of workers reinforce the horizontal architectural element (the three windows), and the workers provide compositional unity among the various registers as they react to the speech of the labor agitator. The cast shadows of the uppermost workers supply further visual interaction between registers. In the lower section, the placement of the man and woman holding children focuses attention on the key figure, the labor organizer. If Siqueiros did not achieve a totally unified composition here (note the awkward treatment of the door), he nonetheless demonstrated for the first time an awareness of a basic tenet of mural painting, the necessity of the painting's compositional integration with the mural's architectural environment. In the Los Angeles murals Siqueiros increased the range of his subject matter from the purely Mexican content of the 1930–32 Taxco works. Here he intended strong social commentary: "its object was to combat the anti-democratic politics of racial discrimination in the south of the United States."[32] Thus Siqueiros portrays construction workers tak-

ing a break from their work, intently listening to a vehement speech by a labor agitator. The speaker is surrounded by the downtrodden, a black man and white woman with children in their arms— the visual representations of the theme of his speech.[33]

Brum has argued that, perhaps because of the conservative tendencies of the school, Siqueiros tried to disguise the meaning of the mural. At any rate, he finished the lower section last, working alone and behind closed doors.[34] The dedication was celebrated on July 7, and Siqueiros spoke out strongly against capitalism, North American imperialism, and "snob" easel painting before an enthusiatic audience of 800 people.[35]

The publicity generated by events surrounding *Workers' Meeting* resulted in the commissioning of the Plaza Art Center project, *Tropical America,* technically and esthetically the most ambitious of Siqueiros's Los Angeles murals. The mural covered an exterior wall of the center facing Olvera Street, the main street of the Mexican district, and was highly visible from adjoining streets and surrounding buildings. Technically, the work continued the experimentation of *Workers' Meeting*; as Siqueiros wrote a friend during the painting of the mural, which was begun in mid-August: "In this new work we are integrally applying our new technique: fresco on cement instead of painting on lime and sand, air-brush exclusively, photographic sketches, air compressors, etc. Moreover, the fresco can be seen from three different streets."[36]

Another innovation of immense importance for Siqueiros's mature murals was his use of photographs of the wall from various viewpoints instead of the traditional preparatory drawing. He came to realize that photographic "sketches" of a mural site revealed the essential "active" surface of a wall. While Siqueiros's initial interest in the artistic possibilities of the camera surely derived from conversations with S. M. Eisenstein in Mexico, the specific use of photographs taken from different points of view of the mural site to determine

200

200. *Tropical America*, view from the street,
later in the 1930s. (*Courtesy of Jean Bruce Poole,
El Pueblo de Los Angeles State Historic Park.*)

the mural's composition evidently came about by
a fortuitous accident.[37] Siqueiros recalled assign-
ing a "worthless mural assistant," a known cam-
era fanatic, to photograph the Plaza Art Center
mural site from all possible points of view, so as
to effectively remove him from the project. The
photographer proceeded to take pictures from all
possible angles, heights, and distances, and the
results astonished Siqueiros, for he saw from the
photos that the wall assumed different propor-
tions according to one's point of view. It became,
in fact, an "active" surface: "We proved with-
out the slightest doubt in this way that the geo-
metric area of our mural was an active area,
dynamic, an incredibly beautiful 'kinetic' pheno-
menon. . . ."[38] Despite Siqueiros's belief in the
importance of his "discovery," his technical in-
experience prevented him from actually incor-
porating photographic sketches, in lieu of the
preparatory sketch, into this work. His prepara-
tory drawing illustrates a traditional geometric

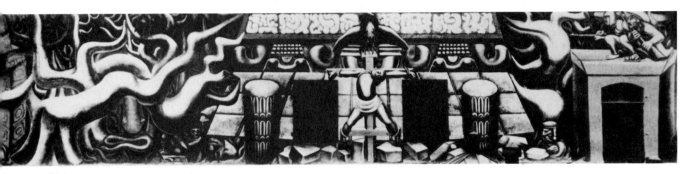

201

analysis of the mural surface. He would, however, use photography later to create pictorial distortion based on the spectator's various viewpoints within a mural's architectural environment.

In *Tropical America* Siqueiros used his first "baroque" composition, the first expression of what would be the primary stylistic tendency of his mature murals, however disguised by his use of twentieth-century technology and his, at times, bombastic rhetoric. The surging motion of sinuous, organic jungle forms evidences the specific influence of the eighteenth-century Mexican *churrigueresque* style.[39] While Siqueiros would later incorporate compositional distortion and introduce new architectural elements of his own in order to create a unified painterly environment, as in the Electricians Union and Chillán murals (Mexico City, 1939–40, and Chile, 1941–42, respectively), here the "baroque" treatment remained limited to surface decoration of the lateral sections and was held in check by the rectilinear

201. *Tropical America*. Fresco applied with airgun on cement, 19.7 x 98. 4 ft. (*Courtesy of Siqueiros Archives*.)

orientation of the central area. In the columns and inscriptions of the central section there is a counterplay of the curvilinear elements against the geometric. Also, two elements appeared in this area that Siqueiros would develop further: the strong, even harsh, modeling of the crucified indigene and the recessive pyramid as the focal point for the action within the mural. Siqueiros's composition vis-à-vis architectural elements also improved, as evidenced by his adapting into the design the window on the far right and two doors in the center.[40]

In addition to the technical and compositional innovations of *Tropical America*, the mural marked Siqueiros's first treatment of United States imperialism in Latin America. F. K. Ferenz, the director of the Plaza Art Center, had suggested what Siqueiros believed to be a purposely innocuous theme, one that would deal with "a continent of happy men surrounded by palm trees, where fruits fell of their own volition into the arms of happy mortals."[41] Yet, Siqueiros had a radical approach in mind:

> It has been asked that I paint something related to tropical America, possibly thinking that this new theme would give no margin to create a work of revolutionary character. On the contrary, it seems to be that there couldn't be a better theme to use. I am pleased and hope to demonstrate this.[42]

Siqueiros's combative political position regarding the colonial status of Latin America in respect to its relations with the United States would have been particularly meaningful to residents of "Sonora Town" (the Mexican barrio in Los Angeles) who were being deported to Mexico in large numbers during the depression years, in many cases even if they held United States citizenship.[43]

Siqueiros depicted a lush tropical jungle scene, with his version of a pre-Conquest temple lying in ruins in the center of the mural. In front of the temple, an American indigene has been crucified on a double cross, surmounted by the imperialist eagle, symbolizing the United States. To

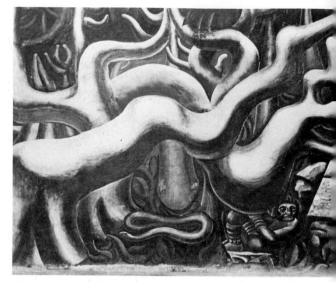

202

203

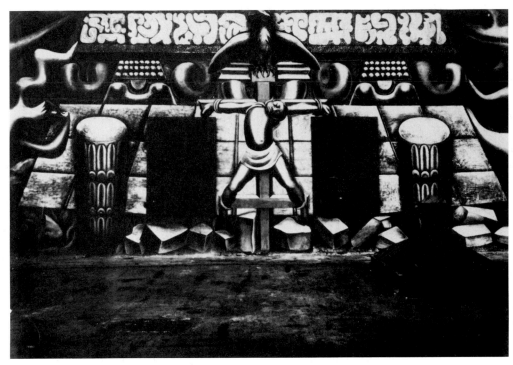

204

the right, a Peruvian Indian and Mexican *campesino*, both armed, ready their revolutionary attack; to the left surges a mass of organic tropical forms. Siqueiros clearly intended a strident presentation of the revolutionary, antiimperialist theme of the mural:

> It is a violent symbol of the Indian *peon* of feudal America doubly crucified by the oppressors, in turn, native exploitive classes and imperialism.
>
> It is the living symbol of the destruction of past national American cultures by the invaders of yesterday and today.
>
> It is the preparatory action of the revolution that enters the scene and readies its cartridges to effectively launch the life-restoring battle for a new social order.[44]

The artist illustrated Latin America's colonial dependence in the central section of *Tropical America*. In placing the imperial eagle atop the cross, Siqueiros denounces the United States as the cause and controlling force of Latin Ameri-

202. Detail (left), *Tropical America*. (*Courtesy of Siqueiros Archives.*)

203. Study for *Tropical America, The Warriors,* n.d. Pencil and ink drawing, 8½ x 13 in. (*San Francisco Museum of Modern Art, Albert M. Bender Collection.*)

204. Detail (center), *Tropical America*. (*Courtesy of Siqueiros Archives.*)

205

205. *Portrait of Present-Day Mexico*, 1932.
Fresco, 52.5 sq. ft.

206. Detail (left), *Portrait of Present-Day Mexico*.

See also Plate 13.

can colonialism. The rapacious eagle, poised to attack the opposing Peruvian and Mexican forces, is intent on subjugating the submissive peon. Siqueiros saw the agents of United States economic imperialism as desiring, through force if necessary, to preserve the status quo—the misery and underdevelopment of Latin America. In the image of the temple he shows that, in addition to the destruction of its pre-Conquest civilizations, Latin America has been denied entry to the technological world of the twentieth century. He presents the peon dressed in a loincloth in an overgrown and uncultivated jungle, which symbolizes the lack of industrial development of Latin American resources. The only positive factors are the armed representatives of Peruvian and Mexican "preparatory action of the revolution." The work lacks, however, an entirely consistent treatment of the theme. Siqueiros recognized his mistake in relying on traditional Christian imagery—the cross—to portray the twentieth-century

206

political situation of Latin American colonization and wrote that "the only error [regarding the depiction of the theme] lies in the use of the cross . . . that lends itself to ideological confusion."[45]

The dedication ceremony for *Tropical America* was held October 9, and, although the mural received generally favorable critical reaction, many saw in it Communist propaganda, which apparently brought about the partial covering of the painting.[46] (The sections visible from the street received a coat of whitewash sometime before April 1934.) Some years later, according to the critic Arthur Millier, the entire mural was covered by demand of the building's owner, Mrs. Christine Sterling, who allegedly hated the "ugly" painting.[47]

Siqueiros painted his final Los Angeles mural—the only one surviving today in good condition—*Portrait of Present-Day Mexico*, in the semienclosed patio of the Santa Monica home of the film director Dudley Murphy, a close friend of S. M.

Eisenstein.[48] If, in its small size and semi-exterior environment the mural closely resembled Rivera's Stern mural, in contrast Siqueiros exhibited a far greater degree of political combativeness. The dimensions, some sixteen square meters, necessitated a smaller work force, composed of Siqueiros, Luis Arenal, Reuben Kadish, and Fletcher Martin, and the artists worked in traditional *buon fresco*. According to Fletcher Martin, Dudley Murphy asked for an introduction to Siqueiros, saying "Wouldn't it be great if Siqueiros would do a fresco on the wall in my garden?" Siqueiros quickly agreed, not only for the mural opportunity, but also because living in Murphy's residence near Malibu would keep him out of the clutches of immigration authorities (his visitor's permit had expired). Martin recalls the working procedure for the mural:

Siqueiros would indicate a section for that night. I would mix the mortar and prepare the section. This

207

208

207. Detail of Martyred Workers, *Portrait of Present-Day Mexico.*

208. Detail of Calles, *Portrait of Present-Day Mexico.*

209. Detail, an armed Red guard, *Portrait of Present-Day Mexico.*

would take maybe a couple of hours. . . . Usually Siqueiros painted each section himself, but he occasionally would let me develop an unimportant part. He always contended that public murals should be done as a collective effort, but in practice he couldn't stand to have anybody else paint parts that were of any importance to the composition.

He usually painted between midnight and three or four in the morning. There was always a sense of elation and accomplishment after the night's work.[49]

Arthur Millier remembers Siqueiros accepting the commission, planned for two and one-half months, as payment for summer rent, and that originally the artist painted "flower girls around a fountain." On Murphy's insistence for "stronger" subject matter, Siqueiros came up with his portrait of the administration of the current Mexican president, Plutarco Elías Calles.[50]

While obvious in content and direct in treatment—the familiar generalized, monumental fig-

209

ural types appear with strong light and dark modeling contrasts—*Portrait of Present-Day Mexico* exudes a more somber mood than the other Los Angeles murals, recalling the gravity of the Taxco political paintings. The mural was Siqueiros's most personal in content of the Los Angeles works. Instead of depicting the general condition of North American racial discrimination or United States economic imperialism in Latin America, Siqueiros here dealt with the more specific topic of contemporary Mexican political conditions. His bitter description of the political theme of the mural surely resulted from his experiences at the hands of the Calles regime:

> It represents General Plutarco Elías Calles, dressed in a Mexican outfit and armed to the teeth, with a mask, raised upon a mountain of money. One could represent Calles as the lowest symbol of corruption. . . . About the "Highest Chief" (thus he had been ponderously named in Mexico as he received the Mexican "throne") appear anguished women, in the state of greatest misery, and many, many corpses. Possibly one of them represents José Guadalupe Rodríguez, one of the first Communists sacrificed by the ascending oligarchy.[51]

On the three adjoining walls of the far left area, Siqueiros delineated the cause, and result, of the "corruption" of the Calles administration. He placed Calles, with mask, moneybags, and rifle, directly opposite United States imperialism, in the person of J. P. Morgan, whose presence was intended to recall that a Morgan employee, Dwight Morrow, served as United States ambassador to Mexico during the Calles era.[52] Between Calles and Morgan lie martyred progressives and workers, the result of illicit dealings between foreign business interests and the Calles administrations. Protecting the women and child (framed by two painted columns repeating the actual patio columns and seated in front of a recessive pyramid), the living victims of Calles's politics, an armed "Red Guard" stands at the far right position analogous to the attacking revolutionaries of *Tropical America*. As realistic as the rest of the

210

210. Harold Lehman, *Analogy: Labor-Capital*,
1933. Portable fresco, dimensions unknown.
Destroyed by "Red Squad," Los Angeles
Police Department, Feb. 11, 1933. (*Photo by
Floyd H. Faron, courtesy of Harold Lehman.*)

211. *Proletarian Victim*, 1933. Duco on burlap,
81 x 47½ in. (*Museum of Modern Art, New York,
gift of the estate of George Gershwin.*)

mural was in its depiction of the grave state of
leftist opposition to Calles, the falsely positive
aspect of this figure makes little sense since at
this time there existed no viable leftist resistance
to Calles in Mexico.

The hard-hitting political criticism of Siqueiros's Los Angeles work made it impossible for
him to obtain another mural commission after *Portrait of Present-Day Mexico*, and mounting political pressure against his presence in the United
States led to his deportation in November 1932.
Nonetheless, the "Bloc of Mural Painters" continued to function for a period after Siqueiros's
departure. An indicator of the social conditions
that brought about Siqueiros's deportation and of
general opposition to the political art he espoused
was the raid on the Bloc exhibition of socially oriented portable murals in February 1933 by the
Los Angeles Police "Red Squad." The police
actually shot and bashed with rifle butts the figures of blacks in the paintings.[53]

211

South America, 1933: Continued Technical Experimentation and a Conceptual Approach to the Mural as a Painted Environment

After his deportation from Los Angeles, Siqueiros felt that "to return to Mexico now seems to me useless"; he believed the reactionary political climate would prevent him from functioning as an artist and as a member of the Mexican Communist Party.[54] Consequently, he spent 1933 in Argentina and Uruguay, where he painted the mural *Plastic Exercise,* a crucial work in his muralistic evolution. Nitrocellulose pigments, silicates, and the camera (both still and cinema) for preliminary compositional work furnished important technical innovations. Also, the mural marked the first appearance of a conceptual approach to the environment as a "plastic box" (*caja plástica*) that provided the basis for its composition.

Siqueiros's discovery of nitrocellulose pigments,

or "pyroxyline," would have far-reaching technical effects on his mural art. At the time used exclusively for industrial purposes, especially for painting automobiles, the Dupont brand "Duco" was most widely used in the United States. The advantages of these pigments—rapid drying, transparency, a variety of textural effects impossible to achieve with the traditional fresco medium, and permanency—would make Siqueiros's new mural technique a feasible proposition.[55] He discovered these pigments by accident; as a stranger in Montevideo he could find only industrial paint produced in the United States. His first work with nitrocellulose pigments, the "portable mural" *Proletarian Victim,* depicts a massive female nude, bound, with her head bowed. In

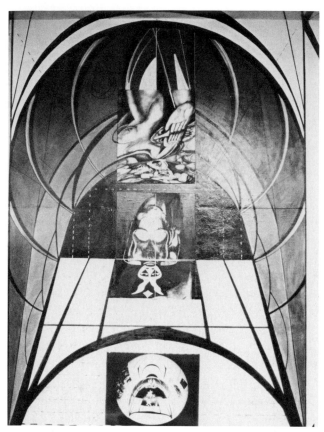

212

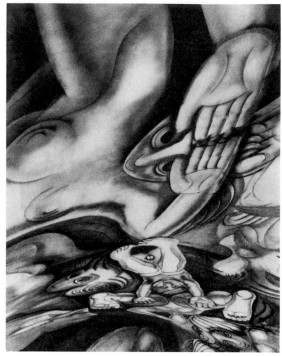

213

212. *Plastic Exercise*, 1933. Spray gun and nitrocellulose pigments on cement, 656 sq. ft. (*Courtesy of Siqueiros Archives.*)

213. Detail, *Plastic Exercise*, 1933. (*Courtesy of Siqueiros Archives.*)

214. Detail, *Plastic Exercise*, 1933. (*Courtesy of Siqueiros Archives.*)

the forceful light, dark modeling, and generalized treatment, the figure brings to mind the similar treatment of the crucified indigene in the Los Angeles mural *Tropical America*. The bound nude, threatening to burst the arbitrary and restrictive confines of the easel format, also recalls the "mural details" painted in Taxco in 1930–32.

Plastic Exercise covered some 200 square meters in the cylindrical bar of the Don Torcuato country home of Natalio Botana, editor of the important Buenos Aires newspaper *Crítica*.[56] A five-man artist team (Siqueiros, the Argentinians Lino Spilimbergo, Juan Carlos Castagnino, Antonio Berni, and the Uruguayan Enrique Lázaro) painted the work, while the filmmaker Leon Klimovsky had charge of photographic matters. The artists used exclusively mechanical means, such as a spray gun and drill, in painting the mural, and employed both cinematic and still cameras to determine the accuracy of the prelim-

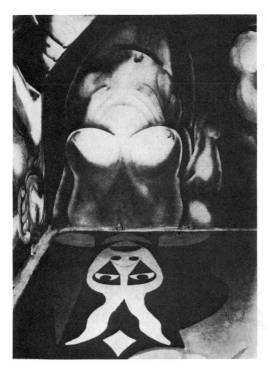

214

technology was in *Plastic Exercise*, a logical extension of the Los Angeles experimentation, the most dramatic innovation of the mural concerned Siqueiros's conceptual approach to the mural's architectural environment. *Plastic Exercise* was Siqueiros's first "painted environment," the first instance of painterly transformation of architectural space that would become standard practice in his later murals. This procedure involved an analysis of the room's geometrical structure and creating a "plastic box," in which he treated the entire architectural environment as integral to the painting of the mural. The logical progression of the spectator determined the flow of the mural's composition. Thus, Siqueiros posited no arbitrary, fixed points of view. Photographs—the only form of preliminary studies—taken in the course of plotting the viewer's logical movement were the only compositional guides; thereafter, in Siqueiro's words, the artists "directly attacked" the walls.

Siqueiros was attempting to create an active mural space, a "monumental dynamic . . . polifaceted . . . in living action." While acknowledging that *Plastic Exercise* was not an "ideologically revolutionary work," he considered it the "initial contribution to revolutionary form," the "embryonic realization" of an art form that would combine not only revolutionary content but also revolutionary form. He explained his conceptual intent in *Plastic Exercise* in largely rhetorical terms, however, and failed to provide precise information regarding his "objective determination" of various points of view within the mural. Despite the major difficulties that exist in evaluating the mural, such as the impossibility of firsthand viewing and the poor quality of the few extant photographs, one can conclude that Siqueiros failed in his goal of using the spectator's progression through architectural space to enhance the composition in *Plastic Exercise*. One misses a sense of visual progression from section to section within the mural and experiences a disturbing disparity in the scale of the figures. Whatever Siqueiros's

inary layout of the mural and final readjustments. Other integral elements of the mural included colored mortar cement, applied to the floor and painted, and artificial lighting.[57] Along with nitrocellulose pigments, Siqueiros painted with Keim silicate[58] to provide a final protective layer for the mural. The few extant photographs, unfortunately of poor quality, give only a general and incomplete picture of the mural. Yet, one receives the impression that rather than passively viewing the paintings, the gigantic female nudes and strange monster-types in severely distorted postures confronted, even challenged, the spectator passing through the mural environment. Siqueiros achieved this effect by having nudes pose on top of plate glass mounted off the floor, photographing them from different angles and positions through the glass, and then projecting the results onto the walls of the room.[59]

As important as the consistent use of the new

assertions, the mural must be judged as a visual experiment—Siqueiros called it an exercise—whose compositional failure paralleled earlier design problems in the Preparatory School and Los Angeles mural projects. Nonetheless, in the assortment of widely diverse and often wildly distorted figures covering the walls and floor of the room in a variety of postures and positions (as in "The Tempest" section), Siqueiros must have seen enormous future possibilities. For example, Siqueiros would develop the painting of figures across wall and floor boundaries, probably inspired by the unusual cylindrical shape of the room, in future murals to create a "baroque" painted mural environment.

While the imagery of *Proletarian Victim* continued the political protest of the Los Angeles murals, even to the extent of using the identical motif of the bound captive from *Tropical America*, *Plastic Exercise* appears as highly unusual in Siqueiros's art of the 1930s, being totally devoid of any sociopolitical commentary. This apparently resulted from local political opposition to Siqueiros, who has maintained that reactionary influences on the Justo government thwarted his original plans to paint an exterior mural in "La Boca," the port of Buenos Aires.[60]

His first talk on art in Buenos Aires created a furor and resulted in the cancellation of the other two talks of this series.[61] The ensuing controversy forced Siqueiros to seek private patronage for his mural work, as he did with *Plastic Exercise*. Siqueiros attempted to explain the nonpolitical content of *Plastic Exercise* by asserting that he found the entertainment room of a suburban residence unsuitable for a political mural, although he had conveniently ignored that issue a year earlier in painting the mural for Dudley Murphy.

In *Plastic Exercise* Siqueiros extended the experimentation with the modern technology he had first advocated in Los Angeles. Nitrocellulose pigments emerged as a key element in the successful practical development of his new technique. Despite the compositional failure of *Plastic Exercise*, the work represented a major advance in Siqueiros's conception of mural composition and marked an important technical and conceptual stage in Siqueiros's progression toward the culminating mural of this period, the Electricians Union mural of 1939–40.

Continued political opposition to Siqueiros forced an abrupt halt to his artistic activities and resulted in his deportation from Argentina in December 1933.[62]

New York, 1936: The Siqueiros Experimental Workshop

Siqueiros arrived in New York in early 1934, his earlier difficulties with United States immigration authorities apparently resolved, and spoke of plans to execute "a series of murals, preferably exterior," using the instruments of modern technology. These murals would have combined the outdoor aspect of the Los Angeles murals with the photographic experimentation of Argentina:

> The camera and the motion picture machine play an important part. Quick action pictures of the mass-

es or other interesting scenes are taken, then the anatomy of the wall and the body of the building is studied by means of these motion pictures to discover the best symmetrical proportions. The members of the group study the arrangement, submit sketches, discuss the possibilities, and finally work together on different portions of the scheme.[63]

Siqueiros lectured on his plans for experimental mural projects during this period. Hugo Gellert recalls Siqueiros speaking to the John Reed Club

about "multireproducible" murals, but for un-
known reasons the project did not materialize.[64]
Before returning to Mexico, Siqueiros had his first
New York exhibition in mid-March at Alma
Reed's Delphic Studios where he showed ten
paintings, termed "studies for murals," and pho-
tographs of his Mexican, Los Angeles, and Argen-
tinian murals.[65]

Siqueiros's running, at times violent, contro-
versy with Diego Rivera on the problem of con-
temporary revolutionary art heated up during
1934–35. Siqueiros's attack on Rivera, "Rivera's
Counter-Revolutionary Road" (*New Masses*, May
29, 1934) escalated this controversy, with his
rejection of what he termed Rivera's "archeo-
logical" point of view. Instead, Siqueiros posit-
ed adoption of the tools of modern industry as a
more suitable technical base for the social func-
tion of twentieth-century murals. At the North
American Conference of the New Education Fel-
lowship in Mexico City during the summer of
1935, the artists' feud exploded in public. Bran-
dishing a pistol, Rivera interrupted Siqueiros's
fiery denunciation and demanded an opportuni-
ty to reply to his charges. For the next several
days the artists traded inflammatory rhetoric in
the media and at public meetings, but the tem-
pest soon subsided and finally sputtered out in
mid-October when Rivera allegedly signed sev-
eral "confessions" regarding political and artistic
errors on his part.[66]

Siqueiros arrived in New York in mid-February
of 1936 as one of the official Mexican delegates
to the American Artists Congress representing the
Mexican League of Revolutionary Artists and
Writers, L.E.A.R.[67] Within two weeks, Siqueiros
had organized an "initial nucleus" of artists, the
North Americans Jackson Pollock and his broth-
er Sanford McCoy, Harold Lehman, Axel Horr
(today Horn), George Cox, Louis Ferstadt, Clara
Mahl (today Claire Moore), the Mexicans Luis
Arenal, Antonio Pujol, Conrado Vasquez, José
Gutiérrez, and the Bolivian Roberto Berdecio.
The artists declared themselves "ready to raise
the standard of a true revolutionary art program,"

215

215. Mexican delegation to American Artists
Congress, New York, 1936. Left to right:
Rufino and Olga Tamayo, Siqueiros, Orozco,
Roberto Berdecio, Angélica Arenal de
Siqueiros. (*Courtesy of R. Berdecio Archives.*)

221

216

and the Siqueiros Experimental Workshop—"A Laboratory of Modern Techniques in Art"—opened in April 1936 at 5 West 14 Street.[68] While the art executed at the workshop did not include murals, it extended Siqueiros's technical experimentation in various media and in the depiction of subject matter illustrating the aims of the Communist Party of the United States of America. It also had a direct and substantial impact on his evolution as revolutionary muralist. Harold Lehman succinctly described the activities of the collective workshop:

> Two main points were embodied in the Workshop plan: the Workshop should (1) be a laboratory for experimentation in modern art techniques; (2) create art for the people. Under the first heading came experiment with regard to tools, materials, aesthetic or artistic approach, and methods of working collectively; under the second point came a utilization of media extending from the simple direct statement of the poster, whose service is fleeting, to the complex statement of the relatively permanent mural.[69]

The experimental easel paintings Siqueiros produced at the workshop, which would provide the formal basis for his revolutionary political art, represented a major advance in his attempt to use the tools of twentieth-century industrial technology. Only with the New York easel work did Siqueiros believe he had achieved some success in coordinating new formal means and political content:

> Now I well see my technical road as a revolutionary painter is in using a technique and a dialectic suited to its ideological and aesthetic end. If you could see how well I am able to think plastically on political problems! Before it was almost impossible for me. The emotional and sensual part of art dominated me entirely. A pleasant texture of a beautiful abstract form made me forget the initial proposition of my political thought and for this reason I didn't succeed. Now I have the energy to sacrifice those things in my painting that are not in concordance with my mental objective.

216. Portrait of David Alfaro Siqueiros, 1936. (*Photo by Peter Juley, courtesy of National Museum of American Art.*)

217. The Siqueiros Experimental Workshop, 1936. (Siqueiros in center). (*Courtesy of Harold Lehman.*)

217

Until the workshop period, Siqueiros had encountered serious difficulties with new tools, particularly the spray gun, although he did not reveal this to the artists working with him:

> . . . I suffered many secret disillusions because of this fickle instrument [spray gun] invented by capitalist industry. Disillusions that frequently totally reduced me to a grave moral depression in Los Angeles, in Argentina, and here recently. I knew that the modern machine had great force to be of extraordinary utility. But I could only present that truth; I had only fundamental premises and basic arguments for its defense, nothing more.[70]

Workshop member Axel Horn has described the freewheeling nature of the workshop's experimental practices:

> Spurred on by Siqueiros, whose energy and torrential flow of ideas and new projects stimulated us all to a high pitch of activity, everything became material for our investigation. For instance, lacquer opened up enormous possibilities in the application of color. We sprayed through stencils and friskets, embedded wood, metal, sand, and paper. We used it in thin glazes or built it up into thick gobs. We poured it, dripped it, splattered it, hurled it at the picture surface. It dried quickly, almost instantly, and could be removed at will even though thoroughly dry and hard. What emerged was an endless variety of accidental effects. Siqueiros soon constructed a theory and system of "controlled accidents."[71]

While Horn noted the "literary [more accurately, political] content" of the workshop paintings, he neglected to explain the serious rationale for all this experimentation. Siqueiros believed that the "fundamental problem of revolutionary art is a technical problem, a problem of mechanization, a physical problem in sum, tied to a problem of dialectical methodology." Siqueiros saw the importance of the workshop as initiating a second period of twentieth-century mural painting, in which the adoption of modern industrial technology would supplant the "primitivism" of earlier mural efforts, such as his own murals at the National Preparatory School and Rivera's work in general.

> The Yankee artists, who during a long period reacted violently against me as a result of my controversy with Rivera, are beginning to understand clearly that my asseverations and experimental practices are opening the door to a second period or grade of agitational or propaganda art, initiated (in an idealized manner) by us in Mexico.[72]

An examination of three political workshop paintings discloses the particular nature and purpose of Siqueiros's New York work. While they represented only a tentative artistic expression on Siqueiros's part, the paintings were important in their innovative approach to techniques and materials and are directly related to the Electricians Union mural of 1939–40. According to Siqueiros, the "first revelation" of the possibilities inherent in the nitrocellulose pigments—the

218

transparency, elasticity, almost instantaneous drying—occurred in a series of small paintings antedating the experimental political easel works. Siqueiros was fascinated with the new effects:

> The absorption of the colors on the surface produced snails and conches of forms and sizes most unimaginable with the most fantastic details possible. But that accidental phenomenon could have plastic value only with the means in which we could coordinate, direct, and utilize it; that is, what we made using such a premise.[73]

Birth of Fascism, the first attempt to incorporate these strange and accidental effects into a political context, illustrated Lenin's metaphor, "The Soviet Union as an immovable rock resists all tempests." At the right "floats a book, as symbol of the religions, or the morals, and philosophies of the bourgeoisie, in total shipwreck." The central image of the painting is a raft on the "tempestuous sea" of capitalism in which "the bestial childbirth" of a monster with the heads of Hitler, Hearst, and Mussolini takes place. At the upper right, standing on a rocky island, looms a symbol of the Soviet Union, the true salvation and democratic alternative to the capitalist "shipwreck." Finally, the superimposition of poured pigments and lacquers created the dynamic painterly "catastrophic sea" of capitalism. In *Stop the War*, painted concurrently with *Birth of Fascism*, Siqueiros worked primarily with the airbrush to illustrate "the transformation of the imperialist war into a civil war against the capitalist aggressor." Siqueiros aimed to depict the international character of Popular Front opposition to fascist/imperialist forces and the ultimate triumph of the "unanimous action of the masses." Thus, a multitude of humanity advances, determined by their collective efforts to halt war, while in the upper register various capitalist/fascist images include a symbol of war—the small monster with gas mask

224

and swastika. Above, a head represents the capitalist nations joined to fascism and to the left appears a visual synthesis of World War I. To the right stands an armed lighthouse flying the flag of International Communism, with various beams of light directed to key areas of the painting. This theme, the necessary revolutionary violence of Popular Front forces or the "war against the imperialist war," would be more fully developed in the Electricians Union mural. Here Siqueiros used the airbrush and stencils to superimpose the various transparent beams from the lighthouse, serving to interrelate the painting's imagery and to create the visual effect of the advancing Popular Front masses.[74]

Collective Suicide, a virtual compendium of the workshop's stylistic experimentation, must be considered of paramount significance not only to Siqueiros's New York period but also to the incorporation of innovative techniques and materials in his subsequent mural paintings. The painting took form as follows: first Siqueiros applied a white primer coat to the wooden panel (to hold the paint), followed by a reddish brown ground coat. Next, both paint and lacquer were poured directly from the can and dripped with sticks onto the panel laid flat on the floor. The action of the lacquer, causing "holes" in the painting after evaporating and halting or "freezing" the interaction between the pigments created the "accidental" quality so praised by Siqueiros. Next, the airbrush imparted its characteristic "transparent" effects; note especially the "clouds" over the central area. Finally, the artist joined the applied sections, worked over with a jigsaw, to give added three-dimensional relief; in these sections Siqueiros sprayed the pigment with airbrush through stencils.[75] In *Collective Suicide*, the spray gun and nitrocellulose pigments, as well as Siqueiros's new manner of dripping and pouring paint resulted in a two-dimensional surface design whose emphasis on a planar pattern vastly differed from the formal intent of his earlier easel work, in which the artist represented subjects using traditional perspective. Yet, despite Si-

219

218. *Birth of Fascism* (first version), 1936. Nitrocellulose pigments on wood, 3.28 x 2.46 ft. (*Courtesy of Siqueiros Archives.*)

219. *Stop the War*, 1936. Nitrocellulose pigments, 2.95 x 2.46 ft. (*Photo Guillermo Zamora, Mexico City, courtesy of Siqueiros Archives.*)

See also Plate 14.

225

queiros's concern here with radically experimental painting procedures, clearly the work's basic interest, he meant to produce a work with a political theme: the self-destruction of various Inca groups who hurled themselves from the mountains into the sea rather than capitulate to sixteenth-century Spanish invaders.

Siqueiros would incorporate the technical experience he had acquired in the workshop experimental paintings into the Electricians Union mural of 1939–40, where he was able to use the spray gun, stencils, and nitrocellulose pigments more effectively. The all-over composition of *Collective Suicide* would be paralleled in this mural by a coordinated, or "baroque", composition in which Siqueiros treated the entire architectural environment as integral to his mural painting. Moreover, the three-dimensional applied sections of *Collective Suicide* appear to have been the earliest work, their combination of painting and sculpture anticipating a major concern of Siqueiros's mature career, his formal approach to the mural as a "sculpture-painting" (*esculto-pintura*).

The other category of workshop production—"Art for the People, executed collectively"—or temporary works of art, such as floats and posters for specific political functions, were turned out during brief but highly concentrated periods of activity:

> It is necessary to remember—the workshop operated in spurts. Short bursts of activity (for parades, demonstrations, union, etc.) would be followed by periods of relative quiet during which Siqueiros would develop his own personal work. And there was a lot of it. He was always working. At such times people would drift off and only the central core would remain—the Mexicans, other Latins, and a few, a very few, Americans.[76]

Siqueiros described the first makeshift float—it was a chicken-wire armature covered with *papier-mâché*, then mounted on a flatbed truck and decorated with bunting. It represented the Popular Front Farmer-Labor Party in the May Day 1936 parade. Siqueiros called it "an essay of polychromed monumental sculpture in motion." In calling for the overthrow of Wall Street control of the United States economic and political systems, the workshop depicted Wall Street capitalism as a supine figure, its head topped with a swastika and holding in its outstretched hands emblems of the Republican and Democratic parties, thereby symbolizing its domination over the United States political parties. The political emblems, in turn surmounted by cutout figures of the opposing party, indicated the fundamental lack of differentiation between the two major political parties. A gigantic moving hammer, adorned with the Communist hammer and sickle and representative of the unity of the North American people, smashed a Wall Street ticker-tape machine, which spewed its tape blood-like over the prone capitalist figure. The float presented the workshop's conception of the enormous political power of Wall Street and the progressive response required by the CPUSA and Popular Front coalition organizations. In using these techniques—the cut-out figures of the political parties, spray-gun painting, the collage effect of contemporary newspaper headlines—the workshop floats were much more exciting visual productions than the typical New Deal period float.[77]

The next float, mounted on a small boat intended to sail past thousands of bathers at Coney Island, was produced for the American League Against War and Fascism for "Anti-Hearst Day" (July 4, 1936) and portrayed Hearst and Hitler seated back to back. Their heads revolved, creating two interchangeable figures, illustrating what the artists saw as their identical fascist politics. "Bloody" (red paint) hand prints smeared the sides of the boat, a visual metaphor for the suffering wreaked on the masses by the forces of fascism. Other temporary works of political protest recall earlier postrevolutionary Soviet models, such as "agitational-instructional" trains, boats, and cars. They included two floats, again for the League Against War and Fascism, for an

220

antiwar protest in August 1936, a large cut-out figure for a Loyalist Spain rally in January 1937, and a May Day 1937 float. The latter, evidently the only one to be published (*Art Front,* June–July 1937), shows an enormous *papier-mâché* worker reading the *Daily Worker,* whose headline declares "Workers Rally CIO Drive."[78]

The workshop also did collective projects for the CPUSA, with which it was closely associated at this time: "For all important things they [the CPUSA] apply immediately to us. For all—or about all—matters concerning graphic questions we are consulted."[79] Further, Siqueiros discussed with CPUSA cultural representatives the "tactics" he would follow vis-à-vis the CPUSA and his New York artistic activities. Siqueiros's role as Communist artist required that he become active in the "bourgeois intellectual sectors" without losing sight of his "true ideological objectives." He would use galleries, the press, and other "presti-

220. Farmer-Labor Party float, 1936. (*Courtesy of Harold Lehman.*)

221

222

221. *Earl Browder*. Photo-enlargement, sections with nitrocellulose pigment applied with air gun. (*Courtesy of Harold Lehman.*)

222. *James Ford*. Photo-enlargement. (*Courtesy of Harold Lehman.*)

gious bourgeois platforms" to achieve CPUSA goals. He also noted plans for exhibitions in New York, New School lectures, and meeting with journalists and critics.[80]

The gigantic painted photo-enlargements, some fifteen feet high, of the CPUSA 1936 presidential candidates, Earl Browder and James Ford, constituted the most technically innovative of the temporary political art for the CPUSA. Here Siqueiros and Lehman collaborated:

> The original paintings were done from actual photos of Browder and Ford. They were done on masonite panels with lacquers, and were about 4 or 5 feet high. I did the Browder and Siqueiros did the Ford. Photos were then taken of these panels by Peter Juley. . . . Next we projected the 8 x 10 prints directly onto the prepared full-size panels— to establish the drawing and to block out the light and dark areas.[81]

In an attempt to heighten the photographic realism of the portraits, the artists painted the blown-up images with nitrocellulose pigments. This procedure carried over directly from workshop technical experimentation in which sections of easel paintings executed by Siqueiros and others would be photographically enlarged and polychromed with nitrocellulose pigments applied with the airbrush. The heavily encrusted treatment of Ford's hair, possible because of the strong modeling qualities of the nitrocellulose pigments, demonstrated the adoption of Siqueiros's new techniques. These portraits combined the most basic of the workshop's technical aims: the use of reproducible mechanical and/or industrial elements—the photograph, spray gun, and nitrocellulose paint—all for the purpose of synthesizing a public art form of modern technological means and overt contemporary political content.

Siqueiros's search for a twentieth-century revolutionary political art form, with its technique based on the use of the machinery and materials of modern industry, progressed at the New York workshop in the areas of technical and compositional experimentation and in the treatment of more specific political subject matter. Yet, despite his preoccupation with radical technical experimentation, especially in *Collective Suicide*, Siqueiros's ultimate goal was to produce political art that would radicalize the viewer. All this experimentation, then, had one basic aim—to create a new realistic, revolutionary art:

> In the end, a new plastic language, a new and infinitely more rich graphic vocabulary for the art of the epoch of the REVOLUTION, something definite for the surging of a form corresponding to the ideological discourse of the revolution. . . . The realism which our new technique permits us to initiate is an active realism . . . that uses the present, palpable object and the objects *sui generis* filtered and reconstituted through the imagination and memory.[82]

Through the workshop experience it became clear that Siqueiros's art—"the vocabulary for the art of the epoch of the REVOLUTION"—would reflect official Communist party policy. Siqueiros, however, never precisely defined his new style of "active" or "dialectical" realism. While he consistently espoused the cause of revolutionary technique and content in art during the 1930s, and workshop paintings demonstrated their "realism" in that they specifically referred to current events and personalities, Siqueiros's "dialectical realism" remained markedly distinct from the academic, literal brand of realism characteristic of Soviet art during the Stalinist era. In contrast to this heavy-handed brand of "social realism," primarily intended to fulfill a particular political function, such as the glorification of the peasant and industrial worker, the emphasis given innovative processes and materials in the New York Workshop reveals Siqueiros's independent approach to Marxist art.[83] In fact, Siqueiros's technical concerns reflected the experimentation of Soviet artists of the immediate postrevolutionary era. For example, the "agit-prop" art of this period using the relatively untested media of banners, billboards, and posters—anticipated Siqueiros's call for a multi-instructional graphic art, as he called it, the "formidable instrument for agitation and education of the masses." Further, the painting experimentation at Inkhuk (abbreviation of the Soviet Institute of Culture) in the early 1920s presaged the workshop's experimental intent: "At Inkhuk experiments were carried out on the material properties of paint, on the psychological effects of color, in the interrelationships of color and sound—experiments that produced the term *laboratory art*".[84] Siqueiros's "dialectical realism" differed from Soviet "social realism" in its stressing of modern technology and stylistic innovation, and the subject matter of his New York paintings owed little to prescribed Soviet imagery, but rather depicted the contemporary struggles of Western Communism. Thus, Siqueiros claimed the artist's right to interpret independently while

223

presenting Communist subject matter, as well as exercising complete freedom in technical areas.[85]

Another much smaller body of work exists from Siqueiros's New York period, privately commissioned easel paintings that had great practical importance in securing necessary funds for the workshop's operation, even though they were hardly significant in the context of his pursuit of a revolutionary technical and political mural form. Workshop member Conrado Vasquez recalls the extremely trying financial situation at the workshop; it was a "constant touch-and-go battle" to obtain funds for the rented compressor, vital for the function of the workshop. As a result, Siqueiros found it necessary to procure private commissions, which apparently came easily because contemporary Mexican art was in fashion. Siqueiros's most important private patron, George Gershwin, commissioned several works, including his portrait, based on the November 1, 1932 concert he gave at the Metropolitan Opera House,

with various family members and friends in the front rows. Gershwin's psychoanalyst, Gregory Zilboorg, commissioned *Collective Suicide*, and even suggested the topic.[86] Other prominent wealthy patrons included Gershwin's brother, Ira, for whom Siqueiros did *Two Children*, a sort of Raggedy Annie "Mexico curious" work with distinct technical overtones from the workshop (the poured pigments, lacquer touches) surrounding the figures. A far more dynamic painting, *Echo of a Scream*, bought by the collector Edward M. Warburg (a Harvard classmate of Lincoln Kirstein and active in the establishment of the Museum of Modern Art) took a news photo of a child wailing alone in the ruins of a bombed Manchurian railroad station as its visual source.[87] Finally, Abby Aldrich Rockefeller purchased at least two of Siqueiros's works from the 1930s, the lithograph *Zapata* (1930) and the painting *Ethography* (1939).

The Siqueiros Experimental Workshop grad-

224

225

ually disintegrated after its leader's departure for Spain in early 1937, and the members drifted apart. Without Siqueiros's powerful personality and artistic prominence, little existed to hold the workshop members together as a unit. There were, however, a few post-Siqueirian workshop productions: the May Day 1937 float and a mural for the "Save Czechoslovakia Rally" of October 2, 1938.[88]

223. *Portrait of George Gershwin*, 1936. Oil on canvas, approx. 64 x 100 in. (*Courtesy of Siqueiros Archives.*)

224. *Two Children*, n.d. Duco on masonite, 30 x 24 in. (*Santa Barbara Museum of Art, gift of Mr. and Mrs. Ira Gershwin.*)

225. *Echo of a Scream*, 1937. Pyroxolin, 50 x 36 in. (*Courtesy of Siqueiros Archives.*)

The Mexican Electricians Union Mural, Mexico City, 1939–40:
Synthesis of Modern Technology and Revolutionary Political Commentary

In contrast to the frankly experimental practices of the New York workshop, Siqueiros's Electricians Union mural represented his initial functional utilization of the instruments and materials of modern industry and a rationally ordered composition based on the spectator's progression through the architectural environment. With the addition of contemporary photographs as the source of the mural's thematic imagery, Siqueiros and his team of Mexican and Spanish artists produced a politico-esthetic commentary on the Spanish Civil War and its aftermath. The mural heralded in more elaborate and detailed fashion than the New York paintings a positive alternative to the threat of fascism: the surging, inevitable force of revolutionary socialism.

The political theme of the Electricians Union mural drew heavily for its imagery from the Spanish Civil War, in which Siqueiros participated from early 1937 until 1939, rising to the rank of lieutenant colonel under the command of "Carlos Contreras" (pseudonym of the Italian Vittorio Vidali), leader of the Communist Fifth Regiment. He served as staff assistant to Contreras, with secondary command duties, and participated in liaison-reconnaissance missions. During 1938 and 1939 he fought in the battle of Teruel, served in the Extremadura region, and performed confidential diplomatic missions to Italy and Mexico.[89] José Renau has recalled welcoming Siqueiros, along with a group of Mexican artists and writers, to Spain in early 1937, when Siqueiros—evidently unaware of the critical military situation— immediately proposed to organize a collective of Mexican and Spanish painters to produce murals and graphics for the Republican cause.[90] This proved impossible since most Spanish artists were engaged in active military service. After his first encounter with Siqueiros, Renau suggested that

he lecture to Spanish artists on the general nature of revolutionary art, as well as specific technological and methodological matters. Siqueiros delivered his talk, "Art as a Tool in the Struggle," before a large, and for the most part very enthusiastic, audience at the University of Valencia in February 1937. Following this lecture, Siqueiros left for active military duty on the southern front. The basic character of the Spanish Civil War served as a topic of discussion during a lengthy conversation among Siqueiros, Renau, and Ernest Hemingway in mid-1937, centering on the different conceptions Hemingway and Siqueiros held regarding the war. Hemingway viewed the war as the individual's life-and-death struggle, symbolized for him by the bullfight. While not directly attacking Hemingway, Siqueiros spoke from the Communist point of view, stressing the necessity of presenting an organized, disciplined, and unified opposition to Falangist forces. Renau, supporting the Communist position, epitomized his view of the war with an image that would find visual expression in the Electricians Union mural: "steel against human flesh."[91]

Siqueiros's mural in the office headquarters of the Mexican Electricians Union also reflects the political turmoil surrounding the progressive administration of President Lázaro Cárdenas, 1934–40. By the time of Siqueiros's mural, 1939–40, Cárdenas had expropriated foreign-owned oil properties, nationalized the railway system, seized large property holdings, appropriated land to small farmers, and implanted a system of "socialist" education. In international matters, the Cárdenas administration adopted a pro–Republican Spain policy, as Mexico became the only Latin American nation to supply aid to the Republican government. With the defeat of Republican forces, Cárdenas allowed the immigration of several thou-

226

sand Spanish refugees to Mexico, among them members of the Spanish Communist Party and other foreign communists. Yet this implicit official sanctioning of the Stalinist refugee contingent clearly contradicted the granting of political asylum to Leon Trotsky in 1937, as did the later swing to the right of the Cárdenas government in 1939–40, evidenced by Cárdenas's denunciation of Soviet actions in Finland and Poland and the banning of public Mexican Communist Party gatherings. These three broad areas of Cárdenas's governmental policy—domestic antiimperialism, antifacism in the support of Republican Spain, and the asylum for Trotsky—directly influenced the Siqueiros mural. Cárdenas's policies, paradoxical in the cases of joint admission of Stalinists and Trotsky, parallel the intrigue, complexity, and contradictions involving Siqueiros's politico-esthetic activities of this peri-

226. Mexican Electricians Union mural, *Portrait of the Bourgeoisie*, 1939–40. Nitrocellulose pigment on cement, total painted surface, 328 sq. ft.

See also Plate 15–16.

233

od, most notably his role in the attempted assassination of Trotsky in May 1940.

When he returned to Mexico in 1939, Siqueiros condemned "counterrevolutionary conspiracies" against the Cárdenas administration and the burgeoning development of reactionary forces and social repression, and appealed for "all liberal forces of the country to unite."[92] The volatile political situation in Mexico had reached the level of a small-scale guerrilla war between leftists and fascist supporters. Siqueiros threw himself into these violent confrontations, and police seized him as "ringleader" of the group responsible for the stoning of several profascist newspaper plants. On the right occurred the notorious public celebration of Franco's victory by Falangist supporters at the headquarters of the local Spanish colony (some 25,000 strong), the Casino Español, in direct violation of governmental warning. Only the intervention of a sizeable police force broke up the tumultuous group of leftists, led by several hundred "shock troops" of the Mexican Workers Confederation (CTM).[93] These two events, indicative of the tense political situation in Mexico on the brink of World War II, demonstrate the character of leftist opposition to the widespread fascist influence in Mexico. In his public actions and the Electricians Union mural, Siqueiros viewed the situation as the "second front" in the struggle against fascism.[94]

On ascending the small cubical stairwell (some 100 square meters) of the Electricians Union headquarters containing the mural, a barrage of images across the walls in the form of a stridently presented anticapitalist "newsreel" confronts the viewer. The painting virtually explodes in its depiction of the rampant chaos and destructive forces unleashed by the capitalistic system and what Siqueiros demands to be seen as its offspring—imperialism and fascism. To further enhance the work's purposefully discordant tone, Siqueiros and the other members of the mural team employed jarring, garish color and painterly distortions, primarily by continuing images through wall and ceiling intersections, creating

not only a "cinematic" composition but also a greatly enlarged sense of space.[95] Opposing the confusion and cacophony of capitalism and what Siqueiros saw as its product, imperialist war, surges the largest single figure of the mural, an armed worker symbolizing revolutionary socialism as the only positive alternative to capitalism in contemporary society. The legend above the painting proclaimed Siqueiros's orthodox Marxist position, so distinct from the political views of his colleagues Orozco, who was at this time against all political ideology, and Rivera, a "Trotskyite" disowned by Trotsky:

> These paintings, conceived and executed by D. A. Siqueiros, José Renau, Antonio Pujol, and Luis Arenal, were begun in July 1939 and finished in October 1940. They represent the actual process of capitalism toward its death. The demagogue, moved secretly by the force of money, propels the masses toward a great holocaust. A monstrous mechanism, crowned by the imperialist eagle, concludes the general function of capitalism, transforming the blood of the workers—who form the infrastructure of the real economic system—into the flood of gold that nourishes the benefiting incarnations of world imperialism, generator of war. The revolution surges impetuously, hastening to finish with the exploitation and the slaughter with which the classical regime of our days sustains itself. Crowning all, the sun of Liberty shines resplendently over a symbol of the elements of Work, Solidarity, Peace, and Justice.

The artists intended the original version of the mural, *Portrait of Fascism*—best summarized by the leftist slogan, "War Against the Imperialist War"—as a "dialectically elaborated theme" of counterrevolutionary and revolutionary elements in contemporary society. The first image encountered by the spectator projects the notion of counterrevolution: a motorized strongbox (representing capitalist finance) directly controls the primary figure of the wall, the parrot-headed "Great Fascist Demagogue," who harangues the masses and represses the working class and progressive forc-

234

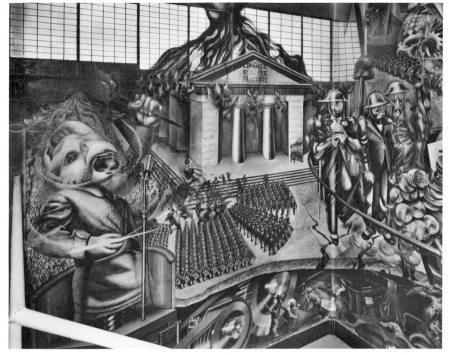

227

227. Mexican Electricians Union mural detail, *The Great Fascist Demagogue.* (*Photo by Guillermo Zamora, Mexico City, courtesy of Siqueiros Archives.*)

228. Mexican Electricians Union mural detail, *Portrait of Fascism* (original version), left and center walls.

228

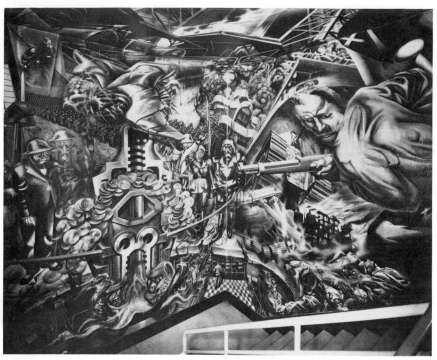

229

229. Mexican Electricians Union mural, detail, *The Infernal Machine of Capitalism* and *The Revolutionary Worker*. (*Photo by Guillermo Zamora, Mexico City, courtesy of Siqueiros Archives.*)

230. Study for central wall, 1939. Charcoal and pastel, approx. 4 x 3 ft. (*Courtesy of José Renau.*)

231. Turbine model for *The Infernal Machine*. (Courtesy of José Renau.)

232. Nazi air attack on Madrid. (*Courtesy of José Renau.*)

233. Dead Italian soldier, Spanish Civil War, 1932. (*Courtesy of José Renau.*)

234. Dead Italian soldier, Spanish Civil War, 1932. (*Courtesy of José Renau.*)

es. The next view, the central wall, exposes the entire range of forces opposing the socialist transformation of society, dominated by the *Infernal Machine* of private ownership of the means of production, whose convex bands contain capitalist and fascist representatives (to the left Great Britain, France, and the United States, and to the right Japan, Italy, and Germany). The *Infernal Machine*, "energized" by the sacrifice of workers' lives, acts in conjunction with the imperialist eagle to produce a huge, regimented military complex—capitalism's totalitarian agent of control—responsible for the destruction wreaked on the masses throughout the mural. Next, an armed revolutionary worker portrays the "working class [socialism] in the midst of struggle against imperialist war, fascism and the exploitation of man by man." From the final viewing point at the top of the stairway, the three lateral walls—in effect, three interlocking cinematic "frames" —and the ceiling painting (depicting peace

230

232

231

233

234

emerging as the production of industrial energy for the people) merge to challenge the spectator with their powerful message.

The detailed and factually specific imagery sprang from the team's desire to create a truly popular art form. In this attempt the artists looked toward modern technology, particularly photography:

> This [the enormous influence of modern technology on the masses] led us to understand that a popular form of art ought to be fundamentally an eloquent form. . . . We spoke of a realism coming to affirm that all new true realism should be documentary and dynamic. For this route I consider that photography in and by itself constitutes our most important ally. We said that among photographic documents we should choose precisely those that were the most known, for they would be the most eloquent and for this effect we would sacrifice all abstract, esthetic impulses. . . . We considered that all the tradition of art belonged to us, but of this the most immediately useful was that which would become a part of the functional political character of our effort; this is: the commercial poster, photography, documentary photography, cinematography, photomontage, etc. Helped by these elements we would sacrifice, even throttle, all traditional esthetic impulses.[96]

From photographic sources, the specific origin of the mural's imagery may in many cases be identified. For example, a turbine-mould photo from *Life* was the model for the "Infernal Machine" of the central wall, while one from *Look* inspired the hanged black. For the right wall the effects of Nazi aerial bombardment of Madrid, along with Italian soldiers killed in the battle of Guadalajara, were adapted from *Life* photos. Another aspect of the team's attempt to create a new popular esthetic involved the depiction of popular political slogans ("War Against Imperialist War"), leftist propaganda images (the imperialist eagle and strongbox of capitalism), or the strictly Mexican images of the parrot and flower.[97] These slogans and images—appearing at the time in the leftist

235

238

236

237

press, the publications of the Marxist artists and writers group L.E.A.R., the Popular Graphics Workshop, and the Electricians Union's publication *Lux* ("the magazine for the workers")— would have been instantly comprehended by union workers as they passed the mural during their daily activities.

Yet, the hard-hitting, vociferous antifascist content of *Portrait of Fascism* raises the first problem concerning the mural, for its antifascist theme obviously ran counter to official Soviet policy of mid-1939–41, as established by the Molotov–von Ribbentrop pact. The Soviet-Nazi nonaggression agreement, a complete turnabout from the antifascism of the Popular Front years, surely stunned Mexican Communists as it did North Americans, but both immediately endorsed the new position.[98] Why did Siqueiros, whose high-ranking party position dated from the mid-1920s, dissent *as an artist* from official Soviet policy? Unfortunately, no clear answer emerges here, as he

235. Mexican Electricians Union mural, detail, (*Photo by Guillermo Zamora, Mexico City, courtesy of Siqueiros Archives.*)

236. Photograph from *Life* magazine showing the destruction wreaked by the Spanish Civil War. (*Courtesy of José Renau.*)

237. Mexico D.F. Thermoelectric Center, 1939. (*Courtesy of José Renau.*)

remained uncharacteristically silent on this matter. Reasonable speculation might indicate that as an artist Siqueiros opted for an independent interpretation of Marxist subject matter, surely the arch heresy for Communists during this period. Perhaps, too, Siqueiros viewed the pact as strictly expedient from the Soviet point of view, and therefore discountable.

In any case, Siqueiros called for "revolutionary" compositional devices and technical means to project the mural's revolutionary political content. He proposed a continuous mural composition across the four walls to be painted, or as he put it, "activated":

> First, we can opt for a discontinuous spatial conception, dividing the general theme into independent matters for each wall—following in this the traditional static idea that has prevailed since the Renaissance. Second, or better, we can decide to develop the general theme on a continuous pictorial surface, singular and dynamic, thus creating a new space that breaks visually with the architectonic structure of the cube of the stairwell, which will test a spatial conception without precedent, completely new and revolutionary. . . .[99]

Adopting Siqueiros's compositional program made it necessary to construct his "continuous pictorial surface." To accomplish this, the team studied more than 100 people in the act of climbing the stairway to determine the movement of an "average" spectator. The results of the empirical study are illustrated in Renau's "reconstitutions" of the spatial scheme of the mural environment. He postulated six successive points of view, or "principal focal angles forming the polyangular vision." After analyzing the spectator's visual route, the next task involved the superimposition of a compositional scheme based on the movements of the ascending spectator on the static geometry of the four walls. The curvilinear superimpositions based on this route reveal several baroque compositional devices, which break the stairwell's cubical structure to a unified "painting-environment." In the upper left,

238

the window is continued in *trompe-l'oeil* fashion into the central wall; in the lower section a curve continues through the three lateral walls, demarcating the subterranean factory level; above, a curve breaks the planar angle between the ceiling and lateral walls, defining the electrical energy zone.[100]

The team clearly succeeded in activating the stairwell space by following the movements, thus creating a "baroque" composition that served to dissolve the mural environment's architectural space. These formal devices also allowed a more effective presentation of the mural's political theme by creating the effect of a single painting across the four walls rather than four individual paintings. However, Siqueiros's claim to the invention of "a spatial conception without precedent, completely new and revolutionary" is an overstatement. The elaborate program of the Electricians Union mural fulfilled the basic tenent that the work must be comprehensible from vari-

239

240

ous points of view, a lesson Siqueiros surely learned from his study of Mexican and European murals. In his painterly means, Siqueiros obviously recalled the Mexican eighteenth-century *churrigueresque* manner. Its most exuberant examples, such as the *Camerín* of Tepozotlan or Santa María de Tonantzintla, combined painted and sculptural elements, resulting in a loss of the physical sense of the mural's architectural setting.[101] A specific twentieth-century precedent for the painterly experimentation and revolutionary political commentary of the Electricians mural also existed in the Marxist photomontage art of John Heartfield. Not only did Heartfield influence Siqueiros technically (through the example of Renau's work), but his depiction of Communist subject matter during the early and mid-1930s anticipated the basic political thrust of the Electricians Union mural, as well as much of its actual imagery. For example, in *Göring, Der Henker* (September 14, 1933), the raging "butcher," clad in a Nazi uni-

238. Diagram showing the composition for the Mexican Electricians Union mural. (*Courtesy of Dolores Valdivia Hurlburt.*)

239. Route of spectator ascending stairs, Mexican Electricians' Union mural. (*Courtesy of José Renau.*)

240. Spatial scheme. (*Courtesy of José Renau.*)

form and butcher's apron, wields an executioner's cleaver while the Reichstag burns in the background, a scene that closely prefigures the wall of *The Great Fascist Demagogue*.[102]

Actual work began on the mural with the construction of a maquette (an unfolding box) of the architecture of the stairway on the scale of 1:10. Renau then inscribed on the maquette the compositional lines obtained from the spectator study, and the artists cleaned the newly constructed walls with a specially prepared solution to accelerate the necessary deacidification process and applied primers. Next they transferred compositional lines from maquette to the walls with an electric projector to establish the correct proportions for the "active" spectator. The last stage involved painting with spray gun and nitrocellulose pigments (the Dupont "Duco" brand). From Renau's photographs of his preparatory photomontage studies and the work-in-progress, one can detail aspects of the actual painting process. While the "Fascist Demagogue" of the left wall derived from a photograph of Mussolini, subsequent alterations in this figure brought forth a parrot-headed monster who simultaneously presents the masses with a flower and a flaming torch. A comparison of the preparatory photomontage and completed painting discloses further modifications in the "demagogue," now activated by the strongbox, and the inclusion of a lower subterranean factory extends across the lateral walls, providing a greater sense of compositional unity and clarity.

The team members had the following roles: Siqueiros, absent on numerous occasions for unspecified (political?) activities, often appeared at the mural site only for general criticism or the completion of certain areas. His major contributions were the capitalist and fascist figures of the central wall and the revolutionary worker of the right wall. Renau's work included the entire preliminary photographic documentation and photomontage studies, as well as the painting of the ceiling section and most of the mechanical and architectural elements. Pujol collaborated with Siqueiros on the major figural work and with Arenal on the background masses, and painted the subterranean factory level, while Arenal painted minor background elements.[103]

Siqueiros's part in the abortive Trotsky assassination raid of May 1940 lies at the very heart of an assessment of him as political activist and artist during this period.[104] The Trotsky incident, which should be seen not as an isolated event but as part of the general political turbulence of the years of the Cárdenas administration, led directly to thematic modifications in the mural, grave personal consequences for Siqueiros (political exile, governmental refusal to paint a public mural in Mexico until 1945), and the critical rejection of his art, particularly in the United States.[105] Yet, to dismiss Siqueiros as a "Stalinist" artist grossly distorts the situation as does uncritical "fist-waving" celebration of his art. It also obscures the fact that Siqueiros operated simultaneously in the unlikely roles at this time of orthodox Marxist political activist and independent Marxist artist.

Why did Siqueiros participate in the Trotsky attack and what was its significance? Although facts are lacking for the first part of the question, it seems that Siqueiros's Spanish experience lies at the root of the answer. According to Roberto Berdecio, close to Siqueiros during the 1930s, the artist returned to Mexico "a changed man, a fully dedicated Stalinist."[106] Also, the presence of foreign Stalinists in Mexico, veterans of the Spanish War ("Contreras," the Argentinian Vittorio Codovila, the German Margarita Nelkin), would naturally have done much to reinforce Siqueiros's "conversion."[107] Trotsky's biographer Isaac Deutscher also considers Siqueiros a Stalinist and supplies a reason for his planning and leading the assassination attempt:

The man in charge of this attack was to be David Alfaro Siqueiros, Rivera's former friend, the celebrated painter, communist, and leader of Mexican miners. The year before he had returned from Spain, where he commanded several brigades during the Civil War—he withdrew from the fighting

at the head of only two or three score survivors. That so eminent and even heroic an artist should have agreed or volunteered to become Trotsky's murderer speaks volumes about the morals of Stalinism in these years; but it was, of course, a national habit in Mexico to settle political accounts gun in hand. In Siqueiros's art, revolution and gangsterism were inseparable—he had in himself much of the Latin American buccaneer. In Spain he had entered into a close connection with G.P.U. and, some say, with the Mercader family. Yet, despite the zealous service he had rendered, the Communist party had censured him for a misdemeanor in his handling of party funds. He was hurt and eager to regain favor by a conspicuous and hazardous act of devotion. He worked out the plan of an armed raid on Trotsky's house and for its execution he called on men who had fought under him in Spain, and on Mexican miners.[108]

Although Siqueiros's political action mirrored the Stalinist line both thematically and formally, the Electricians Union mural reflects a distinct anti-Stalinist position. For unlike other artists and intellectuals who succumbed, in critic Ernst Fischer's words, to the "Stalin myth" and the "terror" it spawned, Siqueiros totally separated his political activity from his art. Was this a carefully considered decision, representing a "fundamentalist" brand of Marxism? Again, the answer is unclear.

The trial of Siqueiros (after his capture in late September 1940 in Jalisco state where he had been hidden by his miner comrades) further continued the confusion, even mystery, surrounding the Trotsky incident. It raises the possibility of governmental intervention in the court decision to dismiss all charges against Siqueiros, a verdict reached despite a virtual nondefense by Siqueiros, who refused to admit anything beyond the obvious—that there had been a raid on Trotsky's residence and that he had been involved. When pressed for motives and explanations for the attack, Siqueiros replied meaninglessly about "hypotheses," the "independent act," the "autonomous action," and gave this bewildering answer

to a question about the death of Sheldon Harte, Trotsky's abducted secretary: "Without knowledge of the circumstances in which this happened I cannot venture a judgement on the matter, in as much as repressions of a political type are linked to specific attitudes of the victim and these specific attitudes are unknown to me at the moment."[109] Given the swing to the right of the Cárdenas administration of 1939–40, sympathy and possibly a behind-the-scenes pardon for an admitted Stalinist seems curious indeed. But there were significant counterbalancing pressures: Siqueiros was primarily a celebrated Mexican artist, an eminent leader of the far left, and an officially acclaimed hero of the Spanish Civil War. A minor incident here illustrates the contradictory aspects of the entire matter: on his return to Mexico, President Cárdenas publicly presented Siqueiros with a pistol in a ceremony honoring Mexican participants of the Spanish Civil War. With his customary flair for the sensational, Siqueiros threatened to shoot the police with the honorary presidential gift when they arrested him shortly thereafter for the stoning of newspaper plants. Given Siqueiros's fame and position (and the fact that by this time Trotsky had been killed and his murderer was in prison), a decision to imprison him could only have been highly unpopular. The matter ended, at any rate, with Siqueiros's exile to Chile, arranged primarily by Pablo Neruda, then Chilean consul to Mexico.

Modifications in the strident antifascist theme of the Electricians Union mural resulted from the Trotsky affair. In hiding from government forces during the repainting, Siqueiros placed the blame squarely on the union directorship:

> The work stopped practically finished during the first fortnight of May 1940. Later, José Renau independently made some modifications in his own specific style of commercial poster-maker [*cartelista*] because of condemnable political pressure by members of the Directorship of the Mexican Electricians Union. However, this did not obstruct the auto-critical base of the work as we had previously expressed it.[110]

From May to October 1940 Renau repainted the *Infernal Machine* of the central wall and removed the specific references to the Spanish Civil War, the dead children. Their replacement, an octopuslike creature, spews forth a flood of golden coins and entraps workers of the lower level in its tentacles. Renau also painted out the identifying insignia of the capitalist and fascist representatives to either side of the "Infernal Machine" and the smaller figures of the persecuted workers. In enforcing the removal of the original version's specific political references—especially to the Spanish Civil War—the union directorship disassociated itself from the political views of the artists and, by extension, the Mexican Communist party. Elimination of key images, if not substantial in terms of the painted surface of the mural, nonetheless eradicated the notion that fascism represented the last stage of capitalism and destroyed the team's vociferous antifascist theme.

Even though *Portrait of the Bourgeoisie* represents a dilution of the team's original thematic intent, what remains is a more general, though perhaps a more effective, criticism of twentieth-century capitalism. No equally powerful denunciation of the capitalist class as inherently vicious, repressive, and destructive exists in, say, socially oriented New Deal murals executed by left-wing artists in the United States. Siqueiros's mural stands in marked contrast to the universally acknowledged "political" masterwork of the period, Picasso's *Guernica*, which represents "multilevels of meaning and emotion in human as well as artistic terms" involving Picasso's Spanish heritage and current domestic difficulties as expressed in the metaphor of the bullfight and the horse and bull.[111] That is, Picasso reacted to the Spanish Civil War solely on esthetic and allegorical levels, apparently incapable of addressing his art to the immediate political subject of the brutal Spanish conflict, epitomized by the wanton barbarity of the Nazi bombing and machine-gunning of the Basque center of Guernica. Max Raphael has observed:

Picasso's allegories are rooted neither in his own age nor in tradition, but in the isolated individual; he alone posseses the key to them. By resorting to a personal system of allegories he confesses his inability to portray the driving forces of modern society in a work which treats a specific historical event—and this alone is the meaning of a genuine historical painting.[112]

In contrast, Siqueiros approached the Spanish Civil War from the standpoint of a military participant and militant Communist, and systematically analyzed the role of the horribly destructive violence of modern warfare in the context of twentieth-century capitalism. The irony of the situation here is that with its particularized political commentary Siqueiros's mural has remained all but unknown, while Picasso's "wall-sized" easel painting expressing no overt political subject matter has received wide-ranging critical acclaim as the most important "political" painting of the twentieth century.

Since this time, Trotskyite and anti-Communist critics—especially in the United States—have censured Siqueiros as a "Stalinist" artist, despite the fact that his art of the 1930s portrayed increasing graphic opposition to the tenets of Stalin's "socialist realism." In fact, on both formal and thematic grounds it appears highly unlikely that the Electricians Union mural could have been painted in the Soviet Union during the late 1930s. In addition to his independent critical interpretation of capitalism and his opposition to Stalinist artistic policy, Siqueiros's 1955 "Open Letter to Soviet Painters" further criticized aspects of Soviet art of the Stalinist period. His criticism centered on two points: an "academic formalism," comparable in its Soviet manifestation to the denationalization, impersonality, and formalism of the School of Paris. He charged that Soviet art persisted in representing "obsolete realistic styles such as the styles of Yankee commercial realism of the early years of the century." Siqueiros contrasted his belief in the necessity of change in realistic art ("Neither the forms of realism nor its tools and materials are static") with Soviet "me-

chanical realism." Secondly, he criticized the lack of concern with innovative implementation of new artistic techniques and materials: ". . . there have not yet appeared among you any advocates of changing technical materials."[113]

In insisting that the artist must operate freely within Communist society, Siqueiros clearly had more in common with Trotsky's more sophisticated approach to art than with Stalin's limited esthetic conceptions.[114] In his statement "Art must make its own way and by its own means," Trotsky demonstrated his recognition of the complex process involved in the creation of a meaningful art form for the new Marxist society. Whereas Stalin would try to impose an authoritarian style that was particularly leaden, Trotsky emphasized the needs for a "broad and flexible policy in the field of art."[115] Like Siqueiros, Trotsky called for the use of modern technology in art, and in summarizing the "new art" of the postrevolutionary epoch he mirrored the goals Siqueiros had for mural art: "It is realistic, active, vitally collectivistic, and filled with a limitless creative faith in the Future." Seemingly unaware of the divergence of his art from the officially sanctioned Stalinist style and the similarity of his esthetic position to Trotsky's, Siqueiros emerges as a paradoxical Marxist: a conformist political militant yet a self-directed artist. Yet, the contradictions in Siqueiros's work and personality from this time ultimately validate Renau's contention that the conception and painting of the mural was indeed a "living process," not a piece of cranked-out Stalinist "socialist realism." The final irony surrounding these contradictions and the complicated politico-artistic matters related to the Electricians Union mural are connected with Siqueiros's attempt to assassinate Trotsky, with whom he shared a fundamental (if perhaps unrecognized) agreement on the necessity of a dynamic, independent, and imaginative approach to the possibilities of Marxist art. The Electricians Union mural was not only the artist's culminating work of the 1930s both in terms of methodology and revolutionary political content, but also the single key work in his entire career, from which all the later murals, no matter how much larger or complicated, clearly derive.

CONCLUSION

Rivera was the first to return to Mexico. The irony is that he, who had achieved by far the greatest success of *los tres grandes* in the United States, should also suffer the most, crushed by the sudden and irreversible loss of his North American capitalist patronage. Moreover, the specter of living again in Mexico and how that would affect his art enraged the artist, as he made clear in New York during the fall of 1933, when he slashed his painting of Mexican cacti to bits, screaming, "I don't want to go back to that!"[1] By July 1934, some eight months after his return to Mexico, Rivera had still not been able to resume painting because of poor health and mental depression. One should remember that he was an artist who habitually worked twelve to fourteen hours daily. The North American debacle had left him "weak, thin, yellow, and morally exhausted" and even doubting the ultimate importance of his work. Frida Kahlo wrote to a friend at this time: "He says that he no longer likes *anything* of what he has done, that his painting done in Mexico and the United States is *horrible,* and that he has wasted his life miserably, that he no longer wants to do anything."[2]

Not until November of this year was Rivera able to resume work at the National Palace, where he completed the last staircase wall with the mural *Mexico of Today and Tomorrow,* a full-scaled revision of his original 1929 sketch depicting workers and farmers employing modern industrial technology to construct a twentieth-century Mexico. The new version would be far more politically explicit, recalling the leftist thrust of the RCA and New Workers School murals, and proclaim an imminent Marxist revolution to transform violently Mexican society. Also at this time he began to create paintings and watercolors of largely folkloric Mexican themes.

In the summer of 1936, after undergoing operations on both eyes for a tear duct infection (ongoing eye and kidney problems would result in further hospitalization during this year and 1937) Rivera completed his re-creation of the RCA mural at the Palace of Fine Arts. His next mural project at the new Hotel Reforma (Mexico City), commissioned by Alberto Pani, politician, financier, and earlier patron of Rivera, comprised four portable panels of almost twenty-five square meters. In the last panel, which Rivera intended

as a caricature of contemporary Mexico, the artist included unflattering portraits of political, religious, and business leaders. Angered by Rivera's imagery, Pani had some of the identifiable visages painted out. Although Rivera won damages in the subsequent court suit that allowed him to restore the works, not only did the paintings suffer consignment to storage, but—far more important—he did not receive another public commission until 1942. Bertram Wolfe maintains that the lack of official patronage stemmed directly from the Reforma controversy, yet Rivera insisted after the fact that they were "years of bad health."[3] In any case the artist turned entirely to the creation of portable works; as Wolfe puts it, he produced an "endless succession of sketches, oils, watercolors—he sold all he could turn out; commissions showered upon him beyond even his Gargantuan capacity."[4]

The late 1930s also marked his ardent support of Leon Trotsky, as Rivera aligned himself at the opposite end of the revolutionary spectrum from Siqueiros. In the summer of 1936 Rivera had joined the Trotskyite International Communist League, and in November of that year interceded with President Lázaro Cárdenas to grant Trotsky's request for political activity. The Trotsky entourage lived, through Rivera's generosity, at Frida Kahlo's Coyoacán home; subsequently, however, relations soured owing to political differences, and by early 1939 Rivera had left the Trotskyite IV Internationale and personally broken with Trotsky. In 1940, as Rivera illustrated in his Golden Gate International Exposition mural, he retained an anti-Stalinist position while he espoused a new political message: Pan-American unity against Fascism.

In 1942 Rivera returned to the National Palace to begin work on a series of panels dealing with indigenous Mexican life and cultures, which would occupy him intermittently until 1952. Here, in other murals, and in much of the portable art of his later years Rivera retreated to Mexican history and folkloricism. Only in 1951 would Rivera again paint the theme of the modern industrial environment that had so captivated him in the United States during the early 1930s. At this time he depicted the construction of the new Lerma Water Supply System (Mexico City), and painted with resistant industrial pigments, as these murals were intended to be submerged underwater. Politically, Rivera's final years were marked by his applications for readmission to the Mexican Communist Party. His "self-criticism" reached the nadir in 1952 as he described himself as "a coward, traitor, counterrevolutionary, and abject degenerate" and called his work outside the party "the weakest period in the plastic quality of my painting."[5] (He was readmitted to the party in 1954.) He now embraced Stalinism with a fervor, evident in his large portable mural, *The Nightmare of War and the Dream of Peace* of 1952, which caused yet another public controversy, when Mexican cultural officials removed the painting from display at the Palace of Fine Arts.[6]

Orozco returned to Mexico in 1934 and enjoyed the most productive post–United States period of his compatriots; from this year until 1941 he worked intensely on various mural projects, the most important of which were the Guadalajara masterworks of 1936–39. In these he drew in themes from the Dartmouth murals, as in the Cortés panel that he enlarged to multipanel proportions for his interpretation of the Conquest in the vault paintings of the Hospicio Cabañas series (1938–39). Orozco turned to specifically Mexican subject matter that acutely heightened the pessimism he had displayed at Dartmouth regarding the human situation. Thus Orozco savagely depicted contemporary Mexican society (*False Leaders and the Masses* at the University of Guadalajara; the alliance of religion and the military at the Palace of Government) and the Independence Movement (the ceiling and central wall of the Palace of Government), while brutally denouncing the twentieth-century revolution (the side panels at Jilquilpán) and the current state of Mexican "justice" (the Supreme Court, Mexico City, 1941). At the same time Orozco did not, as Rivera and Siqueiros did, advocate Marxism

as the panacea for Mexico's problems. In retaining his fiercely independent and basically anarchic point of view, he mocked and disdained Marxism in these works (the *False Leaders* of the University of Guadalajara; the caricature of Marx in the *Contemporary Circus* panel at the Palace of Government; the howling faceless *Masses* at Jilquilpán).

Siqueiros arrived back in Mexico last, in 1939, after two years of active military service in Spain, where, as I've shown, he executed during 1939–40 at the Mexican Electricians Union the culminating work of the decade, which incorporated both innovative technique and architectonic conception with revolutionary political subject matter. In typical Siqueirian fashion, politics (the Trotsky affair) prevented his finishing this mural and forced his exile from his homeland from 1940 to 1944. In 1944 he was commissioned to paint a public wall at the Palace of Fine Arts, where he painted *New Democracy* between the Rivera and Orozco murals. Until 1960 Siqueiros continued his technical experimentation with pigments such as pyroxylin, vinylite, and acrylic, and with surfaces such as cement, aluminum, and glass mosaic. He also explored concepts such as the effects of polyangular viewing and the mixed-media form of "sculpture-painting." During this time, he completed fourteen major mural projects, which were accompanied by several controversies. One dispute, at San Miguel de Allende in 1948–49, was so severe that the mural never passed the preliminary compositional stage. In a notorious event that elicited worldwide protests, Siqueiros was incarcerated from 1960 to 1964 for the crime of "social dissolution." (Beginning in 1941 the law declared guilty anyone who by act or work "tends to provoke rebellion, sedition, tumult, or riot." It was first envoked by the Lopéz Mateos administration; Siqueiros and hundreds of others were jailed for public protests against the government.) Siqueiros's last years were marked by his mammoth mural project, *The March of Humanity* (over 2,000 square meters, Mexico City), and his increasing acceptance by various Mexican administrations, beginning with the National Arts Prize in 1966 from President Díaz Ordaz.[7] In 1975, a huge posthumous retrospective entirely filled the Palace of Fine Arts; it was inaugurated by President Echeverría, who had been the interior secretary responsible for the brutal student repression in 1968 at Tlatelolco in which hundreds died, an incident that Siqueiros, strangely enough, did not protest.

Why did the monumental political art of the Mexicans totally fall from grace in the United States during the post–World War II era? With the concern during the depression for economic reform seemingly solved by the surging prosperity of the postwar era, intellectuals focused their attention on the problems of the nation's postindustrial society and the individual's desire for privacy, personal freedom, and fulfillment. Writers turned from criticism of capitalist society in general to criticism of popular culture, the cause, in their minds, for the deteriorating quality of American life. As Richard Pells has noted, writers such as David Riesman (*The Lonely Crowd*) and William Whyte (*The Organization Man*) viewed key concepts of the 1930s in an entirely new way:

> What the writers of the 1930s called "community," the postwar intelligentsia labeled "conformity." Cooperation now became "other-direction," social consciousness had turned into "groupism"; solidarity with others implied an invasion of privacy; "collectivism" ushered in a "mass society"; ideology translated into imagery; economic exploitation yielded to bureaucratic manipulation; the radical activist was just another organization man.[8]

Further, this transformation of jargon indicated that "the intellectuals of the 1950s had transferred their attentions from the substance of politics to styles of behavior, from the sharecropper to the suburbanite, from labor to leisure, from conditions to consciousness, from revolution to resistance."[9]

With this dramatic reversal of priorities, the profoundly anticollectivistic fervor of these years rejected what were now termed the "smelly orthodoxies" of the 1930s, and the intellectual climate of the postwar years can be seen as hostile to the political and esthetic ideas of the Mexicans. Actually, developments in the visual arts anticipated this situation, the result of the influx of emigrating European artists to the United States during the late 1930s and early 1940s. Among these immigrant abstract artists were Hofmann (the earliest arrival and most important teacher), followed by Albers, Moholy-Nagy, Bayer, Feininger, Glarner, Mondrian, Ozenfant, and Léger and Surrealists Dali, Ernst, Tanguy, Matta, Seligmann, and the poet Breton, who deeply influenced younger American artists anxious to find an alternative to what Stuart Davis called the prevailing "domestic naturalism" of the 1930s. In his praise for French modernism ("the best painting of the last half century") Davis cited what he saw as the central motif of this school: "a spirit of democratic freedom of individual action which resulted in a series of real discoveries in the field of painting."[10] Other American artists looked with great interest to the Surrealists' burrowing inward to the subconscious, using the devices of psychic automatism, accident, and chance, and to their insistence on what art historian Robert Goldwater called "the importance of art even in the midst of cataclysm":

> It was a proper accompaniment of their surrealism, with its reliance upon the intuitive promptings of creation, and its trust in the subconscious impulse as the best artistic guide; it was a point of view that the American *avant garde* of the time (most of them adherents of the American Abstract Artists) who had based themselves upon careful post-Cubist or even more measured post-Mondrian deliberations, had not yet experienced.[11]

Throughout the postwar period, then, the mainstream direction of modern American painting, predicated on the notion of "intuitive, isolated individuality," veered sharply away from the Mexicans' figural, public, and socially oriented art.[12]

The extent of this shift can be demonstrated by several events during these years. As noted in the Introduction, two of Rivera's San Francisco murals were concealed during the 1940s and 1950s. Furthermore, galleries and museums showed little interest in the Mexicans. Only Orozco and Rivera showed in the United States during the postwar decades, but barely at all. The most important shows were Rivera's small retrospective (thirty-three paintings) at the Museum of Fine Arts in Houston in 1951 and Orozco's larger show (200 items) in 1952, organized by the Institute of Contemporary Art in Boston. Rivera's return to the New York gallery world more than fifty years after he was, in effect, evicted was revealing in that the exhibition (IBM Gallery of Science and Art, June–August 1984) comprised his Cubist paintings of 1913–17. The show stressed the modern European aspect of his career, rather than the monumental Mexican, certainly his primary achievement. Siqueiros's New York exhibition in 1964 at the New Art Center was directly related to his jailing and should be seen more as a humanitarian gesture rather than as an indication of interest in his art per se. One critic correctly viewed the works as inferior, a judgment that applies generally to the work of Siqueiros's late period (1964–74), when the art became nonpolitical. Commenting on several later small paintings, the critic said: "They are politically neutral, completely unmonumental, and indicate nothing of Siqueiros's ability as colorist and draftsman."[13]

The mid-50s saw the publication of a pioneering work of Mexican scholarship, David Scott's study of Orozco's *Prometheus*, yet Scott subsequently found himself unable to pursue studies leading to the Ph.D. in the area of twentieth-century Mexican art, an accurate reflection of the prevailing art historical bias against the Mexican modern school. Further objections to the Mexicans, although in fact only Rivera and Siqueiros

apply here, stemmed from intellectuals' hostility toward Communism, which reached fever pitch during the late 1940s and early 1950s. Communism was equated by most intellectuals with Stalinism—that is, with totalitarianism, *not* socialism. To them, Communism was "simply the most extreme example . . . of the general principle (favored by many writers in the 1950s) that all political movements threatened to rob the individual of his distinctive identity."[14] In the intensity of their anticommunism, these intellectuals, particularly those associated with *Partisan Review* and *Commentary*, willingly became coopted by government policy, exemplified by the Truman Doctrine. In spite of their opposition to the twin evils of mass conformity and totalitarian politics, they "found themselves supplying the philosophical ammunition for the Cold War."[15] Thus, the pro-Soviet Marxism championed by Rivera, whose activities included campaigning for the Stockholm Peace Petition in 1950 and demonstrating against the CIA-backed overthrow of Guatemalan President Jacopo Arbenz Guzmán in 1954, and by Siqueiros, a party member at this time, ran antithetical to the views of North American intellectuals. As a result of Rivera's actions, particularly his *Nightmare of War and Dream of Peace*, dominated by the imposing figure of Stalin presenting a pen for the world to sign the Stockholm Peace Petitition, conservatives pressed the Detroit Institute of Art in 1952 to remove the Rivera murals from the museum. (The controversy quickly died.)

Because of the Trotsky affair, Siqueiros angered the many ex-Trotskyites of *Partisan Review* and *Commentary*. If Meyer Schapiro felt Siqueiros's jailing in 1960 a "barbaric" act, he nonetheless refused to sign the protest petition, and condemned him forthwith: "During much of his life he has been a Communist militant, more active in leading demonstrations, planning and participating in murders, and carrying out faithfully the instructions of Moscow dictators, than in painting pictures."[16]

The alarming proportions of the anticommunist mania of these years can be illustrated by an incident involving Orozco, who was as much anticommunist as antifascist (if also anticapitalist). His primary theme has been succinctly stated as "the eternal threat to individual freedom," a central philosophical concept also for the postwar North American intellectual.[17] A major retrospective of his work, organized by the Boston Institute of Contemporary Art in late 1952 and the first large-scale showing of his art in this country since the 1930s, was banned in Los Angeles. This resulted from charges brought forth by a UCLA political scientist involving Orozco's "left wing tendencies" and his "definitely incorporating Communist motifs" in his paintings; although woefully inaccurate, the allegations typify the extreme distortions of the time.[18]

North American dismissal of the Mexicans' art and politics during the 1940s and 1950s can be traced to the fact that the United States emerged from World War II as the most powerful economic and military force in the world. A related matter concerning U.S. hegemony, especially on the American continent, involves the concomitant appearance of the New York School as the dominant art movement of the postwar era, and New York City as the new art capital of the world.[19] In his seminal study of this topic, Max Kozloff maintains:

> The complete transformation of this state of affairs (that before World War II this country lacked significant world-wide artistic prestige), the switching of the art capital of the West from Paris to New York, coincided with the recognition that the United States was the most powerful country in the world. . . . The most concerted accomplishments of American art occurred during precisely the same period as the burgeoning claims of American world hegemony. It is impossible to imagine the esthetic advent without . . . this political expansion.[20]

The Abstract Expressionists abandoned, above all, the sociopolitical concerns of the 1930s and devoted themselves to the "assertion of individ-

ual uniqueness" and "highly personal inventiveness" in addressing not specific political themes but rather "eternal humanist freedom."[21] Their esthetic position thus ran totally counter to the Mexicans', whose fall from critical favor became complete. Indeed, anathema accurately describes the Mexicans' assessment at this time, illustrated by their place in Ad Reinhardt's 1946 cartoon, "How to Look at Modern Art in America." On the "tree" of American art, he portrays the dead weight of "Mexican Art Influence" hanging next to other negative factors (Subject Matter, World War II Art, Regionalism, Still Lifes, Landscapes) that have cracked the realist branch of the tree.[22]

Yet with the dramatic shift in the political climate in the United States during the 1960s back toward issue orientation, with demonstrations and civil disobedience involving civil rights, the Vietnam War, urban poverty, university education, and the notion of a counter-culture, interest again grew in the art of the Mexicans, whose painted walls addressed, above all, social and political causes. Certainly the emergence of a community mural movement in the 1960s fueled by Chicano and black activism, whose radical political messages emulated the Mexicans' example, signaled a North American resurgence of attention to the work of Orozco, Rivera, and Siqueiros. Related factors, such as art historical investigation of the New Deal projects and regionalism (two especially despised topics of the 1940s and 1950s), and the attraction of figurative art and expressionism for today's artists, have helped to make the Mexicans relevant again.[23]

My text has focused on a critical period in the careers of Orozco, Rivera, and Siqueiros—their work in the United States during the 1930s. Definitive investigation of their Mexican art, the bulk of their achievement, has yet to be done. The critical question of the contribution of the monumental political art of the Mexican school within the broad context of the twentieth-century art also remains to be assessed.

APPENDIX A

Technique of Fresco Painting

Fresco, or "fresh" in Italian, refers to the application of wet plaster to a wall and the subsequent painting on this surface with dry pigments ground in water. The resultant chemical process involves the reaction of the pigment with calcium hydroxide (the pure lime in the plaster mixture acting as the binder) on the surface of the wet plaster. Although the pigment only slightly penetrates the plaster, it becomes permanently bonded with the plaster surface as the calcium hydroxide eventually is converted to calcium carbonate by the absorption of carbon dioxide present in the air. Thus, the pigment remains petrified, as it were, on the surface, a sort of miniature mosaic.

One begins the process of fresco painting by preparing the wall and plaster. The wall must be totally free of dampness (or else the plaster will not suitably adhere), and a new wall should set, preferably for a year. Before painting, the wall should be thoroughly hosed down daily for a week to effect a firmer bond of the plaster and to help to remove any nitrate of potassium (saltpetre), completely ruinous to pigment. The plaster, a mixture of slaked lime, sand and/or marble dust, and water, is applied in several coats to the wall.

Slaked lime, or caustic lime mixed with water, becomes in time (up to two years aging is required) calcium hydroxide, a fully inert substance known as lime putty that bonds the pigment to the plaster mixture. The sand, forming the porous "body" of the plaster, must be completely free from organic impurities such as sea-salt, clay, and mica. The lime putty and sand are first mixed, without water, to assure thorough coating of the sand particles with lime, and then as little water (pure or distilled) as possible is added to produce the strongest possible binding quality for the plaster.

Several thin coats decrease the probability for plaster cracks. The first of these coats, the "rough-coat" (*trullisatio*), is literally thrown by trowel on a wall saturated with water. This coat, applied to the thickness of one-half inch with the addition of animal or vegetable fibers soaked in lime putty to strengthen the layer, should be scratched to provide a firm grip for the second "browncoat" (*arriciato*). While Rivera used the same mixture for the first two coats (2 parts marble dust to 1 part lime; at times, however, he used more than one "browncoat"), the second had a less liquid

253

texture, and was applied only one-third inch thick. The thin "finish-coat" (*intonaco*) covers only that section of the wall to be painted during that day's working session, a period of eight to sixteen hours according to temperature and humidity, and it is smoothed to the desired texture with a wooden or metal float as it begins to set.

The Mexicans generally followed the practice of enlarging their small preparatory sketch for the mural to the actual size of the fresco. This sheet, or cartoon, perforated along the lines of the design, would be placed over the browncoat surface and dusted with colored chalk over the perforations, leaving the enlarged drawing on the browncoat. Duplicate tracings made of that portion of the enlarged drawing to be painted in one work session served to transfer the design to the *intonaco* coat. Yet Rivera and Orozco at times abandoned this traditional practice to draw directly on the wall.

A critical matter in painting fresco involves the matching of both color and composition from one day's work session to the next. That is, the design must be conceived so that various compositional lines can also be used as boundary lines when applying the plaster. Rivera excelled as a technical master in this area, to the extent that restorers find it necessary to employ special lights to detect the junctures between his daily work sessions.[1] Correcting may be made on the wall while the plaster remains damp, or in tempera on the dry wall. But if an extensive error has been made, the artist must cut out both the finish and browncoats and repeat the entire fresco procedure.

Fresco painting demands the highest quality powdered pigments, which—after testing for permanency against the effects of lime, light, hydrogen sulphide, ammonium hydroxide—are ground in water. Rivera used yellow, golden and dark ochre, raw sienna, Pozzuoli red, red ochre, Venetian red, *almagre morado*, burnt sienna, transparent oxide of chromium, cobalt blue, and vine black, or primarily organic earth colors. In addition to the necessity for using pure colors and

accurately matching them for each day's work, fresco painters must take into account that most pigments applied to wet plaster lighten considerably as they dry, meaning that the artist must first paint in much deeper and intense hues than his final intended result. Rivera laid his colors on in the classical transparent fresco technique, beginning with the lightest areas first, adding the darker colors in the degree of their intensity, and finishing with the darkest colors last (here I should note that the white of the *intonaco* coat appears through the superimposed pigment and water to produce exquisitely intense tints without the addition of white). In this fashion he gradually built up a richness and luminosity of tone. Rivera recognized that his technical facility in fresco was such that it could create problems for him, so he purposely devised a tense confrontational painting situation for himself. Assistant Lucienne Bloch Dimitroff recalls:

I once asked him: "You know, it is three hours now since the men have called and told me that the wall is ready, and I told you. Three hours and the wall is going to dry." I said, "Why do you always wait so long?" And he replied, "I am giving myself problems, because under pressure I work better."[2]

If Rivera produced superb technical results working primarily in the traditional *buon fresco* manner, Orozco chose to approach the medium in a more flexible, even at times improvisational, way:

There is no rule for painting al fresco. Every artist may do as he pleases provided he paints as thinly as possible and only while the plaster is wet, six to eight hours from the moment it is applied. No retouching of any kind afterwards. Every artist develops his own way of planning his conception and transferring it onto the wet plaster. Every method is as good as the other. Or the artist may improvise without any previous sketches.[3]

Whereas Rivera had his masons apply the plaster for a work session in conjunction with his com-

position, Orozco, in his first Mexican murals of the 1920s, simply had the plaster laid on in square-shaped units and showed little concern for harmony between sections of his murals. Passages of all three of Orozco's North American frescoes reveal the same lack of concern in synchronizing, both compositionally and coloristically, his work sessions. Further, in the interest of his own artistic purposes Orozco violated his tenets for fresco painting in adopting unusually dramatic means to create his murals. First, to enhance the painterly contrasts in his expressionistic renderings Orozco found it necessary to apply the pigment much more heavily than in the traditional *buon fresco* technique. Then, he painted various sections of his *Prometheus* mural using pigment combined with carbonate of lime or fresco plaster itself (the upper "Masses" section), or he painted other deep colors thickly in *fresco secco* on the dry wall with a binding medium such as casein. See, for example, the upper sections of the *Prometheus* figure and areas of the lower register.[4] A Mexican restoration team has noted similar unorthodox *buon fresco* painting practices in Orozco's murals at the New School for Social Research: overpainting in tempera, the use of an extremely dry *intonaco* coat, and an extremely thick application of paint (the last two factors resulting in an inadequate bond between plaster and pigment). These restorers also found that "these junctures (merging of each day's work) are sometimes ostentatiously revealed without the slightest concern for establishing continuity."[5] In further contrast to Rivera's technical procedures Orozco painted in opaque fresco, or mixing the tints with lime putty ground in water to the texture of a creamy liquid. In this manner, the color is laid on in exactly the opposite manner from transparent fresco, beginning with a dark ground for contrast and then progressively adding lighter colors, saving the very lightest for the last. The result gives a heightened key and range of tone, and offers vastly increased possibilities for modeling and color subtlety, effects impossible to obtain with transparent fresco.[6]

Rivera, the most technically proficient of the Mexicans in traditional *buon fresco* technique, also introduced innovations in this medium while working in the United States. First, he had his assistants construct false walls at the various mural sites on which he painted; this "furring" operation protected against exterior moisture seepage and expansion cracks, allowed a more complete bond between the concrete wall and the plaster, and made possible removal of the fresco in the case of building demolition (which in fact happened to Rivera's second Bay Area mural, moved during the 1950s from a private Atherton residence to Stern Hall on the University of California, Berkeley campus). Then Rivera painted two "portable" mural series, eight dealing with Mexican and contemporary North American themes for his Museum of Modern Art exhibition and twenty-one devoted to his Marxist history of this country, the New Workers School *Portrait of America*. Rivera adopted this format because of the temporary nature of both projects. At the New Workers School, for example, the group did not own the building and faced eviction at any time. Assistants constructed the panels by applying a cement plaster coat onto a wood and composition board armature. Before the plaster became completely dry, wire mesh was stapled on and the panel allowed to set for at least a week. After this assistants applied the traditional brown and finish coats and Rivera painted.[7]

Siqueiros's exterior Los Angeles murals of 1932—"the great uncovered mural painting, in the free air, facing the sun, facing the rain, for the masses," in which the artist first experimented with the tools of North American industrial technology—went far beyond Rivera's improvements of the traditional fresco technique. These murals were Siqueiros's first, albeit tentative, expressions of an alternative mural technique that would so dramatically differentiate his mature murals from the more traditional means employed by Orozco and Rivera. In his lecture to the Hollywood John Reed Club, "The Vehicles of Dialectic-Subversive Painting," Siqueiros advocated

255

the use of modern mechanical tools to create public art with revolutionary political content in his first detailed statement concerning the fundamental technical and political problems he would confront during the 1930s. In a key topic, "Toward a Technical Revolution in Painting," Siqueiros maintained that twentieth-century artists "continue using elements and instruments" that had remained unchanged for centuries. Instead, the Siqueiros-led collective painting group, the "Bloc of Mural Painters," urged a "technical revolution" in painting,

> using the modern instruments of plastic production which modern science and mechanics afford. . . . For the Bloc, the modern elements of pictorial production represent a reserve of immense value to the proper essence of plastic as well as to agitational and revolutionary propaganda.

He cited the twentieth-century Mexican movement as an example in which an "anachronous" technique (the paintbrush, *buon fresco*, oil, watercolor, tempera, pastel) and esthetic had resulted in the unsatisfactory expression of a "justly revolutionary theory." In contrast, Siqueiros appealed for the "supremacy of monumental over easel painting," and the employment of collective painting "teams" ("the only valid form of plastic instruction, since it meant the learners themselves participated in the total process of the work"). Further, he called for a "profound knowledge of the physics, chemistry, and mechanics" related to modern industrial technology, and listed some suitable "modern elements and instruments of plastic production":

1. The *drill-gun* for preliminary preparation of the wall: it "affords immense possibilities in the search of textures for the surface."

2. The *cement gun* to apply and spread the mixture to be painted on the wall in a completely uniform manner or with "all the premeditated deformations that may be desired." It also affords obvious time advantage in wall preparation.

3. *White, waterproof cement,* which in the process of crystallization retains the pigments with more solidity. It lacks saltpetre and other deteriorating salts of traditional fresco and has great resistance to physical assault and battery.

4. The *spray gun,* "which should substitute for the hand-brush as the essential element of pictorial work. . . . The air-brush, like all possible mechanical means of plastic production, demands its own style alien altogether to traditional procedures."

5. The *gasoline* or *oxygen blowtorch* to cauterize the final wax layer "necessary in the modern open-air fresco."

6. The *electric projector* to aid with initial tracing of wall. It is used as a substitute for the traditional sketch; visual alterations can be provided according to dimension and shape of mural surface.

7. *Cement mortar* or *asphalt,* applied with a compressor to "create a monumental and marvelous mosaic." It is even more durable than "fresco-on-cement."

8. *Cinematic* or *photographic cameras* to provide initial designs to be developed later into final mural form.

Although Siqueiros failed to achieve technical success in his Los Angeles murals (e.g., the pigment, sprayed on in atomized particles, failed to adhere to the cement surface), they nonetheless marked a decisive period in his quest during the 1930s for a viable twentieth-century mural form incorporating elements such as the spray gun, nitrocellulose pigments, and other industrial technology, revolutionary Marxist subject matter, a "team" or collective painting effort, and an approach to the mural as a totally integrated painted environment.

APPENDIX B

Compositional Considerations:
The Golden Section and Dynamic Symmetry

The Mexicans employed the dictates of the Golden Section for the compositional armature of their murals, a system for the division of painterly space devised by the Greeks and later followed by the masters of the Italian Renaissance. Orozco succinctly described the significance of the Golden Section:

> In the Theaetetus, where there is mention of rectangles derived from squares and their diagonals, Plato speaks of the incommensurability of certain roofs. A geometer named Exodus, one of Plato's contemporaries, investigated the "section," later known as the "Divine" or "Golden Section," which is nothing but the ratio between a shorter and a longer side of the rectangle 1.618 [1 by 0.618].
>
> Euclid's propositions teach us to distinguish between an area with commensurate or rational lines on the one hand and one with incommensurate or irrational ones on the other.[1]

The Golden Section enjoyed a revival among Parisian Cubists, and although Rivera did not participate in the large *Section d'Or* group exhibition at the Galerie de la Boétie in October 1912, he certainly knew many of the artists and their work, as well as Golden Section theory that permeated his European paintings and Mexican murals of the 1920s.[2] By 1932, when Rivera painted at the Detroit Institute of Arts, he used this system only in general, almost instinctual terms, as indicated by museum director W. R. Valentiner, who watched Rivera at work:

> After the preliminary studies for the automotive industry panels were accepted by the Arts Commission the next day, Rivera began to enlarge the composition. I was amazed at the facility he showed in constructing the skeleton: not only was the plane of the wall divided according to the golden section which he carried in his mind—and afterwards measured for accuracy—but he also had such a clear vision of the ideal depth in which he placed his themes that this space, too, harmoniously followed mathematical laws.[3]

As Valentiner recognized, and photos of the work-in-progress illustrate, Rivera did not slavishly follow Golden Section tenets, but rather used this system as an aid in constructing the skeletal framework of his frescoes—first in the preliminary studies and then on the walls to act as guide-

lines in transferring the designs and determining the precise location of the predella panels.

Orozco, lacking Rivera's first-hand exposure to mainstream artistic currents in Europe, came to work with the Golden Section later. Orozco used a twentieth-century manifestation of the Greek system, Jay Hambidge's theories of "Dynamic Symmetry," to govern arbitrarily the composition of his New School for Social Research murals:

> These paintings are of a special nature in being based upon the geometric-aesthetic principles of the investigator Jay Hambidge. Apart from purely personal motives of expression, I wanted to discover how convincing and useful those principles were and what their possibility was. . . .
>
> Hambidge himself carried his conclusions too far, but he did the arts a service in providing them with an instrument without which they cannot survive, a very old but forgotten instrument: geometry.[4]

The influence of the Ashram (the New York City salon of Alma Reed, Orozco's friend, agent, and dealer during his North American years, 1927–34) can again be discerned in Orozco's brief, if total, immersion in Hambidge's system. There he met Mary Hambidge in the late 1920s, soon after her husband's death, where she worked on the Ashram's loom during her trips to New York from her crafts school in North Carolina. With his training in mathematics, Orozco was immediately attracted to the logical calculations of Hambidge, and his interest grew so intent that Mrs. Hambidge proposed Orozco's collaboration with her on her husband's unfinished research. Hambidge, a Canadian artist-designer-geometrician, claimed to have "rediscovered" the principles of Dynamic Symmetry, and his studies, based on detailed structural analyses of Greek monuments, such as the Parthenon, the Temple of Apollo in Arcadia, the temples of Aegina and Sunium, and vases of different periods, first appeared in *The Diagonal* (1919–21). "Symmetry is that quality in a work of art or craft which we recognize as design," said Hambidge, and he proposed the existence of two types of symmetry in art, the "static" and the "dynamic":

> Static symmetry, as the name implies, is a symmetry which has a fixed entity or state. It is the orderly arrangements of units of form about a center or plane as in the crystal. A snow crystal furnishes a perfect example.[5]

"Static" symmetry involves the arithmetical subdivision of forms in any given shape. Hambidge believed "dynamic" symmetry, the system he detected in nature, man, and Egyptian and Classic Greek art, to be entirely different:

> Dynamic symmetry in nature is the type of orderly arrangement of members of an organism such as we find in a shell or the adjustment of leaves on a plant. There is a great deal of difference between this and the static type. The dynamic is a symmetry suggestive of life and movement. Its great value to design lies in its power of transition from one part to another in the system. It produces the only perfect modulation process in any of the arts. This symmetry cannot be used unconsciously although many of its shapes are approximated by designers of great native ability whose sense of form is highly developed. It is the symmetry of man and the plant, and the phenomenon of our reaction to Greek classic art is probably due to our subconscious feeling of the presence of the beautiful shapes of this symmetry.[6]

The basis for Hambidge's Dynamic Symmetry lies in the geometric subdivision of forms. Fundamental to the system are two relationships; one, the square and its diagonal, to construct "root rectangles." The other involves the square and the diagonal to its half, employed to construct the "root-five rectangle," which Hambidge called "the basic shape of vegetable and animal architecture and is the form which has permitted the solving of the mystery of the perfection of classical Greek art," and the "rectangle of the whirling square."[7] As a diagram taken from *The Diagonal*

indicates, the essence of Dynamic Symmetry rests in proportionate relationships of the areas of rectangles—the relationships of measurable areas, then, rather than lines:

> Both nature and Greek art show that the measurableness of symmetry is that of *area* and not of *line*. . . . This is the secret. Dynamic Symmetry deals with commensurable areas. The symmetry of man and plant is dynamic; the symmetry of the entire fabric of classic art, including buildings, statuary, and the products of crafts, is dynamic. The symmetry of all arts since Greek classic times is static.[8]

Dynamic Symmetry was popular in the United States during the 1920s; Hambidge lectured widely on the East Coast, it was taught in many art schools, and prominent artists such as George Bellows, who termed Hambidge's system the "law of the constructive armature of living things," advocated its use:

> Ever since I met Mr. Hambidge and studied with him I have painted very few pictures without at the same time working on this theory. I believe it to be as profound as the law of the lever or the laws of gravitation. No man who practices the arts can, with justice to himself, ignore the research that Hambidge has made.[9]

The root-five rectangle produces a great number of other shapes which are measurable in area with themselves and with parent shape. The principal one of these is that which is called the rectangle of the whirling squares. The relationship of this rectangle to the root-five rectangle is shown by its construction. Draw a square as CB. Bisect one side as at A. Draw the line AB and AE equal to AB. Complete the rectangle by drawing the lines BF, FE. This rectangle, DE, is the rectangle of the whirling squares. It is composed of the square CB and the rectangle BE.

BE is the reciprocal of the shape CF and the diagonals BE and CF cut each other at right angles. The rectangles BE is a similar shape to

the whole, i.e., the area BE is exactly like the area DF, the difference being of size only. The line FE, which is the end of the larger rectangle, is the side of the smaller one.

The geometric proportion 1:1.618 is that which is known as "The Golden Section" or "The Divine Proportion."

NOTES

Introduction

1. From his study of the 1930s, *Radical Visions and American Dreams: Culture and Social Thought in the Depression Years*, p. 232.

2. *Ibid.*, pp. 60–61.

3. *Ibid.*, p. 114.

4. From Charles Beard's article, "Education and the Social Problem," p. 14.

5. Waldo Frank, "Pilgrimage to Mexico," p. 184.

6. Stuart Chase, "Men Without Machines, V: The Basic Pattern," p. 232. See also Ernest Greuning's *Mexico and Its Heritage* (Century, 1928), Frank Tannenbaum's *The Mexican Agrarian Revolution* (MacMillan, 1929), Carleton Beals's *Mexican Maze*, Hubert Herring's *The Genius of Mexico* (Committee on Cultural Relations with Latin America), and Anita Brenner's *Idols Behind Altars*.

7. Stuart Chase, *Mexico: A Study of Two Americas*, pp. 310–11.

8. Frank, p. 183.

9. David Scott's letter to author, dated December 1, 1984, and his unpublished lecture at Dartmouth College, "Orozco's Pomona College and New School Murals, and Their Kinship to Dartmouth," October 13, 1984.

10. Anton Refregier in *American Dialogue*, April 1968, p. 12. For the specific nature of the influence of the Mexicans on North American artists, a topic beyond the scope of my text, which aims to examine solely the murals produced by Orozco, Rivera, and Siqueiros in this country during the 1930s, see Francis V. O'Connor's "The Influence of Diego Rivera on the Art of the United States during the 1930s and After," Detroit Institute of Arts *Diego Rivera* catalog, pp. 157–83, and his unpublished lecture "José Clemente Orozco's Influence on Jackson Pollock" (Dartmouth College, October 13, 1984).

11. Mitchell Siporin, "Mural Art and the Midwestern Myth," in *Art for the Millions*, ed. Francis V. O'Connor, p. 64.

12. Quoted in Francis V. O'Connor, *Federal Art Patronage, 1933–43*, p. 7.

13. Quoted in document from Messrs. Rockefeller Archives, Rockefeller Center, New York.

14. Kahlo quoted in *New York World-Telegram* article of May 10, 1933, "Rivera's Wife Rues Art Ban."

15. Nicholson, Harold, *Dwight Morrow* (New York: Harcourt, Brace and Company, 1935), p. 294.

16. For more on d'Harnoncourt's time in Mexico, see "Profile: Imperturbable Noble," *New Yorker* (May 9, 1960); on Morrow, see Harold Nicholson's biography, *Dwight Morrow*; and for Nelson Rockefeller's activities in Latin America, see *The Rockefellers: An American Dynasty*, by Peter Collier and David Horowitz, pp. 202–11.

17. See Francis V. O'Connor, *The New Deal Projects: An Anthology of Memoirs* (Washington, D.C.: Smithsonian Institution Press, 1972), and his *Art for the Millions*. For a comprehensive picture of the various New Deal programs, see Richard D. McKenzie, *The New Deal for Artists* (Princeton: Princeton University Press, 1973). Karal Ann Marling treats an aspect of the Treasury Department's art program in *Wall-to-Wall America: A Cultural History of Post Office Murals in the Great Depression* (Minneapolis: University of Minnesota Press, 1982).

18. Orozco, from "New World, New Races, and New Art."

Although I have chosen to consider only Orozco, Rivera, and Siqueiros because of the importance of their work in this country and their influence on North American art throughout the 1930s, I am fully aware that other Mexican artists (such as Tamayo, O'Gorman, Cueva del Río, Covarrubias, Ramos Martínez, Guerrero Galván) and resident artists in Mexico (Charlot, O'Higgins, Mérida, Belkin) have created murals of note in the United States. I have not dealt with later North American works of Orozco (his 1940 *Divebomber* mural for the Museum of Modern Art) and Rivera (his mural *Marriage of the Artistic Expression of the North and the South on This Continent* for the Golden Gate International Exposition of 1939–40) because they represent different stylistic tendencies. For the same reason, I have not included Siqueiros's large-scale collaboration with North American artists at San Miguel de Allende in 1948–49, where he directed an abortive mural project that would have depicted the life and career of the nineteenth-century Independence leader Gen. Ignacio Allende.

Chapter 1

1. The term is David Scott's and appears in his pioneering study, "Orozco's *Prometheus:* Summation, Transition, Innovation," *College Art Journal.* Dr. Scott has most generously placed at my disposal the research material he gathered on the mural and related matters.

2. David Scott letter to Orozco's assistant on the *Prometheus* mural project, Jorge Juan Crespo de la Serna, d. October 14, 1954. I am also indebted to his unpublished paper, "The Origins of Modern Arts in Mexico" (College Art Association, January 1957); I thank Dr. Scott for allowing me to publish his photos of Orozco's first murals of 1923–24.

3. Jean Charlot's letter (early 1955) to David Scott details the order of these paintings.

4. José Clemente Orozco, *An Autobiography*, pp. 11–12.

5. Orozco, *An Autobiography*, p. 16. Geraldo Murrillo Cornadó (1875–1964), took this name in 1902 and used it for the rest of his life. "Atl" means "water" in Nahuatl.

6. Atl's murals are illustrated in Rosendo Salazar's *Mexico en pensamiento y en acción*, and in Orlando S. Suarez, *Inventario del muralismo mexicano*.

7. This and the previous quotations taken from David Scott, "Orozco's *Prometheus*."

8. The article appears in *Creative Art* (January 1929): supp. 44–46.

9. Critical reaction quoted by Jean Charlot in "Orozco at the Academy of San Carlos," *An Artist on Art*, pp. 260–61.

10. Orozco, *An Autobiography*, pp. 38–40.

11. José Juan Tablada in *El Mundo Ilustrado*, November 9, 1913; quoted in David Scott, unpublished paper on Orozco's early years.

There exists a curious parallel to Orozco's prostitute series in the group of painting, drawings, and prints Ernst Ludwig Kirchner did of similar subject matter during the years 1913–15, although if Orozco claimed not to know the work of Toulouse Lautrec, one doubts he would have been familiar with the lesser-known Kirchner. Similar elements included grotesque caricature and deliberate spatial distortions, although Kirchner's primary theme "went beyond a mere depiction of [man's urban] alienation to observe its actual cause— the dominance of a money economy." See Rosalyn Deutsche, "Alienation in Berlin: Kirchner's Street Scenes," *Art in America* (January 1983):69. Orozco stopped short of Kirchner's sociopolitical criticism. He did use the prostitutes "as emblems for a specific social order" (Deutsche, p. 72) and show their clients amid a specific urban environment, but he concentrated solely on depicting the prostitutes in generalized interior scenes.

12. David Scott, unpublished Orozco paper, p. I-10.

13. Jean Charlot, "Orozco's Stylistic Evolution," in *An Artist on Art*, pp. 274–75.

14. Quoted in Anita Brenner, *Idols Behind Altars*,

pp. 272–73. Ironically, the next "exhibition" was held in Laredo in 1917 as Orozco entered Texas, when U.S. Customs officials seized and destroyed some sixty of the studies of women as being "immoral" (*An Autobiography*, p. 60). Orozco would live in San Francisco and New York from 1917 to 1919.

15. Scott, "Orozco's *Prometheus*," p. 14.

16. At least this is how the paintings look today; unfortunately, the "restoration" of Orozco's Preparatoria paintings in the late 1960s and early 1970s involved a complete *repainting* of the works, and thus practically nothing of the master's hand remains.

17. From Anita Brenner's contemporary letter to Jean Charlot; quoted in Charlot, "Orozco's Stylistic Evolution" (*An Artist on Art*, p. 280). For further information on the production of this series, see pp. 280–87.

18. Orozco, *Autobiography*, p. 123.

19. Other artwork executed by Orozco in New York City from 1927 to 1930 before he painted the *Prometheus* comprised somber easel paintings that further explored Mexican subject matter: *Woman and Maguey, Mexican House, The Cemetery*. In some canvases Orozco treated the role of revolutionary leaders, as in the sacrificed Zapata contrasted with the destruction wreaked by Pancho Villa. In 1928 Orozco turned for the first time to North American imagery, portraying grim New York City urban landscapes (*Eighth Avenue, The Subway, Fourteenth Street, Manhattan*), a picture of predepression gloom that no doubt reflected Orozco's desperate financial situation and loneliness away from his family and country. Later, in 1932, Orozco—in contrast to many North American artists of the 1930s—would directly address the actual conditions of the depression around him (*Winter, Three Heads*). Orozco's art began to display a totally new direction toward the stylistically experimental (the Cubist semiabstraction *Elevated*) and reveal a concern for the theme of apocalyptic destruction (*The Dead, Broken Glass*, the gouache *Fallen Columns*) that presage his idea of twentieth-century civilization at Dartmouth. Lithographs, the least important segment of this body of work, depicted New York City, Mexican, and depression themes. For a picture of Orozco's day-to-day existence during his United States period, including his social contacts and his initially difficult financial situation, see his letters to his wife, published as *Cartas á Margarita* (Ediciones Era, Mexico City, 1987), pp. 93–281. These, as one would expect, are more personal and far less concerned with esthetic matters than Orozco's

letters during the late 1920s to his fellow artist, Jean Charlot.

20. Information on Alma Reed's life from H. Allen Smith, *The Pig in the Barber Shop*, pp. 92–102, and José Gutiérrez, "La Inolvidable Peregrina."

21. Jean Charlot in his review of Alma Reed's *Orozco* in *An Artist on Art*, p. 316.

22. Reed, *Orozco*, p. 208.

23. From Angelo Sikelianos, *Delphic Festival* (Delphi, 1927). Quoted in Jacqueline Barnitz's "Orozco's Delphic Years," unpublished paper given at Orozco symposium in Guadalajara in 1979.

24. Reed, *Orozco*, pp. 35–36.

25. Orozco letter to Charlot, September 10, 1928, quoted from *An Artist on Art*, p. 309; he refers to one of the *Mexico in Revolution* series.

26. Orozco's letters to Charlot, September 25, October 8 and 15, 1928, in *An Artist on Art*, pp. 309–13.

27. Jacqueline Barnitz writes of the "Mexican sector" in "Orozco's Delphic Years," p. 6.

28. See Alma Reed, *Orozco*, pp. 173–75.

29. From Jean Charlot, "Orozco in New York," in *An Artist on Art*, p. 294.

30. Octavio Paz, "Social Realism: The Murals of Rivera, Orozco, and Siqueiros," p. 64.

31. Quoted from Mark P. O. Moford, *Classical Mythology*, p. 44.

32. Pijoan served as adjunct professor of Hispanic civilization and lecturer on art history at Pomona College from 1924 to 1930; the statement appeared in his letter to the Pomona College student newspaper, *Student Life*, March 23, 1937.

33. Orozco quoted in *Student Life*, May 17, 1930, "Orozco on His Fresco."

34. According to Orozco's assistant, Jorge Juan Crespo de la Serna, in his letter to David Scott, written during the period October 21–December 4, 1951, p. 5. Crespo (1887–1978), worked from 1922 to 1925 under José Vasconcelos, minister of education, and in 1925 accepted a teaching position at the Chouinard School of Art in Los Angeles. Crespo had known Orozco since their association on the Syndicate of Technical Workers, Painters, and Sculptors in 1922, and desired to work with him to learn the technique of *buon fresco*.

35. Description of the Centaur panel from Crespo de la Serna, "Sentido y Gestación del *Prometeo* de Orozco," p. 21.

36. David Scott has made this observation in his

October 13, 1984 lecture "Orozco's Pomona College and New School Murals, and their Kinship to Dartmouth" at the Dartmouth College symposium honoring the fiftieth anniversary of Orozco's Baker Library murals, and in various letters to the author during October–December 1984.

37. Information on the theme from Crespo's and Pijoan's letters to David Scott, and Crespo, "Sentido y Gestación del *Prometeo* de Orozco," p. 19.

38. From letter to editor, *Student Life*, May 15, 1930, by English faculty member Harold Davis.

39. From "Prometheus: An Appreciation," by the men of Frary Hall (Pomona?, 1930).

40. Crespo de la Serna, letter (October 21–December 4, 1951) to David Scott, p. 3.

41. The description of Pijoan's position via-à-vis the administration from interview (September 4, 1980, p. 3) with Mr. and Mrs. Earl Merritt, the rectors of the Eli P. Clark Residence Hall, for which Frary Hall served as refectory when Orozco painted.

42. Pijoan, letter to David Scott, October 21, 1954. One "ignored" piece, according to Pijoan, was a Greek bust in the possession of a Hollywood artist, who imagined it a portrait of Napoleon.

43. The *Pomona College Bulletin* of September 1931 shows Frary Hall with the tapestry (subject not visible) installed. Mrs. Dorothy Merritt recalls the figure of $22,000 for the tapestry (interview, September 4, 1980, p. 5).

44. Letter courtesy of the artist's daughter, Lucrecia Orozco.

45. *Student Life*, March 23, 1930.

46. Alma Reed, *Orozco*, pp. 176–77.

47. Letter to Gilberto Crespo Iglesias to author, November 29, 1983, p. 2. For studies of Hetsch's proposed murals see *Art Digest*, March 1930.

48. Edmunds's memo to Pijoan from Pomona College files. Curiously, in light of Edmunds's concern for following traditional bureaucratic procedure, no records exist in Pomona College administrative records concerning funds raised for the mural and paid to the artist, nor is there a contract.

49. Memo of March 26, 1930.

50. Crespo de la Serna letter to David Scott, October 21–December 4, 1951, p. 3.

51. Edmunds's memo to Pijoan, April 30, 1930.

52. Marston's letter included in Edmunds's May 27 memo to Pijoan. Marston, a wealthy businessman who operated a San Diego department store, request-

ed that the hall be named the "Lucien Frary Refectory," in the memory of his friend, a former pastor of the Pilgrim Congregational Church in Claremont and college trustee from 1892 to 1903.

53. Pijoan facetiously called his *Student Life* letter of April 19 "my last will and testament," and the paper reported on April 25 that Pijoan had resigned and would teach at the University of Chicago. Whether he resigned is unclear, as both Thomas Beggs and Dorothy Merritt believed that Pijoan was fired (interviews).

54. Information on the Eli P. Clark complex from E. Wilson Lyon, *The History of Pomona College, 1887–1969*, pp. 264–69. Pijoan quote in *Los Angeles Times*, June 8, 1930.

55. Beggs's comments in interview, March 5, 1980, pp. 8–10.

56. Spaulding to art critic Arthur Millier, in "The Survival of *Prometheus*," *Los Angeles Times*, March 7, 1965.

57. Twenty-three studies for the *Prometheus* are extant, sixteen (the general study, three sketches for the side panels, and twelve figure drawings) in the collection of the Orozco family, two (both for the Prometheus figure) in the collection of Crespo de la Serna, four (one Prometheus, three general figure studies) in the collection of John Goheen, and one (figure study) in the collection of Murray Fowler, a young Pomona faculty member and Orozco's roommate in 1930. Two studies in the Merritts' possession were lost when their house burnt down and five to eight, strangely enough, apparently were lost within the Claremont Colleges' Honnold Library during the mid-1950s.

58. From Zakheim's letter to author of January 14, 1983; his comments came in the course of his restoration of the *Prometheus* at this time.

59. Beggs interview, March 5, 1980, p. 15.

60. Orozco's comment in *Textos de Orozco*, edited by Justino Fernández (Mexico City, 1955), pp. 78–79.

61. The length of the painting period from *Town and Country*, September 15, 1931.

62. Pijoan letter to David Scott, October 21, 1951, p. 2.

63. Interview with Mrs. Ames, emeritus member of the Scripps College art faculty, August 12, 1980, who found Orozco highly intelligent and well informed regarding artistic matters. He invited her to undertake the underpainting of one of Prometheus's upraised arms during their visit.

64. Earl Merritt asserts that Orozco reworked this

area at least four times (*Pomona Progress Bulletin*, September 2, 1968), and Jean Ames recalls a different image on her second viewing of the mural (interview, August 12, 1980).

65. Scott, "Orozco's *Prometheus*," p. 17.

66. Orozco intended the color symbolism to be "obvious" and direct, according to Crespo de la Serna, and he never tested the effect of a particular color in advance. Orozco chose all the colors spontaneously, but with consummate surety. Crespo letter to David Scott October 21–December 4, 1951, p. 5.

67. As David Scott noted in "Orozco's *Prometheus*," p. 16, Orozco certainly saw an exhibition at Alma Reed's Delphic Studios of the paintings of Mistra just before he left for California. These frescoes "characteristically show white opaque brushwork that stands out against more thinly painted passages." Also in the gouaches and oils of the 1927–30 period Orozco had experimented with the "expressive possibilities" of opaque brushwork.

68. All information not specifically cited elsewhere on Orozco's manner of working on the *Prometheus* comes from Crespo de la Serna's lengthy letter to David Scott, October 21–December 4, 1951.

69. Quoted in Alma Reed's *Orozco*, p. 186.

70. The Merritts flatly contend that Alma Reed invented the idea of an official dedication in their interview of September 4, 1980, pp. 30–31. Crespo letter to David Scott, October 21–December 4, 1951, p. 6.

71. In a letter written to a Pomona student shortly before his death in 1949, Orozco said that he received no money for the mural (quoted in *Student Life*, October 27, 1953), and his widow also understood this to be the case (Pomona College interview with Alfredo Orozco, August 22, 1957). Orozco recalls in his *Autobiography* (p. 139) that: "Still the work got done, and I went back to San Francisco—though with less money in my purse than when I arrived the first time, in 1917. It was not even enough for my return passage to New York [about $200]." The perplexing matter, which contemporary reports and later recollection do not explain, is: *precisely what happened to the funds raised* (some $2,000–$2,400)? It does not seem possible that Orozco could have used all these funds for painting expenses during April and May, since at Dartmouth during two years of work his material costs amounted to some $2,200. The answer may be found in the recollections of Chandler Ide (Pomona College, 1930), who was summoned by Pijoan to help him with packing his belong-

ings. Ide recalls: "He proceeded to empty various bureau drawers which contained money—dollar bills, five-dollar bills, coins, etc.—the contributions from students that he had accumulated. All this he put in a big paper sack which he asked me to deliver to the contractor in payment of amounts still owing on the mural" (*Pomona Today*, Spring 1985, p. 39).

72. Alma Reed, letter to Dr. Alvin Johnson, April 28, 1931 (from Johnson's papers in the possession of his daughter, Felicia Deyrup).

73. Pijoan letter to Scott October 21, 1951, p. 2. Covering the mural would have proved embarrassing to the college, particularly since annual "Friends of the Mexicans" conferences were held at Pomona during the 1920s and early 1930s, hosting up to 600 visitors and official guests, and addressing topics such as immigration, economic status, and educational needs of Mexicans and Mexican-Americans in southern California.

74. Harold Davis letter in *Student Life*, May 15, 1930, and Pijoan's letter in *Claremont Courier* of the same date.

75. Beggs interview, March 5, 1980, pp. 10–11.

76. Scott interview, February 28, 1980, pp. 15–16.

77. See Alma Reed, *Orozco*, p. 179, regarding this matter; she offers no documentation concerning the issue. David Scott's statement from letter to author, March 13, 1983, p. 2. Scott concedes, however, that there existed a racist attitude toward Mexican workers living in two small colonies on the edge of Claremont.

78. Brown letter to Dean Beatty, October 1, 1957, p. 1.

79. Quoted in "Orozco and Pijoan Dream of Giants," *Art Digest*, August 1930.

80. Quoted in Arthur Millier, "Orozco's Fresco Complete," *Los Angeles Times*, n.d., but surely mid-June 1930.

81. Orozco letter to the Merritts of November 25, 1930. Crespo's reaction in letter to David Scott, October 21–December 4, 1951, p. 6. At the same time Mrs. Merritt described Alma Reed as a "pompous, self-centered, and aggressive" personality who created bad feeling in Claremont. She compared Reed's trip to "fetch" Orozco to a "mother retrieving a run-away child" (interview, August 12, 1980). Similarly, Pijoan has noted that "Miss Reed arrived when the fresco was almost completed and did no good, as usual, for

Orozco" (statement quoted in letter of Pijoan to John Goheen, March 1, 1955).

82. Orozco letter to Crespo, July 12, 1930 (quoted in Cardoza y Aragón, *Orozco*, p. 28).

83. See Orozco's letters in Cardoza y Aragón, *Orozco*, pp. 286, 291.

84. President David Alexander's comments in *Student Life*, February 16, 1978. A final note of irony surrounds the *Prometheus* and Pomona College involving the students. When Orozco painted the mural, by and large they understood and appreciated his symbolic statement and in some cases became active participants as models in the project. During the 1970s, however, they vandalized the mural. Their acts ranged from mindless destruction, such as throwing food at the mural, to defacing the Prometheus figure's genital area. Concerning the latter, David Smith (a student at Pomona during the early 1970s) recalls that students had come to believe that the administration had originally painted out the private parts. Thus, in decorating the titan with bananas, breadsticks, etc., the students felt they were providing their own commentary on the supposed—but in fact totally fictitious—censorship on the part of college authorities (Smith interview, August 25, 1980).

85. Orozco exhibited the large (4x5 feet) *Zapata* and four other oils on the Mexican Revolution, two oils in a lighter vein (*Échate la otra* and *Mannequins*), two studies for the Preparatory School murals, and two drawings from the *Mexico in Revolution* series. On August 13 Orozco wrote to Crespo de la Serna that he had just finished the pictures for the Metropolitan and thought that they had gone well, especially the *Zapata* — "that is something like a fragment of the Pomona mural." He noted that assistants of "you know who" (Rivera) swarmed about and that he found himself in the midst of "enemy territory." Orozco's tone became openly derisive on his return to New York, as he wondered how "John Doe" (again Rivera) would fare in the United States where he would have to work in a nonfolklorist manner, "without Indians, *ejidos*, codices, *enchiladas*, and *huaraches*." (See Cardoza y Aragón, *Orozco*, pp. 281–83.)

86. Letter of Alvin Johnson, director of the New School, to Orozco, quoted in *Student Life*.

87. Reed, *Orozco*, pp. 163–64.

88. Reed letter to Johnson, April 28, 1931 (from Johnson's papers in possession of his daughter, Felicia Deyrup).

89. Alvin Johnson, unabridged manuscript for the published pamphlet "Notes on the New School Murals," dated August 20, 1943, pp. 2–3. Johnson described what he felt to be the "essentially complimentary nature" of Benton's and Orozco's murals:

> Benton chose to depict the tremendous burst of human energy and mechanical power that characterizes the present phase of economic life in America, and that, with appropriate qualifications, characterizes the ultra-modern industrial centers of other countries as well. Orozco chose to depict the revolutionary unrest that smolders in the nonindustrial periphery, India, Mexico, Russia.

90. Titles of the paintings from Delphic Studios press release, which appeared in the *New York Times*, October 26, 1930. Orozco noted the contrast of the New School paintings in a letter to his Claremont assistant, Crespo de la Serna: "This is something completely different than what I have done until now. That is, this is not the son of Pomona." Quoted in Luis Cardoza y Aragón, *Orozco*, p. 284.

91. Description of this panel from David Scott's Dartmouth lecture, October 13, 1984, p. 11.

92. The Jew is the Palestinian painter Rubin, the Anglo-Saxon art critic Lloyd Goodrich, the Nordic poet Leonard Van Noppen, and the Frenchman the philosopher Paul Richard (Reed, *Orozco*, p. 209).

93. David Scott Dartmouth lecture, October 13, 1984, p. 11.

94. Orozco, *Autobiography*, pp. 129–30. Orozco also enthusiastically followed newspaper reports of Gandhi's march to the sea in the spring of 1930, ending with his symbolic act of defiance (picking up a lump of sea salt) against the imperial monopoly on salt collection and his subsequent internment until late January 1931.

95. On Carrillo Puerto and his programs of reform, see Ernest Greuning, "A Maya Idyll," *Century Magazine* (April 1924).

96. Alvin Johnson realized the possible negative repercussions to the Communist panel as soon as Orozco painted it: "Lenin and Stalin on a New School wall: what could that mean except that the New School was in league with the Communists?" For his part, Orozco explained that "he was not defending Bolshevism or revolutionary excess, but only expressing the Russian reality," but he offered to remove the section and paint another topic. Johnson decided to let the painting remain. "Notes . . ." draft, pp. 8–9.

97. Octavio Paz, "Social Realism in Mexico," p. 64.

98. Jacqueline Barnitz, "Orozco's Delphic Years," p. 20.

99. According to Alma Reed (*Orozco*, p. 198): "The painter said he desired to interpret not only the scope and implications of the studies pursued at the New School, but to suggest Dr. Johnson's wide range of humanitarian interests and his expressed personal objectives of social justice and brotherhood."

100. Letter in Cardoza y Aragón, *Orozco*, p. 284.

101. See Appendix B for a consideration of this system.

102. Orozco, *Autobiography*, pp. 149–50.

103. According to Orozco's letter to Crespo in Cardoza y Aragón, *Orozco*, p. 284.

104. Information on Orozco's working schedule from Reed, *Orozco*, pp. 198, 204; Alvin Johnson's letter to Agnes de Luma, January 1, 1931, Yale University; and Edward Alden Jewett's review of the paintings, *New York Times*, January 25, 1931.

105. Johnson, "Notes . . ." manuscript, p. 7. His sole assistant was Lois Wilcox, who not only labored on the paintings, but also handled various social and public relations situations (Reed, *Orozco*, p. 204). I have been able to find nothing about her post–New School career.

106. From the study conducted by Tomás Zugurian Ugarte, "Results of the Technical Analysis Completed During the Week of February 11–16, 1974, of the Group of Murals Painted in 1930–31 by José Clemente Orozco at the New School for Social Research in the City of New York," p. 23. This comment is especially ironic since Alma Reed and Orozco came very close to suing the *New York American* for libel, in response to art critic Malcolm Vaughan's contention that Orozco had *not* worked in true fresco at the New School (*Orozco*, pp. 219–22).

107. Commenting on this tendency of Orozco's, here highly pronounced, Zugurian noted: "In most of Orozco's work, these junctures (merging of each day's work) are sometimes ostentatiously revealed without the slightest concern for establishing continuity" ("Results," p. 17).

108. According to Zugurian's report, approximately 50 percent of the surface had been affected by 1974, the result of decades of neglect on the part of New School authorities. The primary agents of damage: (1) moisture, seeping in through the walls from the unsealed top floor of the building directly above the mural; (2) the severe action of New York's industrial pollutants; and (3) Orozco's technical inconsistencies. Apparently, Benton's application of a wax varnish covering in 1956 marks the only restoration work on the mural:

> At this I also made an attempt, with the help of Mario Modestini, of the National Gallery in Washington, to preserve the Orozco murals which were powdering off the walls. A wax varnish was applied; but whether that will serve to insulate the murals is still doubtful. *An American in Art* (University of Kansas Press, 1969), p. 65.

After almost sixty years of neglect, the New School has announced plans to restore Orozco's murals (see *The New York Times*, March 26, 1988). Yet, given the terrible extent of deterioration, one wonders how much pigment survives to be restored.

109. Johnson, "Notes . . ." draft, p. 8. Suzanne La Follette (*The New Freeman*, February 1931) praised the color "as powerful as its form—vibrant notes of blue, green, and red contrasting dramatically with prevailing rusty browns," and Lloyd Goodrich (*Arts*, March 1931) also noted the mural's "prevailing warm, earthy color."

110. Johnson letter to Agnes de Luma, January 5, 1931 (Yale Library).

111. Cardoza y Aragón, *Orozco*, p. 285. Orozco states in his *Autobiography* (p. 144) that "the Negro presiding and the portrait of Lenin were the occasion for the New School's losing a number of its richest patrons, a serious loss to an institution dependent upon gifts." Yet Johnson flatly denied this contention; he wrote to a reporter who maintained that the Orozco mural had cost the New School a million dollars in endowment: "Although I lived with that picture for fifteen years I cannot say that I ever met or heard of a single person who withdrew one dollar on account of the mural" (Johnson letter to Frank Rasky, November 14, 1949, New School archives).

112. Johnson, "Notes . . . ," p. 9.

113. Statement of Dr. Hans Simon, then director of the New School, in the *New York Times* of May 22, 1953, which shows a photo of the mural covered by a curtain. An earlier memo ("Answer to Questions about the Orozco Mural," February 10, 1953) hinted at the possible destruction of the murals:

It is the contents which make this particular section of the walls offensive to the legitimate feelings of too many people. Other aspects of the matter cannot justify the further display of this picture.

The Board of Trustees has been considering a more permanent solution of the problem which is posed by the propagandistic intentions of Orozco's paintings and the prevailing opinion reacting to it.

114. *New York Times*, January 25, 1931.

115. Goodrich, *Arts*, pp. 422–23.

116. Suzanne La Follette wrote in February 1931 that 20,000 people had viewed the New School murals (*The New Freeman* review), and Alma Reed wrote to Albert Bender on February 18 that "the controversy seems to have died down" and "the important thing is that the mural continues to hold its public, being visited by hundreds each day" (Bender papers, Mills College).

117. For more than a year after the completion of the New School murals and the beginning of the Dartmouth program, Orozco devoted himself to easel works, several of which were painted for the prominent collector, Stephen C. Smith. The arrangement continued throughout the Dartmouth period, but the notion of painting solely for a wealthy private collector became unacceptable to Orozco, who allegedly destroyed the last painting in the series, a figure of a Franciscan monk derived from the Preparatory School (Reed, *Orozco*, pp. 236, 266–67). Unfortunately, little documentation survives from this interim period, and one notes with dismay Reed's remark on her collection of "several hundred" photos of Orozco and his work (p. 252), now missing, along with Orozco's letters to her from Dartmouth and all records of the Delphic Studios.

118. *Ibid.*, p. 240.

119. I learned of the mural plan from Professor Emeritus Churchill Lathrop, a member of the Dartmouth art faculty during Orozco's time in Hanover, interview April 22, 1980. President Hopkins's comment in letter to Clarence McDavitt, dated June 13, 1932; Dartmouth College Archives.

120. Alma Reed letter to Artemas Packard, chairman of Dartmouth College art faculty at this time, dated February 20, 1931. Quoted in Churchill P. Lathrop, "How the Murals Were Commissioned," in The Orozco Murals at Dartmouth College (symposium papers presented during the 1980 autumn meeting of the New England Council of Latin American Studies), at Hanover, N.H.

121. Alma Reed letter to Artemas Packard, dated May 22, 1931; quoted in Lathrop paper, noted above.

122. President Hopkins's memo to Halsey Edgerton, dated April 28, 1932; Dartmouth College Archives. Nelson Rockefeller was a member of the class of 1930, hence the Rockefeller interest in Dartmouth.

123. According to the *Boston Transcript*, May 21, 1932.

124. Dartmouth College press release, n.d. but surely May 1932; Dartmouth College Archives.

125. Clarence McDavitt to President Hopkins, June 14, 1932; Dartmouth College Archives.

126. President Hopkins to Clarence McDavitt, June 16, 1932, p. 2; Dartmouth College Archives.

127. According to Churchill Lathrop, "How the Murals Were Commissioned," p. 5.

128. President Hopkins to Matt B. Jones, May 31, 1932, p. 2; Dartmouth College Archives.

129. Reed, *Orozco*, p. 242. A "Memorandum of Agreement," dated June 9, 1932, states: "Orozco agrees to complete a mural project (comprising 2090 sq. ft.) for the Reserve Book Room in Baker Library and to give such instruction in the technique of mural painting as he cares to at his convenience, said project to be handled within the next eighteen months from the date of this agreement" (quoted in Lathrop, p. 9).

130. Reed, *Orozco*, p. 206.

131a) Artemas Packard uses this title in "The Dartmouth Frescoes," *Dartmouth Alumni Magazine* (November 1933) p. 9.

b) Salary figures in Artemas Packard memo, n.d., Dartmouth College Archives; and Orozco's place in Dartmouth faculty salary schedule determined from memo, "Schedule of Salary Adjustments" of Halsey Edgerton (treasurer) to President Hopkins, August 19, 1933; Dartmouth College Archives.

132. Hopkins letter to Jones, May 31, 1932, pp. 1–2.

133. Reed, *Orozco*, p. 235. The deficit for 1931–32 came to $237,500 (on incomes of $1,875,000), which was cut $100,000 by Alumni Fund contributions; the 1932–33 deficit dipped to $43,000; in 1933–34 the college posted a surplus of $3,000, and the financial situation continued to improve throughout the rest of the decade. See Charles E. Widmayer, *Hopkins of Dartmouth*, p. 188.

134. In fact, Hopkins had come to accept the proposition of his close friends "that as a connoisseur of art I am a bum" (letter to MacDavitt, June 16, 1932, p. 2). The college student newspaper, *The Dartmouth*,

reported on June 18, 1932 that during the coming academic year art students would be given the problem of designing the corridor walls between Carpenter Hall and Baker Library, and would study Orozco's technique firsthand. No records exist regarding this course.

135. Letter of President Hopkins to H. C. Byrd, dated April 6, 1933; Dartmouth College Archives. Hardly a militant extremist, Hopkins was a personal friend of Herbert Hoover and an occasional overnight guest at the White House, and his summertime vacation retreats to Manset, Maine, brought him in frequent contact with his neighbor, John D. Rockefeller, Jr. Yet, Hopkins rejected his Republican conservatism in 1932 by voting for Roosevelt, and conducted an educational survey of Puerto Rico for his administration in 1933. Hopkins would denounce the New Deal in 1936 (Widmayer, *Hopkins of Dartmouth*, pp. 192–93).

136. Artemas Packard, "The Dartmouth Frescoes," p. 9. Orozco noted in his *Autobiography* (p. 158) that "I had complete freedom to express my ideas; no suggestion or criticism of any sort was ever made."

137. A man of manifold interests, he was very much involved in college politics and had been responsible for inviting Lewis Mumford to deliver a lecture series on the Brown Decades and on other areas of twentieth-century civilization (according to *College on the Hill*, pp. 161–62). Unfortunately, virtually no documentation in Prof. Packard's hand exists in Dartmouth College Archives.

138. Letter to Clarence McDavitt, June 3, 1932, p. 2; Dartmouth College Archives.

139. Quoted in *Boston Evening Transcript*, May 25, 1932.

140. Statement in Orozco's hand from Dartmouth College Archives (n.d.); first published in *Dartmouth Alumni Magazine*, November 1933.

141. Orozco quoted in Dartmouth College press release, May 25, 1932.

142. Quoted in Hopkins letter to Jones, p. 3.

143. Reed, *Orozco*, p. 241.

144. A manuscript page in Orozco's hand from Dartmouth College Archives, "Proposed Subject of Panels in the Baker Library Reserve Room," lists twenty-one panels in this order, while Alma Reed has a somewhat similar grouping of topics in her preliminary plan (*Orozco*, pp. 244–45).

145. This order from Orozco's diagram published in the November 1933 *Dartmouth Alumni Magazine*.

146. Two-page manuscript in Orozco's hand, "The Return of Quetzalcoatl," n.d., Dartmouth College Archives. No studies remain of the various stages of the originally proposed decorative schemes.

147. Orozco, as quoted in Artemas Packard's pamphlet *An Interpretation of the Orozco Frescoes at Dartmouth*, Hanover, N.H., n.d., but sometime after the author's death in 1961), p. 4.

148. The actual situation involving human sacrifice and Aztec theology was far more complex than the artist pictured:

> The Aztecs, the people of Huitzilopochtli, were the chosen people of the sun. They were charged with the duty of supplying him with food. For that reason war was a form of worship and a necessary activity that led them to establish the *Xochiyaóyotl*, or "flowery war." Its purpose, unlike that of wars of conquest, was not to gain new territories nor to exact tribute from conquered peoples, but rather to take prisoners for sacrifice to the sun. The Aztec was a man of the people chosen by the sun. He was a servant of the sun and consequently must be, above everything else, a warrior. . . .
>
> Since man was created by the sacrifice of the gods, he must reciprocate by offering them his own blood (*chalchihuatl*, "the precious liquid") in sacrifice. Human sacrifice was essential in the Aztec religion, for if man could not exist except through the creative force of the gods, the latter in turn needed man to sustain them with human sacrifice. Man must nourish the gods with the magic sustenance of life itself, found in human blood and in the human heart.

From Alfonso Caso, *The Aztecs: People of the Sun*, pp. 12–14.

149. Fernando Díaz Infante quoted in "The Psyche and Metamorphosis of Quetzalcoatl" from José Lopéz-Portillo et al., *Quetzalcoatl in Myth, Archeology, and Art*, p. 174. For the Quetzalcoatl myth, see also Laurette Sejourné, *Burning Water: Thought and Religion in Ancient Mexico*. The Quetzalcoatl myth reverberated through Mesoamerica, as he was known to the Mayas as *Kulkulcán* and to the Quichés as *Gucumatz*.

150. Irene Nicholson, *Mexican and Central American Mythology*, p. 82.

151. Indigenous American poem, quoted in León-Portilla, *Pre-Columbian Literature of Mexico*, p. 40.

152. Díaz Infante in Lopez-Portillo et al., *Quetzalcoatl . . .* , p. 225.

153. León-Portilla, *Literatures*, p. 116

154. J. H. Cornyn, *The Song of Quetzalcoatl*, p. 131

155. Díaz Infante, in Lopez-Portillo et al., *Quetzalcoatl*, p. 221.

156. On the narrow walls before reaching the central area of reserve book distribution, Orozco painted two small decorative panels depicting the artistic achievements of the northwest Indians. Their counterparts on the post-Cortesian walls, similarly totemic in nature, allude to twentieth-century machine technology.

157. Orozco's statement quoted in Jacquelynn Baas, "Interpreting Orozco's Epic," p. 47.

158. Jacques Soustelle, *The Daily Life of the Aztecs of the Eve of the Spanish Conquest*, p. 214.

159. Lewis Mumford, "Orozco in New England," p. 233. Italics in the original.

160. *Ibid*. Mumford felt a close kinship between Orozco's image and his own writing. In a letter to Katherine Bauer, February 17, 1934, and published in Lewis Mumford *My Works and Days: A Personal Chronicle* p. 219, he noted:

> At length the prophecy of Quetzalcoatl is wryly fulfilled: the Spaniard comes in his sable armor; and out of that springs—it is really an illustration for my book! [*Technics and Civilization*]—the Machine: the machine in its essence, orderly and powerful, disintegrating and dehumanizing, an altogether devastating image.

161. "My stay at Dartmouth, from 1932–34, was altogether agreeable and satisfactory. Dartmouth is one of the best examples of liberalism in the North, and of New England hospitality. New Englanders are completely different from other groups of Americans. Country folk, hostile and formal in their dealings with outsiders and new arrivals, but most cordial on closer acquaintance, and anxious to be neighborly, to understand one, and to help out with the greatest good will, disinterest, and courtesy" (Orozco, *Autobiography*, p. 138).

162. Pells, *Radical Dreams and American Visions*, pp. 26–27.

163. According to the *Boston Evening Transcript*, November 4, 1933, "At the outbreak of the recent Cuban insurrection, Orozco dropped work on the section of the panel [the Anglo section], and plunged with evident zest into the latest patch of his growing wall, painting into its fresh-laid plaster his conceptual synthesis of 'Latin America.' "

164. Quoted in Alma Reed, *Orozco*, p. 245.

165. Prof. Artemas Packard, quoted in *Boston Sunday Post*, April 22, 1934.

166. The cartoon appeared in *El Ahuizote* (August 10, 1912) and is reproduced in Joyce Waddell Bailey, "José Clemente Orozco (1883–1949): Formative Years in the Narrative Graphic Tradition," p. 30.

167. According to Thomas Beggs (interview March 5, 1980), Orozco later confirmed his suspicions that the group of academics contained caricatures of Pomona College President Edmunds and Dean of Students Jaqua (last two figures to the right).

168. Reed, *Orozco*, p. 262.

169. Orozco used the phrase in his preface to *Fresco Painting*, a technical manual by Gardner Hale.

170. This Pantocrator figure brings to mind those in the murals of Romanesque Spain, such as San Clemente de Tahull, which Orozco knew.

171. The early Franciscan missionaries were greatly intrigued by what they saw as the many similarities of Quetzalcoatl and Christ: his use of the cross image; his supposed virgin birth; his pious life and practice of mortification; his belief in one god, the creator of all things. Beyond this, the missionaries' views became reinforced when they saw that the indigenous Americans practiced the rituals of circumcision, oral confession, fasting, and the tonsure, mistakenly believing that these customs could only derive from the Judeo-Christian tradition. See Jacques Lafaye, *Quetzalcoatl and Guadalupe*, p. 155ff.

172. David Scott Dartmouth lecture, October 13, 1984, pp. 19–20.

173. During his European trip of 1932, Orozco expressed outrage regarding the contemporary disclosure of the exchange of critical war material between the Allies and Germans to prolong World War I in order to reap greater profits for speculators, and wrote in horror that the appearances of maimed, crippled, and deformed soldiers "beggared the most lurid artistic imagination" (*Autobiography*, p. 156).

174. As if to indicate the problems posed by these inconclusive works, many critics—and even Prof. Packard's guide to the murals—simply ignore them. Mumford brings up alleged Marxist implications in what he sees as "the image of a workers' world": "the spirit of construction, the will-to-create, is there: the equivalent of the manly confidence and large-minded energy that one finds in Soviet Russia tody" ("Orozco in New England," p. 234). Yet, Cardoza y Aragón notes accurately in this respect that "Orozco no es artista de

'happy end' " (*Orozco*, p. 72). The most perplexing comment comes from the artist himself, who remarked to Laurence Schmeckebier that the worker figure is "a portrait of a worker reading a telephone book" (quoted in Schmeckebier, *Modern Mexican Art*, p. 100). Curiously, Jacquelynn Baas sees the paintings in explicitly optimistic terms and writes of their "utopian import": "These last five panels, serve, in effect, as a coda, balancing the lost utopia of Quetzalcoatl with a contemporary vision of human possibility" ("Interpreting Orozco's Epic," p. 49).

175. Francis V. O'Connor, *Art for the Millions*, pp. 20–21.

176. Karal Ann Marling, "A Note on New Deal Iconography," p. 438.

177. Pells, *Radical Visions and American Dreams*, p. 223.

178. Quoted from J. C. Orozco, *Textos de Orozco*, p. 176.

179. Katz quoted in Reed, *Orozco*, p. 246.

180. Reed, *Orozco*, pp. 241, 243.

181. *The Dartmouth*, June 18, 1932.

182. Orozco, *Autobiography*, p. 157.

183. Reed, *Orozco*, p. 250.

184. According to *Boston Evening Transcript*, November 4, 1933.

185. Prof. Packard, "The Dartmouth Frescoes," p. 11.

186. Gobin Stair, "The Making of a Mural," p. 11.

187. Information on the order of painting from David Scott's notes on his conversation with Churchill Lathrop, October 6, 1984.

188. Orozco letter to "Mr. Harris," October 8, 1933; Dartmouth College Archives.

189. Orozco produced—primarily in pencil, but also in charcoal and gouache—some 400 sketches for the murals, which have been dispersed. During the 1950s the Orozco family offered the entire set to Nelson Rockefeller at evidently a modest fee, but Rockefeller curiously enough—given his family's commissioning of the project—was not interested (interview with Orozco's daughter, Lucrecia, March 18, 1981). The Museum of Modern Art exhibited fifty-eight of the studies in late 1961, the largest number to have been shown at one time.

190. A Museum of Modern Art press release, November 22, 1961, speaks of "drawings from life in which Orozco transformed Dartmouth athletes into ancient Aztec warriors."

191. Gobin Stair, "The Making of a Mural," p. 23.

192. *Ibid.*, pp. 22–23.

193. Prof. Packard, in "Orozco at Dartmouth," p. 10.

194. For example, in *Time*'s coverage (February 26, 1934) of the destruction of Rivera's murals and the completion of the Dartmouth murals, Orozco came in a decided second in terms of article space.

195. "The Orozco Frescoes at Dartmouth," Hanover, N.H., n.d., but seemingly soon after the completion of the murals.

196. Quoted in Widmayer, *Hopkins of Dartmouth*, p. 183.

197. Harvey M. Watts, director of Philadelphia Moore Institute of Art, Science, and Industry, to Albert Dickerson (Dartmouth College News Service Director), August 1, 1934; Dartmouth College Archives.

198. Walter Beach Humphrey, Dartmouth 1914, "A New Dartmouth College Case," a five-page document submitted to President Hopkins and college trustees on the completion of Orozco's murals, p. 3.

199. *Ibid.*, p. 4.

200. Letter of Dr. Van Ness Dearborn to *Boston Transcript*, March 10, 1934.

201. From *New York Times*, June 10, 1933. While the committee received almost unanimous praise from the press, John Sloan, president of the Society of Independent Artists, characterized the "regret list" as bringing American artists "justified contempt and ridicule," and found Orozco and Rivera "the most purely and truly American artists (with the exception of our own Indians) who are now working on this continent" (*Art Digest*, July 1, 1933).

202. Robert C. Strong, secretary of President Hopkins, quoted in *ibid*.

203. Quoted in Widmayer, *Hopkins of Dartmouth*, p. 182.

204. Schulberg letter to author, April 3, 1982.

205. E. M. Benson in *The Nation*, November 8, 1933.

206. Mumford, "Orozco in New England," p. 232.

207. Mumford's remarks quoted in *The Bulletin* 11 (Hanover, N.H., February 20, 1934): 1.

208. Orozco quoted in *Ibid.*, p. 2.

209. Hopkins letter to Philip S. Marden, October 19, 1934, Dartmouth College Archives.

210. A. J. Phillpot, "Great Murals Always Inspire Factional Wars," *Boston Sunday Globe*, January 27, 1935.

211. According to the *Magazine of Art*, July 1940.

212. Dorothy Adlow, "Orozco Murals in Retrospect: Decoration at Dartmouth Takes on New Significance," *Christian Science Monitor*, August 28, 1941.

213. The murals have survived in excellent condition largely owing to the efforts of Prof. Emeritus Churchill Lathrop, who in his roles as art faculty member and director of art galleries acted for decades as the unofficial "curator" of the murals. They were restored in the summer of 1968 by Oliver Bros., Inc. (Boston), with the primary task of cleaning "thirty-some years accumulation of dirt, dust, cigarette smoke, and white paint drops," and filling in small holes, scratches, and larger cracks. Finally, the paintings were coated with a light spray of polyvinyl acetate (from report of restorers Carroll Wales and Constantine Tsaousis, Dartmouth College Archives).

Chapter 2

1. For a study of Rivera's artistic education and the European artistic apprenticeship (1898–1906 and 1907–21, respectively) see Ramón Favela's *Diego Rivera: The Cubist Years*. The artist's first murals in Mexico have yet to receive a definitive scholarly treatment.

2. Leopoldo Zea, *The Latin American Mind*, p. 33.

3. Leopoldo Zea, *Positivism in Mexico*, p. xx.

4. Zea, *Latin American Mind*, p. 275.

5. Zea, *Positivism in Mexico*, p. 117.

6. Paraphrased from *ibid.*, pp. 110, 176.

7. *Ibid.*, p. 171.

8. Favela, *Diego Rivera: The Cubist Years*, p. 9.

9. *Ibid.*, p. 13.

10. *Ibid.*, p. 15.

11. Zea, *Latin American Mind*, p. 285.

12. Zea, *Positivism in Mexico*, p. 163.

13. Diego Rivera, "Dynamic Detroit," p. 295. Diego Rivera is quoted above, without attribution, in Bertram Wolfe, *Diego Rivera: His Life and Times*, p. 183.

14. Quoted in Jean Charlot, *The Mexican Mural Renaissance: 1920–25*, p. 123.

15. *Ibid.*, p. 261.

16. These artists met at the house of Jacques Villain in the Parisian suburb of Puteaux, hence the name for the group.

17. Robert Rosenblum's description in *Cubism and Twentieth Century Art*, p. 129. Curiously, Rosenblum, a perceptive historian of the Cubist movement, misses the enormous impact of Cubism on Rivera's Mexican murals, terming his "mature viewpoint remote from Cubism" (p. 204).

18. Gleizes's and Metzinger's book on Cubist theory, *Du Cubisme*, was published in 1912. Severini's statement of 1917 quoted in Charlot, *The Mexican Mural Renaissance*, p. 124.

19. The terms are from Rosenblum, *Cubism and Twentieth Century Art*, p. 133.

20. Not only did Léger and LeCorbusier share similar architectural concerns in their works, but also displayed their art together in a LeCorbusier-designed three-dimensional environment. Léger's painting *Composition* hung in the room Le Corbusier designed for the 1925 Paris Exposition Internationale des Arts, his machine like composition, *Pavillon de l'Espirit Nouveau*. Rosenblum saw the painting serving as "an authoritative dictionary of the forms and relationships realized three-dimensionally in the room itself" (*ibid.*, p. 155).

21. For a consideration of Rivera's highly faithful, if eclectic (he often transposed images from different chronological periods and locales), use of indigenous Mexican subject matter, his idyllic portrayal of pre-Conquest Mexican societies, and his emphasis on the elitest Aztec empire at the expense of agrarian cultures, see Betty Ann Brown, "The Past Idealized: Diego Rivera's Use of Pre-Columbian Imagery" in the 1986 Detroit Institute of Arts *Diego Rivera* catalog, pp. 139–55.

22. Demetrio Sodi, "Ethnohistoric and Archeological Testimony, in José López Portillo, Demetrio Sodi, and Fernando Díaz Iufante, *Quetzalcoatl in Myth, Archeology, and Art*, p. 35.

23. *Ibid.*, p. 36.

24. See his unpublished lecture at the Detroit Institute of Arts, "The Diego Rivera Murals," March 20, 1977, p. 4ff. O'Connor considers this matter in greater detail in "An Iconographic Interpretation of Diego Rivera's *Detroit Industry* Murals in Terms of Their Orientation to the Cardinal Points of the Compass" (1986 Detroit Institute of Arts *Diego Rivera* catalog, pp. 215–29).

25. These are some of Rivera's activities during 1926–30:

1926–27: He works on both the Education Ministry and Chapingo murals.

1927: He visits USSR to participate in the tenth celebration of the October Revolution.

His plans to paint murals were thwarted for various reasons.

1928: He does forty-five drawings of May Day celebrations in Moscow. With continued opposition to his planned projects and artistic points of view he leaves Moscow shortly thereafter.

He meets his future wife, Frida Kahlo, while painting the Education Ministry third-floor *corrido* series.

1929: He becomes director of the Academy of San Carlos.

He paints frescoes (six symbolic nudes) at the Ministry of Health.

He begins his comprehensive mural history of the Mexican Republic at the National Palace.

He is expelled from the Mexican Communist Party.

December 1929–November 1930: He paints the Cuernavaca murals and continues work at the National Palace.

26. Rosemary Fish quoted in the *Chicago Evening Post*, December 29, 1931.

27. Rivera's painting "Flower Day" won the $1,500 purchase prize at the Los Angeles Museum of History, Science and Art at its 1925 Pan-American Exhibition; the American Institute of Architects awarded him their Fine Arts Gold Medal in 1929; and in 1930 alone Rivera sold more than $8,000 worth of his art to collectors in this country (the last figure from Frida Kahlo's catalog of Rivera's work from 1926 to 1932 in the Bertram D. Wolfe papers, Hoover Institution of War, Peace, and Revolution, Stanford University).

28. Rivera's letter of October 1927 to Bender, from Albert Bender papers, Mills College Library.

29. The Club did not formally open until October 22, 1930, with the premises at 155 Sansome Street leased from the San Francisco Stock Exchange. The original roster comprised 200 names, consisting of (according to notes from the club's files) "all the first families of finance and a number from business." It is unclear why the Luncheon Club mural became Rivera's first San Francisco project, since Rivera's correspondence with San Francisco patrons during 1926–30 spoke of his painting a mural at the California School of Fine Arts, commissioned by William L. Gerstle, a wealthy industrialist and president of the San Francisco Art Association. The only mention of this matter is the incomplete explanation in Bertram Wolfe, *Diego Rivera: His Life and Times* (p. 325) that Gerstle's "soft-heartedness" accounted for allowing Rivera to begin work first on the other mural.

30. Letter of Beatrice Judd Ryan to Bertram Wolfe, October 16, 1940; from Wolfe papers, Hoover Institution.

31. Quoted in *San Francisco Chronicle*, September 25, 1930, and *San Francisco News*, September 26, 1930.

32. Description of the Riveras from *San Francisco Chronicle*, November 11, 1930.

33. Interview with Lord Huntingdon (Beaulieu, Hampshire), July 3, 1979, at the time Viscount Hastings. For Rivera's and Kahlo's social activities during this time, see Hayden Herrera, *Frida: A Biography of Frida Kahlo*, pp. 117–20.

34. Rivera's statement from *San Francisco Chronicle*, November 11, 1930.

35. Receipts from Wolfe papers and files of San Francisco Luncheon Club indicate that Rivera received $1,000 on January 12, $1,800 on April 12, and a further $500 from William Gerstle on June 3 for the mural studies. Various local artists, such as Stackpole, Wight, Ruth Cravath, Adeline Kent, and Robert Howard, executed small sculptural pieces and murals.

36. *San Francisco Chronicle*, September 25, 1930.

37. On the architectural and decorative features of the club see R. W. Sexton, "An Unusual Use of Metals," *Metalcraft* (February 1932), "Luncheon Club Stock Exchange, San Francisco, California," *American Architect* (July 1932), and Carleton Monroe Winslow, "The Stock Exchange Luncheon Club, San Francisco," *Architect and Engineer* (December 1931).

38. Letter from Lord Huntingdon, November 18, 1981. Clifford Wight, an English sculptor, studied with Rivera in Mexico during the mid-1920s, and would be his chief assistant in San Francisco and Detroit.

39. For Rivera's early training, see Jean Charlot, "Diego Rivera at the Academy of San Carlos," *An Artist on Art*, vol. 2.

40. Rivera's statement in *San Francisco Examiner* article (n.d.), "Rivera, Sketching Helen Wills, Calls Her Typical 'Modern American Girl.'" Mrs. Moody's

recollection from *Fifteen-Thirty* (C. Scribner & Sons, 1937), pp. 183–85.

41. Goodman information from interview with Masha Zakheim Jewett, and her letter to author, July 8, 1981.

42. Emily Joseph, "Rivera Murals in San Francisco," *Creative Art* (May 1931).

43. From Stanton Catlin's unpublished manuscript on the Palace of Cortés murals (1948), Museum of Modern Art Library, p. 47.

44. As Timothy Pflueger later wrote to Rivera, then at work in Detroit: "I have seen some of the photographs of the Detroit murals, and think them very fine; however, I am still unwilling to trade the Stock Exchange Luncheon Club mural for any other of like size." Letter to Rivera, March 31, 1933, from files of San Francisco Art Institute.

45. "The evolution of a Rivera Fresco: An Interview with Mrs. Sigmund Stern," *California Arts and Architecture* (June 1932).

46. The commission included $800 for Rivera's fee, $250 for five studies, $340 for the plasterer, Matthew Barnes, and $110 for the construction of the portable frame. Receipts in Wolfe papers, Hoover Institution.

Information on the restoration, done in June 1982, from tape of Lucienne Bloch Dimitroff and Stephen Dimitroff, who would assist Rivera in Detroit and New York (July 15, 1982, p. 11).

47. From April 30 until June 2, 1931 when he received $2,500; payment receipt from San Francisco Art Institute archives, signed by Rivera.

48. Rivera letter to Carl Zigrosser, May 5, 1931; I have uncovered no information on the nature of the seven other mural projects.

49. Letter of E. Spencer Macky, director of the San Francisco Art Association, to William L. Gerstle, May 23, 1929.

50. The dimensions of the loggia area, assuming that Rivera painted the two side walls, measured 1,120 square feet, while the wall that Rivera eventually painted measured (discounting the unimportant lower trompe l'oeil scaffolding) 1,295 square feet. Thus, Wolfe's assertions (*Diego Rivera: His Life and Times*, p. 350, and *The Fabulous Life of Diego Rivera*, p. 294) that Rivera painted 1,200 square feet, instead of the originally offered *120* square feet, are entirely erroneous.

51. Information on the Goodman study from Masha Zakheim Jewett letter to author (July 8, 1981) regard-

ing her interviews with Goodman, and my interview with Goodman, July 10, 1980.

52. Paraphrased from Timothy Pflueger letter to Spencer Macky, executive director of the San Francisco Art Association, July 9, 1931.

53. The Communist hammer and sickle insignia appearing today in the worker's pocket was not present in photographs from the 1930s. However, Harry Mulford, archivist of the San Francisco Art Institute, informed me that he had heard that the hammer and sickle did originally appear, but were painted out by Ralph Stackpole as being "unsuitable" (interview, June 26, 1980).

54. *Hesperian* (San Francisco), Spring 1931.

55. Correspondence discussing the "Gerstle Reception" from San Francisco Art Institute files; the dedication covered in *San Francisco Chronicle*, August 12, and *San Francisco Examiner*, August 9, 1931.

56. The covering was mentioned, though not discussed in detail, in the *San Francisco Examiner*, November 27, 1957, and the *San Francisco Chronicle-Examiner*, November 1957. Although the files of the San Francisco Art Institute contain no relevant documentation on this incident, *Sunset Magazine* (January 1966) asserts that "the directors [of San Francisco Art Association] voted to cover up the wall. The reason they gave was that it distracted from the art exhibits displayed in the gallery."

57. *Art Digest*, February 15, 1932.

58. According to Frances Flynn Paine's letter to Mrs. Rockefeller, September 14, 1931; from the private archives of the Messrs. Rockefellers, 30 Rockefeller Plaza, New York.

59. Harry McBride in the *New York Sun*, December 26, 1931.

60. Frances Flynn Paine was a key figure in stimulating attention in Mexican art generally, and "the driving force behind the exhibition," as one reviewer called her. But there exists tantalizingly little factual evidence to document her actual capacity in the exhibition and the later Rockefeller Center debacle. Paine was an artistic entrepreneur and crusader for the cause of Mexican folk crafts. Primarily through her association with Abby Aldrich Rockefeller, she played a major role in creating interest in Mexican art during the late 1920s. By the time of the exhibition, this interest had reached such proportions that one critic spoke of "the current cult for any art which is both native and from below

the Rio Grande." Mrs. Paine had spent much of her youth in Mexico, and evidently knew rural areas well, the result of her family's frequent travels to attend to their mining and agricultural holdings. She first received Rockefeller Foundation funds to organize a New York exhibition, held in 1928, of Mexican pottery, other crafts, and paintings. Her work intended to establish a self-reliant native Mexican crafts industry and received further Rockefeller support from 1928 to 1931. In fact, by mid-1929, Mrs. Paine's lawyer wrote to Rockefeller Foundation officials that "the movement has gained such proportions that it seems advisable to create another entity in the form of a membership corporation. . . ." Mrs. Rockefeller approved, and incorporation papers for the "Mexican Arts Association, Inc.", consisting of sponsor Abby Aldrich Rockefeller, thirteen other prominent New Yorkers, with Paine as secretary, were filed in June 1930. These papers stated the organization's primary function: "to promote friendship between the people of Mexico and the United States of America by encouraging cultural relations and the interchange of Fine and Applied Arts." To do this, exhibitions would be held in the United States and Mexico, literature distributed in both countries, and training provided for Mexican artisans. As part of her work for the association, Paine traveled to Mexico several times regarding the Rivera exhibition, and wrote in August 1930 that Rivera "is delighted with the prospect" of the forthcoming show. (Paine letter to Mrs. Rockefeller, d. August 13, 1930, and other quoted documentation from Messrs. Rockefeller Archives). Paine also helped organize the ballet H. P. ("Horsepower") with music by Carlos Chávez and costumes/scenery by Rivera. The ballet symbolizes the relations between the industrial North and the Tropics as suppliers of new materials, and opened at the Metropolitan Opera on March 31, 1932, with the orchestra conducted by Leopold Stokowski. Yet the ambitious Rockefeller plans for fostering appreciation for Mexican art fell victim to the depression, and the association had ceased to function by the fall of 1930. Ramon Alva had accompanied Rivera from Mexico, where he had worked with Rivera for eight years. Lucienne Bloch, a daughter of the composer Ernest Bloch and trained as an artist, had recently been serving as a companion to Mrs. Sigmund Stern on her tour of Europe in the summer of 1931. Arriving in New York, Bloch met Rivera through Mrs. Stern's sister,

Annie Meyer Liebman, and asked him if she could work as an assistant, grinding colors. Bloch would continue to work with Rivera on the Detroit and later New York mural projects (letter to author, January 25, 1982).

61. Description of Rivera at work from *The New Yorker*, December 26, 1931, pp. 9–10.

62. On January 7, 1932, the *New York Herald Tribune* reported the New York panels had been added to the exhibition.

63. From Rivera's comments on his arrival in New York, *New York Herald Tribune*, November 14, 1931.

64. Rivera quoted in Diego Rivera and Gladys March, *Diego Rivera: My Art, My Life* (1960), pp. 181–82.

65. Rosemary Fish in the *Chicago Evening Post*, December 29, 1931.

66. Henry McBride, "The Palette Knife," *Creative Art* (February 1931), and the reviews cited in *Art Digest*, January 15, 1932.

67. Fish in *Chicago Evening Post*.

68. The eight frescoes, temporarily stored in Mrs. Rockefeller's garage after the exhibition closed, were thereafter purchased by the Weyhe Gallery. The Museum of Modern Art purchased *Zapata* and the Philadelphia Museum *Sugar Cane* and *Uprising*, while the other panels remained at Weyhe until they (and the cartoons) went on sale at Sotheby Parke-Bernet on May 26, 1977. The frescoes sold for about $30,000 apiece.

69. Margaret Sterne, *The Passionate Eye: The Life of William R. Valentiner*, p. 192.

70. Valentiner letter to Rivera, April 2, 1931, from Wolfe Collection, Hoover Institution.

71. Valentiner letter to Rivera, May 27, 1931, Wolfe Collection, Hoover Institution.

72. Sterne, *Passionate Eye*, pp. 143, 162.

73. Valentiner comment in *Passionate Eye*, p. 192, and E. P. Richardson in interview with Linda Downs, February 6, 1978, p. 24 (in files of Archives of American Art).

74. Information paraphrased from Linda Downs, "The Rouge in 1932: *The Detroit Industry* Frescoes of Diego Rivera," *The Rouge*, 1978 Detroit Institute of Arts exhibition catalog, notes to illustrations 74 and 106.

75. Sterne, *Passionate Eye*, p. 200.

76. Figure cited in *Rouge* catalog, p. 49.

77. From Linda Downs interview with E. P. Richardson (February 6, 1978), p. 29.

78. *Ibid.*

79. Allan Nevins and Frank Ernest Hall, *Ford: Expansion and Challenge*, p. 293.

80. *Ibid.*, chapter 13, "Labor: A Bright Dawn Pales."

81. Rivera quoted in *Detroit News*, March 20, 1933, explaining the intent of his murals.

82. Nevins and Hill, *Ford*, p. 590.

83. See Edmund Wilson, "Detroit Paradoxes," *New Republic*, July 12, 1933.

84. In his Detroit Institute of Arts lecture (March 20, 1977) Francis O'Connor noted the contrasting interior and exterior dualities Rivera employed throughout his mural program.

85. The foregoing descriptions generally adapted from Linda Downs, *The Rouge*, notes 74 and 106.

86. These similarities noted in *ibid.*, p. 51.

87. Dimensions from George F. Pierrot and Edgar P. Richardson, "An Illustrated Guide to the Diego Rivera Frescoes," Detroit Institute of Arts, 1934, p. 14.

88. Ernst Halberstadt, "Transcript of the Panel Discussion held September 20, 1978, at the Detroit Institute of Arts during the exhibition *The Rouge: The Image of Industry in the Art of Charles Sheeler and Diego Rivera*," p. 8.

89. From Lucienne Bloch Dimitroff letter to Linda Downs, April 17, 1978; this letter annotated by Dimitroff and sent to author April 10, 1982.

90. Earl of Huntingdon letter to author, November 18, 1981.

91. Quotation from transcript of tape prepared for author by Ernst Halberstadt (April 28, 1982), pp. 5–6. Other information on assistants from tapes of Stephen Pope Dimitroff (March 1 and April 28, 1982).

92. Lucienne Bloch Dimitroff diary entry, May 30, 1932, in April 1978 letter to Linda Downs.

93. Rivera's statement in Rivera and March, *Diego Rivera: Mi Arte, Mi Vida* (Mexico, 1963) p. 143, an apparent exaggeration of the numbers involved. Today there exist some 200 sketches for the murals under the control of Sra. Dolores Olmedo, the president of the "Comité Técnico del Fideicomiso Diego Rivera."

94. Lucienne Bloch Dimitroff on the DIA panel, p. 9 (see note 88).

95. Regarding the contents of this library, Lucienne Bloch Dimitroff remembers "lots of paperbacks from France," and while there were books on art and politics, most of the publications concerned scientific matters. Specific titles included a subscription to *Le Surréalisme au Service de la Révolution*, and works by Rivera's friend, Elie Faure, and by Ozenfant and Poincaré, the mathematician whom Rivera considered "very important for artists." There was also a "large book on African sculpture" (Lucienne Bloch Dimitroff letter to author, January 8, 1983).

96. The cartoons for the upper registers of the north, south, and east walls came to light in May 1979, when Linda Downs and the Detroit Institute of Arts staff found them neatly rolled up in a museum storage area where they had lain unnoticed for almost fifty years; Linda Downs letter to author, May 7, 1979.

97. I am greatly indebted to Linda Downs for her information concerning the chronology of events at the Detroit Institute of Arts in her letters to the author of June 16 and December 10, 1982.

98. Rivera, "Dynamic Detroit," p. 289.

99. *Ibid.*, pp. 289–91.

100. Prof. Dorothy McMeekin (Department of Natural Science, Michigan State University), unpublished article on the Detroit murals, "The Creative Process in Science and Art" (1983); noted for Plate III.

101. Rivera on Frida Kahlo's miscarriage from *My Art, My Life*, pp. 289–90. I thank Linda Downs for her perceptive insight regarding Rivera's distinction between a "born" and "unborn" child ("—a child, not an embryo," as Rivera wrote) and its meaning for the mural program; letter to author, December 10, 1982.

102. According to Lucienne Bloch Dimitroff, April 10, 1982, DIA transcript, p. 8.

103. Lewis Mumford, *Technics and Civilization*, p. 363.

104. See John Dewey's *New Republic* articles, "Middletown: A House Divided Against Itself" (April 24, 1929), " 'America' by Formula" (September 18, 1929), and *Technics and Civilization*, p. 422.

105. Rivera must have enjoyed the visual irony surrounding the red star on the worker's glove, for the Monte Glove Company (of Maben, Mississippi; supplier of gloves for all Rouge workers) used this motif as their logo at this time; Linda Downs letter to author, January 21, 1982.

106. Rivera, "Dynamic Detroit," p. 291.

107. *Ibid.*, p. 293. The Ionic column behind the figure symbolizing the white race surely symbolized the achievements of Western civilization.

108. I thank Prof. Dorothy McMeekin for allowing me to refer to her research on the murals from her articles "The Historical and Scientific Background of

Three Small Murals in the Detroit Institute of Arts," *Michigan Academy of Science, Arts and Letters Journal* [1983]; "The Creative Process in Science and Art," unpublished [1983], and her letters to the author (February 19, March 21, and April 10, 1983). I am especially grateful to her for the precise identification of the imagery in these smaller panels.

109. According to Lucienne Bloch Dimitroff's letter to Linda Downs, p. 2. A drawing of the child appeared on the cover of *Time* magazine on May 2, 1932, the probable model for Rivera.

110. Information on identification of objects in this panel from C. R. Sheldon (Public Relations Services, Parke-Davis Co.) in his letter to Linda Downs, February 12, 1983.

111. Rivera's intent according to letter of Lucienne Bloch Dimitroff to author (March 28, 1983).

112. McMeekin on the *Pharmaceuticals* and *Surgery* panels in letter to Linda Downs, January 4, 1983.

113. Information on *Commercial Chemicals* from letter of Prof. Raul E. Chao of Commercial Engineering, University of Detroit, to Linda Downs, February 27, 1983.

114. From Prof. McMeekin's lecture, "Science and Its Broad Cultural Context in the Detroit Murals," part of the symposium at the Detroit Institute of Arts on March 5, 1983 to celebrate the 50th anniversary of the painting of the murals.

115. Rivera, "Dynamic Detroit," p. 293.

116. Max Kozloff, "The Rivera Frescoes of Modern Industry at the Detroit Institute of Arts: Proletarian Art under Capitalist Patronage," p. 62.

117. Justino Fernández, *A Guide to Mexican Art*, p. 42.

118. The preceding passage paraphrased and quoted from *ibid.*, pp. 43–44.

119. From *Diego Rivera: 50 Años de su Labor Artística* (Mexico, 1951); see Walter Pach, "Relaciones entre la cultura norteamericana y la obra de Diego Rivera," p. 207–10. Translation by Jacinto Quirarte in "The Coatlicue in Modern Mexican Painting," p. 5. Prof. Quirarte also notes Rivera's anthropomorphizing of the stamp presses.

120. Above two quotations from Rivera manuscript, pp. 2, 8, dated August 3, 1930 in the Bertram Wolfe collection, Hoover Institution.

121. I am grateful to Linda Downs for the *ballet mécanique* image (letter to author, December 10, 1982). On the topic of the machine and art, see Barbara Zabel,

"The Machine as Metaphor, Model, and Microcosm: Technology in American Art, 1915–30," *Arts* (December 1982). Zabel makes the point that, although most inventions of the "first machine age" (1910–20) came from America, European artists (especially Duchamp and Picabia) made the first and most conspicuous esthetic responses to them, and in doing so "awakened American Artists to their new machine environment and stimulated them to develop their own machine aesthetic" (p. 100). Rivera, in Europe from 1907 to 1921, knew these artists and their work, and certainly heard them discuss their notions of the importance and inherent beauty of the machine. A fellow Mexican, Marius de Zayas, advocated a new discovery of the American continent through machine art, a call directly anticipating Rivera's "New Order of Beauty"—almost two decades before Rivera painted at Detroit. Similarly, artists such as Paul Strand, working in a more ideological sphere, warned of the danger man faced in being controlled by his own inventions and insisted on the need for man's supremacy over "the new God" (this in 1927). Yet Zabel finishes her otherwise interesting article by completely missing the point here vis-à-vis Rivera's Detroit murals ("representative of the political art of the Thirties") as she maintains that these paintings "present all phases of automobile production in epic terms with *the worker featured as hero*" (my emphasis).

122. Yet Bertram Wolfe, a member of the Central Committee of the Mexican Communist Party (along with Rivera) during the mid-1920s, maintains that Rivera was a woefully undisciplined and ineffective party member (*Fabulous Life*, pp. 226–28): ". . . he was constantly forgetting the day of the week and the hour of the day, and so absorbed in his painting that he missed committee meetings and even speaking dates . . . and in constant hot water of being expelled for nonattendance at the regular 'three successive meetings' and for forgetting or neglecting to execute assigned tasks."

123. Rivera quoted in *Detroit News*, March 20, 1933.

124. Noted by Stanton Catlin, in "Political Iconography in the Diego Rivera Frescoes at Cuernavaca, Mexico, in Henry A. Millon, *Art and Architecture in the Service of Politics* (Cambridge: MIT Press, 1978).

125. "The Rivera Squall," *Art Digest* (April 15, 1933). In contrast, the museum had only 26,244 visitors during March 1932.

126. Quotes from *Detroit News*, March 17, 1933, and *Art Digest*, April 1 and 15, 1933.

127. Richardson in unpublished interview with Linda Downs, p. 36; he recalls a "violent emotional crisis" endured by the staff. Valentiner quoted in *Magazine of Art* 26, no. 5 (May 1933): 255.

128. *Ibid.*, p. 254.

129. Rivera, "Dynamic Detroit," p. 295.

130. The murals would again become the focus of controversy in 1952, when Councilman Eugene I. Van Antwerp declared they should be removed or painted over: "I see no reason why we should sponsor art for our children and people that depicts Communist education. I would destroy a portrait of myself if I found out it had been painted by a Communist." Richardson (who succeeded Valentiner as director in 1945) installed a plaque on the east wall columns that dismissed Rivera's "politics and his publicity seeking" as "detestable," but more generally cautioned viewers "not to lose our heads over what Rivera is doing in Mexico" (*Detroit Free Press*, March 21, 1952). But to Richardson's surprise, "Nobody came, nobody was interested" (Downs interview, p. 41). A third controversy occurred in late 1979 when the Arts Commission, acting on Director Frederick Cummings's suggestion, voted to drill a hole in the middle of what is now "Rivera Court" and install a stairway to the museum's lower level. Protests from art historians, the general public, and more than one-third of the museum's staff forestalled the construction work (*New York Times*, December 17, 1979).

131. From account in *New York Herald Tribune*, May 10, 1933.

132. For illustrations of some of the approximately forty murals and fifty sculptural pieces and an account of the construction of the Rockefeller Center complex, see Carol Herselle Krinsky, *Rockefeller Center*.

133. From copy of synopsis signed by Rivera in Rockefeller Center archives.

134. Lucienne Bloch's account of this episode in her letter to author of January 25, 1982.

135. "The Stormy Petrel of American Art: Diego Rivera on His Art" (London) *Studio* 6 (July 1933):24.

136. From letter in Rockefeller Center Archives, October 13, 1932.

137. From Rivera's letter, November 5, 1932, in Rockefeller Center Archives. Brangwyn and Sert, I should add, would paint in monochrome and on canvas.

138. Although I have not seen a copy of the contract, the November 2 date appeared in the *New York Herald Tribune* article of May 10, 1933. Rivera's signing the contract recounted by Lucienne Bloch Dimitroff (letter to author January 25, 1982, p. 4); for her recollections of this time see her article "On Location with Diego Rivera," *Art in America*, February 1986.

139. Wight letter dated December 2, 1932, to Ralph Stackpole (courtesy of Peter Stackpole).

140. Transcript of Halberstadt tape, prepared for author April 28, 1982, p. 4.

141. Lucienne Bloch Dimitroff letter, January 25, 1982, p. 5.

142. Quoted in Laning's recollections, "The New Deal Mural Projects," in *The New Deal Art Projects: An Anthology of Memoirs*, edited by Francis V. O'Connor (Smithsonian Institution Press, 1972), p. 82.

143. Quoted in Joseph Lily's *World Telegram* article of April 24, 1933.

144. From "A Profile of Ben Shahn," segment of *The Open Mind* (NBC-TV), January 17, 1965, p. 24; manuscript in Museum of Modern Art Library.

145. According to Lucienne Bloch Dimitroff, letter to author of July 3, 1982.

146. I am indebted to Lucienne Bloch Dimitroff for her explanation of the "hidden" imagery and symbolism, letters to the author, July 3 and 15, 1982.

147. Rivera, "The Stormy Petrel," pp. 24–25.

148. Anita Brenner, "Diego Rivera: A Crusader of Art," *New York Times Magazine*, April 2, 1933.

149. See Rivera, "The Stormy Petrel," p. 26.

150. Quoted by Rivera in his postcontroversy article, "The Radio City Mural," in *Workers' Age*, June 15, 1933.

151. Information on RCA work procedures from Lucienne Bloch Dimitroff, letter January 25, 1982, pp. 2–3. Assistants for the RCA project were Arthur Niendorf, chief assistant and plasterer, Stephen Dimitroff, Lucienne Bloch as "chief photographer," Andrés Sanchez-Flores, Hideo Noda, Ben Shahn, and Lou Block. Rivera's popularity was such that Rockefeller Center issued tickets for the painting sessions, and frequently 100 or more attended (*New York Herald Tribune*, May 10, 1933).

152. Beaumont Newhall, "How Diego Rivera Paints," unpublished manuscript in Museum of Modern Art Library, pp. 2–5.

153. Information from Lucienne Bloch Dimitroff in letter to author, July 3, 1982.

154. Information on Rivera's working methods from

"Diego Rivera: A Crusader of Art," *The New Yorker* "Profile," May 20, 1933, and Anita Brenner, *New York Times*, April 2, 1933.

155. Brenner, *ibid.*

156. Rivera quoted in *New York Herald Tribune*, May 19, 1933.

157. Brenner article, April 2, 1933.

158. Rivera asserted he had sent the sketch to Hood in his May 6 letter to Nelson Rockefeller (published in the *New York Times*, May 10, 1933).

159. "A Profile of Ben Shahn," transcript, pp. 19–20.

160. Copy of letter from Rockefeller Center Archives.

161. Rivera quoted in *New York Herald Tribune*, May 10, 1933.

162. Paraphrased from Rivera letter printed in *ibid.*

163. Lucienne Bloch Dimitroff letter to author, July 3, 1982.

164. Todd-Robertson-Todd letter of May 9, quoted in *New York Herald Tribune*, May 10, 1933.

165. Minor in *The Daily Worker*, May 11, 1933.

166. Pach's letter to Abby Aldrich Rockefeller, dated May 10, 1933, from Rockefeller Center Archives.

167. "Memo for Mr. Nelson—from his Father," dated May 12, 1933, from Rockefeller Center Archives.

168. Pach's letter, dated September 11, 1933, and Rockefeller secretary reply, dated September 18, 1933, from Rockefeller Center Archives. In September Pach also published in *Harper's* an article, "Rockefeller, Rivera, and Art," in which he argued as usual in a controlled, thoughtful manner that the real issue ultimately lay in the choice between an art of integrity (Rivera) versus "counterfeit art" (Ezra Winter, Sert, Kenyon Cox).

169. The architects and Todd-Robertson-Todd quoted in *New York Times*, May 10, 1933.

170. Ernst Halberstadt, tape prepared for author, April 28, 1982, p. 4; *ibid.*, Stephen Dimitroff, p. 6; Lucienne Bloch Dimitroff letter of July 3, 1982.

171. From Anita Brenner, "The Rockefeller Coffin," *The Nation* (May 24, 1933). On problems involving rent of office space and the Rockefellers subletting space at lower than usual rates, see Krinsky, *Rockefeller Center*, pp. 75–78.

172. The poem appeared in *The New Yorker*, May 20, 1933.

173. Quoted in *New York Sun*, May 12, 1933. The mural, tentatively entitled *Forge and Foundry*, would have depicted "the beauty and the utility of the machine," allegedly without political subject matter, in seven specially constructed "portable" frames, measuring sixty-three by forty-three feet.

174. In the autumn of 1933, when Rivera was painting his portable murals at the New Workers School, he and Frida Kahlo argued at length about whether to remain in New York or return to Mexico. Rivera's rage at his current situation reached such heights that he slashed to pieces one of his paintings of Mexican desert cacti, shouting "I don't want to go back to that!" (Herrera, *Frida*, p. 175). When they did return to Mexico in early 1934 anger, apathy, and poor health did not allow him to paint, and Frida Kahlo described him as "weak, thin, yellow, and morally exhausted" (*ibid.*, p. 181).

175. John R. Todd letter to Nelson Rockefeller, December 15, 1933, from "Messrs. Rockefeller" collection.

176. The Dimitroffs accidentally discovered the remains of the murals, pieces of colored plaster, in several fifty-gallon cans outside the RCA building, and raised the alarm to Rivera and others (Stephen Dimitroff transcript, April 28, 1982, pp. 11–12).

177. Mrs. Rockefeller quoted in Sterne, *The Passionate Eye*, p. 196. Surely she meant the building managers, Todd-Robertson-Todd, and not "the architects."

178. The destruction of the murals and resultant protests reported in the *World-Telegram*, February 12, 1934, *New York Times* of February 13, and the *Herald Tribune* of February 13 (where Rivera's cable appeared) and 19.

179. Rockefeller's account in *New York Times Magazine*, April 9, 1967, an abridged article based on his lecture.

180. Stephen Dimitroff transcript, April 28, 1982, pp. 8–9.

181. From draft in Bertram Wolfe's hand, no date, apparently an intended press release (Wolfe collection, Hoover Institution).

182. For a firsthand account of the purge of the Lovestone group from the CPUSA, see Wolfe, *A Life in Two Centuries*, chapters 24–33.

183. Rivera's comment in his address on the occasion of Jay Lovestone's departure for a trip to Europe, n.d. (Wolfe collection, Hoover Institution). Active membership in the CPO, according to Wolfe, probably did not exceed 500, with a large number coming

from Local 22, a Yiddish local of the ILGWU (Wolfe, *A Life in Two Centuries*, p. 563).

184. Wolfe speaks on physical attacks in *ibid.*, p. 561, and Lucienne Bloch Dimitroff recounts the incident of a stink bomb thrown into the hall stairs during the hot summer of 1933 in her January 25, 1982, letter, p. 6. Albert Halper, in his recollections *Good Bye, Union Square* (Chicago, 1970), gives an account of the sabotaged John Reed Club meeting, in which Rivera was shouted down in a preplanned denunciation.

185. Rivera greatly admired the cartoon form—not political cartoons, but the colored Sunday cartoons—and felt that they offered some of the best artwork done by Americans. He considered this comic-strip format to be a direct connection to the New Workers School panels and hoped this link would bring his paintings closer to the workers studying at the school. From Dimitroffs' tape of July 15, 1982. Marx quoted in Rivera and Wolfe, *Portrait of America* (Covici-Friede, 1934), p. 82.

186. Description of murals taken from Rivera's lecture at the New Workers School, "Portrait of America" (December 9, 1933), and Rivera and Wolfe, *Portrait of America*, pp. 82–232. Wolfe acted as Rivera's iconographer, searching out books and contemporary documents, translating speeches, and preparing "notes" with important facts and quotations of the personages Rivera painted in the murals (*A Life in Two Centuries*, pp. 613–14).

187. The art historian Laurence Schmeckebier's statement is typical; he saw Rivera's North American murals as "a mass of microscopic details, enlarged and thrown over the wall like a giant handful of confetti" (Wisconsin *State Journal* [Madison, Wisc.], July 1, 1934).

188. Dimensions from Detroit Institute of Arts *Diego Rivera* catalog, p. 301.

189. Some compositional matters taken from Rivera's New Workers School lecture, "The Plastics of Painting," December 8, 1933.

190. Quoted in A. Sanchez-Flores, "The Technique of Fresco," p. 7.

191. The assistants included Ben Shahn, Lou Block, who left the project very early, and Seymour Fogel, who joined the group for a short time. Hideo Noda left the team and Arthur Niendorf went to Europe, leaving only Sanchez-Flores and Stephen Dimitroff as plasterers and Lucienne Bloch to do the lettering (in India ink after the plaster dried) and photographic work. The panels, most of them 1.83 x 1.52 m, weighed about 300 pounds, and were approximately 1½ inches thick. Assistants constructed them from May until late July 1933, when Rivera began to paint. On a one-by-four-inch structural wood frame were added layers of composition board and wire lath, attached by staples and, last, the plaster coats. Technical information from Lucienne Bloch Dimitroff letter (January 25, 1982, p. 2), Stephan Dimitroff tape (p. 8), Sanchez-Flores, "The Technique of Fresco," p. 10, and the Dimitroffs' tape of July 15, 1982.

192. Technical matters discussed by the Dimitroffs in their July 15, 1982 tape; painting dates from *Herald Tribune* of August 19, 1933 and the *Art Digest* of October 1, 1933.

193. Attempting to market Rivera's popularity, Covici-Friede commissioned Rivera and Wolfe to collaborate on *Portrait of America*, with copious illustrations of the murals Rivera produced in this country, a general introduction by the artist, and thousand-word segments on each New Workers School panel by Wolfe. Quotes from Harry Hansen in the *New York World Telegram*, May 7, 1934, Nancy Wynne Parker in *The New Frontier*, September 1934, and Beaumont Newhall in *American Magazine of Art*, June 1934.

194. Mather wrote in the *Saturday Review of Literature*, May 19, 1934; and Brenner's article appeared in *The Nation*, June 27, 1934.

195. The terms are Bertram Wolfe's, in "Diego Rivera on Trial," p. 338, which summarized the attacks on Rivera. Siqueiros's article appeared in the *New Masses* of May 29, 1934.

196. Also in 1936, with the beginning of Stalin's purge "trials" in Moscow, the CPO in protest dropped the word *Communist* from its title and adopted "The Independent Labor League of America" as their title to emphasize the group's trade union activities (Wolfe, *A Life in Two Centuries*, p. 654).

197. The "censored" murals included *Proletarian Unity*, the flanking side panels, *Mussolini* (which would have been objectionable to Local 89, an Italian-speaking group), *The New Deal, The New Freedom, World War I,* and *Big Business*. Information from Wolfe, *A Life in Two Centuries*, p. 613, and the Dimitroffs' April 10, 1982 tape, p. 18.

198. On the fire, see the *New York Times*, July 6, 1969, and Greer Gallery catalog, *Portrait of America*

(1969). Four paintings were sold to a Mexican party, the New Deal panel is today in the Arkiv for Dekorativ Konst (Lund, Sweden), and two remain in private hands in New York.

Chapter 3

1. The young Mexican artists emulated, of course, the practice of the nineteenth-century French painters of Barbizon, such as Rousseau, Corot, Daubigny, Millet, Diaz, and their younger admirers (Sisley, Renoir, and Monet among them), who, as John Rewald has commented (*The History of Impressionism* [Museum of Modern Art, 1974], p. 94):

> . . . tried to forget all the official precepts concerning historic or heroic landscapes and endeavored instead to let themselves become steeped in the actual spectacle offered by rural surroundings. . . . Although the individual methods and concepts of the Barbizon painters showed considerable differences, they had in common a complete devotion to nature and a desire to be faithful to their observations.

2. For Siqueiros's early life I have relied largely on Orlando Sauréz, *Inventario del Muralismo Mexicano*, and Raquel Tibol, *David Alfaro Siqueiros: un Mexicano y su Obra*. Siqueiros's extant art of c. 1908–18 comprises a few small oils and drawings and a series of Art Nouveau–derived illustrations. Not only do these works reveal no formal knowledge of contemporary European art, but they are also inferior in quality to advanced Mexican art of this period. The tentative elongation of the form and the distorted figures of the oils and drawings lack the distinctive use of Romantic forms, as in the work of Julio Ruelas. Similarly, the Art Nouveau illustrations lack the more knowing and personalized use of this style by Ruelas and Roberto Montenegro. A comparison with the contemporary work of Orozco, the *House of Tears* series of c. 1910–16, already breaking with the more traditional artistic trends of the period to achieve a personalized artistic expression, reinforces the impression that in his earliest efforts Siqueiros imitated other Mexican artists rather than created a personal artistic synthesis from the various styles around him. Siqueiros's works of his early Mexican peri-

od lacked any political or social commentary, and were also almost entirely devoid of a specifically Mexican content ("Mexicanidad") characterizing much contemporary Mexican art. Jean Charlot (*Mexican Art and the Academy of San Carlos 1785–1914*) and David Scott ("The Origins of Modern Art in Mexico") have shown that many Mexican artists portrayed Mexican themes before the postrevolutionary murals. These works ran the gamut from the traditional academic classicism of Izaguirre (*The Torture of Cuauhtémoc*, 1892) to the contemporary Mexican genre paintings (dancers, flower sellers, beggars, etc.) of Herrán and the Santa Anita "Open Air" School artists. That there existed a general consciousness on the part of Mexican artists to create a specific Mexican art is also indicated by the San Carlos "Show of Works of National Art" exhibition of 1910, part of the centennial celebrations celebrating Mexico's independence from Spain. For an illustrated survey of the art of this period, see Justino Fernández, *El Arte Moderno en Mexico* and *El Arte del Siglo XIX en Mexico*.

3. See Jean Charlot, *The Mexican Mural Renaissance: 1920–25*, p. 201.

4. According to an interview with the artist's widow, Angélica Arenal de Siqueiros, August 1975.

5. Quoted in Marianne Martin, *Futurist Art and Theory, 1909–15*, p. 200.

6. Rivera claimed Giotto as his great master, while Siqueiros's enthusiasms were Masaccio, Uccello, Leonardo, Michelangelo, and especially the Baroque muralists. In their talks, Siqueiros "defended the Baroque with all the passion of which I was capable," since he felt that the period's merit was the "transition from the hieratic to the dynamic in search of a more perfect realism." For more about Siqueiros's meetings with Rivera, see Julio Scherer García, *La Piel y la Entraña (Siqueiros)*.

7. Published in the first and only number of *Vida Americana* (Barcelona, 1921), and reproduced in Raquel Tibol, *Siqueiros: Introductor de Realidades*. May 1921, the publication date, provided a key date in the Mexican mural movement-to-be, as José Vasconcelos, the new Minister of Education commissioned his first mural, and the site for the new Education Ministry building was placed under his control.

8. The aggressive "Dynamism" of this statement appears strikingly akin to Futurist theory of 1910–15. As Siqueiros had only generally characterized Futur-

ism in this section as "liberating new emotive forces," it remains unclear whether he recognized the similarity of the tone of this passage to earlier Futurist manifestoes. Also, other elements of Futurist theory, such as the machine esthetic, the necessary agitational action of the artist and his work, the "cinematic" quality of Futurist art, and *Guerrapintura*, clearly anticipated many of Siqueiros's artistic concerns during the 1930s, yet he did not express his debt to Futurism.

9. Quoted in Charlot, *Mexican Mural Renaissance*, p. 200.

10. Quoted by Elsa Rogo in "David Alfaro Siqueiros," p. 7.

11. Charlot says in *Mexican Mural Renaissance* (p. 202) that Siqueiros himself chose this area: ". . . the small staircase of the third patio, cramped in space and badly lighted, and disdained by the five young painters who had had first choice."

12. *Ibid.*, p. 202 ff. In similar fashion, the unrelated paintings of the second and third stairways, done by various artists, perhaps further indicate Siqueiros's technical incompetence at this point, which simply did not permit him to work on so large a scale. According to Charlot's interview with Siqueiros's unnamed helper, the "perspective illusions" of the first stairway were done by a "house painter named Vasquez," who also did the "corkscrew pattern" of the third stairway. Similarly, Xavier Guerrero supposedly painted the woman of the vaulting of the second stairway, and the helper said that he also did the hammer and sickle of the upper area of the third stairway.

13. Tibol, *Siqueiros: Introductor de Realidades*, p. 25.

14. Siqueiros in *Mi Respuesta*, p. 22. Charlot gives the title as "Spirit of the Occident"; that is, European culture alighting on Mexico (*Mexican Mural Renaissance*, p. 202).

15. *Ibid.*, p. 71.

16. *Ibid.*, p. 11.

17. The Mexican artists followed the example of Europeans such as Picasso (introduced to African art by Derain in 1906), who had been primarily attracted by the formal power and expression of this art. As Robert Goldwater has noted (*Primitivism in Modern Art* [Harper & Bros., 1938], p. 118): "the contact with primitive art is now directly through the objects themselves, that their individual effects of form and expression are studied apart from any general ideas about the primitive outside of its manifestation in art." Later, however—and in *total* contrast to Picasso and other European artists—Rivera especially among the Mexicans devoted his art to a portrayal of "primitive" pre-Conquest Mexican civilizations, such as his murals at the Palace of Cortés, 1929, and the National Palace panels of 1935 and 1945.

18. In this respect Siqueiros cited the influence of the Spanish Communist writer, Rosendo Gómez Lorenzo; see *Mi Respuesta*, pp. 22–23.

19. Quoted in Anita Brenner, *Idols Behind Altars*, p. 254–55.

20. From a speech given by Siqueiros at the Palace of Fine Arts, Mexico City, on December 10, 1947; quoted in Tibol, *Siqueiros: introductor de realidades*, p. 29.

21. For the Preparatory School riots of 1924, resulting in the discontinuance of painting at the school and much damage to the murals, see Charlot, *Mexican Mural Renaissance*, chapter 22. Apparently Siqueiros's single artistic activity during this period involved his participation as assistant to Amado de la Cueva for his mural *Labor and Agrarian Ideals of the 1910 Revolution*, fresco and tempera, 480 square meters, in the ex-University of Guadalajara (now the Telegraph Office) in 1925–26. Although little evidence of Siqueiros's hand exists in these paintings, his influence is obvious in the designs for the carved doors at either end of the building.

22. Among these was the portrait of Hart Crane, who reportedly offered Siqueiros the use of his home in Mixcoac (Mexico City) when the artist became ill with malaria, and thereafter hid Siqueiros's Communist friends in his residence. Later, in an alcoholic rage, Crane destroyed the painting:

> Before long Crane appeared, haggard and untidy, carrying under his arm the Siqueiros portrait which had hung on the wall of his own room. Setting the painting up for their inspection, he burst into a stream of criticism and abuse, pointing out with voluble wrath that the pigments, which were applied on burlap according to Siqueiros's habitual technique, were cracking and peeling, and reviling the artist and all his ilk for a painter of doormats. Suddenly, when his fury had reached a towering height, he seized a razor and despite cries of protests from the women, slashed the portrait to ribbons.

From Phillip Horton, *Hart Crane: The Life of American Poet* (New York: Viking Press, 1937), p. 297.

23. The exhibition, organized by several Mexican

and foreign notables, took place at the Casino Español (Mexico City) under the official patronage of the ambassador of the Spanish Republic, Julio Álvarez del Bravo, from January 25 to February 15, 1932, and comprised seventy works—primarily oils, but also including lithographs, woodcuts, and watercolors—from the years 1930–32.

24. From Siqueiros, manuscript "América Tropical" (n.d.), Siqueiros Archives (Mexico City).

25. The success of the Casino Español exhibition was such that the government could not, in the face of strong public response, censure Siqueiros for the content of his speech. Siqueiros, for his part, took this lack of governmental action as license to resume political activity in the capital, in violation of the conditions of his Taxco confinement. The Calles administration thereupon gave him the option of going into exile or returning to the seclusion of Taxco, and Siqueiros left Mexico at this time (Tibol, *Siqueiros: introductor de realidades*, p. 33).

26. Clement letter to Lozowick, July 26, 1932, from Archives of American Art, Washington, D.C. The "difference" was not explained.

27. There can be no doubt that Eisenstein's ideas regarding the role of revolutionary art, and specifically the revolutionary cinema, spurred Siqueiros's development as revolutionary muralist. Lincoln Kirstein, who knew both Eisenstein and Siqueiros, has written ("Siqueiros: Painter and Revolutionary"):

He saw much of Sergei Eisenstein, the great Soviet film director, who was then occupied in shooting footage for his subsequently sabotaged masterpiece, *Que Viva Mexico!* From Eisenstein he heard much of the Russian's electric and savage theoretical ideas of the reform of the scale and proportions of the cinema screen, the relation of biology, chemistry, and psychology to the visual arts. It is important to realize how vitally these seminal notions affected Siqueiros' important subsequent development.

Fletcher Martin has recalled attending Siqueiros's lecture (H. Lester Cooke, Jr., *Fletcher Martin*, p. 22):

Siqueiros rose to speak in Spanish, with a lady acting as interpreter. He suffered through a couple of her colorless translations, then jumped up and said he would speak in English, which he did with passionate eloquence and an atrocious accent. Soon afterward, he announced that he was accepting students to assist him on a large outdoor fresco on Olvera Street. . . . Since I had to work all day

[Martin at the time was a painter for a Hollywood film studio], I didn't think I could sign up, but I did spend every night down there watching the progress and talking with the Maestro.

28. Siqueiros previously had had a major exhibition of more than fifty paintings, plus graphics, in Los Angeles from May 12 to 31 at the Stendahl Ambassador Galleries. According to José Pages Llergo's article ("David Alfaro Siqueiros Marca Nueva Etapa, a golpes de Pincel"), the show was a success: three days after the opening more than 1,000 people had viewed the works and more than a third had been sold.

The class consisted of Paul Sample (president of the California Art Club), Merrill Gage, Henry de Kruif, Lee Blair, Donald Graham, Phil Paradise, Tom Beggs (director of art at Pomona College), Millard Sheets (an instructor at Chouinard), and Barse Miller. Katharine McEwen, apparently not a class member, was involved in *Workers' Meeting*.

29. Siqueiros, *Mi Respuesta*, p. 28.

Shifra Goldman has pointed out to me (letter to author, November 16, 1972) that there may be a discrepancy regarding Siqueiros's arrival in Los Angeles. She "tends to feel" after discussions with art critic Arthur Millier and Millard Sheets that Siqueiros "came here because he had to, and then came to the attention of Sheets who invited him to teach the mural class." Siqueiros told Millier that Calles had ordered him killed, and therefore he had fled from Mexico (Millier letter to Jack Jones, May 26, 1970, and phone conversation summary, February 23, 1971).

30. According to Thomas Beggs (interview, March 5, 1980):

Siqueiros painted with an airbrush because he was fascinated with the gun. He went into the hall, or rather it was a patio—an outdoor fresco, to the ruination of the result—he put on his mortar, then he took pigment in water with this airbrush. He'd never seen an airbrush before, he never used it down in Mexico, so he was fascinated by the quick way you could cover. But the trouble was that the atomized water only deposited itself very gently on the outside of the mortar, which proceeds to set. And then right after he finished painting on one of the walls of the patio, they had one of those rare California downpours, and Siqueiros' work was washed down. . . .

31. From Brum's article in *El Universal* (Mexico City), August 17, 1932.

283

32. David Alfaro Siqueiros, *La Trácala*, p. 20.

33. There is practically no information concerning Siqueiros's use of color here: the orator's shirt was evidently red, and one contemporary source says that the mural "was painted in more brilliant color than Siqueiros generally uses" (Rogo, "David Alfaro Siqueiros," p. 7).

34. There was much curiosity on the part of onlookers as to what the construction workers were doing in the lower section. Brum reports that Siqueiros told Mrs. Chouinard that the workers were watching a Los Angeles street athletic event, and drew a sketch of the purported final state of the mural. The Brum article also states that Siqueiros finished the mural in secret. Another source (Shifra Goldman, "Siqueiros and Three Early Murals in Los Angeles," p. 323) says that Siqueiros professed tiredness, and completed the mural by himself after the other artists went home for the evening.

35. Confusion surrounds the ultimate fate of the mural. According to Siqueiros, unceasing newspaper criticism forced Mrs. Chouinard to construct a wall that hid the mural from sight, and it was thereafter destroyed (*Mi Respuesta*, p. 31). Yet, in a contemporary manuscript, Siqueiros implied that the team of artists themselves destroyed this work since it constituted a "nonprofessional commission—only simple class exercises in mural painting" (manuscript, Siqueiros Archives, Calle Tres Picos 29, Mexico City). Another source, Merrill Gage, one of the "Bloc" painters, says that police pressure resulted in Mrs. Chouinard's decision to have the mural painted over. Finally, other "Bloc" artists have asserted that, owing to technical incompetence, the colors ran off the wall with the first rain, and the wall was thereupon whitewashed (Goldman, p. 323).

36. Siqueiros said in his John Reed Club lecture that the actual work period was twenty days. For this project artists Dean Cornwall, Luis Arenal, Murray Hantman, Reuben Kadish, Sanford McCoy (brother of Jackson Pollock, who communicated his enthusiasm for Siqueiros to Pollock), and Harold Lehman joined the painting "team." For varying lists of artists involved on the Plaza Art Center project, see Goldman, "Siqueiros and Three Early Murals," and Tibol, *Siqueiros: introductor de realidades*, pp. 281–82. Both sources fail to mention Harold Lehman, who worked with Siqueiros in Los Angeles and New York. The assistants performed the manual tasks necessary before actual painting could begin: preparing the surface, applying the cement (in this case and the following Dudley Murphy mural ordinary grey cement, not the waterproof white type used at the Chouinard School), painting small sections, applying the lower level of encaustic, etc.

Contemporary evidence strongly suggest that Siqueiros worked on another mural during this period at the John Reed Club. Arthur Millier wrote in mid-September:

> A third fresco by Siqueiros is now in progress, this time in the auditorium of the John Reed Club in Hollywood. The four walls are to be covered by a mural symbolic of the cultural role of the Club, it is announced. The work will be done, as with Chouinard and the Plaza Art Center, by a class of students working with the noted Mexican (*Los Angeles Times*, September 18, 1932, part III, p. 16).

In a manuscript from the Siqueiros Archives, Siqueiros wrote about this mural: "The place is of small proportions. Because of this, intensive work was prevented. The situation demanded a limiting of the team. . . . In this case traditional procedure and tools were used." Finally, the *Christian Science Monitor* (April 27, 1935) mentioned the covering of these paintings.

37. To Siqueiros, cinematic concepts presented by Eisenstein such as "camera eye," "montage," "moving perspective" would have been entirely new. Further, Eisenstein would surely have spoken of the essentially social role of the Soviet artist during the early 1920s and would have cited examples from the broad range of his production.

38. Siqueiros, *Mi Respuesta*, p. 59.

39. According to Tibol (*Siqueiros: introductor to realidades*, p. 10), Siqueiros's father, a great admirer of the art of colonial Mexico, introduced him to the art of this era. Also, Siqueiros would have known one of the most important *churrigueresque* monuments, Santa Prisca of Taxco, very well from his period of confinement in that town.

40. It seems that Siqueiros, as with *Workers' Meeting*, painted all the important parts of the mural himself (Goldman, p. 324). Here an unresolved contradiction developed in Siqueiros' mural concepts: while espousing the cause of collective painting, his association with younger, inexperienced artists meant that for all practical purposes he would not only personally plan the

mural, but also would execute the most important sections himself.

41. Siqueiros, "Dear Caroline" letter, d. August 31, 1932, from Siqueiros Archives. Caroline Durieux was a North American artist and one of the organizers of the Casino Español exhibition.

42. *Ibid.*

43. For accounts of this period, see *North From Mexico*, by Carey McWilliams (New York: Lippincott, 1949), and *A Documentary History of the Mexican Americans*, edited by Wayne Moquin with Charles Van Doren (New York: Praeger, 1971).

44. From Siqueiros's unpublished manuscript, "América Tropical" (Siqueiros Archives).

45. *Ibid.*

46. For example, Arthur Millier's *Los Angeles Times* article, October 16, 1932, "Power Unadorned Marks Olvera Street Fresco."

47. Arthur Millier letter to Jack Jones.

The final part of the *Tropical America* story concerns its "rediscovery" in the late 1960s and attempts, thus far unsuccessful, to raise the c. $75,000 necessary to restore the work, which now retains—owing to the effects of faulty technique and the damaging agents of sun, rain, and atmospheric pollution—only some 30 percent of its original pigmentation (see "Controversial Mural Fading Away," *Los Angeles Times*, April 20, 1982).

48. Murphy directed, among other films, *The Emperor Jones*. Siqueiros's association with Eisenstein in Mexico gave him access to patrons in Hollywood; for example, one of his first commissions was a portrait of the director Josef von Sternberg.

49. Lester H. Cooke, *Fletcher Martin*, pp. 23–24. Yet Reuben Kadish recalls that John Huston, then a screenwriter, arranged the introduction of Murphy to Siqueiros, and that Murphy, extremely protective of his home, did not admit the artists into the house, let alone allow Siqueiros to live there. He also remembers Siqueiros painting all the major figures, while assistants did elements such as the architectural setting. Kadish felt a similar attraction to him "as being someone who had a tremendous amount of energy and vigor" (interview, December 2, 1980).

50. Millier letter to Jack Jones, May 26, 1970.

51. Siqueiros, *La Trácala*, p. 20.

52. In view of Siqueiros's harsh denunciation of the Morgan–Wall Street influence in Mexico, it is particularly ironic that the present owners of the house,

Mr. and Mrs. Willard Coe, are Morgan relatives. The Coes purchased the house in 1949 (from Murphy?), and the mural has been restored twice, most recently in 1960, according to Goldman (p. 326).

53. This information from interviews with Arenal and Lehman, July 18, 1973 and January 19, 1973, respectively.

54. Siqueiros manuscript, "Los Angeles, 1932" (n.d., Siqueiros Archives).

55. Ralph Mayer's *The Artist's Handbook of Materials and Technique* questions the permanency of nitrocellulose pigments, saying "they are of small value in permanent artistic painting, as their durability is extremely questionable" (p. 177). Mayer also writes (p. 178): "Disastrous lack of adhesion, cracking, and darkening have been the fate of easel paintings in which cellulosic coatings have been used. Pigmented lacquers usually begin to show signs of disintegration after exposure to light after 15 years." Yet Siqueiros's easel painting *Collective Suicide* (1936) and mural *Portrait of the Bourgeoisie* (1939–40), both painted with nitrocellulose pigments, are in excellent condition today, and neither has been restored.

56. According to Tibol, interview July 1975, the mural has been whitewashed (date unknown). No film documentation (preliminary filmic "sketches," states of the work-in-progress, etc.) exists in the Siqueiros Archives.

57. Summarized from Siqueiros's essay "What is *Plastic Exercise* and How It Was Realized," which first appeared in *Crítica* (Buenos Aires), November 22, 1933. All following statements by Siqueiros are from this source.

58. Keim silicate, invented in the 1880s by Adolf Keim of Munich, was "the final improvement and standardization of the method (i.e., 'water-glass') under the name of mineral painting" (Mayer, p. 361). Mayer criticizes the "erratic reactions" caused by the Keim silicate-ground combination. The later development of *ethyl silicate*, which Siqueiros would later work with, represented a great improvement over Keim silicate (Mayer, *The Artists' Handbook of Materials and Technique*, pp. 362–71).

59. Information from Harold Lehman (interview, January 8, 1973), who recalled seeing both photos of the models and the mural in New York, 1936. Lehman said he found the work "very exciting," a "whole new thing," at the time. Similarly, Reuben Kadish and

Philip Goldstein, while in Mexico in 1934, were very enthusiastic about *Plastic Exercise*. Yet, Goldstein wrote to Lehman in July 1934 of Siqueiros "waving his hands and saying 'it's merely a plastic exercise.' "

60. Siqueiros, *La Trácala*, p. 21.

61. See Tibol, *Siqueiros: introductor de realidades*, p. 58.

Siqueiros gave many other lectures on art during 1933; representative titles were "The Return to Architecture," "The Historical Progression from the Renaissance to Mexico," "The New Bloc of Painters and Its Revolutionary Ideology and Technique." In these talks and published articles, Siqueiros called for monumental painting based on the antecedents of the Mexican mural movement and his Los Angeles "Bloc of Mural Painters"; these murals-to-be would be executed for the masses on edifices such as union buildings, public offices, sports stadiums, open-air theaters, etc. He was equally strong in his denunciation of easel painting as the "aesthetic of the decadent international bourgeoisie." Although Siqueiros published harshly worded criticism of the XXIII Salon de Bellas Artes, Buenos Aires (he was one of the judges), he saw some artists as representing a "new impulse" stemming from a "social revolutionary conviction." Some of these artists, such as Spilimbergo and Castagnino, would work with Siqueiros on *Plastic Exercise*.

Siqueiros had five one-man exhibitions during 1933 in Buenos Aires and Montevideo; these included paintings, graphics, and photographic reproductions of his murals.

62. Siqueiros wrote to the Argentinian intellectual Luis Ernesto Pombo (dated December 5, 1933; from Siqueiros Archives), that he had been jailed for twenty-four hours for unspecified reasons, and was allowed ten days to leave the country. During this period the only activity permitted him was obtaining authorization to enter the United States. Further, he said (in *La Trácala*, p. 23) that the pretext used to deport him was "my participation as a simple spectator in a great labor event." Perhaps he meant the meeting of the Furniture Union referred to by Tibol, *Siqueiros: introductor de realidades*, p. 60.

63. Quoted in *Art Digest*, February 1, 1934. The article noted that this work would be sponsored by an unnamed "wealthy woman and an eminent physician from Argentina."

64. Interview with Hugo Gellert, January 8, 1973.

65. In the gallery brochure for the exhibition (March 12–25) Siqueiros waxed enthusiastic on the possibilities of the still and movie camera for exterior murals—"an art for the masses, which is revolutionary art"—and claimed to have invented "polygraphy," defined only as "a richer form of plastic expression."

66. See *Time*, September 9, 1935, and for the CPUSA point of view, Emanuel Eisenberg's "Battle of the Century," *New Masses*, December 10, 1935. While generally ridiculing Rivera and denouncing his Trotskyite position, the article is curious as it *also* criticizes Siqueiros:

Finally, Siqueiros has reminded people with fresh intensity that he represents the peak of *caudillaje* (independent leadership) of the petty-bourgeoisie revolution, that his unquestionably brilliant talent has been wasted to *épater le bourgeois* for too many years now, that he has indulged in his own brand of opportunism and is almost completely incapable of joining in any solidly collective work with any continuity.

67. Information concerning the Mexican delegation in the report of the Asamblea Nacional de Productores de Artes Plásticas (copy in Siqueiros Archives). At the congress, Orozco delivered a paper, "The Mexican Experience in the Plastic Arts," while Siqueiros read a collectively prepared paper, a brief history of twentieth-century Mexican painting (both reprinted in *Proceedings*, First American Artists Congress, New York, 1936, pp. 97–103).

68. According to what appears to have been a press release, typewritten manuscript on workshop stationery (n.d., Siqueiros Archives).

69. Harold Lehman, "For an Artists Union Workshop." Lehman has been an extremely valuable source of information on Siqueiros's New York period, and he has generously provided me with copies of all workshop documentation in his possession as well as discussing the period at length with me during the course of several interviews. A six-page manuscript written by Siqueiros and Harold Lehman and read by Lehman to an Artists Union meeting details the aims and organization of the Workshop. Funds, for example, were obtained by tuition ($5–$15 per month) and lecture and sales percentages (copy from MOMA library).

70. Passages of Siqueiros's letter to María Asúnsolo, dated April 6, 1936 (from Tibol, *David Alfaro Siqueiros: un mexicano y su obra*. p. 196).

71. Axel Horn (Horr in the 1930s), "Jackson Pollock: The Hollow and the Bump," pp. 85–86.

72. Siqueiros letter to Blanca Luz Brum, June 9, 1936 (Siqueiros Archives).

73. *Ibid.*

74. The above paragraph from Siqueiros's lengthy descriptions of these paintings in letter to María Asúnsolo (dated April 17, 1936; in Tibol, *David Alfaro Siqueiros*, pp. 199–201). According to Angélica Arenal de Siqueiros, both paintings were studies for photomurals that could not be completed because of workshop interruptions (interview, July 15, 1975). Thus, in addition to their technically innovative painterly aspects, Siqueiros also intended the works to extend to the Workshop the photographic experimentation of *Plastic Exercise* and related projects of 1933.

75. Technical information from Lehman interview, January 9, 1973, and tape of April 24, 1973. Lehman does not recall any artist outside the workshop employing the airbrush at this time; its use was confined to the commercial art field, such as the contemporary Wrigley gum advertisements displayed in the subways (Lehman interview, April 14, 1980).

76. Harold Lehman letter to author, January 7, 1974.

77. See *Art Front* (February 1937) for representative floats by New Deal artists.

78. Information on the floats from Harold Lehman (various interviews during 1973). The Hearst "float-on-a-boat," as if to demonstrate the temporary nature of these hastily constructed "agit-prop" pieces, did not make it through the protest rally. First, the police insisted that the boat had to be positioned at least 500 yards offshore, making its message indecipherable to the bathers. Then due to choppy seas, the boat threatened to capsize on its first turn, necessitating throwing the float overboard. Siqueiros, a more prudent sailor than political artist, remained onshore throughout.

79. Siqueiros letter to Angélica Arenal de Siqueiros, *David Alfaro Siqueiros: un mexicano y su obra* (June 5, 1936, in Tibol, p. 204).

80. Siqueiros memo addressed to "Comrades Kunitz [Stanley?], Burnshawn, Garlin, Krichton, Burch [Jacob?], and Noda [Hideo? Rivera's assistant for a time at Rockefeller Center], in which he summarizes the meeting held at "Comrade Kunitz's" house the previous night (from collection of Roberto Berdecio, no date or signature).

Although Siqueiros was a Communist and his workshop produced art for the CPUSA, this did not mean that all the workshop artists had party affiliation.

Rather, as so often occurred during the Popular Front years, 1935–39, unaffiliated—though leftist-oriented—artists working with Siqueiros knowingly offered their independent support to CPUSA programs and objectives. For example, according to Harold Lehman, neither he, Jackson Pollock, nor Sandford McCoy were party members (interview, January 8, 1973). On the matter of the enthusiastic, but independent, support of Popular Front activities by United States intellectuals, see Matthew Josephson, *Infidel in the Temple: A Memoir of the Nineteen-Thirties*, p. 365:

> The Popular Front called men of good will to take their stand. As writers we could at any rate use works to awaken our people to the peril around us and to petition our government (our statesmen and academic authorities had said nothing as yet). It is not surprising, therefore, that many non-communists willingly signed the call to the American Writers Congress.

Paralleling Josephson's statement is the case of artists active in New York at this time described by Francis O'Connor in his introduction to *Art For the Millions*, p. 27:

> That the Artists Union had a Communist Party "fraction" is certain. Such influence was natural since the Party was the only disciplined body capable of galvanizing the disorganized and panic-stricken artists into effective groups. The artists accepted this leadership not because they were willing to accept the at times obtuse Party line and strict Party discipline, but because they saw no contradiction between the Party's aims and their economic needs. It was purely a pragmatic and essentially an apolitical relationship.

81. Harold Lehman letter to author, September 7, 1974.

82. Siqueiros letter to Blanca Luz Brum, June 9, 1936.

83. For Soviet art during the Stalinist era, see Donald Drew Egbert, "Socialism and American Art," in *Socialism and American Life*, vol. 1, p. 703:

> Meanwhile, as long as nationalism and the state exist, Soviet artists are to be carefully controlled by the Soviet State under the leadership of the Communist Party to make sure that works of art meet the specifications of socialistic realism. For ever since the Stalinists gained complete control in Russia, the artist, like the literary man, has been

expected to do all his work under the "careful and yet firm guidance of the Communist Party." This ever-increasing demand for conformity by artists probably became inevitable when—particularly after the ending of the New Economic Policy—the state became the sole middle-man between artist and client.

84. John W. Bowlt, "The Failed Utopia, Russian Art 1917–32," p. 47. Such experimentation, primarily in the area of nonrepresentational art, by Soviet artists decreased during the 1920s with the growing official predilection for realistic art. Artistic independence, with few exceptions, ended in 1932 with the decree, "On the Reconstruction of Literary and Art Organizations," which effectively placed all artists under governmental control.

85. Siqueiros would maintain this independent position throughout his career, and in 1955 he went to the extent of issuing an "Open Letter to Soviet Painters" broadly critical of many tendencies of Soviet art during the Stalinist era (reprinted in *Masses and Mainstream* 9:3 [1956]).

86. According to Roberto Berdecio, interview, July 24, 1974.

For Siqueiros's association with Gershwin and Gershwin's at-the-time dependent relationship with Zilboorg, see Charles Schwartz, *Gershwin: His Life and Music* (Bobbs-Merrill, 1973), p. 238 ff.

87. See *As I Recall: Some Memoirs of Edward M. M. Warburg* (privately printed, n.d.) for recollections of this time.

88. For a description of the making of the large three-dimensional mural (28 x 40 feet) and its part in the rally, see Axel Horr, "Minute Men and Women of the UAA," *Daily Worker*, October 3, 1938.

89. Tibol, *David Alfaro Siqueiros: un mexicano y su obra*, pp. 249–54, reprints an article by Contreras, "David Alfaro Siqueiros in the Spanish War" (Havana, February 1941), testifying to the loyal service and personal bravery of Siqueiros and completely lists his command posts. Siqueiros also lectured on art during the war years, and his letters from Spain indicate his confidence in his technological experimentation and approach to the problem of revolutionary political art.

90. José Renau, born in Valencia in 1907 and educated at the San Carlos Academy (Valencia), served as the director of fine arts under the Republican government from 1936 until 1939, when he sought political asylum in Mexico. Although specializing in posters and photomontage art, he produced several murals in Mexico. In 1958 he moved to the German Democratic Republic, where he resided until his return to Spain in the late 1970s (biographical information from Suarez, *Inventario del Muralismo Mexicano*, pp. 263–64). Renau had at the time only a "vague idea of the personality and work of D. A. Siqueiros," which he attributed to the fact that publicity surrounding Rivera's Rockefeller Center commission had monopolized the attention of Spanish artists at this time vis-à-vis Mexican muralism. (From Renau's text, "History of the Mural Painting *Portrait of the Bourgeoisie*," in *Revista de Bellas Artes*, Mexico City, January–February 1976.)

91. For Renau, "This cold equation says it all, at least for me—a painter who understands with his eyes" (*ibid*). Orwell's classic *Homage to Catalonia* presents, of course, a chilling refutation of the Communist position.

92. From the jointly authored article by Mexican war veterans, "Hablan los Combatientes Mexicanos que Regresan de España," *Futuro* (Mexico City), March 1939, p. 37.

93. Siqueiros's detention was viewed as directly ordered by Cárdenas and, moreover, as an indication that the Mexican president would not tolerate illegal acts neither from the left nor right (he also deported leading Franco supporters at this time). During this period Siqueiros acquired the derogatory nickname *el colonelazo* ("the big colonel") from, he said, a Spanish reporter on the staff of the conservative *Últimas Noticias* (La *Trácala*, p. 28). For contemporary Mexican politics, see *New York Times*, April 5–9, 1939, and Betty Kirk, *Covering the Mexican Front* (1942).

94. For the depth of fascist penetration in Latin America, an outgrowth of German imperialism in this area, and widespread support of Franco under the slogans of "Hispanidad" and "One race, one language, one culture, one religion," see Kirk, *Covering the Mexican Front* (chapter 12), and Virginia Prewitt, *Reportage in Mexico* (chapters 9–12).

95. The painting collective, "The International Team of Graphic Arts," consisted of the Mexicans Siqueiros, Antonio Pujol, Luis Arenal, and the Spanish refugee artists José Renau, Miguel Prieto, and Antonio Rodríguez Luna. (Prieto and Rodríguez Luna, trained as easel painters, could not function collectively and left early in the work on the mural.) The team operated as a democratically conceived collective, with "free initiative and free discussion of all questions, decision decided collectively and democratically regarding

all problems of form and content." Siqueiros had obtained the commission through his contacts with union officials and the building's architects. The artists' wages were fixed at 17.50 pesos for each team member (the same as union officials received) for eight hours of daily work, the mural was to be completed in six months, and the union would pay for all painting expenses. Siqueiros, the oldest artist as well as the most experienced muralist—and the most forceful personality—assumed leadership of the painting team, responsibility for selecting artists for the collective and the mural site, and maintenance of a working arrangement with the architects (from José Renau, "History of the Mural Painting *Portrait of the Bourgeoisie*").

96. From Siqueiros's unpublished manuscript from 1939, "Auto-critical Thesis on the Work Executed by the International Team of Plastic Arts in the Social Building of the Mexican Electricians Union," p. 4. The decision to employ contemporary documentary photographs to illustrate the mural's political theme also formed a logical choice, since both Siqueiros and Renau had previously worked in this medium. While Siqueiros had only experimented with photo processes in Los Angeles, Argentina, and New York during 1932–36, Renau arrived in Mexico thoroughly accomplished in the area of photomontage (see C. Naggar, "Photomontages of José Renau," pp. 32–36), and therefore assumed primary responsibility in this area.

97. The image of the parrot-headed "Fascist Demagogue" derived from the popular Mexican expression "*se habla como périco*" ("one talks like a parrot," or nonsense). The term, illustrated by the gesture of simultaneously presenting a flaming torch and *pensamientos*, a Mexican flower customarily given as a gift, can be considered as analogous to the English expression "the carrot and the stick."

98. It should be understood that CPUSA leader Earl Browder also had responsibility for Latin American Communist parties, making the Mexican Communist Party, for all practical purposes, the satellite of a puppet. A contemporary joke ridiculed total Soviet control of non-Soviet communism: "Why is the CPUSA like the Brooklyn Bridge? Both are held up by strings."

99. Renau's summary of Siqueiros's statement in *Mi Experencia con Siqueiros*, p. 10.

100. The original compositional plan, Renau has emphasized (letter to author, August 30, 1974), was nowhere "as logical, systematic and clear" as his photodrawings indicate, since it derived primarily from empirical observation there occurred many revisions during the course of work.

101. Siqueiros planned a piece of polychromed sculpture for the upper landing of the stairway (unpublished ms., *Arte Civil*, 1941–42, Siqueiros Archives). This would seem to be the germinal manifestation of Siqueiros's later formalized conception of *esculto-pintura*, a combination of painting and sculpture in a mural format, first executed in *Cuauhtémoc Against the Myth* (Mexico City, 1945).

102. For Heartfield photomontages illustrating similar themes of the Electricians Union mural, see Wieland Herzfeld, *John Heartfield, Leben und Werk*, figures 145, 151, 166, 174, 215, and 217.

103. Technical information from Renau's "History," and interview with Antonio Pujol, July 14, 1975.

104. The Siqueiros-led assassination attempt of early May 24, 1940, a small-scale military operation, consisted of an attack force of some twenty-four to thirty men (primarily miners from Jalisco state, where Siqueiros had been active as a union organizer in the late 1920s) under the command of Spanish refugees and Mexican participants of the Spanish war. Siqueiros—in the flamboyant disguise of a Mexican Army major's uniform, a false-Villa-like mustache, and dark glasses—and the raiding party mysteriously encountered no resistance in gaining entrance into Trotsky's fortified residence and proceeded to fire several hundred rounds of automatic fire into Trotsky's bedroom and his grandson's room, managing only to inflict a surface wound on the grandson's toe. The raiders left behind two fire bombs, and a three-pound dynamite bomb (intended at least to destroy Trotsky's archives, the only bomb to detonate damaged part of the garden) and absconded with Sheldon Harte, Trotsky's secretary, as unresisting hostage. The complete story surrounding the total failure of the May 1940 assassination attempt has yet to be told.

105. For examples of the campaign against Siqueiros by North American "Trotskyite" and/or anticommunist intellectuals, see Meyer Schapiro, "David Siqueiros: A Dilemma for Artists," and "The Siqueiros Affair."

106. Interview with Berdecio, August 15, 1975.

107. These foreign communists, including the North American James Ford, had much to do with the "hardline" policy adopted by the Mexican Communist party in Mexico in March 1940. At this time in the party convention secret session, a discussion of the topic "The Struggle Against Trotskyism and Other Enemies

of the People" took place. This session was in fact a pretext for a purge of the Mexican party, conducted by a commission dominated by the foreign communists. They purged Secretary Hernán Laborde and his secretary Valentin Campa and their followers for complete support of the Popular Front policy, which meant explicit support of the Cárdenas administration, and by extension—albeit by strained logic—carried with it a "conciliatory" policy toward Trotsky.

108. Deutscher's undocumented assertions in *The Prophet Outcast: Trotsky 1929–40* (volume 3 of the definitive biography), pp. 485–86.

109. Quoted by Nicholas Mosley in his *The Assassination of Trotsky* (London, 1972), p. 47.

110. From Siqueiros manuscript, *Arte Civil.*

111. See Hershel Chipp, "*Guernica:* Love, War, and the Bullfight."

112. Max Raphael, *The Demands of Art,* p. 174.

113. Reprinted in *Masses and Mainstream* 8 (April 1956):3. Evidently his criticism hit home, according to a later article (Ralph Parker, "Siqueiros on New Forms in Art".) Siqueiros's letter, subsequently "mislaid," was not circulated until Siqueiros's next trip to the USSR in 1958. Parker quotes Siqueiros on difficulties with Soviet cultural officialdom:

> If in the past I met with resistance (one might even say sabotage) to my ideas on the part of certain elements in Soviet academic life, the results of this latest visit enables me to say with confidence that the Party is now taking a keen and active interest in the Mexican contribution to realism.

114. See Trotsky's fundamental work on art, *Literature and Revolution,* his later anti-Stalinist letter, "Art and Politics," *Partisan Review* (August–September 1938), and "Manifesto Towards a Free Revolutionary Art," *Partisan Review* (June 1939; though attributed to André Bréton and Diego Rivera, it was, according to Deutscher, [*The Prophet Outcast: Trotsky 1929–1940,* p. 432], co-authored by Trotsky).

115. To illustrate this matter: while he comprehended the original nature of Tatlin's proposed "Monument to the Third International" (1919), the imagery of "his own personal invention, a rotating cube, a pyramid and cylinder all of glass," disturbed Trotsky. However, Trotsky proposed to grant Tatlin the opportunity "to prove that he is right" by allowing him to complete the project in Trotsky, *Literature and Revolution,* see "Revolutionary and Socialist Art," p. 246.

Conclusion

1. Herrera, *Frida,* p. 175

2. *Ibid.,* p. 181.

3. Rivera, *My Art, My Life,* p. 222.

4. Wolfe, *Fabulous Life,* p. 362.

5. Rivera's statement in *The New York Times,* November 22, 1952.

6. For a more detailed account of the years 1934–57, see sections 5 and 6 (pp. 89–115) of my Rivera chronology in the Detroit Institute of Arts catalog *Diego Rivera: A Retrospective* (1986).

7. For the political activities of Mexican intellectuals and their concomitant cooptation by the government, see Alan Riding, *Distant Neighbors: A Portrait of the Mexicans* (Knopf, 1985), chapter 15. Peter Smith discussed the evocation of the murals of Orozco, Rivera, and Siqueiros by succeeding conservative Mexican administrations after World War II to bolster their self-defined "revolutionary" conscience in his unpublished lecture, "The Mexican Revolution: Perspectives and Legacies" at Dartmouth College, October 12, 1984. Leonard Folgarait treats Siqueiros's last mural at the Hotel de Mexico (Mexico City) and related political matters in his book to be published by the Cambridge University Press.

8. Richard H. Pells, *The Liberal Mind in a Conservative Age: American Intellectuals in the 1940s and 1950s,* p. 246.

9. *Ibid.,* p. 248.

10. From Davis, "Abstract Painting Today," in O'Connor, *Art for the Millions,* pp. 126–27.

11. Robert Goldwater, "Reflections on the New York School," *Quadrum* 8 (1960): 24. On the intellectual immigration of European intellectuals to the United States during the 1930s, see Laura Fermi, *Illustrious Immigrants* (University of Chicago Press, 1968).

12. Goldwater's term in "Reflections . . .", p. 34. Jackson Pollock provides an example of an artist who dramatically changed his interests and direction at this time. A member of the Siqueiros Experimental Workshop in 1936, who later in the decade incorporated images from Orozco's Dartmouth and Guadalajara

murals into his own work, Pollock fell under the influence of Picasso and Miro in the early 1940s, particularly in the assertion of a flat picture plane. See Francis O'Connor's unpublished lecture, "José Clemente Orozco's Influence on Jackson Pollock," given at Dartmouth College, October 13, 1984, and "The Genesis of Jackson Pollock," *Artforum* (May 1967): 21–23.

13. *Art News* review, March 1964, p. 10.

14. Pells, *The Liberal Mind*, p. 277.

15. *Ibid.*, p. 76.

16. Meyer Schapiro, "On David Siqueiros: A Dilemma for Artists," p. 197.

17. Michael Brenson, "Orozco: Mexican Conscience," a review of his European retrospective of 1979–80, in *Art in America* (September 1979):78.

18. Prof. Russell H. Fitzgibbon's article, "Mexican Communism and Diego Rivera," quoted in *Art Digest* (August 1953):14.

19. U.S. programs and pacts of the postwar era designed to preserve our dominant place in the hemisphere and Latin American dependence on North American manufactured goods included the Rio Pact of 1947 (collective measures against attack on any American state), the establishment of the Organization of American States in 1948, the "Point Four" technical assistance program of 1949, bilateral mutual defense pacts with ten Latin American nations (i.e., arming these countries with U.S. weaponry) during 1952–54, and in 1961, in response to the humiliation of the Bay of Pigs fiasco, the ballyhooed Alliance for Progress, which if concerned with measures for economic and social development also funded an accelerated counterinsurgency program (under the label of "public safety"). Along with these political measures, military and quasi-military actions to protect U.S. interests during these years include the CIA-assisted overthrow of Guatemalan President Arbenz (1954) and its attempts to assassinate Castro (early 1960s), the military occupation of the Dominican Republic (1965), and the CIA-"destabilization" of Chile's Allende regime (1973). On the United States in Latin America after World War II, see Thomas E. Skidmore and Peter H. Smith, *Modern Latin America* (New York: Oxford University Press, 1984), pp. 335–51.

20. Max Kozloff, "American Painting During the Cold War," *Artforum* (May 1973): 43–44.

21. Goldwater in "Reflections," pp. 20 and 24; Kozloff in "American Painting," p. 45.

22. Reinhardt's cartoon reproduced in *Artforum* (April 1971): 46.

23. As was the case during the 1930s, Rivera leads the way both in terms of exhibitions—the 1984 Cubist exhibition and the 1986 Detroit Institute of Arts retrospective—and sales. In 1959 twenty-seven Rivera paintings sold for a total of $167,000: in 1984 his *Flower Vendor* brought in $429,000, the highest price ever paid for a work of a Latin American artist.

Appendix A

1. From "Results of the Technical Analysis Completed during the week of February 11–16, 1974, of the Group of Murals Painted in 1930–31 by José Clemente Orozco at the New School for Social Research in the City of New York," by Tomás Zigurian Ugarte, Director of the National Center for the Conservation of Art Works (INBAL, Mexico), p. 17.

2. From transcript of the Panel Discussion held September 20, 1978, at the Detroit Institute of Arts during the Exhibition *The Rouge: The Image of Industry in the Art of Charles Scheeler and Diego Rivera*. Panelists: Lucienne Bloch Dimitroff, Stephen Pope Dimitroff, Ernst Halberstadt (assistants to Rivera at Detroit). Commentator: Linda Downs, p. 8.

3. From "Orozco 'Explains,' " Museum of Modern Art *Bulletin* (July 1940):8, which contains technical information concerning the six portable fresco panels (each nine by three feet), *Dive-Bomber and Tank*, which Orozco painted in the museum at this time.

4. I am grateful to restorer Nathan B. Zakheim for his diagram and related technical information in his report of January 29, 1983, "Evidence of Overpainting on the Surface of the *Prometheus* by José Clemente Orozco," prepared by Zakheim during his restoration of the mural and based on his visual analysis of Orozco's painting technique. Zakheim's first awareness that Orozco worked in a manner apart from purely *buon fresco* came in 1962 when he noticed flakes of painting that had fallen quite freely from the surface of Orozco's Hospicio Cabañas murals (Guadalajara, 1939); *ibid.*, p. 3.

5. Zigurian Ugarte, "Results . . .," pp. 17 and 23.

6. For fresco technique I have relied on the WPA/FAP pamphlet, "Fresco Painting" (WPA Technical

Series: Art Circular No. 4, Washington, D.C., September 10, 1940), Robert W. Dodds, Jr., "Fresco Painting" (Federal Works Agency, Works Project Administration, Washington, 1949); and the technical sources quoted in notes 1–4.

7. Andrés Sanchez-Flores, "The Technique of Fresco," p. 7.

Appendix B

1. *José Clemente Orozco: An Autobiography*, p. 145.

2. For more about the Section d'Or group, see John Golding, *Cubism: A History and an Analysis, 1907–14* (London: Faber and Faber, 1959), pp. 30–32.

3. Margaret Stern, *The Passionate Eye: The Life of William R. Valentiner* (Wayne State University Press, 1980), p. 194.

4. Orozco, *Autobiography*, pp. 144, 149.

5. Jay Hambidge, *The Diagonal*, p. 10.

6. *Ibid.*, pp. 10–11.

7. *Ibid.*, p. 15.

8. *Ibid.*, p. 27.

9. George Bellows, *American Art Student* (June 1921):5. Bellows's notebooks at the Archives of American Art reveal his indebtedness to Hambidge's theories to the extent that he had his stretchers constructed to fit "Dynamic Symmetry" specifications. See also S. Boorsch, "Lithography of George Bellows," *Art News* 75 (March 1976):60–62.

At the same time the doubtful nature of Hambidge's system received negative critical notices. Three important articles of this type are: E. M. Blake, "Dynamic Symmetry—A Criticism," *Art Bulletin* 3 (March 1921):107–27; R. Carpenter, "Dynamic Symmetry: A Criticism," *American Journal of Archeology* 25:1 (1921):18–36; and D. E. Smith, "Review of *Dynamic Symmetry* and *The Greek Vase*" (both by Hambidge), *The Nation* 3:2881 (1920):326–27. Blake's comment typifies the general tone of these articles:

It is difficult to understand how the followers of this method—now numerous and lacking neither faith nor enthusiasm—can credit a collection of simple rectangles with having occult power to decide the last subtle gradation of proportion necessary to the production of a masterpiece, be it a pottery vase, a silver bowl, or a figure composition.

SELECTED BIBLIOGRAPHY

The state of research concerning *los tres grandes* can best be illustrated by the fact that biographies accepted as standard works have been written by people with no training in the arts. Although Alma Reed, in her role as dealer, agent, and friend, had intimate knowledge of Orozco's North American years, her *Orozco* (1956) is flawed by her accounts of events and situations distorted at times to better suit her "cause": the master's reputation. Bertram Wolfe's biographies of Rivera (*Diego Rivera: His Life and Times*, 1939; *The Fabulous Life of Diego Rivera*, 1963) are weak in discussing his art in terms of style, technique, iconography, and conception. Moreover, as Ramón Favela has shown in his excellent account of the artist's early years (the exhibition catalog *Diego Rivera: The Cubist Years*, 1984), Wolfe's books contain many factual errors for this period. Finally, Wolfe, early in his career a Marxist educator, later an anti-Stalinist at the service of the conservative Hoover Institution on War, Revolution, and Peace, held political views antithetical to Rivera's late pro-Soviet position that taint his treatment of this period of Rivera's career in his second biography. Raquel Tibol, a journalist and self-styled art critic, has performed a valuable function in editing anthologies of Siqueiros's and Rivera's writings, yet her study, *Siqueiros: introductor de realidades*, also fails to discuss Siqueiros's art or to present an informed account of his political activities, especially relating to the Trotsky matter. More comprehensive studies of twentieth-century Mexican art (e.g., Schmeckebier's *Modern Mexican Art*, 1939; Meyers's *Mexican Painting in Our Time*, 1956) are marked by a superficial treatment. Schmeckebier wrote about Orozco's Guadalajara murals without viewing them (Orozco reacted in characteristic acid fashion). Mexican studies (e.g., Justino Fernández's *José Clemente Orozco: forma e idea*, 1942; Luis Cardoza y Aragón's *Orozco*, 1959) tend to center on description rather than interpretation. In contrast, David Scott's seminal article on Orozco's *Prometheus* (1957) stands as a model, albeit lonely, of art historical scholarship and insight in the field of modern Mexican painting.

Research Materials

OROZCO

The unfortunate difficulties involving the Orozco interfamily relationships have resulted in the dispersal of Orozco archival documentation and works of art. This material is divided among the widow, Sra. Margarita Valladares Orozco, the eldest son, Clemente, and daughter, Lucrecia, who all live in Guadalajara, and another son, Alfredo, of Naucalpan (a Mexico City district). Sra. Orozco, Lucrecia, and Alfredo have recently turned their possessions over to the state, and Orozco's work will be on permanent display in galleries at the Hospicio Cabañas, while the former Museo José Clemente Orozco (also in Guadalajara) will be an Orozco study center.

Clemente Orozco has published *Orozco, verdad cronología* (Universidad de Guadalajara, 1983). One wonders how the chronology can in fact be complete given the fact that he did not have access to documentation controlled by the other family members.

Orozco's letters to Charlot from December 1927 until February 1929 (published as *The Artist in New York: Letters to Jean Charlot and Unpublished Writings, 1925–29*, Austin: University of Texas Press, 1974) give a superb picture of Orozco's feelings about his situation in New York. Other writings of Orozco's are his at times laconic autobiography, which does not deal with his work after his return to Mexico in 1934, the useful technical writings, *Textos de Orozco* (ed. Justino Fernández, UNAM, Instituto de Investigaciones Estéticas, 1955), and his personal letters to his wife covering the years 1921–49 (*Cartas a Margarita*).

The Honnold Library (Claremont, California) and Baker Library (Hanover, New Hampshire) have extensive material relating to their respective Orozco murals, while the Museum of Modern Art Library in New York and the Departamento de Documentación e Investigación (INBA, Mexico City) have important documentation about Orozco's life and work in general. The Juley Photography Archives of the National Museum of American Art contains contemporaneous negatives of Orozco's New School for Social Research murals. They are valuable, in view of the deterioration of these works, in establishing how the panels looked when Orozco painted them. The Ferdinand Perret Research Library at the Archives of American Art (Washington, D.C.) has much useful information on art in southern California during the 1930s.

During his research on the *Prometheus*, David Scott corresponded with those closely associated with the mural (Pijoan, Crespo de la Serna) who are now deceased, and gathered related material on Orozco's early career.

The great loss in this area is the disappearance of Alma Reed's possessions after her death, including all records of the Delphic Studios, her papers from Orozco's time in the United States (1927–34), and even her Orozco art collection.

RIVERA

I have been told that Rivera's will stipulated that his archives not be made available to scholars for ten years after his death; however, almost thirty years later this material still has not been released. As head of the Fideicomiso Técnico Diego Rivera, Sra. Dolores Olmedo controls access to this information. Fortunately, researchers at the Departamento de Documentación e Investigación have amassed a collection of Rivera's published writings plus articles about him from various Mexican libraries and other sources; a selected group of Rivera's articles have been published by Raquel Tibol in *Arte y política* (Editorial Grijalbo, S.A., 1979). The Bertram Wolfe Collection at the Hoover Institution also contains a fair amount of material (up to 1939), clearly from Rivera's papers.

For the North American years I have obtained much relevant visual and written documentation from the archives of Lucienne Bloch Dimitroff and Stephen Dimitroff, who, along with another Rivera assistant at Detroit and New York, Ernst Halberstadt, patiently answered my many questions regarding this time in correspondence and tape recordings. For the "Detroit Industry" murals I have relied on Linda Downs's research and catalog *The Rouge: the Image of Industry in the Art of Charles Scheeler and Diego Rivera*. The San Francisco Museum of Modern Art and the San Francisco

294

Art Institute are important sources of information concerning Rivera's Bay Area murals, while the Messrs. Rockefeller Archives contain nearly everything ever published about the RCA mural controversy.

Rivera's endless ability to recast and invent autobiographical events colored his tales to biographers and his own accounts, the most extreme case being *My Art, My Life*.

His career until 1950 is voluminously illustrated in the exhibition catalog *Diego Rivera, 50 años de su labor artístico* which also contains articles by friends, artists, and critics. The recently published Detroit Institute of Arts exhibition catalog, with essays by various Mexican and North American art historians, provides a fresh assessment of Rivera's long and productive career.

SIQUEIROS

In contrast to the papers of Orozco and Rivera, Siqueiros's archives were organized and in use during his lifetime, although his brother-in-law, Leopoldo Arenal, has told me that a substantial amount of material concerning the pre-1940 period burned in their Mexican storage facility during the artist's exile of 1940–44. A selection of texts and photographs has been published by Raquel Tibol in *David Alfaro Siqueiros: un mexicano y su obra*, with more writings in *Textos de Siqueiros* (Archivo del Fondo, 1974); another selection appears in English under the title *Art and Revolution* (Camelot Press, 1975).

The papers of Harold Lehman and Roberto Berdecio contain a great deal of information concerning the California and New York years, as do the archives of José Renau about the Mexican Electricians Union mural.

As opposed to Orozco's terseness and Rivera's fantastic loquaciousness, Siqueiros (in *La trácala, Mi respuesta,* and the posthumous *Me llamaban el colonelazo,* 1977) and others (his wife Angélica Arenal de Siqueiros in *Páginas sueltas con Siqueiros,* 1979) wrote from the viewpoint of "official history," intending to solidify both the importance of Siqueiros's art and the correctness of his politics. There is no definitive history of the Mexican Communist Party and Siqueiros's association with it. The artist's most important publication, *Comó se pinta un mural* (Ediciones Mexicanos, 1951), delineated his approach to the conception and technique of mural painting in the specific case of the San Miguel de Allende project of 1948–49. As with Rivera, a large exhibition catalog (*Siqueiros: Por la vía de una pintura neorrealista o realista social moderna en Mexico,* 1951) illustrates in detail much of Siqueiros's career.

The last years and the disastrous final mural project, *The March of Humanity,* have been discussed by Leonard Folgarait, which I've read in manuscript.

THE UNITED STATES DURING THE 1930S

Indispensable research tools for the New Deal art projects are the publications edited by Francis V. O'Connor: *The New Deal Art Projects: An Anthology of Memoirs* (Smithsonian Institution Press, 1972) and *Art for the Millions: Essays from the 1930s by Artists and Administrators of the WPA Federal Art Project.* For the intellectual climate of these years, see Richard H. Pells, *Radical Visions and American Dreams: Culture and Social Thought in the Depression Years.*

Future Research Needs

OROZCO

The late years, 1934–49, from the Bellas Artes mural *Katharsis* (1934) to the final mural in Guadalajara (the Chamber of Deputies at the Palace of Government, 1948–49) need to be studied, along with many paintings, among them the important late series, *Los teules*, drawings, and graphics. This is a difficult, if not impossible, task given the problems involved in gaining access to all of Orozco's papers. Particularly important here is the contemporary meaning of Orozco's murals, which in their negative view of the human condition speak more for today's Mexico than the Marxist rhetoric of Rivera and Siqueiros. For example, his mural at the former Temple of Jesús (Mexico City, 1942–44) on the theme of the Apocalypse caused a scandal, yet its prophetic message seems perfectly suited for the urban catastrophe of today's Mexico City, with its teeming millions, incredible noise, pollution, poverty, and rampant corruption throughout the public and private sectors.

RIVERA

Studies are needed in two areas, the first Mexican murals of 1921–30, and the later Mexican years 1933–57. The latter period was one of great productivity and controversy; he completed a dozen major mural projects and hundreds of easel paintings, drawings, and graphics. In addition, the relationship of Rivera's political positions to his art and the actual importance politics held for Rivera require investigation, especially his association with the Mexican Communist Party during the 1920s, his espousal of Trotskyism during the late 1930s, and his adoption of a pro-Soviet stance in the late 1940s and 1950s, culminating with his readmission to the party in 1954. The reasons for Rivera's attraction to Stalinism should be examined, and the deleterious effect this had on his later "official" works (*The Nightmare of War and the Dream of Peace*, 1952; *Glorious Victory*, 1954), the only time in his career when his art assumed a purely propagandistic function. Again, difficulties in researching these areas arise from the problems in obtaining permission to consult Rivera's archives.

SIQUEIROS

Little research has been done on the mature years, 1941–60, during which he completed more than a dozen mural projects, entailing intensive technical and conceptual experimentation, his jailing, 1960–64, and after his release a complete change to a more free, almost calligraphic, painting style that at times becomes nonpolitical. The irony here is that Siqueiros, the most political of the artists and the only consistently orthodox Marxist, became the *least* concerned with politics at the end of his career.

Books

Azuela, Alicia. *Diego Rivera en Detroit*. Mexico: Universidad Nacional Autónoma de México, 1985.

Beals, Carlton, *Mexican Maze*. New York: Lippincott, 1931.

Benton, Thomas Hart. *An American in Art*. Lawrence: University of Kansas Press, 1969.

Berger, John. *The Success and Failure of Picasso*. London: Penguin, 1965.

Brenner, Anita. *Idols Behind Altars*. New York: Payson and Clarke, 1929.

Cardoza y Aragón, Luis. *Orozco*. Mexico: UNAM, 1959.

Caso, Alfonso. *The Aztecs: People of the Sun*. Norman: University of Oklahoma Press, 1958.

Charlot, Jean. *An Artist on Art*. Honolulu: University of Hawaii Press, 172.

———. *Mexican Art and the Academy of San Carlos, 1785–1914*. Austin: University of Texas, 1962.

———. *The Mexican Mural Renaissance*. New Haven: Yale University Press, 1963.

Chase, Stuart. *Mexico: A Study of Two Cultures*. New York: MacMillan, 1931.

Collier, Peter, and David Horowitz. *The Rockefellers. An American Dynasty*. New York: Holt, Rinehart, and Winston, 1976.

Cooke, H. Lester, Jr. *Fletcher Martin*. New York: Abrams, 1977.

Cornyn, J. H., trans. *The Song of Quetzalcoatl*. Antioch: Antioch Press, 1931.

de la Torriente, Lola, comp. *Memoria y razón de Diego Rivera*. Mexico: Ed. Renacimiento, 1959.

Detroit Institute of Arts. *Diego Rivera: A Retrospective*. New York: W.W. Norton, 1986.

Deutscher, Isaac. *The Prophet Outcast: Trotsky, 1929–1904*. London and New York: Oxford University Press, 1963.

Diego Rivera: 50 años de su labor artístico. Exhibition catalog, Mexico, Instituto Nacional de Belles Artes, 1951.

Exposición nacional de homenaje a Diego Rivera, con motivo del XX anniversario de su fallecimiento. Exhibition catalog, Palacio de Bellas Artes, 1977–78.

Egbert, D. D., and Stew Persons, eds. *Socialism and American Life*, Princeton: Princeton University Press, 1952.

Favela, Ramón. *Diego Rivera: The Cubist Years*. Phoenix: Phoenix Art Museum, 1984.

Fernández, Justino. *El arte moderno en Mexico*. Mexico: UNAM, 1937.

———. *A Guide to Mexican Art*. Chicago: University of Chicago Press, 1969.

———. *José Clemente Orozco: forma e idea*. Mexico: UNAM, 1942.

———. *Prometeo, ensayo sobre pintura contemporánea*. Mexico: Editorial Porrúa, S.A., 1945.

Flaccus, Kimball, ed. *Orozco at Dartmouth: A Symposium*. Hanover, N.H.: Arts Press, 1933.

Folgarait, Leonard. *So Far from Heaven: Siqueiros' "The March of Humanity" and Mexican Revolutionary Politics*. Cambridge: Cambridge University Press, 1987.

Helm, MacKinley. *Man of Fire: J. C. Orozco; an interpretive memoir*. New York: Harcourt, Brace, 1953.

Herrera, Hayden. *Frida: A Biography of Frida Kahlo*. New York: Harper & Row, 1983.

Herzfeld, Wieland. *John Heartfield, Leben und Werk*. Dresden: Verlag der Kunst 1970.

Hill, Ralph Nading, ed.. *The College on the Hill: A Dartmouth Chronicle*. Hanover, N.H.: Dartmouth Publications, 1964.

Josephson, Matthew. *Infidel in the Temple: A Memoir of the Nineteen-Thirties*. New York: Knopf, 1967.

Kirk, Betty. *Covering the Mexican Front: The Battle of Europe Versus America*. Norman: University of Oklahoma Press, 1942.

Krinsky, Carol Herselle. *Rockefeller Center*. London: Oxford University Press, 1978.

Lafaye, Jacques. *Quetzalcoatl and Guadalupe: The Formation of Mexican National Consciousness, 1531–1813*. Chicago: University of Chicago Press, 1976.

León-Portilla, Miguel. *Pre-Columbian Literatures of Mexico*. Norman: University of Oklahoma Press, 1969.

Lopéz-Portillo, José, Demetrio Sodi, and Fernando Díaz Infante. *Quetzalcoatl in Myth, Archaeology, and Art*. New York: Continuum, 1982.

Lyon, E. Wilson. *The History of Pomona College, 1887–1969*. Claremont: Pomona College, 1977.

Mayer, Ralph. *The Artist's Handbook of Materials and Technique*. 3rd ed. New York: Viking Press, 1970.

McMeekin, Dorothy. *Science and Creativity in the Detroit Murals*. East Lansing: Michigan State University Press, 1985.

Morford, Mark P. O. *Classical Mythology*. New York: David McKay Company, 1971.

Mosley, Nicholas. *The Assassination of Trotsky*. London: Abacus, 1972.

Mumford, Lewis. *My Works and Days: A Personal Chronicle*. *New York:* Harcourt Brace Jovanovich, 1979.

Museum of Modern Art. *Diego Rivera*. Exhibition catalog, 1931.

Myers, Bernard Samuel. *Mexican Painting in Our Time*. New York: Oxford University Press, 1956.

Nevins, Allan, and Frank Ernest Hill. *Ford: Expansion and Challenge*. New York: Scribners, 1957.

Nicholson, Irene. *Mexican and Central American Mythology*. London: Paul Hamlyn, 1967.

O'Connor, Francis, ed. *Art for the Millions*. Greenwich: New York Graphic Society Ltd., 1973.

———. *Federal Art Patronage, 1933–43*. College Park: University of Maryland Press, 1966.

Orozco, José Clemente. *An Autobiography*. Austin: University of Texas Press, 1962.

———. *Cartas a Margarita*, Mexico City: Ediciones Era, 1987.

———. Preface to *Fresco Painting*, a technical manual by Gardner Hale. New York: Edwin Rudge, 1931.

Orozco, Clemente V. *Orozco, verdad cronológica*. Guadalajara: EDUG/Universidad de Guadalajara, 1983.

Pells, Richard H. *Radical Visions and American Dreams: Culture and Social Thought During the Depression Years*. New York: Harper and Row, 1973.

Pierrot, George F., and Edgar Richardson. *An Illustrated Guide to the Diego Rivera Frescoes*. Detroit: Detroit Institute of Arts, 1934.

Prewett, Virginia. *Reportage on Mexico*. New York: E. P. Dutton, 1941.

Proceedings, First American Artists Congress (New York, 1936).

Reed, Alma. *Orozco*. New York: Oxford University Press, 1956.

Rivera, Diego. *Portrait of America*. Includes an explanatory text by Bertram D. Wolfe. New York: Covici, Friede, 1934.

Rivera, Diego, and Gladys March. *Diego Rivera: My Art, My Life*. New York: Citadel Press, 1960.

Rochfort, Desmond. *The Murals of Diego Rivera*. London: South Bank Board, 1988.

Rosenblum, Robert. *Cubism and Twentieth Century Art*. New York: Prentice-Hall, 1979.

Salazar, Rosendo. *México en pensamiento y en acción*. Mexico: 1926.

Scherer Garcia, Julio. *La piel y la entraña (Siqueiros)*. Mexico: Ediciones Era, 1965.

Schmeckebier, Lawrence. *Modern Mexican Art*. Minneapolis: University of Minnesota Press, 1939.

Sejourné, Laurette. *Burning Water: Thought and Religion in Ancient Mexico*, London: Thames and Hudson, 1967.

Siqueiros, David Alfaro, *La trácala*. Mexico: privately printed, 1962.

———. *Mi respuesta*. Mexico: Arte Público, 1960.

Smith, H. Allen. *The Pig in the Barber Shop*. Boston: Little, Brown, 1958.

Soustelle, Jacques. *The Daily Life of the Aztecs on the Eve of the Spanish Conquest*. New York: MacMillan, 1962.

Sterne, Margaret. *The Passionate Eye: The Life of William R. Valentiner*. Detroit: Wayne State University Press, 1980.

Suaréz, Orlando S. *Inventario del muralismo mexicano*. Mexico: UNAM, 1972.

Tibol, Raquel. *David Alfaro Siqueiros: un mexicano y su obra*. Mexico: Empresas Editoriales, 1969.

———. *Siqueiros: introductor de realidades*. Mexico: UNAM, 1961.

Trotsky, Leon. *Literature and Revolution*. London: Russell and Russell, 1957 (first published 1923).

Warburg, Edward M. M. *As I Recall: Some Memoirs of Edward M. M. Warburg*. Privately printed, n.d..

Widmayer, Charles E. *Hopkins of Dartmouth: The Story of Ernest Martin Hopkins and the Presidency of Dartmouth College*. Hanover, N.H.: University Press of New England, 1977.

Wolfe, Bertram. *Diego Rivera: His Life and Times*. New York: Knopf, 1939.

———. *The Fabulous Life of Diego Rivera*. New York: Stein and Day, 1963.

———. *A Life in Two Centuries*. New York: Stein and Day, 1981.

Wolfe, Bertram, and Diego Rivera. *Portrait of America*. New York: Covici-Friede, 1934.

Zea, Leopoldo. *The Latin American Mind*. Norman: University of Oklahoma Press, 1963.

———. *Positivism in Mexico*. Austin: University of Texas Press, 1974.

Baas, Jacqueline. "Interpreting Orozco's Epic." *Dartmouth Alumni Magazine* (January–February 1984): 44–49.

Bailey, Joyce Waddell. "José Clemente Orozco (1883–1949): Formative Years in the Narrative Graphic Tradition." *Latin American Research Journal* 15 (1980):30.

Barnitz, Jacqueline. "Orozco's Delphic Years." Unpublished paper given at Orozco symposium, Guadalajara, 1979.

Beard, Charles. "Education and the Social Problem." *Social Frontier* (April 1935): 13–16.

Bloch, Lucienne. "On Location with Diego Rivera." *Art in America* (February 1986): 102–23.

Bowlt, John W. "The Failed Utopia, Russian Art 1917–32." *Art in America* 59 (July 1971): 40–51.

Brenner, Anita. "Diego Rivera: A Crusader of Art." *New York Times Magazine* (April 2, 1933): 10, 11–25, 26.

———. "The Rockefeller Coffin." *The Nation* (May 24, 1933): 595–96.

"The Evolution of a Rivera Fresco: an Interview with Mrs. Sigmund Stern." *California Arts and Architecture* (June 1932).

Chase, Stuart. "Men Without Machines, V: The Basic Pattern." *New Republic* (July 15, 1931): 231–33.

Chipp, Hershel. "Guernica: Love, War, and the Bullfight." *Art Journal* 33, no. 2 (Winter 1973–74): 100–115.

Crespo de la Serna, Jorge Juan. "Sentido y gestación del *Prometeo* de Orozco." In *José Clemente Orozco: homenaje*, Universidad de Guadalajara, 1951.

Dodds, Robert W., Jr. *Fresco Painting*. Washington, D.C.: Federal Works Agency, WPA, 1939 (pamphlet).

Downs, Linda. "The Rouge in 1932: The *Detroit Industry* Frescoes of Diego Rivera." Detroit Institute of Arts exhibition catalog *The Rouge* (1978).

———, commentator. "Transcript of the Panel Discussion held September 20, 1978, at the Detroit Institute of Arts during the exhibition *The Rouge: The Image of Industry in the Art of Charles Scheeler and Diego Rivera* (panelists Lucienne Bloch Dimitroff, Stephen Pope Dimitroff, and Ernst Halberstadt)

Deutsche, Rosalyn. "Alienation in Berlin: Kirchner's Street Scenes." *Art in America* 71 (January 1983): 64–72.

Eisenberg, Emanuel. "Battle of the Century." *New Masses* (December 10, 1935): 18–20.

Faure, Elie. "Diego Rivera." *Modern Monthly* (1934): 545–46.

Frank, Waldo. "Pilgrimage to Mexico." *The New Republic* (July 1, 1931): 183–84.

Goldman, Shifra. "Siqueiros and Three Early Murals in Los Angeles." *Art Journal* (Summer 1974): 321–27.

Greuning, Ernest. "A Maya Idyll." *Century Magazine* (April 1924): 832–36.

Gutiérrez, José. "La Inolvidable Peregrina." *Selecciones de Readers's Digest* (November 1968): 57–64.

Hambidge, Jay. *The Diagonal*, 1919–21.

Horn, Axel. "Jackson Pollock: The Hollow and the Bump." *Carleton Miscellany* (Summer 1965): 80–87.

Hurlburt, Laurance P. "David Alfaro Siqueiros' *Portrait of the Bourgeoisie*." *Artforum* (February 1977): 39–46.

———. "Notes on Orozco's North American Murals, 1932– 34." In the exhibition catalog *¡Orozco!*, Museum of Modern Art, Oxford (England), Fall 1980.

———. "The Siqueiros Experimental Workshop: New York, 1936." *Art Journal* (Spring 1976): 237–346.

Johnson, Alvin. "Notes on the New School Murals." Pamphlet from 1943, n.p., but probably the New School.

Kirstein, Lincoln. "Siqueiros: Painter and Revolutionary." *Magazine of Art* (January 1944): 23–34.

Kozloff, Max. "The Rivera Frescoes of Modern Industry at the Detroit Institute of Arts: Proletarian Art Under Capitalist Patronage." *Artforum* 12, no. 3 (November 1973): 58–63.

"Profile: Imperturbable Noble." *New Yorker* (May 9, 1960).

Lehman, Harold. "For an Artists' Union Workshop." *Art Front* (October 1937): 10–12.

Llergo, José Pages. "David Alfaro Siqueiros marca nueva etapa, a golpes de pincel." *La Opinión* (May 15, 1932): n.p.

Marling, Karal Ann. "A Note on New Deal Iconogra-

phy: Futurology and the Historical Myth." *Prospects* 4 (1979): 421–40.

McMeekin, Dorothy. Unpublished article, "The Creative Process in Science and Art" (1983).

———. "The Historical and Scientific Background of Three Small Murals in the Detroit Institute of Arts." Michigan Academy of Science, Arts and Letters *Journal* (1983).

———. Unpublished lecture, "Science and Its Broad Cultural Context in the Detroit Murals" (March 5, 1983).

Millier, Arthur. Various columns in *The Los Angeles Times*. July 3, 1932; September 4, 1932; October 9, 1932; October 10, 1932; October 16, 1932. December 11, 1932; August 26, 1934; June 23, 1935.

Mumford, Lewis. "Orozco in New England." *The New Republic* (October 10, 1934): 231–35.

Naggar, C. "Photomontages of José Renau." *Artforum* 17 (Summer 1979): 32–36.

Newhall, Beaumont. "How Diego Rivera Paints." Unpublished article, n.d.; Museum of Modern Art New York. archives.

"Rivera's Wife Rues Art Ban." *New York World-Telegram*, May 10, 1933.

O'Connor, Francis. "The Diego Rivera Murals." Lecture given at the Detroit Institute of Arts, March 20, 1977.

Orozco, José Clemente. "New World, New Races, and New Art." *Creative Art* 4, no. 1 (January 1929): suppl. 44–46.

———. "Orozco 'Explains'." Museum of Modern Art *Bulletin* 7, no. 4 (August 1940): 1–12.

Pach, Walter. "Rockefeller, Rivera, and Art." *Harper's* (September 1933): 476–83.

Packard, Artemas. "The Dartmouth Frescoes." *Dartmouth Alumni Magazine* (November 1933).

Parker, Ralph. "Siqueiros on New Forms in Art." *New World Review* (February 1958): 13–17.

Paz, Octavio. "Social Realism: The Murals of Rivera, Orozco, and Siqueiros." *Arts Canada* (December–January 1979–80): 58–66.

Pomona College, men of Frary Hall. *Prometheus: An Appreciation*, 1930.

Quirarte, Jacinto. "The Coatlicue in Modern Mexican Painting." University of Texas-San Antonio *Research Center for the Arts Review* (April 1982): 5–12.

Refregier, Anton. "David Alfaro Siqueiros." *American Dialogue* (April 1968): 4–5.

Renau, José. "Mi experencia con Siqueiros." *Revista de Bellas Artes* (January–February 1976): 3–26.

Rivera, Diego. "The Radio City Mural." *Worker's Age* (June 15, 1933): 4 pages (not numbered).

———. "Dynamic Detroit." *Creative Art* 12, no. 4 (April 1933): 289–95.

———. "The Plastics of Painting." Lecture at the New Workers School, December 9, 1933.

Rogo, Elsa. "David Alfaro Siqueiros." *Parnassus* (April 1934): 5–7.

Sanchez-Flores, Andrés. "The Technique of Fresco." *Architectural Forum* (January 1934): 7–10.

Schapiro, Meyer. "David Siqueiros: A Dilemma for Artists." *Dissent* 10 (1962): 106–7.

Scott, David. "The Origins of Modern Art in Mexico." Paper delivered at the College Art Association meeting, January 1957, New York.

———. "Orozco's Pomona College and New School Murals, and Their Kinship to Dartmouth." Lecture, Dartmouth College, October 13, 1984.

———. "Orozco's *Prometheus:* Summation, Transition, Innovation." *College Art Journal* 17, no. 1 (Fall 1957): 2–18.

Siqueiros, David Alfaro. "Arte Civil," Unpublished manuscript, Siqueiros Archives, Mexico City, 1941–42.

———. "Open Letter to Soviet Painters." *Masses and Mainstream* 9, no. 3 (1956): 1–6.

———. "Qué es *Ejercio Plástico* y cómo fue realizado." Pamphlet published in Buenos Aires, December 1933.

———. "Rivera's Counter-Revolutionary Road." *New Masses* (May 29, 1934): 16–19.

Stair, Gobin. "The Making of a Mural: A Handyman's Memoir of José Clemente Orozco." *Dartmouth Alumni Magazine* (February 1973): 22–23.

Wilson, Edmund. "Art, the Proletariat, and Marx." *The New Republic* (August 23, 1933): 41–45.

———. "Detroit Paradoxes." *The New Republic* (July 12, 1933): 230–33.

Wolfe, Bertram. "Diego Rivera on Trial." *Modern Monthly* (July 1934): 337–41.

WPA Technical Series, "Fresco Painting." Arts circular no. 4 Washington, D.C., September 10, 1940).

Zakheim, Nathan B. "Evidence of Overpainting on

the Surface of the *Prometheus* of José Clemente Orozco." Unpublished report, January 29, 1983.

Zugurian Ugarte, Tomás. "Results of the Technical Analysis Completed during the Week of February 11–16, 1974, of the Group of Murals Painted in 1930–31 by José Clemente Orozco at the New School for Social Research in the City of New York." Unpublished report.

INDEX

Numbers in bold face refer to plate numbers; numbers in italics are figure numbers.

303